"In *The Saint John's Bible* the art, plentiful and beautiful, is not there as decoration or even as illustration: it is there to illuminate, to light up Holy Scripture from within. It is sacred art, focused intently on Sacred Revelation. Susan Sink's magnificent book is above all a biblical book. She leads us into every section of the Bible, puts it in context for us, and makes clear how the art springs from and refers back to a salvific meaning. It is a book almost impossible to comprehend; it does not ask us to comprehend. What it does ask is that we open our minds and hearts and allow the Word of God, written, drawn, and painted, to transform us. These pages are not for mere reading. They are for lectio divina, as befits a Benedictine book."

> —Sister Wendy Beckett,
> Contemplative nun, author, art commentator

"By its sheer beauty and craftsmanship *The Saint John's Bible* compels its viewers to stand in awe. That experience will be further enhanced when readers have in hand Susan Sink's *The Art of* The Saint John's Bible. She presents us with finely crafted answers to questions we might not have even been aware we were seeking. *Why that image? Those colors? How did they . . . ?* A solid contribution to an epic enterprise."

> —George Wilson, SJ

THE ART OF THE SAINT JOHN'S BIBLE

The Complete Reader's Guide

SUSAN SINK

THE SAINT JOHN'S BIBLE

Collegeville, Minnesota

A Saint John's Bible Book published by Liturgical Press.

Donald Jackson – Artistic Director

www.saintjohnsbible.org

Cover design by Ann Blattner.
Front cover images by Donald Jackson (details from *Creation* and *Vision of the New Jerusalem*) and Thomas Ingmire (detail from *Out of the Whirlwind—He Will Wipe Every Tear*).
Back cover images by Donald Jackson (details from *Vision of the Son of Man* and *Vision of the New Jerusalem*) and Thomas Ingmire (detail from *The I AM Sayings*).

The author gratefully acknowledges contributions to this revised volume as well as the previous volumes of *The Art of The Saint John's Bible* by members of *The Saint John's Bible* team. Donald Jackson's presentations to the Committee on Illumination and Text (CIT) and notes on the work were invaluable in understanding his approach, techniques, and visual vocabulary, as well as how the artists collaborated. Jackson and Sarah Harris in Wales read the manuscripts and offered information and clarification. First Carol Marrin and then Tim Ternes and Linda Orzechowski provided me with additional information, insight, and answers to questions from my first encounter with these texts in 2006 until completion of this revised work in early 2013. The chair of the CIT, Father Michael Patella, OSB, generously shared his time throughout the process to help me understand the theological underpinnings of these volumes and the choices made as to what is illuminated and emphasized. He read drafts of the manuscript and offered suggestions that clarified both the ideas and the prose. I am also grateful for the careful work of the editing and production team at Liturgical Press who have paid loving and careful attention to the manuscripts and produced beautiful and accurate books. I am only one reader of the Bible, and what you find here is only one offering in the long discussion that began before Jackson put quill to vellum to write the first words of the book of John and will continue wherever the Word goes into the world. I hope that this book offers a starting point for a deeper experience of the images and texts. I hope that the reader's journey through the Scripture texts will be as rewarding as the *visio divina* that resulted in this book.

CONTENTS

ILLUMINATIONS

PREFACE

T HE FIRST VOLUME of *The Art of The Saint John's Bible* came out in 2007. At the time, three volumes of *The Saint John's Bible* had been completed: *Gospels and Acts*, *Pentateuch*, and *Psalms*. Liturgical Press had hired me as a copyeditor, and it was in my first week of work that director Peter Dwyer came to my office and asked if I would be interested in this project. It was something people had been asking for since pages of *The Saint John's Bible* began touring in a major exhibition in 2005. People wanted to know, "What are we looking at?" Why was a certain passage from the Bible chosen for illumination by the Committee on Illumination and Text (CIT) rather than another? What materials and source imagery are behind the illuminations created by Donald Jackson and his team of artists and calligraphers?

At that time there was quite a bit of reference material available, such as planning documents and detailed descriptions, to accompany the traveling exhibition into museums. As the last four volumes of *The Saint John's Bible* were delivered to Saint John's Abbey and University, however, the reference material became slimmer. Pages from the Bible were mostly on display at the Hill Museum & Manuscript Library (HMML) on campus, often without much explanatory text.

I always had access to a videotaped version of Donald Jackson's presentations to the CIT when he delivered the volumes. This gave me some insight into his process and source materials, as well as clues to the way images and visual motifs worked throughout a particular volume. Each time a volume was completed, I also sat down with Fr. Michael Patella, OSB, the director of the CIT, who walked me through the significance of the biblical texts being illuminated and the way the images emphasized particular theological themes within and across volumes.

That was my foundation. As the project went on, however, I realized that much of what I wrote about the images came out of my own practice of *lectio* and *visio divina*, reflecting on the biblical passages and commentary, often in a reading chair in my office, then moving to the images spread out in the reproduction volumes on my desk. In these sessions, I tried to remain attentive to what I'd seen before in other volumes, such as patterns moving across the volumes or points of reference that deepened my experience with the text and image in front of me.

One way I know that my personal experience made its way onto the page as the project progressed is by the way readers have responded to the books. People have told me they could hear that these volumes were not merely a compendium of material collected by an editor but a reflection written by an individual. Always, I have to say, I have felt the Holy Spirit at work in this writing process. It has been a privilege to work with the Bible in this way and to spend so much time with *The Saint John's Bible*. There is such richness in these texts and images that every time I sat down to work on the project, there was something there for me to discover and to write about.

The purpose of this edition was, first of all, to straighten out the order of the books! They were completed and made available in a reproduction edition in this order: *Gospels and Acts, Pentateuch, Psalms, Prophets, Wisdom Books, Historical Books,* and *Letters and Revelation.* That's the order in which I first encountered and wrote about them. Particularly strange in that process was the way the New Testament bookended the rest. This edition of *The Art of The Saint John's Bible* takes them in the order they appear in the Bible, from Genesis to Revelation. It also attempts to make more connections to images and motifs that reoccur throughout the volumes. And finally, it is much more informed by my later process, that of *visio divina*, than by research into materials produced by *The Saint John's Bible* project. For me to write it, it had to be a new book. I hope this book does not lose what was of value in those original three volumes but rather intensifies the readers' experience of *The Saint John's Bible* by reflecting on the images with a view to the whole.

<div style="text-align: right;">

Susan Sink
January 2013

</div>

INTRODUCTION

Illuminate: \vt\ from *in* + *luminare* to light up, from *lumin-, lumen* light. 1a: to enlighten spiritually or intellectually b: to supply or brighten with light; 2a: to make clear b: to bring to the fore; 3: to make illustrious or resplendent; 4: to decorate (as a manuscript) with gold or silver or brilliant colors or with often elaborate designs or miniature pictures.

S TRICTLY SPEAKING, there can be no illumination of a manuscript without gold. Although the definition has been expanded to apply to any brightly colored illustration, the relationship to light is lost in this broader usage. It is gold that reflects the light to the viewer. In this way, the light is meant to come out of the illumination, not reside in it. In an illuminated Bible, the art attends to the revelation in the words. Text and image both reflect God's presence, both reveal God's mystery.

From an artistic perspective, silver has the same effect, but its use was scaled back in early manuscripts because, unlike gold, it oxidizes black and, worse, eats through the parchment. In *The Saint John's Bible*, "silver" is used throughout the volume *Wisdom Books* to represent Wisdom, but platinum was used to avoid the oxidation issue.

Extensive use of gold leaf, applied to the page over a surface of gesso, is rubbed with a burnishing tool to shine even brighter. Gold became more common in Western manuscripts in the twelfth century, in imitation of Eastern mosaics, icons, and manuscripts. In the Eastern or Byzantine tradition, a background of gold is symbolic of heaven, the incorruptible outside of fallen creation—a tradition that has carried over to the West. In *The Saint John's Bible*, gold was used to show the presence of the Divine. As the fortunes of Abraham and his descendants rise and fall and as God breaks into human experience directly in the person of Jesus Christ, gold reminds us to look for God in the text and be aware of what the text reveals about God and God's relationship to this created world.

Illuminations are full of symbolism and, by nature, theological interpretations. Contemporary theology is exciting, in part, because of both its openness to the past and present and its increased ecumenical sensibility. If the second half of the last millennium (from the Reformation in the sixteenth century to the twentieth) was a period of constant schism and breaking off into multiple denominations within Christianity, then the last

half of the twentieth century seems to mark a shift to a new age of integration and reconciliation as denominations share their treasures with each other and people from varied spiritual traditions focus on their similarities rather than differences. The ecumenical movement, as well as movements within individual traditions, has brought about greater understanding of what it means to worship one God and share the same Scriptures. The ecumenical focus partly determined the choice of the New Revised Standard Version translation—a translation used by not only Catholics but also many Protestant denominations.

This Bible is also intentionally multicultural and contemporary, with its imagery drawing on various traditions and aesthetics from both the ancient and modern world. The images expand our visual vocabulary and invite us to embrace new symbols and contemplate new images in the context of the revelation of the Bible. On the pages of *The Saint John's Bible* you will see the double helix of DNA, images from the Hubble telescope, mandalas, patterns from Middle Eastern and South Asian textiles, an image of the Twin Towers of the World Trade Center in New York, and meticulously drawn butterflies, dragonflies, and black flies. You will also find a variety of images of Christ—as worker, as shaft of light, as Word, as teacher, as icon, as baptized, as transfigured, as crucified, as resurrected, as Son of Man surveying the New Jerusalem.

The Saint John's Bible is more than an artistic work and more than a book. The project is a source of reflection, both for the team that created it and for everyone who views it either in reproduction or in exhibition. As people look at the images and read the text, they become interested in the ancient arts of calligraphy and illumination and in the way text and image work together in an illuminated Bible.

"The illuminations are not illustrations" says Father Michael Patella, chair of the Committee on Illumination and Text (CIT). "They are spiritual meditations on a text. It is a very Benedictine approach to the Scriptures." A primary spiritual practice of Benedictine monks is *lectio divina*, a prayerful, reflective reading of Scripture. *The Saint John's Bible* has opened the door to a practice they're calling *visio divina*, using the illumination to open up and explore Scriptures, letting them speak to us in new ways.

This guide is designed as a reference book for those who are doing their own contemplative study of the Bible. This guide offers some context to place you in the biblical text associated with an illumination and information on the techniques and sources of the images. The reproductions here

are meant as references to the larger scale reproductions in the volumes of *The Saint John's Bible*. It will be difficult to see enough detail in this book alone to do a meaningful reflection.

Like all illuminated and biblical manuscripts, this one reflects the spiritual aspirations of the people who created it. The CIT, comprised of biblical scholars, theologians, artists, and historians, reflected deeply and broadly on the relationship of text and art to tradition and proclamation. This group identified which Scripture passages would receive attention and the scale of the treatment (i.e., special rendering of the text, a small illumination or a full-page illumination). They produced a schema for each volume that outlined the themes to be emphasized, the interpretation and significance of the highlighted Scripture passages, and possibilities for imagery. Reflecting Benedictine values, the illuminations and text treatments were chosen to particularly highlight three biblical themes: hospitality, conversion of life, and justice for God's people. The Benedictine understanding of radical hospitality can clearly be seen in the text treatments of *Pentateuch* that emphasize welcoming the stranger and caring for the widows and orphans in our midst.

Individual volumes also highlight particular themes. In *Wisdom Books* the feminine aspects of God are highlighted. In *Historical Books* marginal text treatments draw attention to the cycle of disobedience and God's mercy throughout the unfolding history of the Israelites. In *Revelation* the connection to the words of the Old Testament prophets are emphasized by reprising images found in the earlier volume.

The calligraphers and artists brought their energy and craft to every visual element. Donald Jackson, the art director, designer, and lead calligrapher and artist on the project, says of calligraphy: "It's capable of picking up emotions from inside me and putting them on the page. There's an energy that comes from the soles of my feet right to the top of my head." *The Saint John's Bible* is not a mechanical rendering of archetypical images assigned to the text. It is an original manuscript with not only the whole history of calligraphy and illumination as its source of reference but also with contemporary theologians, artists, and craftspeople as its contributors.

Each of the 1,127 pages of *The Saint John's Bible* took seven to thirteen hours to write and was written by one of six scribes working in Donald Jackson's scriptorium in Wales. Their work was a nice parallel to the Liturgy of the Hours at Saint John's Abbey, a regular practice of gathering the community at morning, noon, and evening to recite the psalms, listen

to the Word, and pray. Given their practice of *lectio divina*, it is easy to see why Benedictines were so often the early calligraphers, illuminators, and preservers of sacred texts through the Dark Ages in Europe.

The Art of The Saint John's Bible is not meant to be the final word on any of the images but a starting place. We intend it as a companion piece to the reproduction volumes. First and foremost, it has been written with a consciousness of the way text and image work together in *The Saint John's Bible* in order to bring people into contact with the sacred power of God's word. Unlike images in an art exhibit catalog or book of prints, these images mean very little without the Scripture that inspired them. We hope that you will read the entire passage outlined at the top of each entry before diving into the essays and accompany this book with either a Bible or one of the reproduction volumes. The images are here to illuminate the Word, and the Word is also necessary to illuminate the image. For that reason we invite you to approach this reader's guide only as a way to enhance your own experience of the text and image before you. The experience will be richest if it is your own.

Because it is the Bible that we're exploring, the guide will take some time to introduce the context behind the artwork. What is the Pentateuch? Why are there four gospels? Why doesn't *Psalms* have more images? Why did the CIT choose these passages to illuminate? Answers to questions like these will help readers make sense of the Bible project as a whole.

When approaching the essay for each major illumination, take some time with the Scripture passage first. At the beginning of each essay we have provided a question for you to consider. The essay draws your attention to particular elements of the image. Finally, return to the Scripture passage. What strikes you about it now that you didn't notice before? Ask yourself: Have I also been illuminated?

PENTATEUCH

INTRODUCTION

THE PENTATEUCH is the Greek name for the first five books of the Old Testament. In their final form, they were collected from multiple sources after the two-century-long Assyrian and Babylonian captivity (722 B.C.E. through 538 B.C.E.). By the time of exile, Israel had lived through its early formation, from the call of Abraham out of the land of Ur (present-day Iraq) all the way to the Promised Land. After the long period of slavery in Egypt, Moses and then Joshua led the Israelites to Canaan, where the Lord delivered a large territory into their hands.

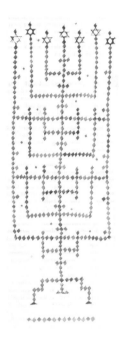

Genesis and Exodus, the first two books of the Pentateuch, tell the stories of the Israelites from their creation in Genesis through their arrival at the Promised Land. After the opening accounts of creation, the flood, and other foundational stories, Genesis 18–50 tells the story of Abraham and his descendants through Joseph, ending in Egypt. Exodus begins with the birth of Moses and ends with the account of Moses setting up the tabernacle with the ark of the covenant in the desert. This house of the Lord will accompany them throughout their wanderings in the desert.

The final three books of the Pentateuch (Leviticus, Numbers, and Deuteronomy) contain the law of Moses. Finally, at the end of Deuteronomy, the story picks up at the edge of the Promised Land, where Moses foretells the history of Israel and then dies on the hills above the Jordan without entering the land of milk and honey.

The displacement and inculturation of generations in exile had ruptured the identity of the people of Israel, and they turned to a unified temple practice and a text—the Torah, the law of Moses—to unite them as the Jewish people. The Torah is the Hebrew name for the Pentateuch. From the time of Moses on, the Old Testament historians tell of the relationship between the people and God through faithfulness or unfaithfulness to the Torah. When King Josiah is brought the book of the Law after a long

period of unfaithful kings, he weeps and mourns, knowing that Israel has broken the covenant and so will face destruction.

Tradition has long claimed that Moses himself wrote the complete Torah as given to him by God on Mount Sinai and that the people of Israel carried it in the ark of the covenant into the Promised Land. It is much more likely that most of the document we now read was written after the Israelites settled in one place (namely, Canaan) and supplemented with other texts after the Babylonian captivity. In any event, it is the story of the people and their relationship to the one true God. It was written to remind them of their ancestors and of the story of God's faithfulness and promises to them—often despite their own unfaithfulness.

These are the stories meant to bring a people home to themselves and keep them on a path with their God. The stories of the Pentateuch have indeed brought comfort to captives and to those living in oppression. Jesus quoted these texts and declared that he came not to replace the Law but to fulfill it. These books provided inspirational text for the songs and sermons of the civil rights movement and other nonviolent movements worldwide. A text treatment in Leviticus highlights the teaching: "The alien who resides with you shall be to you as the citizen among you; you shall love the alien as yourself, for you were aliens in the land of Egypt: I am the LORD your God" (Lev 19:34). This text has special resonance today, as countries wrestle with issues of immigration and nationalism.

The five books of the Pentateuch bring together a variety of foundational accounts and texts that underlie the Jewish, Christian, and Islamic faiths. They include the great moral code engraved by God onto tablets atop Mount Zion: the Ten Commandments. They include the two stories of creation—one of the world and humankind in seven days, the other of the humans Adam and Eve and the Garden of Eden—our first stories about who God is, God's relationship to the universe and, specifically, to humankind.

The challenges for an artist in visually representing even one of these texts are immense. On the pages of Pentateuch, Donald Jackson and his team created eight illuminations that range from a quarter-page to the two-page treatment of Abraham and Sarah. Additionally, there are six special text treatments and a number of decorations in the margins. As you contemplate these images and the texts that accompany them, we invite you to explore the nature of the God represented in this book, God's relationship with us, and what it means to be God's people.

What does this image say to you about the nature of creation?

Looking at the illumination, you'll notice right away that it has seven panels for the seven days. The first panel contains "fractals," the jagged geometric shapes that resemble jigsaw puzzle pieces. Fractals play a role in various collages in *The Saint John's Bible*. They reflect glimpses, fleeting moments of clarity, and layers of symbolic meaning—not unlike our experience of seeing God in Scripture.

This image, created by Donald Jackson with contributions from nature illustrator Chris Tomlin, emphasizes the tension between order and disorder, structure and chaos, and even the fields of mathematics and science. Can ideas of creation and science go together in a unified whole? Jackson suggests that the Genesis story, a story of seven days, nevertheless tells us about timelessness. It tells us about the beginning of space and time. So he assembled seven panels here, irregular and exploding from the dark primordial void, a state expressed verbally at the bottom of the first day with the Hebrew words *tohu wabohu*—formless and void.

Where do you begin on this image? What captures your eye? There's a lot of gold, and you'll see gold leaf throughout *The Saint John's Bible*, most often used to represent the presence of the divine. Gold here is symbolic of God's intervention in the chaos and God's ordering of the universe and its elements. Whenever you see gold in an illumination, contemplate what it means that God is present at that moment in the story—in what way? Accomplishing what purpose? How clearly do we perceive God in the story's action?

Day one is struck through with a thin ribbon of gold. This corresponds to verse 3, "Let there be light!" In what way are God and light connected, even beyond the story of creation?

Day three is made from satellite photos of the Ganges Delta. Notice the variety of color and the sense of movement not just in this panel but everywhere.

Representing archetypal humanity, like representing God, is always tricky. For the creation of human beings on the sixth

Creation

GENESIS 1:1–2:4a

In the beginning when God created the heavens and the earth . . . (1:1)

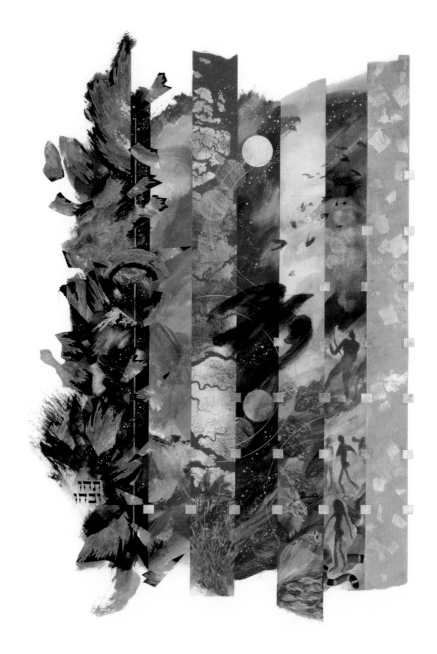

CREATION

THE ART OF THE SAINT JOHN'S BIBLE

day, Jackson used images from aboriginal rock paintings in Australia. The huntress on top is from an even earlier rock painting found in Africa. Woven in is a fragment of Chris Tomlin's coral snake, which appears more clearly in the next illumination, the *Garden of Eden* (which also depicts the ancient huntress), and again in the portrayal of Adam and Eve. The Bible is all one story, and the image of creation includes elements that can carry us all the way from Genesis 1 to Revelation. Chris Tomlin's coral snake makes a dramatic reappearance in *Woman and the Dragon* and *The Cosmic Battle* in the book of Revelation, where it is finally vanquished.

Smudged into the surface of the illumination is the image of a black bird. Donald Jackson says, "birds are these magical, mobile, extraterrestrial creatures." Perhaps this bird connects the heavens and the earth, captures the movement expressed in every part of the illumination, and is a creature of all realms: land, sky, and sea. "The raven is a messenger in the Bible," says Jackson. There will be birds bringing messages to Noah on the ark, and this black bird will reappear most dramatically in Ecclesiastes to navigate between life and death. In legend, it was a raven that brought God's message to St. Benedict, patron of the Benedictine monks at Saint John's Abbey who commissioned this work.

❦ *Reread the story of creation now and notice God's activity, the abundance and energy of the language, and the serenity of the seventh day. What else do you see? What is prominent? How does the illumination open the text for you?*

TEXT AND PAGE ELEMENTS

Script

Scribes call their writing "script," a term we can compare with a "font" in printed texts. Donald Jackson designed the script for *The Saint John's Bible* with many objectives in mind. First, he wanted it to be modern. He made and rejected many samples because they felt too archaic. Of course he wanted the script to be readable even in the reproduction editions, not just on the 2' x 3' original pages. The script needed to have dense lines with clear channels of white between the letters so it wouldn't all turn to mush on the page.* But also, this is the Bible, and Jackson wanted its script to have appropriate substance and seriousness. Finally, he wanted the script to have "juice." The Bible is a living word and needs to be alive on the page.

Once he devised the script he taught it to the scribes, men and women hired to work at the Scriptorium or from their home studios over the course of the project writing the text. Although there are subtle differences in the work of the different scribes, most readers can't see it. There might be an extra flourish in a descender at the bottom of a page or into a margin, but this is just as much about the vellum and quill and page design as the personality of the scribe. Only in *Psalms* were slight differences in the script developed to set off the different books. Writing the script was, of course, the bulk of the project, though much focus also went to the illuminations. Each page took between seven and thirteen hours to write.

Incipit

The first two pages of Genesis are written in all capital letters. This is called an *incipit* and is a special treatment of the opening text of many books in this Bible. The incipits were written by Donald Jackson and reveal a great deal of skill in terms of the calligraphy involved. Unlike the meticulously

* Christopher Calderhead, *Illuminating the Word* (Collegeville, MN: Liturgical Press, 2005), 72.

בראשית

IN THE BEGINNING WHEN GOD
CREATED THE HEAVENS AND THE
EARTH, THE EARTH WAS A FORMLESS
VOID & DARKNESS COVERED THE
FACE OF THE DEEP, WHILE A WIND
FROM GOD SWEPT OVER THE FACE
OF THE WATERS. THEN GOD SAID,
"LET THERE BE LIGHT"; AND THERE
WAS LIGHT. AND GOD SAW THAT
THE LIGHT WAS GOOD; AND GOD
SEPARATED THE LIGHT FROM THE
DARKNESS. GOD CALLED THE LIGHT
DAY, AND THE DARKNESS HE CALLED
NIGHT. AND THERE WAS EVENING
AND THERE WAS MORNING, THE
FIRST DAY. AND GOD SAID, "LET
THERE BE A DOME IN THE MIDST
OF THE WATERS, AND LET IT SEPA-
RATE THE WATERS FROM THE WATERS."
SO GOD MADE THE DOME & SEPA-
RATED THE WATERS THAT WERE
UNDER THE DOME FROM THE WATERS
THAT WERE ABOVE THE DOME.
AND IT WAS SO. GOD CALLED THE
DOME SKY. AND THERE WAS EVE-
NING & THERE WAS MORNING,
THE SECOND DAY. AND GOD
SAID, "LET THE WATERS UNDER THE
SKY BE GATHERED TOGETHER
INTO ONE PLACE, AND LET THE DRY
LAND APPEAR." AND IT WAS SO.
GOD CALLED THE DRY LAND EARTH,
AND THE WATERS THAT WERE GATH-
ERED TOGETHER HE CALLED SEAS.
AND GOD SAW THAT IT WAS GOOD.
THEN GOD SAID, "LET THE EARTH
PUT FORTH VEGETATION: PLANTS
YIELDING SEED, AND FRUIT TREES
OF EVERY KIND ON EARTH THAT
BEAR FRUIT WITH THE SEED IN
IT." AND IT WAS SO. THE EARTH
BROUGHT FORTH VEGETATION:

PLANTS YIELDING SEED OF EVERY
KIND, AND TREES OF EVERY KIND
BEARING FRUIT WITH THE SEED
IN IT. AND GOD SAW THAT IT WAS
GOOD. AND THERE WAS EVENING
AND THERE WAS MORNING, THE
THIRD DAY. AND GOD SAID, "LET
THERE BE LIGHTS IN THE DOME
OF THE SKY TO SEPARATE THE DAY
FROM THE NIGHT; AND LET THEM
BE FOR SIGNS AND FOR SEASONS
AND FOR DAYS AND YEARS, AND
LET THEM BE LIGHTS IN THE DOME
OF THE SKY TO GIVE LIGHT UPON
THE EARTH." AND IT WAS SO. GOD
MADE THE TWO GREAT LIGHTS—
THE GREATER LIGHT TO RULE THE
DAY AND THE LESSER LIGHT TO
RULE THE NIGHT~AND THE STARS.
GOD SET THEM IN THE DOME OF
THE SKY TO GIVE LIGHT UPON THE
EARTH, TO RULE OVER THE DAY
AND OVER THE NIGHT, AND TO
SEPARATE THE LIGHT FROM THE
DARKNESS. AND GOD SAW THAT
IT WAS GOOD. AND THERE WAS
EVENING AND THERE WAS MORN-
ING THE FOURTH DAY. AND
GOD SAID, "LET THE WATERS BRING
FORTH SWARMS OF LIVING CREA-
TURES, AND LET BIRDS FLY ABOVE
THE EARTH ACROSS THE DOME
OF THE SKY." SO GOD CREATED
EVERY LIVING CREATURE THAT
MOVES, OF EVERY KIND, WITH WHICH
THE WATERS SWARM, AND EVERY
WINGED BIRD OF EVERY KIND, AND
GOD SAW THAT IT WAS GOOD. GOD
BLESSED THEM, SAYING, "BE FRUIT-
FUL AND MULTIPLY AND FILL THE
WATERS IN THE SEAS, AND LET
BIRDS MULTIPLY ON THE EARTH."
AND THERE WAS EVENING AND
THERE WAS MORNING, THE FIFTH
DAY. AND GOD SAID, "LET THE
EARTH BRING FORTH LIVING CREA-
TURES OF EVERY KIND: CATTLE
AND CREEPING THINGS & WILD
ANIMALS OF THE EARTH OF EVERY
KIND." AND IT WAS SO. GOD MADE
THE WILD ANIMALS OF THE EARTH
OF EVERY KIND, AND THE CATTLE
OF EVERY KIND, AND EVERYTHING

THE
GREAT
SEA MONSTERS
AND

Or when God began to
create or in the beginning
God created
Or while the spirit of God
or while a mighty wind
Heb adam
Syr Heb and over all the
earth
Heb adam
Heb him

designed script of the body text, each incipit is written with a freer hand. If you look at verse 1:30 you will see a variety of a's and begin to understand. The incipit for the book of Job is Jackson's favorite piece of text, one where the elements of quill, ink, vellum, and individual came together to create a beautiful block of text written in a free hand.

Correction

The text for this Bible was laid out on a computer before the calligraphers wrote on vellum. This way they had a plan that allowed the lines to roughly justify (look at the perfect justification of the regular text columns that begins with Genesis 2:4 and marvel!) and for an even number of lines to be in the columns of a page.

The two columns of the first incipit, however, do not match up! That is because a line was omitted when Donald Jackson was writing the text. It is easy to see how he would flow from "So God created" to "every living creature that moves" without realizing the omission. He left out the great sea monsters! This omission would be noticed only when he reached the end of the column and saw the gap. At that point, it was too late to go back and correct the text. Instead, he noted the text in the margin and inserted it with a simple line and arrow. We will see more elaborate ways of dealing with omissions in the text as we proceed.

Book Heading

The start of each book is also marked by a book heading designed and painted by Donald Jackson. The general design of the book plate had to be strong yet compact and flexible enough to be used for all the books of the Bible. The book plate for Genesis is elegant, a black background scattered with stars. The real challenge for Jackson was fitting the names of the books, which range in length from Job to Zechariah, on the plates!

Capitals

Genesis 3 begins with one of the elaborate, decorative initial capitals that run throughout *The Saint John's Bible*. After the scribe had finished, Donald Jackson returned to the pages to add the capitals and other elements. In fact, the scribes also left space for the chapter numbers, which Brian Simpson came and wrote in *Pentateuch*. Sue Hufton wrote the running chapter heads in English, and Izzy Pludwinski, a certified religious scribe living in Israel, wrote the running heads in Hebrew.

The capitals in *The Saint John's Bible* are another element that highlights the calligraphy. Jackson drew original capitals for each chapter; no two are alike. If there was an image on the page, he coordinated the color and sometimes even the decoration of the letter with the image. A good example is found at Leviticus 17–19, where the capitals clearly reflect the design of the text treatments.

Paragraph Marks

One other thing you might notice are the small diamonds that mark paragraph breaks in the text. *The Saint John's Bible* uses the New Revised Standard Version and must follow the conventions of that text. This includes all the marginal notes on the text, which were written by the scribes assigned to the page. However, it also required paragraph breaks. The Bible team worked with the copyright holders of the translation to get approval to use the diamonds instead of full breaks in prose passages. This made a large difference in the project's completed size. As it is, *The Saint John's Bible* runs to 1,127 pages. Actual paragraph breaks would have added additional pages, meaning more sheets of rare and expensive vellum and more weight to the volumes.

Garden of Eden and Adam and Eve

GENESIS 2:4b-25 / GENESIS 3

*And the L*ORD *God planted a garden in Eden, in the east; and there he put the man whom he had formed. (2:8)*

GARDEN OF EDEN

How do these images match up to your vision of the Garden of Eden and Adam and Eve?

These two illuminations are directly related to the second creation story in Genesis, the story of the Garden of Eden and Adam and Eve. Notice how gold is used as a frame of God's creation (including the snake). Creation is abundant, fertile, breaking the bounds of the rectangular image. Creation is messy. The beautiful but predatory harlequin shrimp, the coral snake, and several poisonous insects foreshadow the end of innocence. Adam and Eve have painted faces, also reflective of our "divided but connected relationship" with each other and with our environment.

The figures, inspired by photographs of the Karo tribe of the Omo River in southwest Ethiopia, reflect current archaeological and anthropological theories that humankind evolved from our predecessors in Africa. What other ways do the images reflect that we are made in God's image? What else do they reflect about the first man and first woman, given dominion over the earth? What do the framing images, from textiles and a Peruvian feather cape, say about humans as creators, our fruitfulness?

In the Garden of Eden illumination, the cave paintings tell of the human need to tell stories even from earliest time. Creation is a story of dominion and celebration. Adam and Eve's painted faces, along with the decorated, colorful cloth, speak of humanity's desire to rejoice in being alive. People make patterns, like the textile patterns and the curved piece of a mandala at the center left of the Garden of Eden illumination.

The mandala is an archetypal image common to many faith traditions, a word loosely translated as "circle." Hildegard von Bingen saw mandala shapes in the visions she received from God, and the mandala can be seen throughout Christian architecture, in decorated dome ceilings, in the rose windows of Chartres. "The Buddhist mandala . . . is about the birth of intellect," according to Donald Jackson. You might want to keep a watch for other mandalas in *The Saint John's Bible.* Some will be complete, like the one at the center of the menorah in the frontispiece of Matthew's gospel, and others will be bold

THE ART OF THE SAINT JOHN'S BIBLE

fragments like those in the illumination that opens *Historical Books* at the River Jordan. How do mystery, reason, and consciousness come together when we contemplate something like the brightly colored parrot in this image of creation, the disarming smile of Eve, or the primitive figures playing musical instruments and dancing?

The two stories of creation in Genesis 1–2 both culminate in the place of humankind among the creatures. We are made in the image and likeness of the Creator, combining physical beauty and reason, and with the breath of life breathed into our nostrils by God (Gen 2:7). The wholeness and expressiveness of this origin is brought together in the mandala image. However, the coral snake is also here as fragments of a circle, hinting at a dark element within free will and human reason.

Finally, text plays a large part in these images as well. In the margins are two quotations from letters written by the apostle Paul, tying the Old and New Testaments together. Donald Jackson saw these as captions for the pictures. The text to the *Garden of Eden* captures creation as alpha and omega, the beginning waiting for the final revelation. "For the creation waits with eager longing for the revealing of the children of God" (Rom 8:19). There's a sense of creative expectation: what will we be when we finish our ongoing life of grace and God's final kingdom is revealed? The passage for *Adam and Eve* draws our attention to the platinum background behind Eve, which acts as a mirror. "And all of us, with unveiled faces, seeing the glory of the LORD as though reflected in a mirror, are being transformed into the same image from one degree of glory to another" (2 Cor 3:18). As we move closer to Christ we will see a single image reflecting back: unified in our godliness and vibrant in the variety of our smiles. "God is within us when we look into the mirror," Jackson says of the image. "Eve and Adam are mirrors of us."

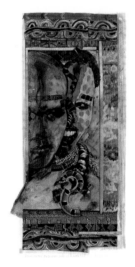

❦ *If you were going to draw an image of something in creation that captures the beauty, mystery, creativity, and rationality of God, what would it be? If not an image, make a list of things that you think express these qualities of creation.*

ADAM AND EVE

MARGINALIA

Marginalia, any writing on the border of a page, was common in medieval and renaissance manuscripts. Marginalia could be commentary or decoration. Often the copyist monks would personalize the manuscripts by drawing fanciful decorations in the margins. Later readers might make a note on the text, as many people do when using textbooks.

At the same time, the integrity of the Bible text was very important to everyone involved. In fact, at some periods of history even the artwork became regulated, with certain archetypes always used for certain passages. The decoration also reflected the cultural situation at the time. For example, in 1131 the Cistercians, an order of monks that broke off from the Benedictine tradition, issued a decree that the elaborately decorated initial capital letters at the beginning of chapters should be in one color and should contain no human or animal figures (a decree that was widely ignored)!

The design of *The Saint John's Bible* pays special attention to Benedictine spirituality and includes images of the flora and fauna of the Minnesota landscape as well as of the Welsh countryside where it was written in Donald Jackson's scriptorium. This rootedness in the present day and local landscape is another link between this illuminated Bible and those made hundreds of years ago. Sometimes one finds in the elaborately decorated initials and margins of manuscripts a depiction of the abbey or grounds where it was being made. Sometimes even the faces of specific monks would make their way into the paintings.

At Genesis 4–6, we find the first exquisite examples of marginal nature illustrations by Chris Tomlin for *The Saint John's Bible*. Butterflies, like birds, will appear again and again in this Bible, delicate messengers between the worlds, but here they seem to be simply a further celebration of the beauty of creation. It is almost as if Jackson and Tomlin couldn't fit enough complex and gorgeous images into the creation illumination and spilled them onto these next pages.

The butterfly depicted here is the common yellow swallow-tail, found in the Norfolk Broads area of the United Kingdom and in areas of the United States, including Minnesota. On the left, one drinks nectar from a purple thistle, the bane of gardeners and landscapers in the United Kingdom and Minnesota. We might associate it with the fallen world, where beauty and thorns are found together. It is not a given, however, that marginalia will reflect on the particular text on the page.

There is another type of marginalia on these pages, directly below the butterflies. These notes are part of the New Revised Standard Version of the Bible, the text used for *The Saint John's Bible*. We can think of them as scholarly annotations, those notes in the margins that early readers might have made on early illuminated manuscripts. You will find some of these notes on virtually every page of the Bible, though some have more than others. The notes were part of the scribes' work and could add considerable time to finishing a page if they were extensive.

Abraham and Sarah

GENESIS 15:1-7 AND 17:1-22

"Look toward heaven and count the stars. . . . So shall your descendants be." (15:5)

ABRAHAM AND SARAH

What does this illumination tell you about the two passages in Genesis?

The covenant God makes with Abraham is at the heart of both the Jewish and Christian traditions. The monotheistic lineage of Judaism, Christianity, and Islam begins with our common father, the patriarch Abraham. The menorah, a seven-branched candlestick used in Jewish worship, is the central image of this illumination and will be used most prominently again as the

frontispiece of the Gospel of Matthew, the genealogy of Jesus through the line of Abraham and Sarah. The menorah is thus used as a family tree, a version of the tree of life in the Garden of Eden. Do you see the leaves on this tree?

Other important elements in the story of God's covenant with Abraham are also represented. The stars fill the sky, as well as delicate gold-stamped figures of arabesques or mandalas. These same stamps will be used in other illuminations— for example, at the birth of Christ in Luke's frontispiece, at the miracle of the loaves and fishes in Mark, and at the Great Commission in Acts 28. *The Saint John's Bible* uses recurring images and motifs to show the unity and interplay between the books of the Bible. Also, Donald Jackson enjoys working with rubber stamps and uses them throughout the project.

The menorah here is rooted in the two names Abraham and Sarah and rises to the inscription of the names of the children of Jacob. This is the beginning of the tree that will rise in the Gospel of Matthew to the birth of Jesus. As a parallel of that image, this family tree reminds Christians that the covenant between God and Abraham through Sarah is the root of both Judaism and Christianity.

The names in the illumination are written in Hebrew. You may have noticed that the names of the books are also written in Hebrew in the upper right margins of the pages. Although to describe this volume we use the Greek word *Pentateuch*, recognizing that *The Saint John's Bible* is a Christian Bible that includes the Old Testament books and order of the Septuagint used by the early church, this annotation acknowledges that they were originally Hebrew texts. Later in the Old Testament, when we encounter books that made their way into the canon from Greek texts, you will see their Greek names in the margins.

◀ *At the lower right is a black and grey figure, representing the sacrificial ram that takes the place of Isaac. Sacrifice is an essential part of the larger story too. What else do you see of the story?*

THE ART OF THE SAINT JOHN'S BIBLE

In what way do the butterflies and angels illuminate Jacob's vision for you?

These two illuminations, separated by four chapters, capture an instance of God's contact with a key figure in the Old Testament. In two stories, God makes his covenant with Jacob, who is renamed Israel. It is another step in the covenant made with Abraham, and you'll remember that the menorahs in our last illumination featured the names of the twelve tribes of Israel, who are Jacob's sons. Here gold angels ascend and descend the space with the ladder connecting this world and heaven. The angels don't need the ladder, as they seem to circle around and through it.

Jacob's Ladder and Jacob's Second Dream

GENESIS 28:10-22 / GENESIS 32:24-32

And he dreamed that there was a ladder set up on the earth, the top of it reaching to heaven; and the angels of God were ascending and descending on it. (28:12)

Jacob was left alone; and a man wrestled with him until daybreak. (32:24)

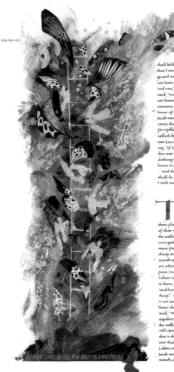

JACOB'S LADDER

Chris Tomlin's butterflies, portrayed in accurately rendered wing fragments, are a striking presence. Butterflies, like birds, are special creatures that seem to bridge both heaven and earth. They are often hard to keep in our vision, as their wings fold closed and they become a sliver on a leaf or flower, or as they dip and disappear into the tall grass.

In *Jacob's Second Dream*, Jacob and God meet again in the night. After reading the story of Jacob wrestling with the man, consider the illumination. It reprises several elements from *Jacob's Ladder*, including the butterfly wings, the blue figures, and scattered gold. Unlike the earlier gold imprint, which was made by applying acrylic to crocheted textiles, the gold here is like squares and diamonds of confetti. There is another shadow figure, the moon of creation or something else. The Hebrew words are Jacob's two names, Israel in gold to replace Jacob in black. Again, the encounter between the heavenly and human world is emphasized in color and form.

But also, look back to the original illumination of creation. There is something of the chaos of the first day in these two illuminations of Jacob.

◀ *What is the relationship between the two Jacob stories and their images? What is the role of chaos here?*

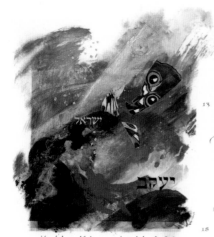

JACOB'S SECOND DREAM

THE ART OF THE SAINT JOHN'S BIBLE

Five passages are incorporated into this single illumination by artist Thomas Ingmire. In addition to the Ten Commandments themselves, what other elements of Israel's story do you recognize?

Thomas Ingmire is the artist behind the *Ten Commandments*. His illuminations appear in every one of the seven volumes of *The Saint John's Bible* except for *Psalms*. They are marked by graphic precision and a love of letter forms—he is someone who clearly loves words and letters. He has illuminated passages where words are often at the center: *Ten Commandments*, *Messianic Predictions* in *Prophets*, and the *I AM Sayings* in John's gospel. He has also illuminated God's answer to Job, Hannah's prayer, and other important passages. It is wonderful to encounter his work first in this illumination, where he has created something that looks like a grand liturgical banner.

Across the top panel four stories are represented: the burning bush, the first Passover, the Red Sea crossing, and the twelve pillars erected at the foot of Mount Sinai to represent the twelve tribes of Israel. Although the illumination is divided into panels, the events combine to make one story—the story of Israel's liberation and establishment as a nation.

Ten Commandments

EXODUS 20:1-26
Then God spoke all these words . . . (20:1)

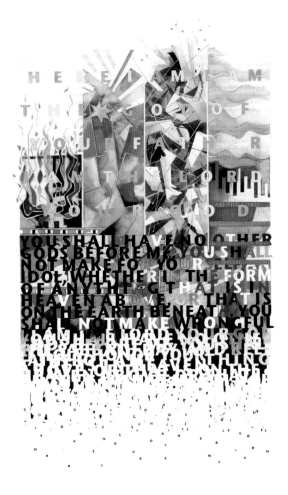

TEN COMMANDMENTS

Look for the elements of water, altar, and mountain across the top half of the illumination.

The Ten Commandments, the foundation on which these stories are built, is envisioned as a creation story. It is the creation of the moral universe, the gift of the Law bringing order to the chaos of human affairs. Do you see elements carried over from the first illumination of creation? Notice the birds—wing and eye. The familiar words of the commandments, stenciled in Stone Sans typeface as though engraved on tablets, eat through the colored background. God speaks in gold capitals here, announcing, "Here I am. I am the God of your Father. I am the LORD your God."

Thomas Ingmire commented on how strange it was that God wrote down the commandments for a culture of people who couldn't read. It established the idea of God as Word, which is carried into the Gospel of John. Christians believe the same God revealed in Jesus Christ gave the commandments to Moses. What does it mean for God to be proclaimed in word, when God's name cannot be uttered as word, when no image can capture God?

◖ *What does the jumble and jockeying of text on image say about us? What does it say about God? What is our relationship to this new creation, the law meant to restore order and harmony to the world? What is our relationship to God as Word?*

CORRECTIONS AND TEXT TREATMENTS

Corrections

We've already mentioned the small correction in the incipit of Genesis. Of the more than eleven hundred pages of *The Saint John's Bible*, the calligraphers made such errors only nine times. In most cases, these omissions came to be seen as artistic opportunities, and the ways the missing line is inserted or pointed to in the text are some of the most loved and delightful images in the project.

In the margin of Exodus 38 and on the second page of Leviticus 19, there are identical brown birds. The ropes in their talons attach to a box of text, and their beaks point to the places where the text should be inserted. At this place the scribe missed a line or two in the copying.

As with medieval manuscripts, on this project the investment in labor, vellum, and ink could not be wasted. There was no crumpling up of the page and tossing it in a wastebasket when an error was made. The solution then, as now, was to make the correction an element of the artwork. Like tapestries into which a flaw is woven to show the work is not perfect, this Bible is not a product of a calculating machine but the work of human hands.

You will find an index to all the corrections, also known as "lines of return," at the back of this book. Particular favorites are the lemur in *Historical Books*, 2 Chronicles 11, and the bumblebee using a pulley system in *Wisdom Books*, Wisdom of Solomon 7.

Text Treatments

The artwork in *The Saint John's Bible* can be broken down into three main types: illuminations, text treatments, and marginalia. There are many other artistic elements that are mainstays of this kind of bookmaking, such as the elaborate capitals at the beginning of each chapter, the book plates that give the title of each book, carpet pages, incipits, and even the squares that mark the end of each paragraph. All of these elements

EXODUS 38

had to be planned and designed, and we will discuss them as they arise.

Leviticus 19 is the first place we see text treatments, the visual representation of a piece of text—sometimes not even a full verse—to highlight its message. As with the illuminations, the Committee on Illumination and Text (CIT) decided which verses should be highlighted and whether they should be a text treatment or an illumination.

Many of the text treatments are not this elaborate. In *Pentateuch* the text treatments introduce us to the work of four calligraphers on the project: Sally Mae Joseph, Hazel Dolby, Thomas Ingmire, and Suzanne Moore. While Sally Mae Joseph, who wrote these three text treatments in Leviticus, worked at Donald Jackson's studio in Wales, the other artists worked from their own studios on different commissioned pieces throughout the volumes. An index of text treatments at the back of this book identifies the passages and artists associated with them. Working on multiple pieces also had an effect on the artists, and we will see connections between their pieces as we proceed.

Text treatments make particular sense in the books of Leviticus, Numbers, and Deuteronomy. It is here that we encounter the law of Moses. It's a part of the Bible we're most likely not familiar with, and the scholars behind *The Saint John's Bible* have done us a favor by highlighting key texts. If you're doing real *lectio divina*, or prayerful, sacred reading through the text, you should read not just the verses extracted here but the whole of Leviticus 19. If you do, you'll recognize an expanded version of the Ten Commandments, and a lot of other commands as well. They reflect the culture and needs of a people living in the desert in that time but also embody certain principles of fidelity to God, fairness, and justice.

LEVITICUS 19:34

Early on, the CIT identified three themes important to Benedictines that they wanted to emphasize throughout the Bible project:

1. *Hospitality:* The Rule of Benedict says the guest should be received as Christ. *The Saint John's Bible* emphasizes texts advocating hospitality for the poor, the pilgrim, the seeker, and the stranger.
2. *Transformation:* Benedictines take a vow of *conversatio,* or conversion of life. *Conversatio* entails an ongoing process of aligning one's life more closely to the life of Christ. Texts that encourage this work in individuals and societies are also given special attention.
3. *Justice for God's People:* Finally, of special concern to Benedictines and all believers in biblical revelation is the repeated call for justice for all of God's people.

The text treatments for Leviticus 19 clearly reflect these themes. One thing you will also notice as you read is that this is decidedly a Christian Bible. The illuminations and text treatments reflect the Christian faith and the story of redemption through Jesus Christ. In the treatment for Leviticus 19:18, we see the words Jesus quoted when asked by the Pharisees to name the greatest commandment: "Love your neighbor as yourself." We will also find, at Deuteronomy 6, a text treatment of the first part of Jesus' answer: "You shall love the LORD your God with all your heart" (v. 5). These emphasized texts remind us of Jesus' affirmation of the law of Moses.

As we read the chapter in its entirety, we also see again and again the emphasis on the poor—we are told not to pick our vineyard clean or harvest to the edge of the field but to leave the gleanings for the "alien" or displaced person to reap. It is easy to apply these words to our own life and times. Christianity is rooted in Judaism, and here we see that relationship in the commandment to love the Lord and neighbor and to serve the poor.

These text treatments stop us as we're flipping through the Bible. When we slow down and pay attention to the passages,

DEUTERONOMY 6:5

we see connections in the ongoing story. God made a covenant. God gave commandments. God instructs the people through Moses with a law that gives more specific direction on how to live and yet is contained in the Ten Commandments. Special text treatments form a thread to draw attention to the unfolding story of God with us, not just at the familiar stories we know and love, but deep in the books of Leviticus, Numbers, and Deuteronomy.

The next text treatment is found at Numbers 6:23, a common blessing that has a liturgical feel. In addition to texts that have thematic significance, text treatments are often used to highlight early hymns and prayers. This is a book commissioned by a Benedictine abbey, a community that uses Scripture daily in liturgy, singing, and proclaiming prayers and blessing. This blessing, offered to the Israelites through the high priest Aaron, is a form of hospitality, a prayer for the visitor and the stranger upon arrival and departure.

The text treatment of Deuteronomy 6:5 by Hazel Dolby will be repeated by the same artist twice in the gospels: Matthew 22:37-40 and Mark 12:29-31. These treatments use a different script, but they are identifiable as the work of one artist. In both gospel references, Jesus proclaims this first commandment, this fullness of the Law. What you will also notice at the citations in the gospels is the presence of a small black cross in the margin and the notes. These crosses mark places where the Rule of Benedict quotes Scripture. Again, *The Saint John's Bible* draws attention to the life of the community that commissioned it and the connection between this particular illuminated book and the Benedictine way of life.

A final text treatment, this time by Suzanne Moore, occurs at Deuteronomy 30. God finishes his declaration of the Law, saying: "I have set before you life and death, blessings and curses. Choose life so that you and your descendants may live, loving the LORD your God, obeying him, and holding fast to him" (30:19-20). The law is completed here in a text treatment using the Stone Sans script that was used in the illumination of the Ten Commandments, impressed on the page as on our hearts. Pause to read the entire closing chapter of Deu-

teronomy, where God speaks of the importance of the Law
and where Moses takes leave of the people.

*◁ Do you have a favorite verse or passage in the Bible? Try your
hand at turning it into a text treatment. Why is it important to
you and what associations does it bring up for you?*

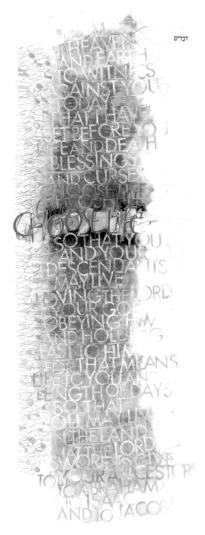

דברים

DEUTERONOMY 30:19-20

You Did Not Trust and A Poisonous Serpent

NUMBERS 20:12 /
NUMBERS 21:1-9

What does this illumination tell us about God's punishment and God's mercy?

This illumination and accompanying text treatment are part of the larger story of Moses' and Aaron's faltering faith and the punishment they receive. Numbers 20 tells the story of the Israelites grumbling and Moses' weakness. Even after their needs are met when God brings water out of the rock, it doesn't take long for the Israelites to lose heart again. So far the illuminations have focused on the positive. They have shown us the story of creation and of God's covenants and promises. They have been celebratory—even the small decoration for the story of the flood in Genesis 8:1 occurs when "God remembered Noah" and the waters abated.

Here we encounter that other vision of God associated with the Old Testament. His judgment against Aaron and Moses seems extraordinarily harsh. Now when the people grumble, miserable and hungry in the desert, the Lord sends poisonous snakes, which further compound their misery. However, when Moses prays, God sends the cure. But the cure is also a snake.

Why would we want to emphasize this story? In terms of the narrative of the Old Testament, we are moving toward *Historical Books* and the story of Israel in the Promised Land. That story is a constant cycle of disobedience, punishment, and return, as the people repeatedly break faith with God and then come back seeking forgiveness and help. Text treatments in that second volume of *The Saint John's Bible* will build on the theme that starts here.

In Christian tradition this story has been seen as foreshadowing Christ's death and resurrection. In John 3:14-15 Jesus is quoted as saying, "And just as Moses lifted up the serpent in the wilderness, so must the Son of Man be lifted up, that whoever believes in him may have eternal life." This image reflects the theological position that the curse of the Fall in Genesis (through Adam) becomes the blessing of salvation in the death and resurrection (through Christ).

There is no snake on a pole here, no realistic picture to accompany the text. This broken image reflects the broken world. God and the serpent are present not only in the colors and the geometry of creation and the Fall but also in the rising toward resurrection. Thomas Ingmire made many illuminations for *The Saint John's Bible*. This one seems to have the most in common with *Let Us Lie in Wait* [for the righteous man], Wisdom of Solomon 1:16-2:24. There, Ingmire uses the same colors and fragments and a similar script. That passage is another foreshadowing of Christ's death and resurrection.

◀ *What emotions are expressed in this illumination?*

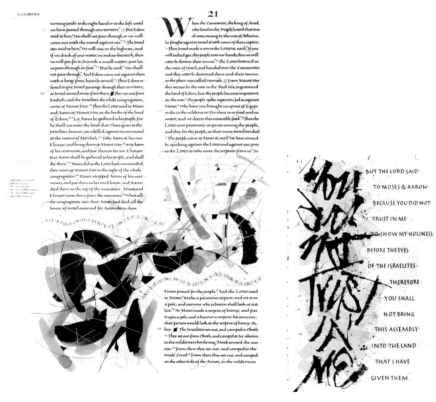

A POISONOUS SERPENT NUMBERS 20:12

Death of Moses

DEUTERONOMY 34:1-12

This is the land of which I swore to Abraham, to Isaac, and to Jacob . . . I have let you see it with your eyes, but you shall not cross over there. (34:4)

Although *Pentateuch* was finished nearly a decade before *Historical Books*, the final illumination depicting the death of Moses fits seamlessly with the opening illumination in the book of Joshua that depicts the Israelites crossing the Jordan into the Promised Land.

You have seen these elements before, the rich colors used to depict the Promised Land, the colors and the quality of the brush strokes seen in earlier illuminations for Noah, for Abraham, for the stories of Israel's passage out of Egypt. Still there is separation, the dual quality that goes back to Adam and Eve, the black night of Jacob surrounding Moses who can only look but not enter the Promised Land. After Adam and Eve, Moses is our first realistically represented face, painted by artist Aidan Hart, who works as a traditional Greek Orthodox iconographer. Moses carries the tablets of the Ten Commandments. He does not enter the Promised Land, but God is with him in the filaments of gold that pierce the darkness, in the thin band that encircles his head. Moses' face is filled with emotion.

This image captures the deep pain of exile that is part of the experience of early Israelites in Egypt and the first readers of the Pentateuch in exile in Babylon. It is an exile that belongs to all descendants of those banished from the garden. Moses' face registers the trials of the journey and the hope, the astonishment, of seeing that which was promised. Do you also see fear in his face? Concern and worry?

The story of Israel's release from bondage and passage to the Promised Land has had great power throughout history. It spoke to early colonists arriving in the new world of America, to slaves seeking freedom in the northern United States, to immigrants landing on Ellis Island or in San Francisco, and it speaks to people today risking their lives to cross the Rio Grande from Mexico into the United States. Finally, it speaks to all of us as we await our entry into God's kingdom. What does it mean that this volume ends with this image?

All year the Jewish people read the Torah in Hebrew. On a day in late October, during the feast of Simchat Torah, they finish this passage in Deuteronomy, roll up the Torah scroll, and begin again immediately at the first verse of Genesis. We

can also do this with *The Saint John's Bible*. Return to Genesis 1 and the illumination of creation. What do you see now that you didn't before?

⟨ *Having considered the illuminations of Pentateuch, do you have a better understanding of our story with God? Where did we start this journey, where have we come, and what do we have before us?*

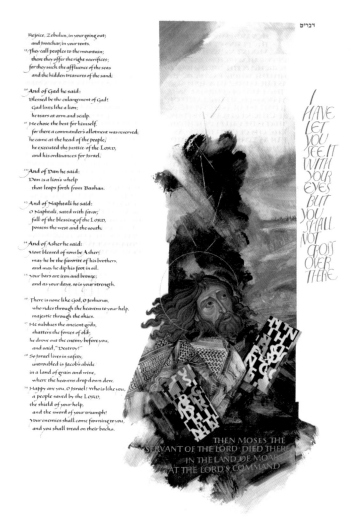

Rejoice, Zebulun, in your going out;
and Issachar, in your tents.
They call peoples to the mountain;
there they offer the right sacrifices;
for they suck the affluence of the seas
and the hidden treasures of the sand.

And of Gad he said:
Blessed be the enlargement of Gad!
Gad lives like a lion;
he tears at arm and scalp.
He chose the best for himself,
for there a commander's allotment was reserved;
he came at the head of the people;
he executed the justice of the LORD,
and his ordinances for Israel.

And of Dan he said:
Dan is a lion's whelp
that leaps forth from Bashan.

And of Naphtali he said:
O Naphtali, sated with favor,
full of the blessing of the LORD,
possess the west and the south.

And of Asher he said:
Most blessed of sons be Asher;
may he be the favorite of his brothers,
and may he dip his foot in oil.
Your bars are iron and bronze;
and as your days, so is your strength.

There is none like God, O Jeshurun,
who rides through the heavens to your help,
majestic through the skies.
He subdues the ancient gods,
shatters the forces of old;
he drove out the enemy before you,
and said, "Destroy!"
So Israel lives in safety,
untroubled is Jacob's abode
in a land of grain and wine,
where the heavens drop down dew.
Happy are you, O Israel! Who is like you,
a people saved by the LORD,
the shield of your help,
and the sword of your triumph!
Your enemies shall come fawning to you,
and you shall tread on their backs.

I HAVE LET YOU SEE IT WITH YOUR EYES BUT YOU SHALL NOT CROSS OVER THERE

THEN MOSES THE SERVANT OF THE LORD DIED THERE IN THE LAND OF MOAB AT THE LORD'S COMMAND

DEATH OF MOSES

HISTORICAL BOOKS

INTRODUCTION

The story of God told in *Historical Books* is of a God who is present in history. This God is engaged with the people and dwells with the people in the ark, in the temple, in a mountain cave in the middle of a storm, and, yes, on the battlefield. We enter the story at a significant point: as the twelve tribes of Israel cross the Jordan into the Promised Land. We can ask the question, "What is God asking of the people?" In so doing we ask, "What is God asking of us?"

This volume, although second in the series, was one of the last volumes to be completed by Donald Jackson and his team. As such, it was able to make full use of the rich visual imagery that had been created for *The Saint John's Bible*. Even so, this is a volume where the artists struggled. Confronted with the violence in these stories, complex characters such as Saul and David, and the continual unfaithfulness of the Israelites, making a cohesive set of images to carry the reader through the volume was a challenge.

Readers who are put off by violence might also have a hard time getting through these books of the Bible. Anyone reading them straight through may want to take a break and jump to the Wisdom Books or flip frequently to the Psalms for a respite. In fact, many of the psalms take on a new intensity in light of the historical context that accompanies them.

These books chronicle the history of a conquering people. There are good kings and judges, but there are also many bad kings. Even good kings take terrible falls. These pages are filled with violence and bloodshed—not promising material for an illuminated volume. How do we make sense of all this bloodshed, much of it sanctioned or required by a God we describe as loving and merciful?

First, it is best not to take this "history" literally, although there are some scholars who do. At the very least, we must consider who is telling the story. Libraries are full of historical books told from the perspective of the conquerors whose veracity, especially when it comes to heroics, doesn't hold up. It is best to read these books with an eye toward conventions in ancient literature. There is much here to compare to the Greek histories, where anthropomorphic, fickle gods guided, obstructed, tricked, rewarded, and

punished warriors and kings. And again our primary purpose in reading this history is to learn more about what it says about us and our relationship with God. What is the nature of the covenant and God's commands? What is the trajectory of the Israelites? What does it mean to claim this as our story? There is much to consider—in the opening of Joshua, two spies are sent to scope out Jericho, and they are protected by the prostitute Rahab. If nothing else, this should tell us we are in for an interesting story!

These accounts, like all the genres of the Bible, tell us first and foremost about the relationship between God and humankind. Our God is not absent from history but present and engaged. However, there is no sudden transformation of the people's character from the days of wandering in the desert at the end of the Pentateuch to the conquering days of the Historical Books. God has a plan for the kingdom, but the people are not on board. It is true that in Joshua and Judges we see the Israelites called to conquer the inhabitants of the Promised Land in the worst way—leaving no one standing. But very soon, the books shift to reflect punishment of the chosen people for forsaking the covenant. As Michael Patella, OSB, chair of the Committee on Illumination and Text (CIT), points out, "In these later accounts, the people are chastised and punished for neglecting the well-being of the widow, orphan, and foreigner in their midst."

Our clue to how *The Saint John's Bible* approaches these books comes in the marginal text treatments running throughout the first book—Joshua. God lists all that he has done for his people in the closing chapter, Joshua 24, captured in these excerpts:

> They fought with you, and I handed them over to you, and you took possession of their land. . . . I sent the hornet ahead of you, which drove out before you the two kings of the Amorites; it was not by your sword or by your bow. I gave you a land on which you had not labored, and towns that you had not built, and you live in them; you eat the fruit of vineyards and oliveyards that you did not plant. "Now therefore revere the LORD, and serve him in sincerity and faithfulness." (Josh 24:8, 12-14)

And what did the people do? Look at the text treatment in the first page of Judges:

> "Then the Israelites did what was evil in the sight of the LORD" (Judg 2:11).

As people, as nations, we continue to struggle to do what is right. As Fr. Michael Patella has written:

If we can glean anything from the *Historical Books*, let it be this: The history of God dealing with his people is not neat and tidy. Humankind, left to its own devices, can spiral downward into a moral abyss, even as we proclaim fidelity to the Lord. Because God has never wavered in his love for the people he has created, we have been spared the worst we could possibly do to ourselves and others. Furthermore, the grace of God's justice and peace can rise from the most unlikely of places, and our redemption is always close at hand.

There is also delight to be found in these books as we encounter key figures of the Bible. The prophets Samuel, Elijah, and Elisha are in these pages, and so is the magnificent story of King Saul and King David and the touching and inspiring account of Ruth, the Moabite from whom David and eventually Jesus are descended; for Christians, there are the rich stories behind the genealogy in Matthew's gospel that show, again, the motley bunch from which God raised up a savior, God's faithfulness to the people, and the importance of the widow and foreigner.

Donald Jackson's treatment of this volume traces the disintegration of the society for failing to keep to the Lord's commands. The constant comment by the writer of Judges, "In those days there was no king in Israel; all the people did what was right in their own eyes" (Judg 17:6), reaches its logical conclusion with the Babylonian conquest of Judah and the exile of its people to Babylon. The army ants, grasshoppers, and scorpions running through the pages carry this motif, and they are juxtaposed against the bright colors of the promise.

Donald Jackson has packed this volume with color, from the initial capitals of each chapter to the full-page illuminations bursting with energy. The task of writing this volume, with 271 pages of illumination and text, engaged the team for years.

There are 25,812 lines of text in *Historical Books*. In addition, there are 306 initial capital letters in this volume, no two alike. There are seventy-nine different *T*s alone, fifty-six *N*s, and thirty-seven *W*s! And on every page, of course, you will find the gorgeous calligraphy.

For those who love illuminations, this volume is a treat. Only *Gospels and Acts* has as many illuminations as this volume, containing twenty-six illuminations of biblical passages, in addition to text treatments and marginalia insects by Chris Tomlin.

CARPET PAGES

The book of Joshua is the first place we encounter a carpet page. When you open the book, you might wonder where the frontispiece is, expecting a full-page illumination to greet your transition from *Pentateuch* to *Historical Books*. What you get instead might seem like a wasted page, mostly blank with the repeated pattern of gold-stamped arches.

This page is actually part of a convention known as a "carpet page," due to the similarity between the pattern on these pages and Oriental carpets. Carpet pages serve an important purpose, allowing for a distinct space between one book and the next. In *The Saint John's Bible*, lightly stamped and stenciled carpet pages like this one provide the eye with a visual pause before embarking on the next book and heavy illuminations. Actually, this is technically a "reverse carpet page" because it comes at the beginning instead of the end of a book. We know it is the beginning and not the end because the imagery fits with *Historical Books*.

The patterns used on these pages often have thematic significance. For example, the carpet pages that open and close the volume *Prophets* are stamped with wings and a rough outline of the floor plan of the temple. They make a strong representation of the prophets' place in society. Again, wings belong to creatures that traverse between two realms, and ultimately it is the prophets' promise of a rebuilt temple and restored Israel that comforts the people in Exile.

The stamp of the gold archway used for this carpet page is one we will see repeatedly in *The Saint John's Bible*. It is used most prominently in the full-page illumination *Life of Paul* in the book of Acts. It is also prominent in the full-page illumination *David Anthology* in 2 Samuel. Its source, according to Donald Jackson, is the arches of the Cathedral of Santiago de Compostela. This Spanish cathedral is the destination point for pilgrims on the Way of St. James, a pilgrimage that brings people annually along various routes across Europe.

JOSHUA CARPET PAGE

THE ART OF THE SAINT JOHN'S BIBLE

Arches are full of resonance, as entryways, thresholds, churches, and seats of power. As the people of Israel and, in the New Testament, the early Christians struggle to define who they will be as people of God, the stamped arches of the Cathedral of Santiago de Compostela provide a strong motif for kingdoms of all kinds. In *Historical Books*, where arches are stamped in gold, they also suggest the ark of the covenant, God's dwelling place among the people.

In Joshua, the carpet page also protects the integrity of the close of Deuteronomy. That book ended with a text treatment of the final chapter telling the death of Moses. The page was adorned with only a simple illustration of a menorah; the rest is blank. Now we are invited to pause and reflect, beginning the next chapter of the story with the words that begin the book of Joshua: "After the death of Moses . . ."

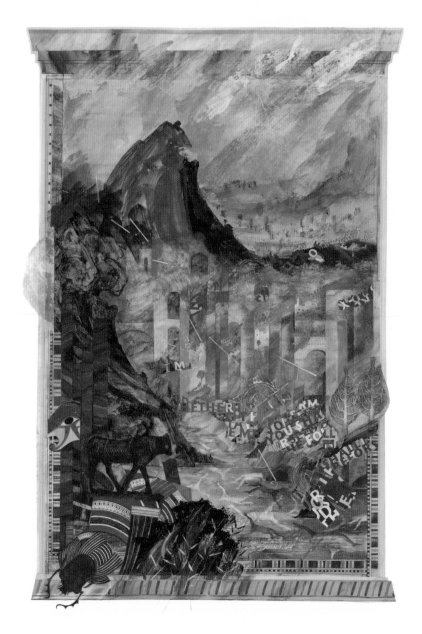

JOSHUA ANTHOLOGY

THE ART OF THE SAINT JOHN'S BIBLE

What catches your eye in this illumination? How do the images representing nature and culture work together to tell the story of the Israelites' move into the Promised Land?

JOSHUA 1–24

Every place that the sole of your foot will tread upon I have given to you, as I promised to Moses. (1:3)

Moses did not reach the Promised Land, and so it falls to Joshua to take the Israelites across the Jordan, out of the wilderness, and into the land that God has given them. But, of course, the land is inhabited, and they do not take possession of it without wars and bloodshed.

All of this is packed into the *Joshua Anthology*. Broken and fragmented along the far shore of the Jordan are pieces of Thomas Ingmire's illumination of the Ten Commandments. In fact, the block of text at the bottom right is the exact fragment held by Moses as a symbolic tablet in *The Death of Moses*. Joshua will bring over the ark of the covenant containing the commandments and the Law, but the people will have difficulty following it. The ark of the covenant is referenced here by the stamp of the gold archway we saw on the carpet page. This stamp will be used throughout *Historical Books*, most dramatically in the *David Anthology* when David brings the ark of the covenant into Jerusalem.

On the right side of the Jordan are also ghostly cities punctuated with flames, the cities that will not stand. This is the bloodshed of conquest, an ongoing theme in coming pages.

On the left side of the Jordan are images from the wilderness, including two pensive lions that watch over the scene. There is also, very prominently, the golden calf of the wilderness disobedience, a menacing scarab beetle that seems prepared to lead the Israelites in the wrong direction, and an image of an Egyptian eye (another sign of the false gods of Egypt).

The Jordan itself is filled with drowned bodies—the cost of this conquering history. It reminds us of Pharaoh's army drowned during the crossing of the Red Sea in Exodus, but it also points toward the conquering of peoples that is to come. The images of headless bodies in the river come from reliefs

in the British Museum from Syrian temples chronicling their own conquests.

In this first illumination, Donald Jackson introduces two visual elements he will continue throughout the volume. The first is a three-tiered color scheme. In addition to gold, which depicts the heavenly kingdom and God's presence, Jackson used green to emphasize the presence of the prophets and priesthood. Like the beauty and fertility of nature, green suggests right relationship and order, the natural world reflecting its true purpose and being in harmony with God. Finally, you will notice Jackson's strong use of purple throughout the volume, which he used to represent the earthly kingdom—people striving to put leaders and kings in place. As you will see, they have mixed results.

Note all the purple in this first illumination. It is as a conquering people, under the leadership of Joshua (and with drowning and flames), that the Israelites arrive.

The second visual element is found in the striped border. As in other volumes dealing with this period in history, Jackson turned to ancient Egyptian elements for inspiration. The design in this border, which will be repeated again and again, is from a frieze on an Egyptian burial tomb. It is, of course, a reminder of where the Israelites came from and where they may have picked up their tendency to turn again and again to foreign gods.

❦ *Compare the illumination* Death of Moses *with this illumination. What similarities and differences do you see?*

What other "gods" call your attention?

This brief illumination draws attention right from the beginning to the mandate given by God. The verse is Joshua 24:15, from the very end of the book, when Joshua addresses the people. Yet it is this verse, this choice by the people, that looms over everything. The full verse reads, "Now if you are unwilling to serve the LORD, choose this day whom you will serve, whether the gods your ancestors served in the region beyond the River or the gods of the Amorites in whose land

Choose This Day

JOSHUA 24:15
(FOUND AT JOSHUA 4)

Choose this day whom you will serve. (24:15a)

you are living; but as for me and my household, we will serve the LORD."

These people arrive in the Promised Land trailing gods. In the illumination we see the Egyptian eye and the bands of color that resemble the rich robes and ornamentation of pharaohs or kings. Much more lightly inscribed is the menorah, that symbol of God's covenant. In *The Saint John's Bible* we first saw an image of the menorah in the illumination *Abraham and Sarah*, when God made his covenant with them. It has been repeated, most prominently between Genesis and Exodus and at the end of Deuteronomy. It carries through Psalms and is the image at the heart of Matthew's *Genealogy of Christ*. The question here to the Israelites is twofold: Whom will you follow as your earthly ruler, and whom will you follow as your God? It is clear that God, who provided the Law, is sufficient for both, but God has competition.

The terms of this relationship are spelled out in the text treatments that can be found in the margins throughout the book of Joshua and into the rest of the volume—God has given the Israelites the land in which they live and everything in it. They are given the choice of whom to serve; God does not control them any more than he controlled Adam in the Garden of Eden. There is no reason for the Israelites to turn to other gods or other rulers, and yet, in the very next book, that is exactly what they do.

◀ *This illumination can be paired with* Choose Life *at Deuteronomy 31. Why do you think there is such emphasis on choice in these early books of the Bible?*

Read Judges 4 and 5. What do you think the song adds to the story of Deborah and Barak and the defeat of Sisera?

The story of the judge Deborah and the rout of the warrior Sisera is a twice-told story. Judges 4 tells the story in narrative form, and then chapter 5 sings it. The story follows an arc we see over and over in these books. Chapter 4 begins, as so many, "The Israelites again did what was evil in the sight of the LORD" (4:1). The Lord gives them to their enemy, King Jabin of Canaan, whose army commander is Sisera. The Israelites cry out for help, and the Lord raises up a judge, this time the prophetess Deborah.

The story of the death of Sisera is highlighted in *The Saint John's Bible* for several reasons: one is to draw attention to a woman who was a great judge. As the Lord will later raise up a savior in Queen Esther, so the Lord raises up Deborah in this early history to deliver the people from the Philistines. In fact, the warrior Barak will not go out against Sisera's troops unless Deborah rides with him. So it is that a woman is not just the chosen one of the Lord and the wise counselor who commands the troops; she also rides into battle with the other warriors.

There is also a double humiliation for Sisera. Not only is he killed by his enemy but he is killed by a woman, a great humiliation for a warrior in this region at the time. In the very next illuminated story, the death of Abimelech, the self-appointed king will beg his armor bearer to kill him so that he can escape the fate of being killed by a woman (9:54).

In this case it is Jael who lures Sisera into her tent and then drives a tent stake through his head. The illumination by Jackson vividly

Death of Sisera

JUDGES 5:1-31

She struck Sisera a blow.
(5:26b)

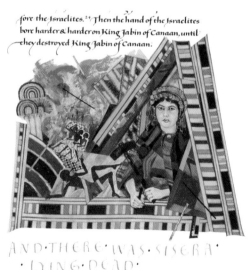

AND·THERE·WAS·SISERA·
·LYING·DEAD·

portrays Jael with her tent stake and mallet, as well as the fallen Sisera, warriors climbing Mount Tabor, and the flames of battle. The pattern from the Egyptian frieze forms the tent over Jael.

Chapter 5, the verse account of this story, has the classic elements of a ballad. It is not unlike the much-later French and British ballads telling the stories of knights or the ancient Greek songs of the *Iliad* that recount great battles. It begins with a declaration that it is a song of praise to the Lord, describes the scene, and invites others to retell the story. These verses sing the account of the battle and move on to the story of Jael, "most blessed of women," for delivering Israel from its enemy Sisera. It imagines another woman, the mother of Sisera, waiting for her son to return from battle and realizing that he will not come home, that his troops have been routed. It is a beautiful piece of poetry inserted in the otherwise narrative account.

This illumination is the first of five small panels painted on the pages as many as nine years after the text was written. These five build up to the *Judges Anthology* page, when all is chaos and, as the text on that page says, "all the people did what was right in their own eyes." These five stories show the rise and fall of the judges, particularly the battles and conquests as they try to solidify a kingdom for Israel. Donald Jackson used thematic elements, including the striped element, pieces of the scarab pattern suggesting the pull of Egypt and Egypt's gods, and the fire of ongoing conflagration and battle. On another frieze in an Egyptian tomb, he found images of Egyptians in battle against African forces that he used to show the defeat of the Philistines. He continued with these figures in the illuminations *Story of Samson* and *Cities in Flames*.

◀ *Does this story surprise you? How does it fit or challenge your understanding of the Old Testament?*

"If in good faith you are anointing me king over you, then come and take refuge in my shade; but if not, let fire come out of the bramble and devour the cedars of Lebanon."

Death of Abimelech

JUDGES 9:22-57

Abimelech ruled over Israel three years. (9:22)

What do you think would be the advantage or disadvantage of being led by a judge instead of a king?

The story of Abimelech raises an important question at this point in the history of Israel: What is the role of monarchy? The tribes the Israelites are fighting against all seem to be ruled by kings. In the previous chapter, Abimelech's father, Gideon, is asked by the people to become their king. He answers, "I will not rule over you, and my son will not rule over you; the LORD will rule over you" (8:23). However, Gideon does make an idol for the people out of their loot, in the same way that Aaron collected jewelry to make the golden calf in the desert, and although he is a good judge and his time is blessed, he sets up the misery of Abimelech's time.

Abimelech is not only the youngest of Gideon's sons but also the son of a concubine and, therefore, not a direct heir. He incites his mother's family to back him in an overthrow of his brothers and kills all but the youngest of the seventy legitimate heirs. One thing to notice in the account is how it breaks completely from the earlier formulas. Where is the

Lord? Abimelech makes himself king and the people follow. God will intervene to avenge the death of the seventy through the "lords of Shechem" (9:23), but that is the only time God appears in this account. And, without God on his side, the very people who put Abimelech in power will now rise against and overthrow him.

Of course, the people of Shechem are no friends of the Lord. In the end, God brings about destruction on both sides. What is also telling is that "when the Israelites saw that Abimelech was dead, they all went home" (9:56). The kingship has no depth, and unlike the situation with the good judges, where God raised up another leader to guide, the people are without a leader and seemingly without hope. They do seem to learn their lesson, however, and they return to depending on good judges, Tola and Jair, experiencing forty-five years of peace.

Notice that this illumination has no bars of gold running through it. All is chaos, fire, and death. The cedars of Lebanon, which feed the fire Abimelech sets on the Tower of Shechem, are depicted on the right side of the illumination.

❧ *Read the parable of the trees in Judges 9:7-15. What kind of predictor is this of Abimelech's reign?*

How do you interpret the white, red, and gold figures in this illumination?

The story of the sacrifice of Jephthah's daughter reads like a Greek tragedy. Jephthah makes a vow that if the Lord gives him victory over the Ammonites, he will give as a burnt offering the first person to greet him after his return from battle. Probably he was hoping one of his servants would be first to greet him, but instead it is his daughter, who rushes out to meet him "with timbrels and dancing" (11:34).

Now Jephthah has a terrible choice. Should he fulfill his vow and sacrifice his daughter, his only child? It is the daughter herself—unnamed throughout the account—who urges him to fulfill his vow. She is permitted first to wander for two months, lamenting her virginity. We can take her virginity

Burning of Jephthah's Daughter

JUDGES 11:29-40

My father, if you have opened your mouth to the LORD, do to me according to what has gone out of your mouth. (11:36)

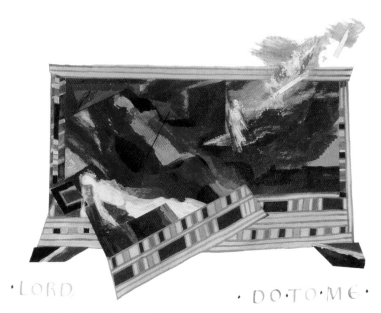

BURNING OF JEPHTHAH'S DAUGHTER

as a symbol of the unfulfilled promise of a life of marriage and offspring. Furthermore, we are told that after her death "there arose an Israelite custom that for four days every year the daughters of Israel would go out to lament the daughter of Jephthah" (11:40). The verb translated as "lament" in this verse is translated elsewhere as "sing, tell, recite."*

Aside from Isaac, who was spared, Jephthah's daughter is the only story of an Israelite offered as a burnt sacrifice in the Bible, though the prophets constantly rail against the people who fall into that heinous sin.

The illumination depicts several aspects of this story. Notice how it breaks the frame at the top and bottom. The whole illumination forms an altar.

❦ *Do you know any stories from other cultures that are similar to this one? What purpose do you think they serve?*

* Victor P. Hamilton, *Handbook on the Historical Books* (Grand Rapids, MI: Baker Academic, 2001), 146.

THE ART OF THE SAINT JOHN'S BIBLE

What kind of hero is Samson? How is he similar or different from the heroes we have seen before in these books?

It is he who shall begin to deliver Israel from the hand of the Philistines. (13:5)

Samson is a great and colorful hero in the Historical Books. Samson is called to deliver (one meaning of the title "judge") the Israelites from the Philistines, who have held them captive for forty years following the introductory and by now familiar verse, "The Israelites again did what was evil in the sight of the LORD" (13:1).

The story of Samson is also familiar in its elements. It begins with a barren woman, identified only as "the wife of Manoah." An angel of the Lord tells her that she will bear a son and that she should not cut his hair. He also tells her not to drink strong drink or eat unclean fruit. She takes the message to her husband, and although he immediately believes, he also wants to see the representative of the Lord with his own eyes. But it is only through his wife that he is brought to this messenger. There is something in the instructions and the dynamic that might make us think of Adam and Eve, and this story has the same elemental, mythical feel. Obey and be blessed. When they see the angel rise with the burnt offering, Manoah fears they will be killed by God, but his wife reassures him. If nothing else, the story demonstrates how confused they are about God and their relationship with God. This is how so many of the stories of salvation begin in the Historical Books. It is probably very akin to how people felt after the exile when they encountered the Lord God in the book of the Law and the rabbinical tradition.

There are many tales in these short chapters about Samson, but the illumination in *The Saint John's Bible* focuses on two elements: the angel's visit to the wife of Manoah and the destruction of the palace. On the left, in gold, we see the figure of the angel of the Lord who appeared to the barren woman and told her she would have a child. The angel seems engulfed in orange flame—it could be that this is a depiction of the angel rising with the burnt offering. This part of the illumination is richly colored, suggesting the favor bestowed upon

ing at our hands, or shown us all these things, or now announced to us such things as these." ¶ The woman bore a son, and named him Samson. The boy grew, and the LORD blessed him. ²⁵ The spirit of the LORD began to stir him in Mahaneh-dan, between Zorah and Eshtaol.

14

Once Samson went down to Timnah, and at Timnah he saw a Philistine woman. ² Then he came up, and told his father & mother, "I saw a Philistine woman at Timnah; now get her for me as my wife." ³ But his father & mother said to him, "Is there not a woman among your kin, or among all our people, that you must go to take a wife from the uncircumcised Philistines?" But Samson said to his father, "Get her for me, because she pleases me." ⁴ His father and mother did not know that this was from the LORD; for he was seeking a pretext to act against the Philistines. At that time the Philistines had dominion over Israel. ⁵ Then Samson went down with his father and mother to Timnah. When he came to the vineyards of Timnah, suddenly a young lion roared at him. ⁶ The spirit of the LORD rushed on him, and he tore the lion apart bare-handed as one might tear apart a kid. But he did not tell his father or his mother what he had done. ⁷ Then he went down and talked with the woman, and she pleased Samson. ⁸ After a while he returned to marry her, and he turned aside to see the carcass of the lion, and there was a swarm of bees in the body of the lion, and honey. ⁹ He scraped it out into his hands, and went on, eating as he went. When he came to his father & mother, he gave some to them, and they ate it. But he did not tell them that he had taken the honey from the carcass of the lion. ¹⁰ His father went down to the woman, and Samson made a feast there as the young men were accustomed to do. ¹¹ When the people saw him, they brought thirty companions to be with him. ¹² Samson said to them, "Let me now put a riddle to you. If you can explain it to me within the seven days of the feast, and find it out, then I will give you thirty linen garments and thirty festal garments. ¹³ But if you cannot explain it to me, then you shall give me thirty linen garments and thirty festal garments." So they said to him, "Ask your riddle;

let us hear it." ¹⁴ He said to them,

"Out of the eater came something to eat.
Out of the strong came something sweet."

But for three days they could not explain the riddle. ¶ On the fourth day they said to Samson's wife, "Coax your husband to explain the riddle to us or we will burn you and your father's house with fire. Have you invited us here to impoverish us?" ¹⁶ So Samson's wife wept before him, saying, "You hate me; you do not really love me. You have asked a riddle of my people, but you have not explained it to me." He said to her, "Look, I have not told my father or my mother. Why should I tell you?" ¹⁷ She wept before him the seven days that their feast lasted; and because she nagged him, on the seventh day he told her. ¶ Then she explained the riddle to her people. ¹⁸ The men of the town said to him on the seventh day before the sun went down,

"What is sweeter than honey?
What is stronger than a lion?"

And he said to them,

"If you had not plowed with my heifer,
you would not have found out my riddle."

¹⁹ Then the spirit of the LORD rushed on him, and he went down to Ashkelon. He killed thirty men of the town, took their spoil, and gave the festal garments to those who had explained the riddle. In hot anger he went back to his father's house. ²⁰ And Samson's wife was given to his companion, who had been his best man.

15

After a while, at the time of the wheat harvest, Samson went to visit his wife, bringing along a kid. He said, "I want to go in to my wife's room." But her father would not allow him to go in. ² Her father said, "I was sure that you had rejected her, so I gave her to your companion. Is not her younger sister prettier than she? Why not take her instead?" ³ Samson said to them, "This time, when I do mischief to the Philistines, I will be without blame." ⁴ So Samson went and caught three hundred foxes, and took some torches; and he turned the foxes tail to tail, and put a torch between each pair of tails. ⁵ When he had set fire to the torches, he let the foxes go into the standing grain of the Philistines, & burned up the shocks and the standing grain, as well as the vineyards & olive groves. ⁶ Then the Philistines asked, "Who has done this?" And they said, "Samson, the son-in-law of the Timnite, because he has taken Samson's wife and given her to his companion." So the Philistines came up and burned her and her father. ⁷ Samson said to them, "If this is what you do, I swear I will not stop until I have taken revenge on you." ⁸ He

ᵃ Cn: Heb *my*
ᵇ Gk Syr: Heb *sixtieth*
ᶜ Heb *them*
ᵈ Gk Tg Vg: Heb *lacks go*

·LET·ME·DIE·WITH·THE·PHILISTINES·

STORY OF SAMSON

Samson. However, it is also interwoven with the Egyptian elements we've seen before. In fact, the depiction of the warrior bodies, representing the Philistines, comes from Egyptian frescos. The frescos are actually made on wet plaster on walls, and Donald Jackson has said that the originals look like batik. They illustrate battle scenes and remind us that this story is part of a long history of stories about conquests and battles.

Samson seems to have been born to a single purpose: to punish the Philistines. In a variety of episodes, he wreaks havoc on them. He seems close to nature and reminiscent of the companion of Gilgamesh, Enkidu, who was a wild man, close to nature and possessed of great strength. In the horizontal part of this illumination that interrupts the text on the page, we see an image of Samson, the blue figure, with his hair grown back and his hands spread, pushing down the columns of the palace. Again in stylized fashion, we see the death of the Philistines among the broken columns.

Donald Jackson has continued the theme across the page, making the initial *A* of chapter 15 out of the columns and scattering a few at the bottom of the page with the motto, "Let me die with the Philistines" (16:30). Unlike other heroes we've encountered so far, Samson dies, as it were, in battle. His death is treated heroically, not as punishment for disobedience or a turn from God. The illumination shares many elements with the panels that precede it in Judges, all building up to the *Judges Anthology*.

◀ *There are so many stories packed into the account of Samson. Focusing on another aspect—his strength, his relationship to nature, or his relationship with women—how might you illuminate the passage?*

Cities in Flames

JUDGES 20

And there was the whole city going up in smoke toward the sky! (20:40)

What do this story and illumination tell us about the nature of violence?

The *Cities in Flames* illumination depicts a real low point for Israel. The story told in Judges 19 is of a Levite, a member of the priestly tribe of Israel, seeking shelter overnight in the Benjaminite city of Gibeah. While there, members of the tribe of Benjamin attack the house. The Levite gives them his concubine, who is raped mercilessly throughout the night. In the morning she makes her way to the doorstep and dies. The Levite takes her body home and sends it in twelve pieces throughout the twelve tribal areas of Israel.

Chapter 20 tells what happens in the aftermath of this crime. By the end, the tribe of Benjamin is almost completely wiped out. What makes this episode stand out from the other acts of violence in these books is the fact that it is internal to Israel. Israel has sinned against itself.

What marks this illumination is the presence of a contemporary person, a young man or maybe a child. This person is a representative of the cities still in flames in the Middle East. Is he Israeli? Palestinian? He is a representative of the currently divided area, where people fight against people who are close neighbors. The illumination is representative of a place where people still do not live as brothers and sisters and cities still burn. Although it is tempting to find parallels to the current violence in Israel throughout *Historical Books*, this is the only reference to the current Israeli/Palestinian conflict in the volume.

◀ *What were your initial thoughts about the figure of the boy in this illumination? Why do you think it's so powerful in this context?*

Israel." But the Benjaminites would not listen to their kinsfolk, the Israelites. The Benjaminites came together out of the towns to Gibeah, to go out to battle against the Israelites. On that day the Benjaminites mustered twenty-six thousand armed men from their towns, besides the inhabitants of Gibeah. Of all this force, there were seven hundred picked men who were left-handed; every one could sling a stone at a hair, and not miss. And the Israelites, apart from Benjamin, mustered four hundred thousand armed men, all of them warriors. ▌ The Israelites proceeded to go up to Bethel, where they inquired of God, "Which of us shall go up first to battle against the Benjaminites?" And the LORD answered, "Judah shall go up first." ▌ Then the Israelites got up in the morning, and encamped against Gibeah. The Israelites went out to battle against Benjamin; and the Israelites drew up the battle line against them at Gibeah. The Benjaminites came out of Gibeah, and struck down on that day twenty-two thousand of the Israelites. The Israelites went up & wept before the LORD until the evening; and they inquired of the LORD, "Shall we again draw near to battle against our kinsfolk the Benjaminites?" And the LORD said, "Go up against them." The Israelites took courage, and again formed the battle line in the same place where they had formed it on the first day. ▌ So the Israelites advanced against the Benjaminites the second day. Benjamin moved out against them from Gibeah the second day, and struck down eighteen thousand of the Israelites, all of them armed men. Then all the Israelites, the whole army, went back to Bethel and wept, sitting there before the LORD; they fasted that day until evening. Then they offered burnt offerings and sacrifices of well-being before the LORD. And the Israelites inquired of the LORD [for the ark of the covenant of God was there in those days, and Phinehas son of Eleazar, son of Aaron, ministered before it in those days], saying, "Shall we go out once more to battle against our kinsfolk the Benjaminites, or shall we desist?" The LORD answered, "Go up, for tomorrow I will give them into your hand." ▌ So Israel stationed men in ambush around Gibeah. Then the Israelites went up against the Benjaminites on the third day, and set themselves in array against Gibeah, as before. When the Benjaminites went out against the army, they were drawn away from the city. As before they began to inflict casualties on the troops, along the main roads, one of which goes up to Bethel and the other to Gibeah, as well as in the open country, killing about thirty men of Israel. The Benjaminites thought, " They are being routed before us, as previously." But the Israelites said, "Let us retreat & draw them away from the city toward the roads." The main body

the Israelites drew back its battle line to Baal-tamar, while those Israelites who were in ambush rushed out of their place west of Geba. There came against Gibeah ten thousand picked men out of all Israel, and the battle was fierce. But the Benjaminites did not realize that disaster was close upon them. ▌ The LORD defeated Benjamin before Israel; and the Israelites destroyed twenty-five thousand one hundred men of Benjamin that day, all of them armed. ▌ Then the Benjaminites saw that they were defeated. ▌ The Israelites gave ground to Benjamin, because they trusted to the troops in ambush that they had stationed against Gibeah. The troops in ambush rushed quickly upon Gibeah. Then they put the whole city to the sword. Now the agreement between the main body of Israel and the men in ambush was that when they sent up a cloud of smoke out of the city, the main body of Israel should turn in battle. But Benjamin had begun to inflict casualties on the Israelites, killing about thirty of them; so they thought, "Surely they are defeated before us, as in the first battle." But when the cloud, a column of smoke, began to rise out of the city, the Benjaminites looked behind them—and there was the whole city going up in smoke toward the sky! Then the main body of Israel turned, and the Benjaminites were dismayed, for they saw that disaster was close upon them. Therefore they turned away from the Israelites in the direction of the wilderness; but the battle overtook them, and those who came out of the city were slaughtering them in between. Cutting down the Benjaminites, they pursued them from Nohah and trod them down as far as a place east of Gibeah. Eighteen thousand Benjaminites fell, all of them courageous fighters. When they turned and fled toward the wilderness to the rock of Rimmon, five thousand of them were cut down on the main roads, and they were pursued as far as Gidom, and two thousand of them were slain. So all who fell that day of Benjamin were twenty-five thousand arms-bearing men, all of them courageous fighters. But six hundred turned and fled toward the wilderness to the rock of Rimmon, and remained at the rock of Rimmon for four months. Meanwhile, the Israelites turned back against the Benjaminites, and put them to the sword—the city, the people, the animals, and all that remained. Also the remaining towns they set on fire.

Verses 22 and 23 are transposed
Gk-Vg: Heb in the plain
this sentence is continued by verse 46
Compare Vg and some Gk Mss: Heb uncertain
Compare Syr: Meaning of Heb uncertain
Gk: Heb surrounding
Gk: Heb pursued them as their resting place

IN THOSE DAYS THERE WAS NO KING IN ISRAEL

AND·THERE·WAS·THE·WHOLE· ·CITY·GOING·UP·IN·SMOKE· ·TOWARD·THE·SKY·

CITIES IN FLAMES

JUDGES 21:25

In those days there was no king in Israel; all the people did what was right in their own eyes. (21:25)

How would you describe this illumination? What story does it tell of the age of judges?

The final verse of Judges (21:25) sets us up for what is to come next (after a brief interlude with the story of Ruth). The people of Israel have not come together under the judges, and now God will give them kings.

JUDGES ANTHOLOGY

THE ART OF THE SAINT JOHN'S BIBLE

Meanwhile, what can we say (or see) about this period of the judges? The illumination here has thick black bars and narrow bands of gold throughout. There is rising and descending, climbing and falling. There are flames. At the top, wild dogs devour the people. At the base of the illumination, more wild dogs devour the people and arrows pierce them. There is blood and fire and, above all, chaos. There is no sense in this illumination of progress or stability, of growth and transformation. Three golden calf idols emerge at various places in the illumination, which is bordered on the right by hieroglyphics. The Israelites may have asserted themselves militarily, but they have not asserted themselves culturally or unified around a single culture. They are still, in a way, slaves to the old ways. Their future at this point, despite living in the land of Canaan, is far from certain. It is not clear if they will ever do what is right in the eyes of the Lord. It is not certain if they will make their stamp on this place and become a people.

After completing this illumination, Donald Jackson returned to add a final layer, the black batons. We can see them as the opposite of the gold batons suggesting divine presence, showing the ongoing bad choices of the Israelites. Jackson suggests that here the gold wedges, showing clearly God's continued presence with God's people, are "sort of scurrying around, almost like divine sheep dogs, trying to pull all these people together, while they're all defying it, going their own way, and still surrounded by the symbols of their yearning for the foreign gods." It is the goodbye to the Egyptian chapter before the Israelites move toward the era of prophets and kings.

◖ *Why do you think the people rejected rule by judges? How might kings be better—or not?*

Ruth and Naomi and Ruth, the Gleaner

RUTH 1:16-18 / RUTH 2:2-23

Where you go, I will go. (1:16)

Let me go to the field and glean among the ears of grain, behind someone in whose sight I may find favor. (2:2)

What strikes you as important about the story of Ruth and Naomi? Do we see examples of their loyalty and love in the world today?

The book of Ruth is like an oasis for readers of *Historical Books*. It is similar to encountering the Song of Solomon in *Wisdom Books* after the hard moral wrangling of Job, Proverbs, and Ecclesiastes. Let us not forget there is love in the world, as well as kindness and kinship. After the accounts of judges and the ongoing captivity and redemption of the Israelites, let us focus our minds for a moment on the story of a woman and her mother-in-law. They are not kings or judges—both are widows. Let us consider how a foreign woman, a Moabite, contributed to the line of David.

We should also realize that it is only in the Christian canon that the book of Ruth appears in this place in the Old Testament. In the Jewish canon it is in a final section known as the Writings, along with the Song of Solomon. Since Ruth is the grandmother of King David, the book of Ruth makes a fine bridge to 1 Samuel, where the reader first encounters the noteworthy monarch. This placement is chronological, not by genre.

The illumination *Ruth and Naomi* by Suzanne Moore has a lot in common with another of her illuminations, *Praise of Wisdom* (Sir 24). Moore loves arcs of color, movement, and images that seem to dance on the page. In their original inks on vellum, the color and movement are even more stunning than in the reproduction books. We see an emphasis on fertility and a stamped motif that appears in all seven volumes of *The Saint John's Bible*, perhaps most prominent in the illumination *Loaves and Fishes* (Mark 6). Donald Jackson describes this image as a reflection of mathematical principles and proportions found in nature (in leaves, shells, etc.). He uses this stamp to suggest a sort of cosmic order to the universe. Here it seems to reflect a sign of God's favor and God's miraculous provision for the two widows in this story.

The image of *Ruth and Naomi* also has similarities with the portrait of Mary and Martha in the *Luke Anthology* (Luke 10). That illumination also shows the backs of two women

with their gaze fixed ahead. In the case of
Martha and Mary, they listened to Jesus
telling the parables. Mary sits and listens,
while Martha stands in her apron with her
hands on her hips, perhaps impatient. In
the image of Ruth and Naomi, they are
seated side by side, looking out to their
future. They are dressed in similar head-
dresses and flowing clothing—who can
say which one is the foreigner? In Moab, it
would have been Naomi who would have
been the presumed outsider, a widow de-
pendent on the households of her sons.
Their love for each other unites the two
women, and Ruth follows Naomi back to
the land of Judah, where she is the outsider.

RUTH AND NAOMI

Two widows are not better than one
when it comes to providing for themselves.
But it is clear that without Ruth, Naomi's
prospects would have been quite dim. Ruth
takes on the dangerous task of gleaning, walking behind the
harvesters to pick up the meager grain left behind. It seems
she might be able to provide the two of them with food this
way during the harvest, but it's unclear how she will continue
to provide after the harvest is over. Also, mention is made of
the dangers of gleaning and the strong possibility of being
"bothered" or mistreated by the men in the fields.

The story of Ruth's love for her mother-in-law and also,
presumably, Ruth's beauty, catches the eye of Boaz. Through
her marriage to him, she is able to keep the land in her first
husband's name, in effect perpetuating Naomi's line. Two
widows—one a foreigner, the lowest in rank in the area—find
favor with the Lord and are rescued. The story of Ruth is a
glimpse of the kingdom, of what God has in mind for Israel, a
success story. Boaz acts rightly toward her, and it is a happily-
ever-after story.

The illumination of *Ruth, the Gleaner* particularly reflects
the movement in the story from famine, barrenness, and

isolation in Moab to plenitude, fruitfulness, and community in Bethlehem, that famous city. They arrive at the start of the harvest and find generosity from Boaz. The marriage results in a son, Obed, who is named by all the women in the community! The swirling image at Ruth's center in this illumination is more than a basket of grain. It seems to speak to the abundance and fertility at the center of Ruth's being, an extension of her swirling skirts. Barrenness and God's promises will play a role in the next story we consider, that of Hannah, and are ultimately seen in the story of Mary, the mother of Jesus, and her cousin Elizabeth, the mother of John the Baptist. The parallels are rich.

It is true that the Israelites often did what was evil in the sight of the Lord. But through a single line of people, including this Moabite woman mentioned in the genealogy of Jesus that opens the New Testament, God's plan was carried through.

The book of Ruth concludes with a special text treatment by Donald Jackson. Above the text treatment are seven stars of David. Beneath it is another representation of a menorah. The stars can be seen as flames on the menorah candles or simply as an extension of the motif. The treatment itself is of the genealogy, the women naming Ruth's son Obed, and the line into which he fits—from Perez, son of Judah by Tamar, to Obed, father of Jesse, the father of King David.

The book of Ruth stands as a witness for inclusivity. The writer wishes to make the point that Israel's greatest king, David, was the grandson of a Moabite woman. For most of their history, Moabites were enemies of Israel.

❧ *Which figure do you think is Ruth, and which is Naomi in the illumination? Why?*

2

Now Naomi had a kinsman on her husbands side, a prominent rich man, of the family of Elimelech, whose name was Boaz. And Ruth the Moabite said to Naomi, "Let me go to the field & glean among the ears of grain, behind some one in whose sight I may find favor." She said to her, "Go, my daughter." So she went. She came & gleaned in the field behind the reapers. As it happened, she came to the part of the field belonging to Boaz, who was of the family of Elimelech. Just then Boaz came from Bethlehem. He said to the reapers, "The LORD be with you." They answered, "The LORD bless you." ⁵ Then Boaz said to his servant who was in charge of the reapers, "To whom does this young woman belong?" ⁶ The servant who was in charge of the reapers answered, "She is the Moabite who came back with Naomi from the country of Moab. She said, 'Please, let me glean and gather among the sheaves behind the reapers.' So she came, and she has been on her feet from early this morning until now, without rest⁸ ing even for a moment." ✦ Then Boaz said to Ruth, "Now listen, my daughter, do not go to glean in another field or leave this one, but keep close to my young women. Keep your eyes on the field that is being reaped, and follow behind them. I have ordered the young men not to bother you. If you get thirsty, go to the vessels & drink from what the young men have drawn." ¹⁰ Then she fell prostrate, with her face to the ground, and said to him, "Why have I found favor in your sight, that you should take notice of me, when I am a foreigner?" ¹¹ But Boaz answered her, "All that you have done for your mother-in-law since the death of your husband has been fully told me, and how you left your father and mother and your native land and came to a people that you did not know before. ¹² May the LORD reward you for your deeds, and may you have a full reward from the LORD, the God of Israel, under whose wings you have come for refuge!" ¹³ Then she said, "May I continue to find favor in your sight, my lord, for you have comforted me & spoken kindly to your servant, even though I am not one of your servants." ✦ At¹⁴ mealtime Boaz said to her, "Come here, and eat some of this bread, and dip your morsel in the sour wine." So she sat beside the reapers, and he heaped up for her some parched grain. She ate until she was satisfied, and she had some left over. ¹⁵ When she got up to glean, Boaz instructed his young men, "Let her glean even among the standing sheaves, and do not reproach her. ¹⁶ You must also pull out some handfuls for her from the bundles, and leave them for her¹⁷ to glean, and do not rebuke her." ✦ So she gleaned in the field until evening. Then she beat out what she had gleaned, and it was about an ephah of barley.

¹⁸ She picked it up and came into the town, and her mother-in-law saw how much she had gleaned. Then she took out and gave her what was left over after she herself had been satisfied. ¹⁹ Her mother-in-law said to her, "Where did you glean today? And where have you worked? Blessed be the man who took notice of you." So she told her mother-in-law with whom she had worked, and said, "The name of the man with whom I worked today is Boaz." ²⁰ Then Naomi said to her daughter-in-law, "Blessed be he by the LORD, whose kindness has not forsaken the living or the dead!" Naomi also said to her, "The man is a relative of ours, one of our nearest kin." ²¹ Then Ruth the Moabite said, "He even said to me, 'Stay close by my servants, until they have finished all my harvest.'" ²² Naomi said to Ruth, her daughter-in-law, "It is better, my daughter, that you go out with his young women, otherwise you might be bothered in another field." ²³ So she stayed close to the young women of Boaz, gleaning until the end of the barley & wheat harvests; and she lived with her mother-in-law.

Compare Gk Vg: Meaning
of Heb uncertain
Or one in whose sight so
explicitly

RUTH, THE GLEANER

My heart exults in the LORD.
(2:1)

What similarities do you see between Hannah's prayer
(1 Sam 2:1-10) and the Magnificat *(Luke 2:46-55)?*

The book of Samuel begins with the story of Hannah, an-
other barren woman, and her two prayers. Both of her prayers
are significant, although it is the second that is most remem-
bered and most often discussed. The illumination depicts both
prayers, showing Hannah approaching God with a lament and
her public exultation of gratitude.

The first prayer is a prayer that comes directly from her
heart, out of her anguish over not being able to have a child.
It has been made clear that her inability to have children has
not caused her any problems with her husband, who loves her
and gives her a "double portion," trying to compensate for
her loss. It is true that the other wife, Peninnah, harasses her,
and that her general status would be less because she hasn't
given her husband an heir. This status is emphasized by the
fact that she goes to the temple without anything to sacrifice
or any official standing. There she "presented herself before
the LORD" directly, and she offers this heartfelt prayer, depicted
in the first half of the illumination: "O LORD of hosts, if only
you will look on the misery of your servant, and remember
me, and not forget your servant, but will give to your servant a
male child, then I will set him before you as a nazirite until the
day of his death. He shall drink neither wine nor intoxicants,
and no razor shall touch his head" (1:11).

No sooner has she mouthed this prayer than the priest,
Eli, accuses her of being drunk herself. This only emphasizes
what a rare thing it is for a woman, or anyone, to pray like
this at the temple, outside the rituals of sacrifice and petition
through the priest. When she tells him her situation, he blesses
her, and she goes away satisfied—with faith that her prayer
will be answered.

And when it is, she sings a prayer of gratitude to the Lord.
"My heart exults in the LORD," begins her prayer in chapter
2. This song hearkens back to the song of Deborah in Judges
5, and also by association back to the song of the women of
Israel along the banks of the River Jordan after the destruction

of Pharaoh and his men (Exod 15:20-21). The theme is that "there is no Rock like our God" (2:2), a deliverer who sweeps away any enemies and raises up the lowly. He looks with favor on the humble and those in distress and offers them riches and freedom from their misery. In this way, Hannah's prayer of gratitude goes beyond thankfulness for the birth of a child. As the illumination emphasizes, "I rejoice in my victory." Her triumph is likened to triumph in battle. This prayer song is another beautiful poem, one that could take its place beside any of the psalms.

Usually, however, Hannah's prayer is not seen as an extension of those women's prayers that have come before but is recognized for its resonance with the *Magnificat*, Mary's prayer in Luke 1:46-55. Like Hannah, Mary has "found favor" with God and identifies herself as a lowly servant who has been exalted by God.

This is another work by Thomas Ingmire, who did the *Ten Commandments*. There are similarities in this treatment to *Beatitudes* and to his treatments in the book of Job, as well as to *Messianic Predictions* in Isaiah. The illumination pairs the two prayers; both of them cries to the Lord.

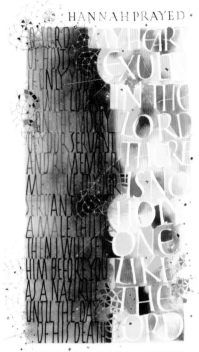

HANNAH'S PRAYER

First Hannah cries out of her misery—the black panel of the illumination. The ghostly text speaks to her humility and her lack of power in the temple. But because "the LORD remembered her" (1:19), she also rejoices in the birth of her son Samuel, whom she returns to the service of God. Like *Messianic Predictions*, this is a public prayer, bold as trumpets. We also see the stamped motif we just saw in the book of Ruth. How might this story speak to the question of cosmic order?

◀ *Both Samson and Samuel are given to the temple as nazirites. However, they couldn't be more different! Keep this in mind as you read more about Samuel and consider what this tells us about God's choice of people to save and lead Israel.*

Call of Samuel

I SAMUEL 3:1-18

Speak, Lord, for your servant is listening. (3:9)

Do you feel, or have you ever felt, called by God?

If only we all heard God's call as clearly as Samuel.

We know that Samuel is given into a corrupt temple where the sons of the priest Eli take the lion's share of the people's sacrifices and consort with the women who serve at the temple. As the NRSV translates it, "The sons of Eli were scoundrels" (2:12).

Despite all the emphasis in that society on heirs and birth order, when a family goes bad, God is quite capable of raising up a just leader or, in this case, calling a just prophet. In fact, we learn that there have not been many prophecies from this temple precisely because Eli's sons show such contempt for the Lord, and their father is incapable or unwilling to restrain them.

God calls Samuel, Hannah's son the nazirite. In the dark of night, as Samuel sleeps near the ark of the covenant, God calls him in a voice as clear and loud as that of Eli sleeping next door. In fact, since Samuel has not heard God's voice before,

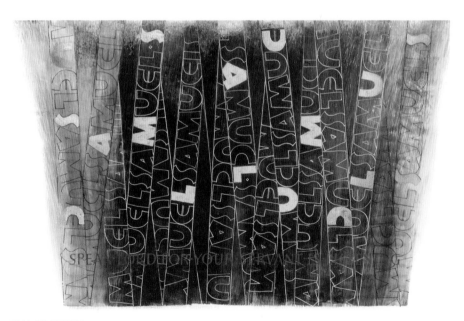

CALL OF SAMUEL

THE ART OF THE SAINT JOHN'S BIBLE

he goes three times to Eli's chamber, assuming he is the one who has called him. Finally Eli figures out what is happening and instructs Samuel to answer, "Speak, LORD, for your servant is listening." When Samuel does this, the Lord reveals himself and his plan to Samuel and instructs Samuel to bring the bad news to Eli—his family is about to be destroyed.

The illumination by Hazel Dolby emphasizes the nature of the call. In strips seemingly folded back and forth, the name of Samuel called in the dark night by God fills the space from top to bottom. God's word comes down and Samuel's attention goes up, until the nature of what is happening becomes clear. Random letters are accented in gold foil, as Samuel learns what it means to hear God's voice, to recognize God in the simple language that wakes him up again and again.

This illumination also resonates with 3:19-20: "As Samuel grew up, the LORD was with him and let none of his words fall to the ground. And all Israel from Dan to Beer-sheba knew that Samuel was a trustworthy prophet of the LORD." The words here, seemingly folded on a single strip, do not fall to the ground but retain their crispness and clarity even as they traverse the spaces of heaven and earth.

This page is also marked by an error—a line left out by the scribe and recognized only when the scribe reached the end of the column and found it too short. In other volumes, such errors are corrected by ingenious illustrations, such as a bee cranking a pulley system in Wisdom 7, a bird lifting the line into place in *Sower and the Seed* (Mark 4), and a lemur marking the spot in 2 Chronicles. But here the treatment is simple, so as not to distract from the illumination, and the ornament, such as it is, is in keeping with the illumination. A gold leaf diamond and a simple line point to the place where the line was omitted, and a simple blue box, accompanied by a matching diamond, marks the line to be inserted by the reader in that place.

❧ *Samuel is the last of the judges, the one who will appoint Saul as the first king of Israel. Having gone through these stories, what have you learned about the role of judges?*

Is Saul a hero? Is he a tragic hero? How do you interpret Saul's character throughout his story?

I SAMUEL 9–31

The LORD has done to you just as he spoke by me. (28:17)

We encourage you to spend time with the whole story of Saul when contemplating this illumination. These stories of the kingship of Saul and David are the core of *Historical Books*.

As Samuel's story begins with a shake-up of the lineage of the priests, so Saul and his sons will not be heir to the kingship of Israel. The story of King Saul takes up more than two-thirds of the book of Samuel. But Saul is still only a transition to the true kingship, that of King David. It is from the house of David, not the house of Saul, that God will send the Savior and Redeemer. The prophets all proclaim this truth. Saul plays his role in the cycle of Israel as the people struggle with their relationship with God here in an earthly kingdom.

It is, in part, the failure of Samuel's own sons to be good judges that leads the people of Israel to beg him for a king. We begin the story of the illumination *Saul Anthology* with a text treatment in the margins of chapter 9. "And the LORD said to Samuel, 'Listen to the voice of the people in all that they say to you; for they have not rejected you, but they have rejected me from being king over them'" (8:7).

Saul is chosen by God; he is as handsome as any hero and from the lowliest of the twelve tribes—that is, the tribe of Benjamin. This time Samuel anoints a king (not a judge) to deliver the people from the Philistines. He lets the people know in no uncertain terms that they have failed by not recognizing that God is their king but insisting on an earthly ruler. Still, despite this weakness on the part of the Israelites, Samuel and God will continue to be on their side. But the Israelites are warned: a king cannot save them, only God. If their king fails to follow God's commandments, the king will fall.

And in the very next story, in the first major challenge to Saul, he does indeed break the Lord's commandment. Although he has been told to wait for Samuel to offer the sacrifice that will bless their battle, Saul becomes impatient as the men start to leave, and he offers the sacrifice himself. But he is no priest and this is not his role. To usurp the role of the anointed priest

and to ignore God's command is serious. And, of course, no sooner has Saul done this thing than Samuel shows up. (Haven't many of us suffered the consequences of impatience like this?) As the marginal text announces, "Samuel said to Saul, 'You have done foolishly; you have not kept the commandment of the LORD your God'" (13:13). In that one move, Saul lost the kingdom and sealed his own fate and that of his sons, who will perish at the end of the book of Samuel and be disgraced.

Almost immediately we meet David, the true king and the challenger to Saul's throne. He, too, is of most humble origins (remember the foreigner Ruth and her son Obed?). His is a hero's story that rivals any in literature. David slays the giant Goliath with his slingshot; he is rescued from the lion and the bear. He is a beautiful shepherd who plays songs to the Lord on his lyre. And the women sing, "Saul has killed his thousands, and David his ten thousands" (18:7), a curse to Saul's ears as dangerous as the pronouncement of any mirror on the wall in a fairy tale.

From very early on, Saul pursues David to kill him. And we have the story of the great friendship between David and Jonathan, Saul's son, who protects David, makes a covenant with him and does not seek the kingship over his relationship with David. Again, the themes are clear: loyalty to both God and God's chosen one is to be treasured. Victory goes to the faithful. Saul, who depends on his own power instead of the Lord, is ultimately vanquished and

THE LORD HAS DONE TO YOU JUST AS HE SPOKE BY ME; FOR THE LORD HAS TORN THE KINGDOM OUT OF YOUR HAND & GIVEN IT TO YOUR NEIGHBOR, DAVID, BECAUSE YOU DID NOT OBEY THE VOICE OF THE LORD

SAUL ANTHOLOGY

driven to an ignoble fate. Finally accepting the consequences, he falls on his own sword.

This illumination uses the three colors—gold, green, and purple—emphasized in *Historical Books*. The focus is on Saul's kingship, and by using a single column, the illumination reflects the hierarchy of God's kingdom, the realm of priests and prophets, and finally the realm of kings. As we see, the heavenly kingdom is beautiful, and the crown of golden archways at the top is suggestive of heavenly mansions. Israel is favored, but the story is always complex. The green realm demonstrates the presence of Samuel, who guides Israel and advises Saul throughout Saul's reign. The text in the margin of the illumination is the final words of Samuel in chapter 28. In this astonishing passage, Samuel speaks from the dead, through a medium, to tell Saul yet again that his kingship has been handed over by God to David. His words are in green with gold caps, suggestive of his place now after death and of the power of his prophecy.

Finally, there is the realm of purple, Saul's kingship, also shot through with gold. We see the presence of a prayer shawl with dangling fringes but also with the Egyptian motif. There are occasional flames, the warring nature of his kingship, and, in the shadow of the prayer shawl, a skull. Saul's skull is separated from his body by the Philistines, and his body is placed on the wall. The men of Israel take his body and those of his sons who were slain with him, burn them, and bury their bones beneath the tamarisk tree in Jabesh. A tree stands above the skull in the illumination, suggestive of the tamarisk and also of the young monarchy taking root in Israel. The book closes with the men of Israel beginning a seven-day fast, the next stage in a cycle that always ends with repentance and an appeal to God for deliverance.

❧ *How might you have chosen to illuminate the story of King Saul? What elements of the story do you think are most important?*

What similarities do you see between this illumination and Hannah's Prayer at the opening of 1 Samuel?

First Samuel began with Hannah's prayer to the Lord expressing her sorrow. Second Samuel begins with David mourning the deaths of his beloved friends Jonathan and King Saul. Again we have an illumination by Thomas Ingmire. This time it depicts the song, in vertical panels, and shows David's multiple emotions, such as the anger that drives him to kill the Amalekite, the public line of the song that will be passed down throughout the ages, "How the mighty have fallen!" and his more personal grief over Jonathan's death, an expression of distress that seems a shadow engraved on the page.

In this single, compact illumination, Ingmire captures all the emotion of this moment, both for the people of Israel and for David personally. The king is dead. The people are vanquished by the Philistines—and so too is his beloved brother Jonathan.

What do we make, if anything, of the left-hand side of this illumination? We can almost make out words, but the letter forms are disrupted. Maybe it is representative of David's rage at the Amalekite who brought him the news, not only because he witnessed Jonathan's and Saul's deaths, but also because he drove his own sword into Saul. The man brought the crown and armlet to the rightful heir, David, and no doubt expected some reward for his actions. David reminds him that Saul was "the LORD's anointed" (1:14). In his statement and in his ordering the man's death, which seems unduly harsh, David nonetheless sides with the Lord and seems to forgive Saul, establishing again that his ambition was to serve, not to overthrow Saul's kingdom.

The song in verses 19-27 praises not only Jonathan but also Saul and calls for collective mourning by Israel for both men. David's character has been ascending in the last half of 1 Samuel, and he is fully worthy of the kingship here.

❧ *David is a passionate character. Can you think of other examples of his passion, for good or bad?*

David's Lament (How the Mighty Have Fallen)

2 SAMUEL 1:19-27

How the mighty have fallen! (1:19)

I Will Raise Up Your Offspring

2 SAMUEL 7:12

I will not take my steadfast love from [your offspring], as I took it from Saul, whom I put away from before you. Your house and your kingdom shall be made sure forever before me; your throne shall be established forever. (7:15-16)

To the covenant with Abraham and the covenant with Moses is now added a third: the covenant with David. This verse is messianic and, as such, is embraced by the Christian church as a prediction of Jesus, who will come from the line of David as the Redeemer.

The text treatment by Sally Mae Joseph is done in all capitals and in purples, reflecting again this time of the kings. The Lord is making this promise not with an individual (as in the Abrahamic covenant) or with the remnant wandering in the desert (as in the Mosaic covenant) but with those who will inhabit the kingdom of God. This kingdom is explored throughout the New Testament, where it is again seen as something in the future, an ideal. In Jewish tradition, the text underscores the Davidic line for the life of the people of Israel. When the Messiah comes, he will usher in an eternal reign of peace and prosperity in this world.

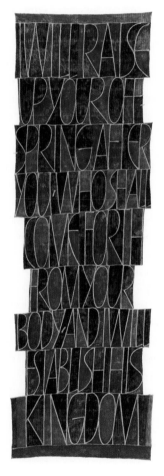

2 SAMUEL 7:12

THE ART OF THE SAINT JOHN'S BIBLE

What elements might you choose to do an illumination of the reign of David?

How to depict the reign of David, shepherd hero, giant slayer, king and warrior, psalmist, the one who brought the ark of the covenant to Jerusalem, the one through whom God will establish the everlasting kingdom? This was a problem for the artists.

In this illumination, Jackson has simplified the entire story to a depiction of a vision of Israel in David's time and placed it in the context of the larger story of *The Saint John's Bible*. He has begun with seven panels, echoing the seven panels of *Creation*. David's kingship is a significant restoration of the establishment of God's kingdom. The clearest images in the illumination are the gold stamped archways. Remember this stamp from the carpet page for this volume? The spires at the top of the panels are also reminiscent of the spires of the Cathedral of Santiago de Compostela. But the top appears to be both cathedral and fortress, perhaps symbolic of God's protection. People seek God in sacred spaces, and David is at the center of this human longing—bringing the ark at last to its destination in Jerusalem. The Divine is present in this city, but it must still be sought. It is hard to tell if the gold permeates or is only at the edges and above the chaos of the city.

The other major parallel for this illumination is to the frontispiece of *Psalms*, a book that purports to collect the hymns written by David. Even if they were attributed to him more as a dedication than a historical fact, the psalms are deeply connected to the story of David. The *Psalms* frontispiece is also in panels, reminiscent of scrolls, crowned with menorah lights instead of the spires at the top of these archway panels. That piece features similar color and movement, which we may read as David's joy and song. The opening verses of Psalm 18 are inscribed in the margin of the previous page: "The LORD is my rock, my fortress and my deliverer." This psalm is also found, with a few slight alterations, in 2 Samuel 22. Sometimes referred to as "The Song of David," it is David's response to his victory over Saul and all his enemies. Here David declares,

1 SAMUEL 16–2 SAMUEL 24 / 2 SAMUEL 6:17

They brought in the ark of the LORD, and set it in its place, inside the tent that David had pitched for it; and David offered burnt offerings and offerings of well-being before the LORD. (2 Sam 6:17)

"For this I will extol you, O LORD, among the nations, and sing praises to your name. He is a tower of salvation for his king, and shows steadfast love to his anointed, to David and his descendents forever" (2 Sam 22:50-51).

That verse also illustrates David's significant place between two other illuminations built on the seven-branched menorah: *Abraham and Sarah* in Genesis and the *Genealogy of Christ* frontispiece of Matthew's gospel. With the seven panels topped with gold we have a faint echo of the menorah and the sense of David's place in the covenant story of Israel. God has made a covenant with David, as with Abraham, that will be ultimately fulfilled in the birth of Jesus.

The detail on the previous page suggests that the arch we see throughout is also symbolic of the ark. It is the holy of holies, a gate that must be passed through to be close to God. The tent itself is merely a veil and certainly not as substantial as the hoped-for temple. Here it is pulled aside to reveal God's dwelling place.

◁ *How do you experience God's presence in sacred spaces? How might you depict your own experience with finding where God resides?*

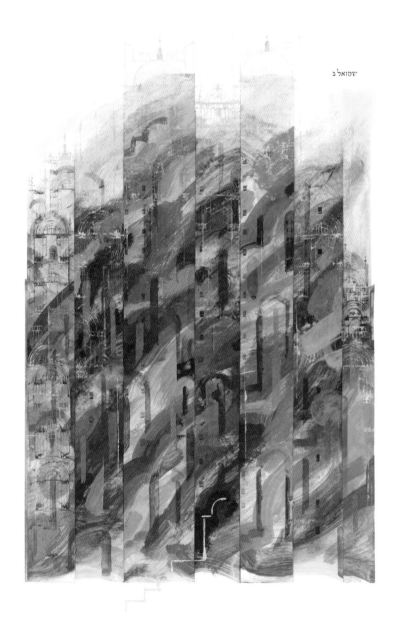

שמואל ב

DAVID ANTHOLOGY

At the end of 2 Samuel, we find the first of Chris Tomlin's insect illustrations in this volume. We saw the swallowtail butterfly and thistle in *Pentateuch* and will continue to see Tomlin's representations of the natural world in each volume. Perhaps the favorite image of readers is that of the monarch butterfly at the end of the Gospel of Mark. The monarch, so prevalent in Central Minnesota, is shown in three stages, caterpillar, chrysalis, and butterfly, representing a perfect image of the resurrection.

When considering how to depict and acknowledge the violence in *Historical Books*, one approach was to reflect how this violence goes on throughout the natural world. The relentlessness of the cycle of life, the battles between predator and prey, become beautiful in Chris Tomlin's detailed illustrations. Note the echoes between the actions of real armies and real peoples in these pages and the insects depicted from here until the end of the volume.

They are most commonly inserted in the space at the end of a book, but some appear in the margins. Their placement

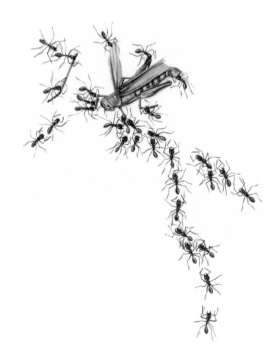

is not meant to correspond to any particular passage or book but rather to provide ornamentation and another visual thematic element for *Historical Books*. With the artists we ask, Is violence a part of our nature? Is it the mark of a fallen world? Remember the menagerie Tomlin and Jackson presented us with in the *Creation*. The snake was the first piece of dark natural imagery. This imagery, both beautiful and sinister, will weave in and out of the text and illuminations all the way to the book of Revelation, where Donald Jackson wove images of praying mantises into the illuminations of the cosmic battle.

Guide to the insect illustrations of Chris Tomlin in Historical Books:

2 Samuel 24	Army Ant Workers and Grasshopper
2 Kings 16	Imperial Scorpion and Arizona Bark Scorpion
1 Chronicles 25	Leafcutter Ants
2 Chronicles 27	Praying Mantis and Banded Damselfly, both United States
2 Chronicles 36	Harlequin Beetle (*Acrocinus longimanus*) South America
Tobit 14	Wasps
Judith 16	Monarch Butterfly Being Eaten by Whip Spider
1 Maccabees 4	Gold Beetle (*Chrysina resplendens*) and Silver Beetle (*Chrysina bates*), both Central America
1 Maccabees 11	Glasswing Butterfly (*Greta oto*) and Black Widow Spider (*Latrodectus mactans*)
2 Maccabees 7	Painted Lady Butterfly (*Vanessa cardui*) and Caterpillars, United Kingdom
2 Maccabees 15	Chameleon

Wisdom of Solomon

I KINGS 3:16-28

And they stood in awe of the king, because they perceived that the wisdom of God was in him, to execute justice. (3:28)

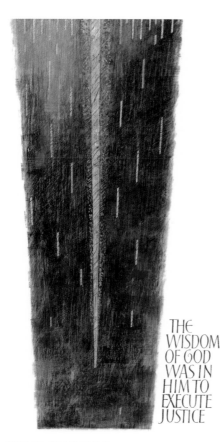

WISDOM OF SOLOMON

How would you define wisdom? Can you think of any examples where someone demonstrated wisdom?

In 1 Kings 2:9, Solomon asks God, "Give your servant therefore an understanding mind to govern your people, able to discern between good and evil; for who can govern this your great people?" Wisdom is privileged in a king, more than might. It's a refreshing break from the battles and "striking down" we've been reading.

This simple, abstract illumination by Hazel Dolby gets to the heart of Solomon's wisdom. We are told the famous case of the two women with the single live baby. One of them is lying about whether or not the child is hers, and she is also ruthless enough to take another woman's baby. Still, there is nothing arbitrary about Solomon's judgment. He decrees what at first is a "fair" but completely ridiculous—unwise—decision. Cut the baby in half and give half to each woman. This follows a cold logic, but of course it wouldn't work with a baby! It does, however, expose the ruthless woman who stole the baby and reveal the woman who is the baby's actual mother.

In the illumination, a light divides the darkness like a sword. This sword is made of gold and silver, used throughout *The Saint John's Bible* to suggest the presence of the divine (gold) and wisdom (silver). Silver was first introduced to the Bible project when the calligraphers were working on *Wisdom Books*, which includes the apocryphal book Wisdom of Solomon, purported to be a collection of Solomon's sayings. Donald Jackson decided to use silver to represent wisdom as a complementary principle to the divine presence. In illuminated manuscripts, however, silver cannot actually be

used as it will oxidize over time and turn black. Instead, Jackson and his team used platinum in the places where you see silver.

The highlighted verse in the margin also uses that great verb "execute." Solomon's wisdom and justice are swift, and he is able to take right action immediately. How often have we seen unwise rulers, in these books and in our own time, rush to wrong judgment and bring about great harm rather than justice?

I KINGS 8:1-66

I have built you an exalted house. (8:13)

How does this image of the temple compare to that found in Ezekiel 40?

David was the keeper of the ark, and he brought the ark to Jerusalem. However, the ark remained in a tent during his reign. It is his son Solomon who builds the temple, fulfilling the ambitions of the people of Israel to have a permanent kingdom and a central place to worship the Lord.

Chapters 5–8 go into great detail about the plans, furnishings, and building of the temple. There is so much detail that over time people have built models of it. Isaac Newton made extensive drawings of it, believing it followed a "sacred geometry" revealed to Solomon. There are definite similarities, although minimal, between the architectural look of Donald Jackson's various images of the temple and Isaac Newton's drawings.

Because *Historical Books* was the penultimate book of *The Saint John's Bible* to be illuminated, we can look for connections to later books, such as the Wisdom of Solomon in *Wisdom Books* and some of the other illuminations in *Prophets*. The illumination here is a version of the illumination first made by Donald Jackson for *Vision of the New Temple* in Ezekiel. Whereas that illumination seems to pulse with visionary energy and is permeated by the rainbow motif that is found throughout *Prophets*, this one is more like an architectural drawing. There is still the complex, delicate gold maze, hinting at the mystery of approaching God. While in no way meant to accurately depict the scriptural instructions, this illumination suggests the solidity of a human-made place.

The emphasis is on the elements of the temple, including the two cherubim, the gold box that represents the ark's resting place in the holy of holies, and the gates and arches on all four sides. However, Donald Jackson has preserved everywhere the aspect of mystery, drawing always on the vision of the temple in Ezekiel. The cherubim in the smoke-filled chamber possess the characteristics of the creatures in *Vision at the Chebar* (Ezek 1). We can see the elaborate wings and the

SOLOMON'S TEMPLE

human faces modeled on funereal art. The labyrinth from the vision is also in this image.

The primary color here is purple, suggesting the majesty of the kingdom united by David and consolidated under Solomon. For the first time, Israel's God has a temple and Israel's people have their king and a center for worship. This is the height of the kingdom of Israel on earth—it is as close to an earthly paradise as humans can come. Solomon's prayer, inscribed in the margin, celebrates this right relationship with God: "O LORD, God of Israel, there is no God like you in heaven above or on earth beneath, keeping covenant and steadfast love for your servants who walk before you with all their heart" (8:23).

The rainbow theme is more pronounced in the details on the two pages. Here we see that idealized, dreamlike vision of the kingdom, with palm trees and golden archways. The temple is only part of the vision realized—the ideal kingdom is yet to be experienced.

By the end of 1 Kings, however, the kingdom of David will be in collapse. First it will be separated into northern and southern kingdoms, and by the end of 2 Kings, both kingdoms will fall, the temple will be destroyed, and the people will be in exile. At the time of Ezekiel, the temple and promise of a kingdom will become more apocalyptic, a vision of a perfect, restored future. When looking at this image, also look at the carpet page for *Prophets*. The wings come from the *Vision of Isaiah* but the gold labyrinth, I would suggest, comes from the temple image.

◀ *What is a place that has great significance to you? How might you represent it in a drawing, highlighting certain elements and its meaning?*

THE ART OF THE SAINT JOHN'S BIBLE

The passage illuminated here is one of the most beautiful accounts in the Old Testament of an encounter with God. Elijah, God's prophet, has escaped Jezebel and has been fleeing and hiding for forty days. Finally, he rests overnight in a cave on Mount Horeb. A voice tells him to go outside the cave because God will be passing by.

Where is God? How is God to be perceived?

We are told that first there was "a great wind, so strong that it was splitting mountains and breaking rocks in pieces," but "the LORD was not in the wind." After that comes an earthquake, followed by a fire, but the Lord is not in either of these. Finally, there is "a sound of sheer silence." Elijah, here depicted in green, the color of the prophets, wraps his face and goes out to meet the Lord in the silence.

In the illumination, we see a steep wall of chaos, including fire and earthquake. We also see the green figure of Elijah with his face covered by his mantle to shield himself from the glory of God. His posture is one of awe and reverence. To the side stand the two angels in white, looking over him. Notice the look of the stone on which Elijah stands. Donald Jackson's brother, who does stone carving, enjoys the beauty of stone in which fossils are embedded, and he loaned polished pieces of stone with fossil traces to Jackson. He used these as the model for this decorative element to give, he said, the sense of the story embedded in the stone.

In the actual illumination, the silver bars that depict the silence are much more subtle than in the reproduction. They are masked by the grey tones in the page and can take you by surprise. The glory is there, embedded in the page, but we must be still and attentive to witness it.

◀ *What has your experience with silence been like? Has it ever been an experience of finding and knowing God?*

I KINGS 19:4-18

And after the fire a sound of sheer silence. (19:12)

prophet Elijah came near and said, "O LORD, God of Abraham, Isaac, and Israel, let it be known this day that you are God in Israel, that I am your servant, and that I have done all these things at your bidding. [37]Answer me, O LORD, answer me, so that this people may know that you, O LORD, are God, and that you have turned their hearts back." [38]Then the fire of the LORD fell and consumed the burnt offering, the wood, the stones, and the dust, and even licked up the water that was in the trench. [39]When all the people saw it, they fell on their faces and said, "The LORD indeed is God; the LORD indeed is God." [40]Elijah said to them, "Seize the prophets of Baal; do not let one of them escape." Then they seized them; and Elijah brought them down to the Wadi Kishon, and killed them there. [41]Elijah said to Ahab, "Go up, eat and drink; for there is a sound of rushing rain." [42]So Ahab went up to eat and to drink. Elijah went up to the top of Carmel; there he bowed himself down upon the earth and put his face between his knees. [43]He said to his servant, "Go up now, look toward the sea." He went up and looked, and said, "There is nothing." Then he said, "Go again seven times." [44]At the seventh time he said, "Look, a little cloud no bigger than a person's hand is rising out of the sea." Then he said, "Go say to Ahab, 'Harness your chariot and go down before the rain stops you.'" [45]In a little while the heavens grew black with clouds and wind; there was a heavy rain. Ahab rode off and went to Jezreel. [46]But the hand of the LORD was on Elijah; he girded up his loins and ran in front of Ahab to the entrance of Jezreel.

19

Ahab told Jezebel all that Elijah had done, and how he had killed all the prophets with the sword. [2]Then Jezebel sent a messenger to Elijah, saying, "So may the gods do to me, and more also, if I do not make your life like the life of one of them by this time tomorrow." [3]Then he was afraid; he got up and fled for his life, and came to Beer-sheba, which belongs to Judah; he left his servant there. [4]But he himself went a day's journey into the wilderness, and came and sat down under a solitary broom tree. He asked that he might die: "It is enough; now, O LORD, take away my life, for I am no better than my ancestors." [5]Then he lay down under the broom tree and fell asleep. Suddenly an angel touched him and said to him, "Get up and eat." [6]He looked, and there at his head was a cake baked on hot stones, and a jar of water. He ate and drank, and lay down again. [7]The angel of the LORD came a second time, touched him, and said, "Get up and eat, otherwise the journey will be too much for you."

AND AFTER THE FIRE
A SOUND OF SHEER SILENCE

AFTER THE FIRE

THE ART OF THE SAINT JOHN'S BIBLE

How is color used here to tell the story?

The two figures in this illumination, drawn by the icon painter Aidan Hart, are the prophets Elisha and Elijah. Although we think of the story of Elijah and the fiery chariot as one of God's triumph, we can tell by the look on Elisha's face that he is worried.

In the Scripture passage, Elijah and Elisha are journeying. Elijah asks Elisha three times to stop and wait, but Elisha insists on following Elijah to the end of his journey. The three points of the journey are Bethel, Jericho, and the Jordan. In a way, he is retracing the steps back to where we last saw Moses.

They pass through Bethel, where the ark of the covenant containing the Ten Commandments was housed, where Jacob received the name Israel, and a place that is mentioned in Ezra and Nehemiah as existing after the time of exile. Next they stop at Jericho, site of the famous first battle by Joshua when the Israelites entered the Promised Land. Finally they cross the Jordan, and Elijah parts the waters with his mantle, reminding us of Moses parting the Red Sea so that the Israelites could escape Pharaoh.

After they cross the Jordan, Elisha asks Elijah to leave him a "double portion" of Elijah's spirit. Elijah throws down his mantle as he is being taken up to heaven in the chariot, a sign of this outpouring. This event is paralleled twice in the Scriptures: first when Moses says he must disappear before Joshua, his successor, will receive his power, and then in the New Testament when Jesus says he will send his Spirit after he ascends to heaven. In all three cases, there is no "body" to be found on earth, although it is presumed that Moses died and his tomb is hidden. The apostles see Jesus ascend, which is followed by Pentecost, the outpouring of the Holy Spirit when they begin testifying in many languages to the people assembled in Jerusalem (Acts 1–2).

In this illumination, we see many elements of the story. At the top left are the groups of prophets waiting to see what God will do. Elisha, saddened by the loss of his predecessor and grabbing hold of his own destiny, looks to Elijah being

Elijah and the Fiery Chariot

2 KINGS 2:1-14

Please let me inherit a double share of your spirit. (2:9)

transported to heaven amid fire and chariot wheels. The connections between the book of the prophet Ezekiel and these stories of Elijah continue. The chariot wheels are based on the same image of wheels used in *Vision at the Chebar* in Ezekiel 1. However, these chariot wheels don't have the addition of "eyes" that were incorporated into the stamp for Ezekiel's vision.

At the top center is the arch, ever present in *Historical Books* as the arches of the kingdom and God's ongoing covenant to raise up a people. And below are fish, reeds, and river, suggesting the River Jordan, which the two prophets have crossed to reach this place. The colors are also quite intentionally used here—the purple of the earthly kingdom, the green of prophecy and priesthood, and the gold of God's heaven to which they aspire.

❧ *Why do you think the chariot was "fiery"?*

ELIJAH AND THE FIERY CHARIOT

What do these miracles say about the role of the prophet in Israel?

Elijah performed miracles, and so does Elisha. We can look at Elisha's miracles to see what kind of prophet he is and what his role among the people is. What is noticeable is that people come to him for basic needs: for food, money to pay their debts, health for their children, a cure for leprosy, and the means for building shelter. When the situation seems hopeless, Elisha has the power to meet their needs. He intervenes in the lives of the people in times of dire need and restores them.

In this illumination we have another depiction of Elisha by Aidan Hart. Elisha is wearing Elijah's mantle, and he looks

Elisha and the Six Miracles

2 KINGS 4–6

Father, if the prophet had commanded you to do something difficult, would you not have done it? How much more, when all he said to you was, "Wash and be clean?" (5:13)

ELISHA AND THE SIX MIRACLES

HISTORICAL BOOKS

81

more confident here than we have seen him in the past illuminations. He is also in green, the color of priests and prophets. The use of a transparent wash of color seems to embed him in the panels, making him part of the events.

The illumination is divided into six panels depicting the miracles. Again they are topped by archways. The miracles are gateways to a vision of heaven, and each panel becomes a portal through which the love of God flows down.

In the first panel we see depictions of bread, because Elisha feeds the multitude on a few loaves of barley. This panel parallels the illumination *Loaves and Fishes* in Mark's gospel, right down to the background of colored squares and gold-stamped filigree. This miracle is twinned to another of Elisha's miracles: the purification of the poisoned pot of stew by throwing a handful of flour into it.

The second panel depicts the jugs of overflowing oil that benefitted the widow and her son. Elisha provides these as a means for getting the widow out of debt. However, the miracle also resonates with Jesus turning water to wine at Cana (John 2:1-11).

The third and fourth panels depict Elisha's healing ministry. After first making it possible that the Shunammite woman will have a son, he later returns to her house and, because of her faith, raises her son from the dead. This story has the closest parallel to Jesus' healing ministry. The quote written across the illumination is actually words of Jesus: "Do not fear, only believe" (Mark 5:36). These are the words that Jesus speaks to Jairus, the official from the synagogue, who came to Jesus to ask that he heal his daughter. When Jairus is told on the way that his daughter is dead, Jesus speaks these words and, encountering the mourners, he says, "The child is not dead but sleeping" (Mark 5:39). He then takes the girl by the hand and raises her up.

Next, Elisha encounters Namaan, an Aramite commander of the enemy's army. Namaan seeks him out because he has leprosy, and his servant, an Israelite captive, has said the prophet would cure him. When Elisha sends word that Namaan should just wash himself in the Jordan seven times and

he will be clean, Namaan is furious. He wanted to see the great prophet and feel the power of the Lord bestowed on him with great fanfare. Again, this resonates with what people wanted and expected of Jesus in his ministry—that is, dramatic shows of power. Finally, Namaan does what he has been told, is healed, and turns to worship only the Lord.

The illumination here also reprises a theme from *Gospels and Acts*, the first volume of *The Saint John's Bible* to be completed. In the illumination *Peter's Confession* in the Gospel of Matthew, Donald Jackson included an image of the AIDS virus as seen under a microscope in his vision of the underworld. Here we have a microscopic representation of leprosy, an image that was also used in the *Vision of the Son of Man* illumination in the book of Daniel.

Finally, we see the ax floating on the waters of the Jordan. The last miracle depicted here is of Elisha providing for a prophet a means to build his house when he loses his ax head in the river. When Elisha throws a stick near the place where the ax went under, it floats to the top and the prophet can lift it out. Again, there is a familiarity with Jesus' miracles on the water, especially providing fish for the fishermen who fished without luck all night long.

Also like Jesus, these miracles address the needs of a wide range of people: a widow, Elisha's hungry followers, a wealthy woman, an enemy commander, and a prophet. It is not surprising that in the story of Jesus in Matthew's gospel—depicted in *Peter's Confession*—when Jesus asks, "Who do people say that I am?" the answer is, "Some say John the Baptist, but others Elijah, and still others Jeremiah or one of the prophets" (Matt 16:14).

◀ *What is the relationship like between Elisha and the people who experience his miracles?*

2 KINGS 22:1-20 / 2 KINGS
23:1-3

*When the king heard the
words of the book of the law,
he tore his clothes. (22:11)*

*Have you ever encountered a book or film that
dramatically changed your perspective? Did it cause
you to act differently or somehow change your life?*

Suzanne Moore is behind this stunning illumination that closes
out the official Hebrew history of Israel, before we move on
to later, Greek texts. As we can see, things end in a rather
mixed fashion. Josiah is a good king and restores the Law to
Israel. However, it is too late for the kingdom, though Josiah
himself will die in peace, as the prophetess Huldah proclaims.

Josiah is the final king before the southern kingdom of
Judah falls (the northern kingdom of Israel fell to the As-
syrians about one hundred years earlier) and the people are
taken into exile. So this will be the end of the cycle of rescue,
disobedience, conquest, and obedience that we've seen play
out again and again throughout the reign of the judges and
the kings.

What is perhaps most notable in the account of Josiah is
how far he is from knowledge of the Law handed down by
Moses. He sends instructions for money brought to the temple
to be given to the caretakers to repair it. We can only imagine
what this means—where has the money been going until this
time? Why has the temple been allowed to fall into disrepair? It
speaks of corruption and neglect of both the temple and God.

Josiah's servant returns from his errand with "the book
of the law" given to him by the high priest (22:8-10). No one
seems to recognize this book or its contents. King Josiah hears
it read for the first time and grasps its meaning. Josiah responds
to the reading of the Law by tearing his clothes in repentance.
He needs someone to interpret this book for him, and the
prophetess Huldah, identified as the "keeper of the wardrobe,"
a married woman living in Jerusalem, gives the prophecy that
the kingdom will soon fall and only Josiah, who has repented,
will be spared.

This illumination, then, depicts the Law one more time. As
only a calligrapher could do, Moore makes great beauty out of
letter forms. The primary image is that of a quill, from which
unrolls an image of a scroll. For this illumination, Moore used

with his ancestors, and was buried in the garden of
his house, in the garden of Uzza. His son Amon suc‑
19 ceeded him. ■ Amon was twenty‑two years old when
he began to reign; he reigned two years in Jerusalem.
His mother's name was Meshullemeth daughter of
Haruz of Jotbah.²⁰ He did what was evil in the sight
of the LORD, as his father Manasseh had done.²¹ He
walked in all the way in which his father walked,
served the idols that his father served, and worshiped
them;²² he abandoned the LORD, the God of his an‑
cestors, and did not walk in the way of the LORD.
²³ The servants of Amon conspired against him, and
killed the king in his house.²⁴ But the people of the
land killed all those who had conspired against King
Amon, and the people of the land made his son Josiah
king in place of him.²⁵ Now the rest of the acts of
Amon that he did, are they not written in the Book
of the Annals of the Kings of Judah.²⁶ He was buried
in his tomb in the garden of Uzza; then his son Jo‑
siah succeeded him.

22

Josiah was eight years old when he began to reign;
he reigned thirty‑one years in Jerusalem. His
mother's name was Jedidah daughter of Adaiah
of Bozkath.² He did what was right in the sight of
the LORD, and walked in all the way of his father
David; he did not turn aside to the right or to the
left.³ In the eighteenth year of King Josiah, the king
sent Shaphan son of Azaliah, son of Meshullam, the
secretary, to the house of the LORD, saying,⁴ "Go
up to the high priest Hilkiah, and have him count
the entire sum of the money that has been brought
into the house of the LORD, which the keepers of
the threshold have collected from the people;⁵ let
it be given into the hand of the workers who have
the oversight of the house of the LORD; let them
give it to the workers who are at the house of the
LORD, repairing the house,⁶ that is, to the carpenters,
to the builders, to the masons; and let them use it

to buy timber & quarried stone to repair the house.
⁷ But no accounting shall be asked from them for
the money that is delivered into their hand, for they
8 deal honestly." ■ The high priest Hilkiah said to
Shaphan the secretary, "I have found the book of
the law in the house of the LORD." When Hilkiah
gave the book to Shaphan, he read it.⁹ Then Shaphan
the secretary came to the king, and reported to the
king, "Your servants have emptied out the money
that was found in the house, and have delivered it
into the hand of the workers who have oversight of
the house of the LORD."¹⁰ Shaphan the secretary in
formed the king, "The priest Hilkiah has given me a
book." Shaphan then read it aloud to the king. When
the king heard the words of the book of the law, he
tore his clothes.¹² Then the king commanded the priest
Hilkiah, Ahikam son of Shaphan, Achbor son of Mi
caiah, Shaphan the secretary, and the king's servant
Asaiah, saying,¹³ "Go, inquire of the LORD for me, for
the people, and for all Judah, concerning the words of
this book that has been found; for great is the wrath of
the LORD that is kindled against us, because our an
cestors did not obey the words of this book, to do
14 according to all that is written concerning us." ■ So
the priest Hilkiah, Ahikam, Achbor, Shaphan, and
Asaiah went to the prophetess Huldah the wife of
Shallum son of Tikvah, son of Harhas, keeper of the
wardrobe; she resided in Jerusalem in the Second
Quarter, where they consulted her.¹⁵ She declared
to them, "Thus says the LORD, the God of Israel: Tell
the man who sent you to me.¹⁶ Thus says the LORD,
I will indeed bring disaster on this place and on its
inhabitants—all the words of the book that the king
of Judah has read.¹⁷ Because they have abandoned
me and have made offerings to other gods, so that
they have provoked me to anger with all the work
of their hands, therefore my wrath will be kindled

THE PROPHETESS HULDAH

fragments of sacred texts in multiple languages, including letters from Deuteronomy in the Dead Sea Scrolls.

In modern times we have never completely "lost" the Scriptures, thanks in large part to the Benedictine monks who kept them safe in their scriptoriums throughout the Dark Ages. This story, however, may have had resonance with people returning from exile, who had minimal or no exposure to the receptacle of knowledge at the center of their tradition.

Again we find the imagery of archways—this time with gates in gold and blue. The source of this image is the double archway of one of Huldah's Gates at the Temple Mount in Jerusalem, now partially blocked by a medieval tower. The gate once provided a passageway to the top of the Temple Mount, but over time the gates were walled up, and people now use a different entrance. Here the gates seem to have more to do with access to the celestial kingdom, the perfect kingdom that becomes the focus after the exile and that is predicted in this text.

The illumination carries over to the next page, with an image viewing the scroll from above. This abstract image again

SCROLL DETAIL

points forward to a time when God's kingdom will be realized in perfect form. This image can be compared with Suzanne Moore's illumination of *The Last Judgment* of Matthew 24–25. How can we, readers of a book, hearers of the Law and of Jesus' parables, grasp what the kingdom will be like?

We are leaving the account of the earthly kingdom of the people of Israel, but the people aren't left hopeless. Those reading this history from exile will recognize the pattern, and they will also recognize God's endless forgiveness when the people repent. What they must do is follow the Law given to them by Moses, worship their God as they have been instructed, and keep the commandments. They need to keep the book close to them and remember what it says.

Again this story makes us think about what it means that the Law, and this history, is written. What are we to make of it? What are we to learn from it? We must not forget the story of God's loving relationship to the people and the call to follow God and trust God, and we must keep the story close to our hearts so that we won't be led astray.

Before we leave these pages, note the decoration on the previous page with the notes for 2 Kings 20–21. Beneath the notes, hidden in the design, are the letters D and R. It was during the time Suzanne Moore was working on this illumination that Brother Dietrich Reinhart died of melanoma. Brother Dietrich, a monk of Saint John's Abbey and president of Saint John's University for seventeen years, was president when *The Saint John's Bible* was commissioned and a champion of the project. It is appropriate that his initials are inscribed here in the context of the image of a scroll and a vision of God's perfect kingdom.

◖ *What history does your family pass on from generation to generation? Why is it important?*

In terms of illuminations, we "leapfrog" over 1 Chronicles and 2 Chronicles, which are what they sound like: a brief retelling of the history of the Israelites from Adam to the exile. They are an important part of Historical Books. They are punctuated in *The Saint John's Bible* by several of Chris Tomlin's beautiful, marginal insects. At 2 Chronicles 11 you will also find the ringtailed lemur that marks a correction to the text.

The Chronicles and the books that follow them also mark a different perspective to the history of Israel. They were written after the exiles had returned to Judah, and the purpose of Chronicles is not to tell a history of Israel but to contribute to the restoration and building up of the Jewish nation. The Chronicles are not full of warning and violence like the books we've read so far. The characters are not complex. Good kings are without flaw, and bad kings are completely evil. You won't find Bathsheba in the Chronicles because she does not make King David look good.

These books attempt to provide hope for a people still living under Persian rule. They affirm the identity of God's people, who can find hope for the future in their identity and in the faith of their ancestors, particularly David and Solomon.

The project of restoring Israel and calling the people together as a nation and as a people who are faithful to God deepens in the books of Ezra and Nehemiah. In the book of Ezra, the temple is restored. In the book of Nehemiah, the wall of Jerusalem is rebuilt. After considering an illumina-

brothers,twelve; to the twenty-fourth, to Romamti-ezer, his sons and his brothers,twelve.

THE ART OF THE SAINT JOHN'S BIBLE

tion in the book of Nehemiah, we will consider the story of Queen Esther.

The deuterocanonical books of the Additions to Esther, Tobit, and 1 and 2 Maccabees are what the name implies, a "second" or "secondary" canon to the Catholic Bible. The Greek version of the Old Testament contains them, while the Hebrew version does not. The Protestant traditions follow the Hebrew, whereas Catholic, Greek, and other denominations use the Greek version. This situation explains why some Bibles contain these books but others do not.

11

When Rehoboam came to Jerusalem, he assembled one hundred eighty thousand chosen troops of the house of Judah & Benjamin to fight against Israel, to restore the kingdom to Rehoboam. [2] But the word of the LORD came to Shemaiah the man of God: [3] Say to all Israel in Judah & Benjamin, [4] Thus says the LORD: You shall not go up or fight against your kindred. Let everyone return home, for this thing is from me." So they heeded the word of the LORD and turned [5] back from the expedition against Jeroboam. ¶ Rehoboam resided in Jerusalem, and he built cities for defense in Judah. [6] He built up Bethlehem, Etam, Tekoa, Beth-zur, Soco, Adullam, [7] Gath, Mareshah, Ziph, [8] Adoraim, Lachish, Azekah, [10] Zorah, Aijalon, and Hebron, fortified cities that are in Judah and in Benjamin. [11] He made the fortresses strong, and put commanders in them, and stores of food, oil, and wine. [12] He also put large shields and spears in all the cities, and made them very strong. So he held [13] Judah and Benjamin. ¶ The priests and the Levites

King Rehoboam of Judah, son of Solomon, and to

Square before the Watergate

NEHEMIAH 8:1-12

For the joy of the LORD is your strength (8:10)

Nehemiah is a faithful Jewish layman. He is an important member of the Persian King Artaxerxes's staff, and it is actually the king who makes it possible for him to carry out his calling. His book is told in the first person, drawn from his memoirs, and that in itself adds another layer to the variety of these historical books. He tells the story of how he rebuilt the walls of Jerusalem, joining forces with the priest Ezra who had rebuilt the temple. Together they offer the people of Jerusalem a way to be restored after exile and to unite as a single people. It has been generations since they have practiced their faith in their own land. Again, it is the book of the Law, a record of what God said to them through Moses, that makes continuity possible.

This illumination by Hazel Dolby, as so many illuminations in *The Saint John's Bible*, makes use of abstraction to tell

SQUARE BEFORE THE WATERGATE

THE ART OF THE SAINT JOHN'S BIBLE

a theological story. On a field of gold, she has set up a pattern of interlocking diamonds, but it is far from complete. In fact, many of the pieces are outside the border. They are still scattered in the margin and on the next page.

When the wall and its gates are completed, Nehemiah says, "The city was wide and large, but the people within it were few and no houses had been built" (7:4). He finds the book of the genealogy of those who had come back first, and he calls the people back inside the walls to settle. This is the context in which the story depicted in this illumination takes place. The people are gathered in the square, and the book of the Law is read aloud to them. Not only do they hear the words but the words are also explained to them by scholarly interpreters present. This is a great parallel to what many "people of the book" do to this day: they gather to hear their sacred texts

FOR THE JOY OF THE LORD IS YOUR STRENGTH

read aloud and interpreted. It is also an important feature of what is called second temple Judaism. After exile, the Jewish people rely on inspired teachers to interpret the word of God as found in the Scriptures. Their interpretations are collected in rabbinical literature and the Talmud.

Once the book of the Law has been read and interpreted, the people are instructed to rejoice and feast. Their natural inclination is to mourn like Josiah and tear their clothes. There will be time for confession, but this is not the day. On this day, the people are instructed to rejoice because God is with them.

Hazel Dolby's illumination is a depiction of the restoration taking place and the joy that is spreading throughout the kingdom. It begins in the center with gold and purple and extends throughout the square. In fact, it breaks the boundary of the square, reaching to gather in all the people. Many see in this illumination God's power and authority, as well as joyfulness punctuated by areas of quiet reverence. Dolby avoided strong patterns as she worked with the squares and triangles (although you might see cross forms, they are not a reference to the crucifixion). The heart of this illumination is the embodiment of the quotation "For the joy of the LORD is your strength" (8:10). As the celebration expands, the people gain strength to move forward. Interestingly, this piece is referenced in *Vision of the New Jerusalem* (Revelation 21). When Donald Jackson was looking for a graphic way to represent people entering the kingdom, he returned to Hazel Dolby's image.

◀ *The Scripture suggests the people returning felt a mixture of joy and sadness. What other emotions might they have felt returning to Jerusalem?*

If you have never read the book of Esther, you are in for a treat. Like the earlier deuterocanonical text Tobit, this piece of historical fiction reads like a fairy tale or melodrama. It is the story of an orphan girl among the exiled people who wins favor in the king's harem and becomes queen. It is the story of a pompous and treacherous official who sets out to destroy the queen's people and how she and her uncle, with the help of a foreign king, turn the tables on him and save the people of Israel.

The illumination of Esther by Donald Jackson celebrates, first and foremost, Esther's dual identity. On the right, she is a natural beauty, a Jewish woman crowned by the menorah and a pattern that parallels the mantle of Elijah. But the left side shows her also as the queen of Babylon, chosen from among all the beauties of the empire to be the king's wife.

In the opening of the book of Esther, we are told that King Ahasuerus "ruled over one hundred twenty-seven provinces from India to Ethiopia." The book tells of the king's wealth at great length and seems to revel in the accounts of his banquets, the costuming and perfuming of his potential wives, and the power of his golden scepter and signet ring. This excess is contrasted to Esther, who is quoted in the margin saying, "You know that I hate the splendor of the wicked" (14:15). Esther goes to the king with only the basics, although we are led to believe other prospective princesses used every means at their disposal to increase their beauty and attract the king's attention.

If the face of Queen Esther looks familiar, it is for good reason. Donald Jackson based the image on a portrait of Adele Bloch-Bauer by Gustav Klimt. She was Klimt's patroness, married to a wealthy, older man. As Jackson says, the image nods at the fact that "t'were always so," that such marriages are known throughout history. But Jackson was also taken with the enormity of what Queen Esther stands to lose if her rescue mission doesn't work and with her ambivalence about her own situation. He has focused on her vulnerability and discomfort with her position in the marginal quotes.

Esther

ESTHER 5:1-14

On the third day, when she ended her prayer, she took off the garments in which she had worshiped, and arrayed herself in splendid attire. (15:1)

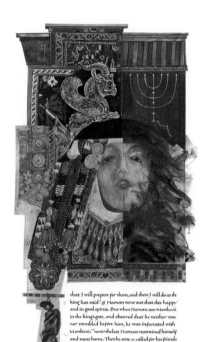

that I will prepare for them, and then I will do as the
king has said." ¶ Haman went out that day happy
and in good spirits. But when Haman saw Mordecai
in the king's gate, and observed that he neither rose
nor trembled before him, he was infuriated with
Mordecai; "nevertheless Haman restrained himself
and went home. Then he sent & called for his friends
& his wife Zeresh," and Haman recounted to them
the splendor of his riches, the number of his sons,
all the promotions with which the king had honored
him, and how he had advanced him above the offi-
cials and the ministers of the king." Haman added,
"Even Queen Esther let no one but myself come with
the king to the banquet that she prepared. Tomor-
row also I am invited by her, together with the king.

ESTHER

From the very first illuminations in the book
of Genesis, Jackson has used period sources
and textiles for some of the rich imagery in
his pieces. Here in the illumination of Esther,
Jackson layers images of the opulence as well as
the integrity of Queen Esther. Although they
are not based on the period in this story, they
are taken from pieces in the region that are
marks of royalty and weddings.

Esther's queenship is marked by finery
and "cosmetic" treatments, crowned by a gold
figure of the lion of Babylon and by rich Per-
sian rugs. The images on the left side of the
illumination are inspired by Turkmen (Afghani)
traditional bridal gifts and ancient Persian gold
artifacts such as coins, jewelry, and textiles.

The other striking feature of this illumina-
tion is the hanged man. This figure, Haman,
who attempts to destroy the Jews and finds him-
self destroyed, wears a rather contemporary-
looking tunic and has sad, limply hanging
slippers. If the image makes us uncomfortable,
that is as it should be. Here Donald Jackson
looks straight at the violence of the accounts
we have read throughout this volume. No
matter how treacherous the hanged man has been, we should
reflect on our reaction to him. *The Saint John's Bible* was writ-
ten and illuminated between 1999 and 2011, a period that saw
the United States and European allies engaged in wars in the
Middle East following the terrorist attacks on September 11,
2001. As the project of writing the Bible drew to a close, *His-
torical Books*, published in 2010, confronted the readers and the
artists with their weariness over the violence of the past decade
and their countries' participation in it. The image of Haman is
based on images of public executions in Saudi Arabia.

◀ *The Jewish holiday of Purim is based on the story of Esther.
What can you find out about this holiday and how it is celebrated?*

Where does the history of Israel end? For *The Saint John's Bible*, it ends with a foreshadowing of the Christian story of redemption. Sally Mae Joseph has written a text treatment of a passage from 2 Maccabees, the final book in this volume, that lays out the themes of *Historical Books* and points toward a greater restoration of the kingdom through resurrection of the dead.

Historically speaking, the Historical Books take us up to the year 134 B.C.E. The final two books, 1 and 2 Maccabees, tell the story of Mattathias the Hasmonean and his sons John, Simon, Judas, Eleazar, and Jonathan Maccabeus. This family defends Judaism against Greek influence during the time of the Greek Empire. The Maccabees repel the attempted invasions of Jerusalem by Greeks Antiochus and Appolonius and defend the Law and their practices, such as circumcision. In 2 Maccabees, the struggle is seen more as a struggle between traditional Jews in the countryside, who have names like those of the heroes above, and Jews who have been heavily influenced by the Greeks, who have Greek names like Jason and Menelaus and are supported by Greek leaders such as Antiochus and Appolonius.

Both books are available only in Greek manuscripts, although 1 Maccabees was originally written in Hebrew. For this reason, they are part of the deuterocanon and are included in Catholic and Orthodox Bibles but not in Protestant or Jewish collections of the Old Testament literature. As biblical studies become more and more ecumenical, the deuterocanon is sometimes included in other translations but collected as a group and placed between the Old and New Testaments. In *The Saint John's Bible* the books appear according to their placement in the Catholic version of the Old Testament.

Historical Books closes, then, with a few more adventure accounts and with the ongoing struggle to build up Israel and maintain a civil society committed to the law of Moses and true to the God of Abraham, worshiping no other gods. Like Esther, 2 Chronicles, and the first-person account of Nehemiah, one of the delights of 2 Maccabees is the way the author reveals himself on the page. The author can be said to

And They Turned to Supplication

2 MACCABEES 12:42-45

[37]In the language of their ancestors he raised the battle cry, with hymns; then he charged against Gorgias's troops when they were not expecting it, and [38]put them to flight. ¶ Then Judas assembled his army and went to the city of Adullam. As the seventh day was coming on, they purified themselves according to the custom, and kept the sabbath there. [39] ¶ On the next day, as had now become necessary, Judas and his men went to take up the bodies of the fallen and to bring them back to lie with their kindred in the sepulchres of their ancestors. [40]Then under the tunic of each one of the dead they found sacred tokens of the idols of Jamnia, which the law forbids the Jews to wear. And it became clear to all that this was the reason these men had fallen. [41]So they all blessed the ways of the Lord, the righteous judge, who reveals the things that are hidden; [42]and they turned to supplication, praying that the sin that had been committed might be wholly blotted out. The noble Judas exhorted the people to keep themselves free from sin, for they had seen with their own eyes what had happened as the result of the sin of those who had fallen. [43]He also took up a collection, man by man, to the amount of two thousand drachmas of silver, and sent it to Jerusalem to provide for a sin offering. In doing this he acted very well and honorably, taking account of the resurrection. [44]For if he were not expecting that those who had fallen would rise again, it would have been superfluous and foolish to pray for the dead. [45]But if he was looking to the splendid reward that is laid up for those who fall asleep in godliness, it was a holy and pious thought. Therefore he made atonement for the dead, so that they might be delivered from their sin.

13

In the one hundred forty-ninth year word came to Judas and his men that Antiochus Eupator was coming with a great army against Judea, [2]and with him Lysias, his guardian, who had charge of the government. Each of them had a Greek force of one hundred ten thousand infantry, five thousand three hundred cavalry, twenty-two elephants, and three hundred chariots armed with scythes.

[3] ¶ Menelaus also joined them and with utter hypocrisy urged Antiochus on, not for the sake of his country's welfare, but because he thought that he would be established in office. [4]But the King of kings aroused the anger of Antiochus against the scoundrel; and when Lysias informed him that this man was to blame for all the trouble, he ordered them to take him to Beroea and to put him to death by the method that is customary in that place. [5]For there is a tower there, fifty cubits high, full of ashes, and it has a rim running around it that on all sides inclines precipitously into the ashes. [6]There they all push to destruction anyone guilty of sacrilege or notorious for other crimes. [7]By such a fate it came about that Menelaus the lawbreaker died, without even burial in the earth. [8]And this was eminently just; because he had committed many sins against the altar whose fire and [9]ashes were holy, he met his death in ashes. ¶ The king with barbarous arrogance was coming to show the Jews things far worse than those that had been done in his father's time. [10]But when Judas heard of this, he ordered the people to call upon the Lord day and night, now if ever to help those who were on the point of being deprived of the law and their country and the holy temple; [11]and not to let the people who had just begun to revive fall into the hands

[a] 163 B.C.
[b] Or the worst of the things that had been done

AND THEY TURNED TO SUPPLICATION

have a "purple pen," writing at times in exaggerated detail and striving for heightened emotional responses from the reader.

If you turn to the very end of 2 Maccabees, you will see that this author has trouble finding a proper ending to his story. We might sympathize, as the Historical Books seem a very long account of people who took a very long time to learn what seems like a simple lesson (and, of course, it is uncertain whether it has been or can ever be learned). The author writes:

> This, then, is how matters turned out with Nicanor, and from that time the city has been in possession of the Hebrews. So I will here end my story. If it is well told and to the point, that is what I myself desired; if it is poorly done and mediocre, that was the best I could do. For just as it is harmful to drink wine alone, or, again, to drink water alone, while wine mixed with water is sweet and delicious and enhances one's enjoyment, so also the style of the story delights the ears of those who read the work. And here will be the end. (15:37-38)

Given such a playful and colorful ending, Donald Jackson could not resist including one more image. So, at the end of this volume you will find a colorful chameleon by Chris Tomlin about to put an end to a very innocuous-looking fly.

WISDOM BOOKS

I learned both what is secret and what is manifest,
for wisdom, the fashioner of all things, taught me.
(Wis 7:21-22)

INTRODUCTION

WISDOM BOOKS marks a very important point in the creation of *The Saint John's Bible*. Most of the work of the scribes came to an end with the completion of the written text in this volume. The text for *Historical Books* and *Letters* had already been written, and Donald Jackson had decided to write the book of Revelation himself to close the project. This meant big changes at Jackson's scriptorium in Wales. For the five scribes, some of whom had been working on the project for six years, it brought an end to a significant piece of work. Jackson and his wife Mabel commissioned from each of the five scribes a text treatment of his or her own choosing for that volume as a way of celebrating their work. For Sue Hufton, Brian Simpson, Susan Leiper, Sally Mae Joseph, and Angela Swan, it was a chance to show another side of their creativity.

Wisdom Books also introduces new visual themes—most significantly the figure of wisdom and the feminine aspects of the divine. In previous volumes, gold has often represented the presence of God. Silver (platinum) indicates God's feminine attributes throughout this volume. As mentioned when we talked about the use of silver in *Wisdom of Solomon* in 1 Kings, silver is not generally used on manuscripts because it oxidizes quickly. Impurities in the air make it blacken when exposed for any length of time. For this reason, platinum leaf or powder was used almost everywhere that you see silver, unless Donald Jackson sealed it with egg white or casein lacquer.

These texts were written, along with the books of the law and history, during the time of exile. They collected wisdom to be passed on from generation to generation, such as Proverbs and Wisdom, and books used in ritual celebrations, including the Song of Solomon. The Wisdom Books offer practical direction for what it means to live as God's people. They encourage the people to live righteous lives even as exiles and show them what those lives look like.

Wisdom Books collects books from many genres, and they do not flow easily one into the other. Each book has its own feel and makes different

demands on the reader and on the artists. As Donald Jackson said, working on each volume made him dig deeper—not just into the text but into the vocabulary of calligraphy, images, and techniques. In Wallace Stevens's poem "Of Modern Poetry," he writes of "the mind in the act of finding what will suffice." The narrator of the poem, an actor and playwright, finds that, having mastered one play, he arrives at the theater to find the stage completely changed and a new script required. He has to find what will suffice for a new audience in a new time. Tackling an illuminated, handwritten Bible for the twenty-first century is a similar task.

The richness and variety of the art in this volume, then, reflects the richness of the team assembled for the project and also the richness and variety in the text itself. To move from Job to Proverbs to the Song of Solomon is to see the many ways God is engaged with us—in our suffering, joy, living, loving, and dying. Perhaps most importantly, how God is engaged with us in the questions.

Wisdom is a character in these books, a female character, and many of the books describe her in rich metaphors. In her book *Women in the Old Testament*, Irene Nowell, OSB, an Old Testament scholar and member of the Committee on Illumination and Text (CIT), writes: "She [wisdom] is the bridge between God and human beings" (139). Wisdom, then, lives among us, speaks directly to us, and, if we can grab her hand, joins ours to God's. In three books particularly we will see her character depicted: Proverbs, Sirach, and the Wisdom of Solomon. She is a tree, the breath of God, the firstborn and architect of creation, the Word, humankind's companion, a wife, and a bride, to be sought after and treasured when she is won. Finally, in chapter 7 of Wisdom of Solomon, it becomes clear that she is the image of God: "she is a breath of the power of God, and a pure emanation of the glory of the Almighty . . . she is a reflection of eternal light, a spotless mirror of the working of God, and an image of [God's] goodness" (Wis 7:25-26).

Another major theme you can trace through the illuminations in this volume is creation. Again and again Jackson went back to Genesis for the sources of the present illuminations. Wisdom is said to be with God at the beginning of the creation, and continues as a guide to humans as we make and remake the world in ever-expanding circles of community: families, neighborhoods, cities, countries, and the globe. Again there is attentiveness to justice and compassion, as the wise enjoy the goodness of life and make that goodness available to those around them.

The Wisdom Books, then, expand our vision and understanding of God. The Wisdom Books present the divine as nurturing and creative, where a well-kept household is a metaphor for a life in God. As a mother, God gently reprimands but also smiles and guides us children in the way we should go. God's home is one of love, concern, and hospitality, and we are expected to act accordingly when we are in it.

Finally, because the script has been so important to *Wisdom Books*, we will occasionally pause to look at a piece of finely executed text or points of page composition you might otherwise overlook.

What do the two sides of this illumination tell us about Job?

There was once a man in the land of Uz whose name was Job. (1:1)

Wisdom Books starts noisily. In this illumination we see not Job himself but rather a portrayal of his world, which is quite clearly in chaos. On the left side of the illumination we see Job's riches: his cattle, donkeys, camels, and servants. There are also the signs of fertility in the birds and fish at the bottom of the panel, and the arches of buildings at the top. But notice, the animals and servants are facing away, already walking offstage, led into captivity by Job's enemies. By the center of the illumination things are starting to come down. Here are fire and the fractals we associate with chaos. Looking back to the *Creation* illumination, you will see the same harsh quality to the swaths of color. By the right-hand side of the panel all is lost, and there remains the black and purple of richness undone by tragedy. Only slender bars of gold remain to tell Job that God is still present.

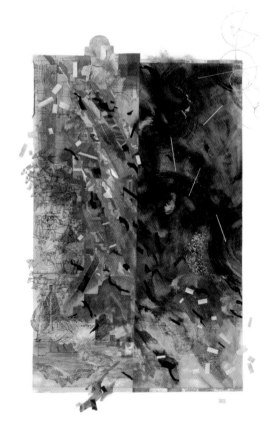

This illumination can also be read from top left down to bottom right, to trace Job's spiritual journey. In *Wisdom Books* we see a new representation of the presence of divinity. In previous volumes divinity has been represented by gold. Wisdom, marked by silver, is another way the divine is present. In the top left you will see chunks of silver along with gold, a sign of Job's closeness to God, his possession of wisdom, and God's favor. Through the center of the illumination the bars turn to black, there is less gold, and God

JOB FRONTISPIECE

seems very far from Job. Finally, though, at the bottom right he receives a full measure of wisdom and reconnection to God's presence. The gold and silver bars return, along with gold stamps. Job's life is once again permeated with an awareness of God's presence.

Another visual motif seen for the first time in *Wisdom Books* is introduced at the top right of the illumination. It is a stamp based on an astronomical chart from an ancient Islamic work. The astronomical chart shows how we try to penetrate the mysteries of the world with our mind. From ancient times, humans have always used reason—and art—to describe the world. Those forces come together in charts like this. Just as Job and his friends did, we also seek answers and try to contain what we know. Our knowledge is always limited, and our ways of grasping the central concepts of creation are only mere representations of the whole truth—the work and being of God—which remains beyond our grasp. This is probably a good time to remind viewers not to look for exact correlations between the elements and ideas. On the top left you see stamped arches inspired by those at the Cathedral de Santiago in Compostela, Spain. In *Historical Books*, that stamp depicted the ark of the covenant as it moved from desert to tent to temple. But we should not think this stamp will always tell us that the ark is present. Here, and more prominently in the illumination *Life of Paul* in the book of Acts, the stamp, in black ink, is a representation of cities, important signs of human creativity, accomplishment, and society, but not divine.

The quotation on the opposite page is from one of Job's early responses to his suffering: "Shall we receive the good at the hand of God and not receive the bad?" Job loses everything in these opening passages, but he maintains his confidence in God. He speaks with wisdom here.

Below the marginal verse is a piece of another new stamp made for *Wisdom Books*. The pattern is based on a piece of cloth from India embroidered and appliquéd with mirrors. This stamp will be used to make the tree of wisdom in later illuminations. Mirrors are at the heart of another important il-

אִיּוֹב

JOB

THERE WAS ONCE A MAN
IN THE LAND OF UZ
WHOSE NAME WAS JOB.
THAT MAN WAS BLAMELESS
AND UPRIGHT, ONE WHO
FEARED GOD AND TURNED
AWAY FROM EVIL. THERE WERE
BORN TO HIM SEVEN SONS AND
THREE DAUGHTERS. HE HAD
SEVEN THOUSAND SHEEP,
THREE THOUSAND CAMELS,
FIVE HUNDRED YOKE OF OXEN,
FIVE HUNDRED DONKEYS, AND
VERY MANY SERVANTS; SO
THAT THIS MAN WAS THE
GREATEST OF ALL THE PEOPLE
OF THE EAST. ⁴HIS SONS USED TO
GO AND HOLD FEASTS IN ONE
ANOTHER'S HOUSES IN TURN;
AND THEY WOULD SEND AND
INVITE THEIR THREE SISTERS TO
EAT AND DRINK WITH THEM.
⁵AND WHEN THE FEAST DAYS
HAD RUN THEIR COURSE, JOB
WOULD SEND AND SANCTIFY
THEM, AND HE WOULD RISE
EARLY IN THE MORNING AND
OFFER BURNT OFFERINGS
ACCORDING TO THE NUMBER
OF THEM ALL; FOR JOB SAID, "IT
MAY BE THAT MY CHILDREN
HAVE SINNED, AND CURSED
GOD IN THEIR HEARTS." THIS IS
WHAT JOB ALWAYS DID.

⁶ One day the heavenly beings came to present themselves before the LORD, and Satan also came among them. The LORD said to Satan, "Where have you come from?" Satan answered the LORD, "From going to & fro on the earth, and from walking up and down on it." ⁸ The LORD said to Satan, "Have you considered my servant Job? There is no one like him on the earth, a blameless & upright man who fears God and turns away from evil."

⁹ Then Satan answered the LORD, "Does Job fear God for nothing? ¹⁰ Have you not put a fence around him and his house and all that he has, on every side? You have blessed the work of his hands, and his posses-sions have increased in the land." ¹¹ But stretch out your hand now, and touch all that he has, and he will curse you to your face." ¹² The LORD said to Satan, "Very well, all that he has is in your power; only do not stretch out your hand against him!" So Satan went out from the presence of the LORD. ¹³ One day when his sons & daughters were eating and drink-ing wine in the eldest brother's house, ¹⁴ a messenger came to Job and said, "The oxen were plowing and the donkeys were feeding beside them, ¹⁵ and the Sabeans fell on them & carried them off, and killed the servants with the edge of the sword; I alone have escaped to tell you." ¹⁶ While he was still speaking, another came and said, "The fire of God fell from heaven and burned up the sheep and the servants, and consumed them; I alone have escaped to tell you." ¹⁷ While he was still speaking, another came and said, "The Chaldeans formed three columns, made a raid on the camels and carried them off, and killed the servants with the edge of the sword; I alone have escaped to tell you." ¹⁸ While he was still speaking, another came and said: Your sons and daughters were eating and drinking wine in their eldest brother's house, ¹⁹ and suddenly a great wind came across the desert, struck the four corners of the house, and it fell on the young people and they are dead; I alone have escaped to tell you." ²⁰ Then Job arose, tore his robe, shaved his head, and fell on the ground and worshiped. ²¹ He said, "Naked I came from my mother's womb, and naked shall I return there; the LORD gave, and the LORD has taken away; blessed be the name of the LORD." ²² In all this Job did not sin or charge God with wrongdoing.

2

One day the heavenly beings came to present them-selves before the LORD, and Satan also came among them to present himself before the LORD. The LORD said to Satan, "Where have you come from?" Satan answered the LORD, "From going to and fro on the earth, and from walking up and down on it." ³ The LORD said to Satan, "Have you considered my ser-vant Job? There is no one like him on the earth, a blameless & upright man who fears God and turns away from evil. He still persists in his integrity, al-though you incited me against him, to destroy him for no reason." ⁴ Then Satan answered the LORD, "Skin for skin! All that people have they will give to save their lives.⁵ But stretch out your hand now & touch

SHALL
WE
RECEIVE
THE
GOOD
AT THE
HAND
OF GOD,
AND
NOT
RECEIVE
THE
BAD?

1:9
Heb *come of God
b or do it by his hand on*
Or do Aramaic) Heb his
Satan
Or All that the man has
he will give for his life

lumination, *Wisdom Woman*. This vision of wisdom is geometrical, ordered and ordering, complex, and delicate. Wisdom reflects truth to us and is beautiful and complex. As we shall see, wisdom is a reflection of the feminine qualities of God.

Finally, note should be taken of the incipit, the opening passage. Donald Jackson wrote this passage, and he says it is his best piece of writing in the completed volumes. Other scribes have commented on the accomplishment of this beautifully written passage as well. Although we might not recognize it, this form of writing is much different from the calligraphy of the body text. The calligrapher is not using the standard "script" to tell him or her how to shape and space the letters. The process is more open, more intuitive. Although this text is also plotted out on the computer beforehand, it is closer to a text treatment. You can say it is less craft and more art, though there is always a balance of the two in calligraphy. For a comparison, look at the incipits for the four gospels. Matthew, Mark, and John open with long written passages. It is hard to find fault with these pieces of writing, and the subtle differences between pieces of text are part of the art. The capitals are written in an improvisatory spirit. Note the variety of *As*, *Hs*, *Zs*, and *Es*, and how some letters flow into each other to maintain spacing and rhythm. Many things contribute to making a good piece of calligraphy—the quality of the particular sheet of vellum, the cooperation of the ink and quill, the length and shape of the passage, and the focus and feeling of the artist on a particular day.

❧ *Looking back on the illumination, what do you think about its representation of the presence of divinity in a time of loss?*

In margins of Job 15 is the first of the five scribal text treatments. Each scribe chose a passage that emphasized the female character of Wisdom as personified in the books from a list put together by the CIT. Most of the text treatments and illuminations in *The Saint John's Bible* were sponsored by donors as a way to help pay for the project. These five text treatments were commissioned by Donald and Mabel Jackson.

The text treatment pictured here is by Angela Swan and is actually the verse Wisdom of Solomon 6:12. The five text treatments by the scribes do not always appear alongside the text to which they refer, which is unusual for the project. They are spaced as evenly as possible throughout the volume to maintain the feminine emphasis in the margins of the plain-text pages.

This first treatment is fairly simple and straightforward. A master calligrapher, Angela Swan lets the words speak for themselves. Brian Simpson also focused on the lettering, and his treatment of Sirach 1:16 has a simple and elegant boldness. Sally Mae Joseph, who has done a lot of ornamental work on the project and other text treatments, adorned her chosen text, Sirach 24:19 (found at Sirach 13), with a jaunty flower. There is a similarity between this piece and her later text treatment at the opening of the book of Ezekiel. More unusual is the treatment by Susie Leiper of Wisdom 7:26 (found at Sirach 35). Her work is heavily influenced by the time she spent in Hong Kong and China, reflecting ideas of light and dark and balance. Here the yin-yang symbol adorns her treatment, which is written on a field of silver and black. Finally, the treatment by Sue Hufton, Sirach 24:12, 13, 15-17 (found at Sirach 44), focuses primarily on the space of the page. The words, painted with a fine brush and separated by deftly applied flecks of powdered gold ink, are like wafting incense or vines of abundant fruit. They carry us to the incense of the temple interior in Isaiah's vision, and the abundance of *Ezekiel's Vision* of the New Temple.

WISDOM
IS
RADIANT
AND
UNFADING
AND SHE
IS EASILY
DISCERNED
BY THOSE
WHO
LOVE HER
AND IS
FOUND
BY THOSE
WHO
SEEK HER

WISDOM 6:12

*Shall a faultfinder contend
with the Almighty? (40:2)*

*After reading these chapters, can you summarize God's
answer to Job in a sentence or two? Is it what you were
expecting?*

At the end of Job is a complex, three-part illumination by
Thomas Ingmire. Ingmire struggled with this assignment,
which is indeed difficult. God's answer to Job is hard to take.
Ingmire joined the project as an artist and calligrapher, primar-
ily concerned with the visual potential of words. Still, these
are not isolated words, and one demand of the assignment is
to engage with the text in its context. This famous story of
Job aims to give God's answer to questions about suffering.
We expect the answer to tell us something about what kind of
god this God of Abraham is. And other assignments Ingmire
completed for *The Saint John's Bible* before this engaged him
directly with the question of who God is. The *Ten Command-
ments* (Gen 20), *I AM Sayings* (John 6–15), and *Messianic Predic-
tions* (Isa 9) directly engage the announcement of God's names
and God's relationship with humanity. What to do, then, with
God's answer to Job?

Another challenge was that this passage covers more or
less the same ground as the frontispiece for Job, which Donald
Jackson created. Thomas Ingmire has focused on the text and
quotations, drawing more attention to the questions raised by
Job and by the text than to God's answer.

God answers Job's pleas for an explanation not with conso-
lation but with questions—questions and demands that sound
like accusations to our ear. "Respond," "Tell me," "Where
were you when I laid the foundation of the earth?" The voice
from the whirlwind is booming and relentless, speaking for
four chapters. Ingmire focused his illumination on the words
coming out of the whirlwind, shouting capital letters pour-
ing from everywhere, overlapping, insistent, without pause.

They are rhetorical: "Can you draw out Leviathan with a
fishhook?" But God wants a response: "I will question you,
and you shall declare to me." In what seems like an unsym-
pathetic reply, God evokes his own power and majesty in his
answer to Job. God, the creator of the universe and all that is

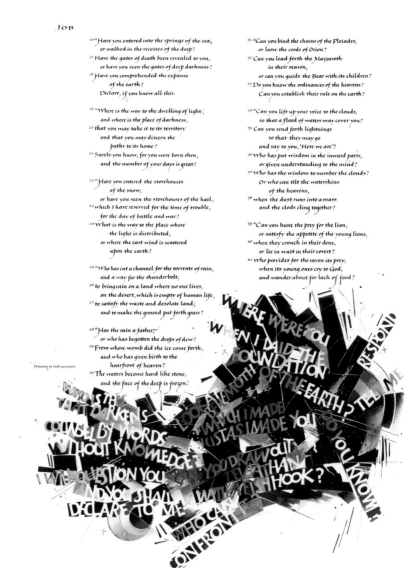

¹⁶ "Have you entered into the springs of the sea,
 or walked in the recesses of the deep?
¹⁷ Have the gates of death been revealed to you,
 or have you seen the gates of deep darkness?
¹⁸ Have you comprehended the expanse
 of the earth?
 Declare, if you know all this.

¹⁹ "Where is the way to the dwelling of light,
 and where is the place of darkness,
²⁰ that you may take it to its territory
 and that you may discern the
 paths to its home?
²¹ Surely you know, for you were born then,
 and the number of your days is great!

²² "Have you entered the storehouses
 of the snow,
 or have you seen the storehouses of the hail,
²³ which I have reserved for the time of trouble,
 for the day of battle and war?
²⁴ What is the way to the place where
 the light is distributed,
 or where the east wind is scattered
 upon the earth?

²⁵ "Who has cut a channel for the torrents of rain,
 and a way for the thunderbolt,
²⁶ to bring rain on a land where no one lives,
 on the desert, which is empty of human life,
²⁷ to satisfy the waste and desolate land,
 and to make the ground put forth grass?

²⁸ "Has the rain a father,
 or who has begotten the drops of dew?
²⁹ From whose womb did the ice come forth,
 and who has given birth to the
 hoarfrost of heaven?
³⁰ The waters become hard like stone,
 and the face of the deep is frozen.

Meaning of Heb uncertain

³¹ "Can you bind the chains of the Pleiades,
 or loose the cords of Orion?
³² Can you lead forth the Mazzaroth
 in their season,
 or can you guide the Bear with its children?
³³ Do you know the ordinances of the heavens?
 Can you establish their rule on the earth?

³⁴ "Can you lift up your voice to the clouds,
 so that a flood of waters may cover you?
³⁵ Can you send forth lightnings
 so that they may go
 and say to you, 'Here we are'?
³⁶ Who has put wisdom in the inward parts,
 or given understanding to the mind?
³⁷ Who has the wisdom to number the clouds?
 Or who can tilt the waterskins
 of the heavens,
³⁸ when the dust runs into a mass
 and the clods cling together?

³⁹ "Can you hunt the prey for the lion,
 or satisfy the appetite of the young lions,
⁴⁰ when they crouch in their dens,
 or lie in wait in their covert?
⁴¹ Who provides for the raven its prey,
 when its young ones cry to God,
 and wander about for lack of food?

OUT OF THE WHIRLWIND—WHERE WERE YOU

in it, has reasons the human mind cannot fathom or plumb, and he tells Job so.

Finally, the roar is interrupted by the simple and faint lines uttered by Job: "I had heard of you by the hearing of the ear, but now my eye sees you" (Job 42:5). We too see God in the whirlwind in Ingmire's calligraphic treatment of God's words. But how do we feel about this God? Is this not the fearful Old Testament God booming judgment from the heavens? How can God be angry with his faithful servant who has lost everything, been badgered by his friends, and simply given in to despair?

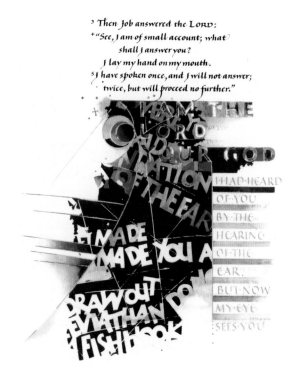

³ Then Job answered the LORD:
⁴ "See, I am of small account; what
shall I answer you?
I lay my hand on my mouth.
⁵ I have spoken once, and I will not answer;
twice, but will proceed no further."

OUT OF THE WHIRLWIND—NOW MY EYES SEE YOU

This is not the end of the story, as the final piece in Job by Ingmire illustrates. However, he retains the tension in this final piece. The illumination is structured like *Messianic Predictions* in *Prophets*, with strings of words like trumpet blasts. However, unlike the words announcing the names of the Messiah, these sentences from the beginning of the book of Job announce destruction. "The fire of God fell from heaven and killed the servants." "A great wind came across the desert, struck the four corners of the house, and it fell on the young people and they are dead." Alongside a column of text that recounts Job's satisfaction with God's answer, we are reminded of all he has lost. And the blame is placed squarely on "the fire of God." This time, however, the words of destruction are laid on a quite different foundation. Even in the midst of the chronicle of devastation, Job's answer begins: "I know that you can do all things, and that no purpose of yours can be thwarted."

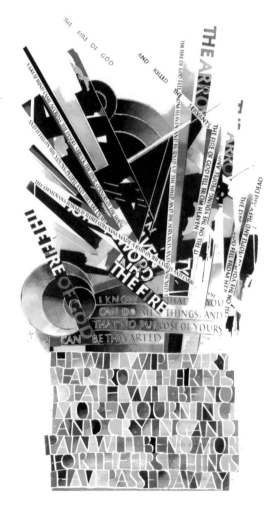

And the foundation of this illumination, a colorful wall of words, is the comfort we have waited for. Ingmire has rested the book of Job on Revelation 21:4, a scriptural cross-reference suggested by the CIT. It is messianic and eschatological, referring to that place beyond human suffering that we cannot grasp but that we know awaits us. "He will wipe every tear from their eyes. / Death will be no more; /

OUT OF THE WHIRLWIND—HE WILL WIPE EVERY TEAR

mourning and crying and pain will be no more, / for the first things have passed away." The answer, he seems to be saying, is not even here in this particular book but beyond.

Scholars have often minimized the passage that restores all Job's goods and riches to him. What matters here is the wisdom of accepting that God's ways are higher than humanity's ways. The words of the final illumination seem to play on the idea of Job's "replacement" riches, that he is given all that he had before and more. At this time in salvation history there was no concept of heaven, of an afterlife where the ones who died would get their reward. Job's long life and his ability to see four generations of his family born into prosperity offer a parallel to Christian images of eternal life.

◁ *What do you think Job means when he says he had heard the Lord by the hearing of the ear but now his eye sees God? What is this deeper vision that Job has and how does that fit our understanding of this whirlwind response?*

THE ART OF THE SAINT JOHN'S BIBLE

Do you know any proverbs? If so, where do they come from? Where did you learn them?

Thomas Ingmire also created the illumination that opens the book of Proverbs. It directly corresponds to his illumination of Isaiah 66:12-13 in *Prophets*. That illumination compares Jerusalem to a nursing mother and promises that the day will come when the people will be comforted and nurtured again at home. The next verse elaborates on this image, describing God's relationship with Israel as maternal: "As a mother comforts her child, so I will comfort you" (Isa 66:13). Feminine images of God, like this one in Isaiah, are central in *Wisdom Books*.

We are formally introduced to Wisdom as a female character in Proverbs. She appears here first as a street prophet: "Wisdom cries out in the street; in the squares she raises her voice" (1:20). The book of Proverbs is a series of instructions from a couple to their son. We begin: "The fear of the LORD is the beginning of knowledge; fools despise wisdom and instruction. Hear, my child, your father's instruction, and do not reject your mother's teaching." They will tell him stories about this woman Wisdom and encourage him to court and eventually marry her, while warning again and again about the dangers of infidelity and that bad woman Folly.

On the original vellum pages Ingmire produced an interesting effect that only comes through faintly in the reproduction. There is considerable "show-through" from the back page, which of course is his final illumination for the book of Job. On the reproductions you can make out some of the columns and arcs from the back of the page, but much of the show-through has been lost in the reproduction process. The modern eye often finds show-through untidy and distracting—a mistake—whereas earlier readers of handmade books accepted these "shadows" as a foretaste of what was to come. The rhythm and continuity of our experience of the book is enhanced by these images caused by the materials themselves.

On the actual page (and in the Heritage Edition, where show-through has been selectively restored) the show-through is dramatic, and you can even make out words announcing

the destruction of Job's family and belongings although, of course, they appear in reverse. It is as though Ingmire does not want us to forget that there is a limit to wisdom and knowledge. Remember what God said to Job: No matter how much knowledge you have, God's ways are higher. Now we read: "The fear of the LORD is the beginning of knowledge."

To fully understand what Ingmire is commenting on, read further in Proverbs. Proverbs 1:24-33, in fact, sounds like Job's friends, who indeed do represent the worldview of their time. The parents advise that the ones who love Wisdom, like Job, "will be secure and will live at ease, without dread of disaster" (Prov 1:33). But the ones who ignore Wisdom will be struck down. In fact, in the book of Job his friends used exactly this logic to argue that Job must have done something wrong to deserve his suffering. They are pious people who live by the worldview represented in Proverbs. The righteous are rewarded and the wicked are punished.

Look at what Wisdom says in Proverbs 1:26-27: "I will mock when panic strikes you [the wicked], when panic strikes you like a storm, and your calamity comes like a whirlwind." Wait a minute! Didn't God scold Job from a whirlwind? Ingmire's heavy show-through on the page tells us to remember Job. However, how are we to read these seemingly contradictory passages? We should hold onto the complexity and realize that much of the truth in the Bible is in the tension between God's ways and human experience. The truth is contained within the interplay of the two statements.

PROVERBS 1:7-8

Also, maybe this is a warning to us not to get too comfortable about what we think we know, especially about God. To bring the mirrors that are such an important element in *Wisdom Books* into the discussion, we should remember Paul's statement in the Letter to the Corinthians that "now we see in a mirror, dimly, but then we will see face to face" (1 Cor 13:12). In fact, Thomas Ingmire was the one who did the elaborate text treatment of this passage in 1 Corinthians. The style of that text treatment has much in common with the illuminations in Job. What is more, the illumination in 1 Corinthians feels almost unbalanced, with the second half battling for attention and rising above the first. Perhaps Ingmire was still wrestling, as we should, with what knowledge and wisdom—and finally, love—contribute to our understanding of God.

Seven Pillars of Wisdom

PROVERBS 8:22–9:6

*Wisdom has built her house,
she has hewn her seven
pillars. (9:1)*

*What images do you see in this illumination that relate
to the text?*

This passage gives more detail about who Wisdom is and
how she works. The NRSV compares Proverbs 8:22-31 with
John 1:1-3. "In the beginning," in other words, there was also
Wisdom. Many read this as an allusion to Wisdom as the pre-
existent Word of God, which Christians see as Christ. Wisdom
plays a part in creation, and "when [God] marked out the
foundations of the earth, then I was beside him, like a mas-
ter worker; and I was daily his delight, rejoicing before him
always, rejoicing in his inhabited world and delighting in the
human race" (Prov 8:29-31). Chapter 9 continues by telling of
the feast Wisdom has prepared for those who wish to follow
her ways. Creation and banquet are a potent combination,
and they come together in the magnificent illumination by
Donald Jackson.

Seven is a symbolic number in the Old Testament, signify-
ing completion or fullness. There is a perfection and fullness to
the created order of Wisdom's world. On each of the pillars is
an orb, a pearl, a precious thing of beauty created by mysteri-
ous processes. It also makes us think of "pearls of wisdom,"
the compact truths found throughout Proverbs. Finally, the
orbs are reminiscent of that heavenly body associated with
feminine forces—the moon.

The tree of wisdom takes center stage, based on the fabric
sample adorned with mirrors. Growing from another pillar
is a complex of buildings, themselves built on columns and
arches and with a series of arched roofs. According to Donald
Jackson, the buildings "just grew" from one another as he
worked. Among the buildings on the upper left hand of the
page is tucked a monochromatic green drawing of the dome
of the church at Saint Benedict's Monastery. Just four miles
down the road from Saint John's Monastery, Saint Benedict's
was founded as a sister monastery in 1857 and is also home to
the College of Saint Benedict. The distinguished scholar and
artist Johanna Becker, OSB (d. 2012), was a member of Saint
Benedict's monastic community as well as the CIT. Richard

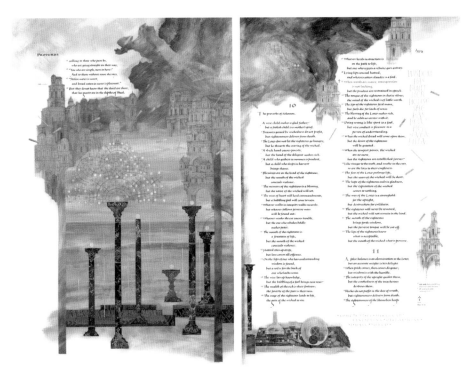

SEVEN PILLARS OF WISDOM

Bresnehan's Johanna kiln on the campus of Saint John's University is named after her.

The cosmos stretches overhead, acknowledging Wisdom's part in creation. Images of the cosmos and space appear throughout *The Saint John's Bible*, from *Creation* in Genesis to the final illumination of Gospels and Acts, *To the Ends of the Earth*. Again in the sky a piece of the wisdom tree, here looking more like one of the heavenly bodies, reveals Wisdom's presence. Wisdom is with us and beyond us, accessible to humans in the world around us but also greater than our minds can grasp. The masculine and the feminine are both here, but the emphasis is on the traditionally female moon and stars, creativity.

A table is set with wine and bread on the right-hand page of the illumination. This image comes out of the text, but it makes yet another connection between Wisdom and Christ. The invitation to "Come, eat of my bread and drink of the wine I have mixed" resonates with the invitation of the eucharistic prayer.

One verse on the page stands out here because it is written in red instead of black. You will notice the cross in the margin that tells us this verse is used in the Rule of Benedict. This verse and Proverbs 15:3 both appear multiple times in the Rule of Benedict and so get slightly heavier treatment here.

Which of these virtues are still relevant and which seem outdated?

The book of Proverbs ends with a hymn to the value of a good wife. This wife may be Wisdom herself, who has been sought throughout the book. The hymn closes out a book of instruction to a young man and logically ends with advice on what kind of woman to marry. This passage also marks a shift in speaker—it is the mother, not the father, who gives the son this advice.

This illumination by Hazel Dolby is in the form of a sampler or tapestry, such as may be found decorating a home. Many of the aphorisms in Proverbs have been rendered decoratively as concrete words to live by. Embroidery is traditionally a woman's art, and this illumination draws attention to the place of women in ethical instruction. The images themselves have a domestic quality, including water jugs, gardens, and quilt patterns. The treatment draws attention to God's domesticity, helping us see God as a nurturer who looks after the well-being of the home. Order and creation, as well as creativity and care, are among the ways we see God's presence reflected in our daily lives. The illumination also extends to the margins, framing the whole page with images of flowers, a vase, and a bee working a honeycomb. Another delicate detail is the tassels on the bottom. These are like the tassels on the hem of a Jewish prayer shawl that are meant to be a specific reminder to the wearer to pray and remember God's blessings.

◖ *What qualities do you look for in friends? If you wrote a hymn praising the virtues of someone you know, what qualities would you sing?*

Hymn to a Virtuous Woman

PROVERBS 31:1-31

Charm is deceitful, and beauty is vain, but a woman who fears the LORD is to be praised. (31:30)

HYMN TO A VIRTUOUS WOMAN

ECCLESIASTES 1

*Vanity of vanities! All is
vanity! (1:2b)*

*What "messengers" between the human world and God
do you see here? What do you think their significance is?*

Ecclesiastes seems, in some ways, a return to the territory of
Job. Here again the big questions are taken up: What gives
life meaning? What hope can there be when the wise and
the foolish suffer the same fate in the end? Here the author,
a philosopher giving his name as Qoheleth (in Latin *Ecclesiastes*),
takes on the persona of Solomon. He gives voice to
the feelings we had when turning from Job to the opening of
Proverbs: "I applied my mind to know wisdom and to know
madness and folly. I perceived that this is also but a chasing
after wind. For in much wisdom is much vexation, and those
who increase knowledge increase sorrow" (1:17-18). It is death
that is troubling this author. There is an old saying that only
two things are certain: death and taxes. Never mind the taxes,
says the author of Ecclesiastes, how can we go on living when
we know that what lies before us is death?

The author is not the first to ask this question and will not
be the last. Scholars see direct parallels between the structure
and message of Ecclesiastes and the earliest known piece of
writing, Gilgamesh. The opening poetry resonates in Hamlet's
famous soliloquy, "To be or not to be, that is the question."
Dostoevsky asks the question repeatedly through his characters
and their moral struggles. Woody Allen takes it up in *Hannah
and Her Sisters*, where a character who gets a reprieve from
a terminal diagnosis loses all sense of meaning and purpose,
realizing the reprieve can only be temporary. He regains his
sense of life's meaning in a dark theater while watching the
Marx brothers—Why not enjoy life while we're here? After
all, there is so much to enjoy.

In fact, this is the very conclusion drawn by the fictitious
Solomon in 2:24-26. "There is nothing better for mortals than
to eat and drink, and find enjoyment in their toil." This joy
too, the wise man says, is the gift of God. In the end, the
philosopher advises: "The end of the matter: all has been
heard. Fear God, and keep his commandments; for that is
the whole duty of everyone" (12:13). This is a confounding

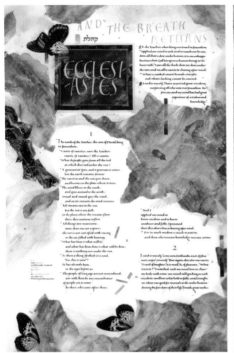
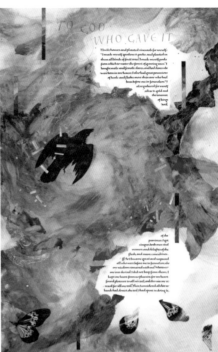

ECCLESIASTES FRONTISPIECE

little book, which can be read as very pessimistic but also as very hopeful. The wise person lives following God and finds peace, freedom, and joy in the very understanding that everything is in God's hands. For the modern existentialist reader, however, the book confirms: Why bother? Things are in God's hands, not mine.

Ecclesiastes' frontispiece sees the return of many elements from Genesis. This is appropriate because Ecclesiastes, like so much in the Wisdom Books, focuses attention on life and death and the place of God in human life.

Most prominent is the raven flying up from the center of the illumination. The raven traversed the illumination *Creation*. Donald Jackson has said that birds are messengers, and this one, also a common symbol of death, seems to carry the

breath of life back to God. Still, it is pierced and surrounded by gold and silver bars, designations of divinity.

Other messengers are present as well, seraph wings that will play a prominent role in *Prophets*. The sometimes frightening guardians of God as king are present. The bars of rainbow color are another sign of God's presence, God's ongoing covenant, asserting itself against the otherwise chaotic image of the cosmos. Human intelligence also asserts itself here in the image of the ancient Islamic astronomical chart. Here is another place where the mind attempts to grasp things that really cannot be fully comprehended. Trusting in the divine and remembering that in the midst of chaos the divine is present may be the only way to soothe the person engaged with these questions.

Finally, the shattered butterfly wings by Chris Tomlin take us back to *Jacob's Ladder* (Gen 28:10-22) and *Jacob's Second Dream* (Gen 32:24-32). Butterflies are also creatures who bridge both worlds, the human and the divine. Beautiful and mysterious, they remind us of God's skill in creation. In fragments here, they speak to us of chaos as well as metamorphosis—life to death and death to life.

The elements of creation are all here: the green of the earth, the blue of water, the sky with its dusting of stars and images of comets. But the elements are disrupted, chaotic, circling, or spinning off the page. Donald Jackson was asked to create a sense of vortex sucking inward as well as its opposite, entropic forces spinning outward into the universe. God is present and in communication between the heavens and the earth. All of this is overshadowed by the speaker's gloom, however, as he proclaims across the top of the page, "and the breath returns to God who gave it" (Eccl 12:7).

◖ *Do you read Ecclesiastes as optimistic or pessimistic?*

What role does desire play in our lives? In our prayers?

I give you the end of a golden string;
Only wind it into a ball,
It will lead you in at Heaven's gate,
Built in Jerusalem's wall.

—*William Blake, "Jerusalem"*[*]

A garden locked is my sister, my bride, a garden locked, a fountain sealed. (4:12)

This quotation from the early nineteenth-century British poet and mystic William Blake could be applied to the illumination of the vision of the temple in Ezekiel, but it also seems apt here. Throughout the Song of Solomon, the literal love poem and the allegory of the love between God and Israel play out in rich and evocative images that also have layers of meaning. Wisdom is a personified quality we seek and hope to catch, and that ultimately leads us to communion with God. In the illumination here of a walled garden we find a type of labyrinth. Later we will see a labyrinth in the temple vision of Ezekiel. At the heart of our exploration of Wisdom in this literature and these illuminations is the search for a closeness with God here on earth. As the groom is lured toward the garden by the scent of its fruit trees and spices, so are we drawn by Wisdom, as if winding up a ball of golden string, until we reach heaven's gate. In the same way an herb garden behind a kitchen draws us in with its scents, fresh greenery, and the order of its geometric plantings, to the delights of those waiting to greet us and nourish us on the other side of the door.

The scattered elements of gold and deep red draw attention to our disconnection from God. Like pieces of a jigsaw puzzle, they desire to be reunited within the formal garden and thus become whole. If they could be assembled, they would make up a *parterre*, a formal garden design using flower beds, hedges, stone walls, and other elements. They represent our longing for oneness with the divine.

[*] *The Oxford Book of English Mystical Verse*, ed. D. H. S. Nicholson and A. H. E. Lee (Oxford: Clarendon Press, 1917).

The Song of Solomon, called in other translations Song of Songs, reminds us again of the variety found in the Wisdom Books. It is quite clearly a collection of love songs sung by a man and a woman and is full of playful eroticism. Aside from the quality of the lyric poetry, what recommended it for inclusion in the sacred canon? There are no really good answers to this question. However, the Song of Solomon certainly fits with what we have learned from the Wisdom Books so far. It is a balance to the darker questions of suffering, loss, and death. You can imagine the young student invoked in Proverbs 1 asking: "What about love?" And if Wisdom advises that enjoyment of life is a gift from God, why not a brief book celebrating romantic love, one of life's greatest pleasures?

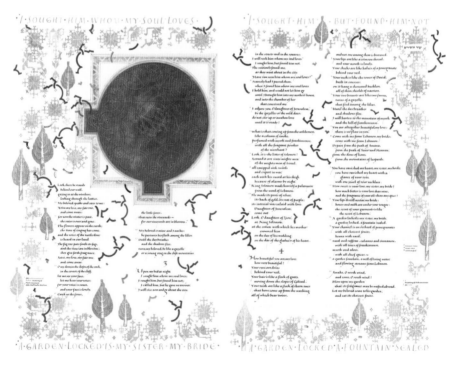

GARDEN OF DESIRE

THE ART OF THE SAINT JOHN'S BIBLE

The Song was probably sung at banquets on religious feasts, and today passages from it are read at weddings. In later times the book came to be read as an allegory for the relationship between Israel and God or the Christian Church and God. However, there is no getting away from the fact that these poems were written not as allegory but as love songs. Like Proverbs and the other Wisdom Books, this one was probably not written by Solomon. As the king's court would have been responsible for assembling anthologies of wisdom, they also assembled collections of poetry. The phrase "song of songs" in Hebrew is a superlative—this is a collection of the best of all possible songs. Solomon's name gives the book authority. There is a parallel to this in Chinese poetry, where early dynasties collected books of the best poetry of the time. Some of it was courtly and some of it was rustic, including love songs. The earliest collection still in existence, the *Shi Jeng* from the eighth century B.C.E. (a century after the Hebrew Song of Songs), is translated into English as the *Book of Songs*.

The opportunity to find a visual language for this poetry was picked up enthusiastically by Donald Jackson. There is definitely a high ratio of illumination to text in this book! Two back-to-back spreads and a text treatment adorn the eight chapters of poetry.

The garden imagery, warm colors, and butterfly, all drawn by Jackson, separate this book from Ecclesiastes starting right at the book title. Chris Tomlin was on another assignment, so Jackson painted this butterfly. Mosaic pieces of the *parterre* dance on the page. Turning the page, we enter more fully into the garden where the lovers look for each other. The image is also used to describe the beloved: "A garden locked is my sister, my bride, a garden locked, a fountain sealed" (4:12).

In this illumination are order and disorder, beauty and pattern and incompletion. The red circle with walls around it is taken from a design of a Middle Eastern garden. Jackson deliberately left it unfinished, only two gates mapped out, asymmetrical. The courtship of these lovers balances the passion that sends her out into the street at night to find him and the propriety that observes the conventions of marriage and

warns again and again, "do not stir up or awaken love until it is ready!" (2:7; 3:1-5). Until their union is complete, there is something off balance about the scene. The margin makes use of stamps again in warm colors and fills in the garden with trees and flowers. The place is warm and inviting, a sanctuary of earthly delights. Finally, another color motif in this book is found in the verse numbers. Three colors are used to signify the alternation between the speakers: the man, the woman, and another speaker marked "unidentified," often interpreted as the chorus of daughters of Jerusalem. The color key is in the marginal notes of the pages where the speakers' verses appear.

How does your reading of the Song of Solomon affect your understanding or appreciation of the Bible as a whole?

The two-page spread titled *I Am My Beloved's* maintains the idea of a border or boundary from the last illumination, this time in lilac, yellow, and gold. The border here was not made with stamps but with pieces of lace dipped in paint and powdered gold ink—a less precise technique to say the least. Warm colors are used for the rather abstract lilies and the block of color behind the text. The gold of divine presence, which has previously appeared in blocks or bars, here appears as petals or seeds. In making the lilies, Donald Jackson tipped his board and let the paint dribble or run down the page to make the stems, only marking off areas of text before he guided it. It was a frightening moment for someone working with these materials, the

I Am My Beloved's and
Set Me as a Seal upon Your Heart

SONG OF SOLOMON 6:3 /
SONG OF SOLOMON 8:6-7

I am my beloved's and my beloved is mine; he pastures his flock among lilies. (6:3)

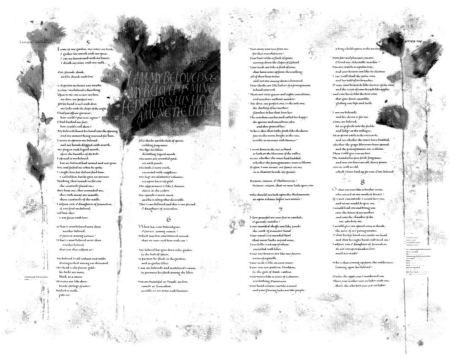

I AM MY BELOVED'S

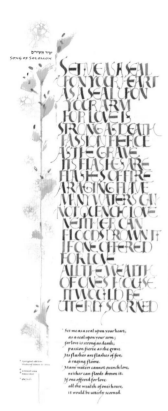

SONG OF SOLOMON

one-time-only chance to get it right with so much of the work on the page already completed. If one can't take risks in the Song of Solomon, however, where can one? The technique gives in to the abandon and single-mindedness, the "fierceness" of love with which the two lovers seek out each other. As with so much of this volume of *The Saint John's Bible*, the focus here is on the words, our attention drawn to the columns of poetry and not distracted by elaborately detailed images. The little blue and yellow butterflies were painted by Sarah Harris, the studio assistant at the Scriptorium. Where the team members could be incorporated they were, and this volume is a testament to the collaboration, some of which was coming to an end with this volume.

On the back of the page is a text treatment. The passionate verses read: "Set me as a seal upon your heart, as a seal upon your arm; for love is strong as death, passion fierce as the grave. Its flashes are flashes of fire, a raging flame. Many waters cannot quench love, neither can floods drown it. If one offered for love all the wealth of one's house, it would be utterly scorned" (Song 8:6-7). The passage is written not with a quill but with a reed pen. The split reed is light and writes like a quill pen dipped in paint except that its woody edge creates softer shapes. Jackson explained you have to keep it moving and get into a rhythm with it. What he wanted was an earthly, primitive feel, emphasized by the variations of color seen here. It exhibits yet another possibility in the techniques of the ancient art of writing.

The Song of Solomon has a long history in monastic traditions. Bernard of Clairvaux, a Benedictine of the twelfth century, wrote a series of beautiful sermons on the book. Bernard was a great reformer and founder of the Cistercian movement, known for its austerity and strict adherence to the Rule of Benedict. It says a lot about Benedictines that the founder of this community so embraced the passionate Song of Solomon. The purpose of monastic life, after all, is to seek out God as the beloved and to live in God's embrace.

Can you think of contemporary films or books that might be reflections of this story of those who pursue folly instead of wisdom?

The starkness and violence of this illumination lets us know something is up. There is no garden here, no tapestry, no meal. Worse yet, the text appears to be written backward on the page. This is another illumination by Thomas Ingmire, who seems to have two sides to his artistry. Whereas pleasing, bright colors and meticulous geometrical patterns marked his *Ten Commandments* and illuminations in the book of Job, this one has more in common with the scratches and jumble of the first column of *David's Lament* in 2 Samuel. But this is truly unlike any other piece by Ingmire in *The Saint John's Bible*. It appears scratched and smudged in places. The horizontal strips are without letters or words and it is hard to find a focal point.

At the same time, this passage in Wisdom of Solomon speaks to the exact issue raised in Ecclesiastes. Of course, it

Let Us Lie in Wait

WISDOM OF SOLOMON
1:16–2:24

Let us lie in wait for the righteous man, because he is inconvenient to us. (2:12)

LET US LIE IN WAIT

does so "in reverse," not through the eyes of the wise man but through the wrong reasoning of the ungodly. It takes the wisdom of Ecclesiastes, that we should enjoy life as a gift from God, and subverts it. In Wisdom 1:16–2:24 we are shown the thinking of the ungodly, those who "reasoned unsoundly" and decided that since life on earth was all there is, they should live for pleasure. Further, their unsound reasoning gives them license to "oppress the righteous poor man" and the widow, allowing "might [to] be our law of right" (2:10-11).

Ultimately, this passage begins to resonate with the story of Christ's passion. The ungodly behave like those in the gospels who follow Jesus around in order to trip him up and eventually kill him. So we see in Ingmire's illumination the "backward" text: "Let us lie in wait for the righteous man" (2:12). The ungodly live in a two-tone world, mostly black, and do not see God. They bring violence and chaos into the world. They are without wisdom.

The verse in the frame tells us the error of the ungodly: "They did not know the secret purposes of God . . . for God created us for incorruption, and made us in the image of his own eternity" (vv. 22a, 23). The crucifixion, paradoxically, carries out God's "secret purposes," God's ultimate plan. Remember the words of Job? "I know that you can do all things, and that no purpose of yours can be thwarted" (Job 42:2). As Paul wrote, "We know that all things work together for good for those who love God, who are called according to his purpose" (Rom 8:28). It is only with this faith that we live in the knowledge of true wisdom and avoid the despair of both Job and the author of Ecclesiastes.

Scholars now believe the Wisdom of Solomon influenced the formation of the New Testament. In addition to this prefigurement of the passion narrative, they also look at the description of Wisdom in chapters 6, 7, and 10, particularly as the agent for God's creation. As Proverbs 8 spoke of Wisdom's presence and role in creation, so this book reinforces the idea of a preexistent Christ, important to the theology of the Trinity. Even more, with the focus on the feminine pronoun and female attributes, it expands our conception of Christ from the historical Jesus to include a more complex set of images to contemplate God as creator, savior, and God with us.

THE ART OF THE SAINT JOHN'S BIBLE

What are the attributes of Wisdom you see reflected in this mirror? Do they match the discussions so far of Wisdom personified as a woman?

This illumination accompanies the prayer of Solomon, the wise king and son of David, the builder of the temple, who calls on God to send Wisdom to help him. The passage again stresses the eternal nature of Wisdom, who was there at the beginning when the heavens and earth were made. Wisdom is seen as a guide who will labor by Solomon's side.

The motif of the mirror comes to full fruition in this illumination, with the face of Wisdom reflected in a mirror. As mentioned earlier, it is in this book that Wisdom is elevated to full divinity. We read in chapter 7: "For she is a breath of the power of God, and a pure emanation of the glory of the Almighty . . . she is a reflection of eternal light, a spotless mirror of the working of God, an image of his goodness" (7:25-26). We can never see God directly in this life, but in Wisdom we see God's reflection in the mirror—and it is a female face we see.

A photograph of a Palestinian woman inspired this image. Another time photographs of actual human faces were used is in Genesis with Adam and Eve. In fact, it is worth going back to that image with its mirrored background (hard to make out in the reproduction), which was accompanied by a quotation from the letter to the Romans: "And all of us with unveiled faces seeing the glory of the LORD as though reflected in a mirror, are being transformed into the same image from one degree of glory to another" (Rom 8:19). The mirror connects both images as well as the idea of humanity created in God's image and reflecting God's glory. In our approach to understanding our relationship with God, Wisdom and the Wisdom Woman are an important step.

The image of the woman's face was silk-screened onto the vellum multiple times. Silk-screening was a terrifying process for Donald Jackson and the team because of its unforgiving nature. You get one pull over the screen and hope for the best. This composition was made more difficult because it spans

Wisdom Woman

WISDOM OF SOLOMON
7:22b-30

For she is a reflection of eternal light; a spotless mirror of the working of God. (7:26)

and life with her has no pain,
 but gladness and joy.
¹⁷When I considered these things inwardly,
 and pondered in my heart
 that in kinship with wisdom
 there is immortality,
¹⁸and in friendship with her, pure delight,
 and in the labors of her hands, unfailing wealth,
 and in the experience of her company,
 understanding,
 and renown in sharing her words,
 I went about seeking how to get her for myself.
¹⁹As a child I was naturally gifted,
 and a good soul fell to my lot;
²⁰or rather, being good, I entered
 an undefiled body.
²¹But I perceived that I would not possess
 wisdom unless God gave her to me —
 and it was a mark of insight to know
 whose gift she was —
 so I appealed to the Lord and implored him,
 and with my whole heart I said:

9

"O God of my ancestors and Lord of mercy,
 who have made all things by your word,
²and by your wisdom have formed humankind
 to have dominion over the creatures
 you have made,
³and rule the world in holiness
 and righteousness,
 and pronounce judgment in
 uprightness of soul,
⁴give me the wisdom that sits by your throne,
 and do not reject me from among
 your servants.
⁵For I am your servant the son of
 your serving girl,
 a man who is weak and short-lived,
 with little understanding of
 judgment and laws;
⁶for even one who is perfect among
 human beings
 will be regarded as nothing without the
 wisdom that comes from you.
⁷You have chosen me to be king of your people
 and to be judge over your sons and daughters.
⁸You have given command to build a temple
 on your holy mountain,
 and an altar in the city of your habitation,
 a copy of the holy tent that you prepared
 from the beginning.
⁹With you is wisdom;

she who knows your works
 and was present when you made the world;
 she understands what is pleasing in your sight
 and what is right according to
 your commandments.
¹⁰Send her forth from the holy heavens,
 and from the throne of your glory send her,
 that she may labor at my side,
 and that I may learn what is pleasing to you.
¹¹For she knows and understands all things,
 and she will guide me wisely in my actions
 and guard me with her glory.
¹²Then my works will be acceptable,
 and I shall judge your people justly,
 and shall be worthy of the throne
 of my father.
¹³For who can learn the counsel of God?
 Or who can discern what the Lord wills?
¹⁴For the reasoning of mortals is worthless,
 and our designs are likely to fail;

· FOR · SHE · IS · A · REFLECTION ·

WISDOM WOMAN

⁴ But when an unrighteous man departed
 from her in his anger,
he perished because in rage he
 killed his brother.
⁴ When the earth was flooded because of him,
 wisdom again saved it,
steering the righteous man by a
 paltry piece of wood.

⁵ Wisdom also, when the nations in wicked
 agreement had been put to confusion,
recognized the righteous man and preserved
 him blameless before God,
and kept him strong in the face of his
 compassion for his child.

⁶ Wisdom rescued a righteous man when
 the ungodly were perishing;
he escaped the fire that descended
 on the Five Cities.
⁷ Evidence of their wickedness still remains:
a continually smoking wasteland;
plants bearing fruit that does not ripen,
and a pillar of salt standing as a monument
 to an unbelieving soul.
⁸ For because they passed wisdom by,
they not only were hindered from
 recognizing the good,
but also left for humankind a reminder
 of their folly,
so that their failures could never go unnoticed.

⁹ Wisdom rescued from troubles
 those who served her.
¹⁰ When a righteous man fled from
 his brother's wrath,
she guided him on straight paths;
she showed him the kingdom of God,
and gave him knowledge of holy things;
she prospered him in his labors,
and increased the fruit of his toil.
¹¹ When his oppressors were covetous,
she stood by him and made him rich.
¹² She protected him from his enemies,
and kept him safe from those who
 lay in wait for him;
in his arduous contest she gave
 him the victory,
so that he might learn that godliness is more
 powerful than anything else.

¹³ When a righteous man was sold, wisdom
 did not desert him,
but delivered him from sin.

¹⁵ for a perishable body weighs down the soul,
 and the earthy tent burdens the
 thoughtful mind.
¹⁶ We can hardly guess at what is on earth,
 and what is at hand we find with labor;
 but who has traced out what is in the heavens?
¹⁷ Who has learned your counsel,
 unless you have given wisdom
 and sent your holy spirit from on high?
¹⁸ And thus the paths of those on
 earth were set right,
 and people were taught what pleases you,
 and were saved by wisdom."

10

Wisdom protected the first-formed father of the
 world, when he alone had been created;
 she delivered him from his transgression,
²and gave him strength to rule all things.

OF · ETERNAL · LIGHT ·

two separate sheets of vellum. The pages fit together in such a way that half of the image is on one sheet while the other half is on the back of another. It is lovely in how it unfolds from the center of the page when opened, but it increased the technical difficulty tenfold.

It is difficult to imagine a more perfect face for Wisdom. The crow's feet around her eyes and the sparkle in those eyes emit more joy than her slight smile suggests. Like Wisdom, she is full of light. She has squinted into the sun, and she has looked hard at life, and she has laughed. The lines on her forehead show she has worried and given her full attention to the task at hand. Her smile is knowing, somewhat secretive, but also intimate—she will tell us her secret if we ask.

The round frame of the mirror depicts the twenty-eight phases of the moon, another association with the feminine. In the four corners of the outer frame are paintings based on images from the Hubble telescope, again pointing to the cosmic nature of Wisdom. The shapes here, of the circle and the frame, hark back to the walled garden in Song of Solomon or look forward to the vision of Solomon's temple in Ezekiel. Fragments of the familiar, mirrored wisdom tree are again stamped along the border. When contemplating Wisdom, we should employ all our metaphors: journey, creation, reflection, and relationship, and any others that help us approach the mystery of God.

◀ *Who in your life has reflected to you the face of Wisdom?*

Over the course of the project, each of the scribes made an error in the text that could not be erased. The only one who seemed to be immune to error was Brian Simpson, until finally, in the last volume he did major work on as a scribe, he left out two lines. As usual when such things happened, the lines seemed striking in their importance! "I called on God, and the spirit of wisdom came to me." Donald Jackson decided that when lines were omitted they should be written in at the bottom and their place in the text acknowledged. In past volumes birds have "carried" the lines to their spot. This time, however, a bee was chosen to do the work. Sarah Harris and Jackson worked out the design of the pulley system based on Leonardo da Vinci's mechanical drawings, and Chris Tomlin came in to paint this whimsical bee doing some heavy lifting.

Along the left margin is the second part of a text treatment by Sally Mae Joseph. It begins on the previous page with a reprise of the verse that was placed in Job and commissioned by the scribe Angela Swan: "Wisdom is radiant and unfading and she is easily discerned by those who love her and is found by those who seek her." On this page the treatment traces a chain of thought called *sorites*, which connects a number of like statements. "The beginning of wisdom" is desire for instruction, which is love of Wisdom, and which, in turn, causes one to obey her commands, thus bringing one closer to God and the kingdom. What is required of us, therefore, is to seek, and if we are sincere we will no doubt end our journey in God's kingdom.

WISDOM OF SOLOMON
10–11

*Wisdom rescued from trouble
those who served her. (10:9)*

*Although the text does not name the characters in
Israel's history under consideration, can you identify
and name them as you read along?*

The Wisdom of Solomon includes two chapters that recount
the history of Wisdom from creation through the Israelites' stay
in the desert. These chapters are the source for the illumination
on these pages, again celebrating Wisdom's creative power and
connection to human life. These chapters reference the major
events in Genesis and Exodus. They retell the history as though
in an address to Wisdom, pointing out her constancy to humans.
Adam, "the first-formed father of the world," when he is outside
the Garden of Eden, is helped by Wisdom to gain dominion over
the earth (Wis 10:1-2). Lot's wife remains a symbol of all of those
who did not trust in Wisdom, "a reminder of their folly" (Wis
10:8). Wisdom is with Jacob in his toil and protects and prospers
him. She also goes with Joseph "into the dungeon" and gives him
power in the kingdom and honor (Wis 10:13-14).

It is understood that the people know these stories. They
are an important piece of the cultural memory, recorded in
Genesis and Exodus. The stories were passed down and appear

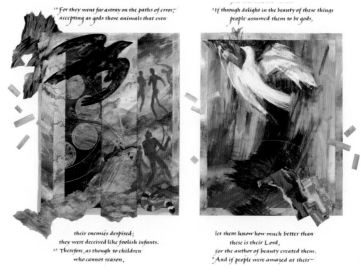

For they went far astray on the paths of error,
accepting as gods those animals that even
their enemies despised;
they were deceived like foolish infants.
Therefore, as though to children
who cannot reason,

If through delight in the beauty of these things
people assumed them to be gods,
let them know how much better than
these is their Lord,
for the author of beauty created them.
And if people were amazed at their

CREATION, COVENANT, SHEKINAH, KINGDOM

in several forms in the Old Testament, including the retelling of them in Psalms. This retelling, however, puts the focus on Wisdom, God's "holy spirit" (with lower case) sent down and walking with us. For the people living in exile in Babylon, among foreign gods and the temples and courts of foreign rulers, a divine presence who knew their troubles and would guide them when the God of temple worship seemed far away was a source of sustenance and joy.

A list of possibilities for this illumination was given to Jackson by the CIT. He devised a series of four panels that draws on illuminations of four passages in *Pentateuch* and *Prophets*. This illumination takes us back to the theme of creation running throughout *Wisdom Books*. Again, the focus is on Wisdom's presence at the beginning of time and throughout history, even to the end of the age. God's plan and Wisdom go hand in hand.

The four panels here bring to mind the four elements of the universe: earth, water, fire, and air. They refer back to the stories in the narrative: the Creation, the Flood, the Exodus, and the Promised Land.

The first two panels are most clearly tied to the creation theme. "She who knows your works and was present when

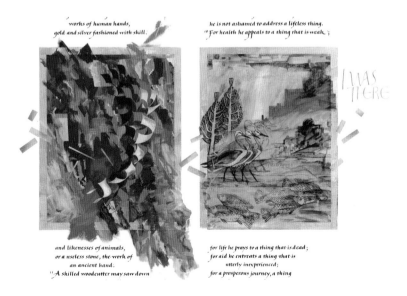

you made the world," reads Wisdom 9:9. In the first panel the seven pieces from the *Creation* illumination are put in various widths, emphasizing the cycles of the moon that are associated with Wisdom, and the creation of humans, along with the coral snake representing the Fall. The raven of the first panel (also seen in the Ecclesiastes frontispiece) is complemented by the dove in the second, an image of the spirit. The story of the Flood is a second creation story, as God again brings the world out of chaos and makes a covenant with Noah, gifting him the world and promising never again to wipe out creation by flood. "When the earth was flooded . . . Wisdom again saved it, steering the righteous man by a paltry piece of wood" reads Wisdom 10:4. It is in the connection between God and humanity that we see Wisdom, the ingenuity of the ark.

Images of destruction, not just creation, also link the second and third panels to each other. The flash of color at the bottom of the second panel is a variation on the *Job Frontispiece*, imagery that continues into the next panel. In both cases, as with chaos in the first panel, destruction breaks the boundaries of the image, taking us beyond God's perfect plan. However, in the first frame the abundance of land and water also break the frame, and in the second the dove soars and lifts the olive branch outside of the margins. In the case of the flood, or of Israel in the desert, the chaos of humankind's disobedience exists alongside God's plan for salvation.

The third panel has the word "Shekinah" (The Hebrew pronunciation is "shuh-khee-*nuh*" although it is often pronounced by English speakers "shuh-*kayh*-nuh.") This is the English equivalent of the Hebrew word that describes God's presence or a symbol of God's presence on earth. The concept is found in Ezekiel when the presence of God leaves Jerusalem and the temple, but also earlier in Exodus to describe God dwelling in the tabernacle. The image is of the column of fire by which God led Israel out of Egypt. Again Wisdom was there: "She brought them over the Red Sea and led them through deep waters" (Wis 10:18). God appeared to Moses first in the burning bush and later to the people as fire on Mount Sinai. The people knew that God was present in the tabernacle because

it glowed with the light of God's glory. The Hebrew word Shekinah itself is feminine, and it has been used by scholars to denote the feminine character of God, again a theme found throughout *Wisdom Books*. Izzy Pludwinski designed the word as it appears in gold in this illumination. Finally, it was in the Exodus that Israel became a nation, another act of creation.

The fourth panel takes a detail from the vision of Solomon's temple in Ezekiel that focuses on the abundance provided to the people in the Promised Land and the eschatological meaning of the temple. Solomon, the invented speaker of the present book, sings the praises of Wisdom, who is with him, helping him to raise up a righteous kingdom. It is Solomon who built the first temple, and even after continued disobedience and the loss of the Promised Land there remains faith in God's mercy and knowledge that the temple will be restored. In God's return and the creation of the New Jerusalem, Wisdom is there. A number of verses in the passage apply here. Donald Jackson mentioned "She gave to holy people the reward of their labors" (Wis 10:17) as his inspiration. However, the following verse also applies to God's reconciling nature and the balance between creation and salvation history: "For you love all things that exist, and detest none of the things you have made . . . you spare all things, for they are yours, O LORD, you who love the living" (Wis 11:24, 26). Wisdom continually draws us to God and reveals God's mercy and promise.

Connecting these panels are batons and frames of gold and silver, wisdom and divinity, as we have seen from the first page of Job. These are not discrete events but connected. Each of these moments in the history of Israel is one moment in the revelation of God's abiding presence with us. The words in the margin, "I was there," come from Proverbs 8:27 when Wisdom declares "I was there" at the moment of the creation. Donald Jackson sees this as a complementary notation to Isaiah's response to God, found in the margins of the *Vision of Isaiah* in *Prophets*, where he answers the call with the words "Here am I."

❡ *Where do you perceive the presence of God in history and the world around you?*

Looking at the work of Minnesota native Diane M. von Arx in this volume, let's begin at the end with her fourth text treatment, in Sirach 39:13-15. The opening verse of the Rule of Benedict is, "Listen carefully, my son, to the master's instructions, and attend to them with the ear of your heart." The command "Listen to him" is prominently treated in two places in the Gospel of Mark surrounding the account of the transfiguration. The references to Saint John's Abbey are further deepened by two motifs running through this text treatment. Just under the words "listen to me my faithful children," you will see the faint pattern of honeycomb, which is the pattern of the stained glass windows at both Saint John's Abbey Church and Sacred Heart Chapel at Saint Benedict's Monastery. Also running through the text are voiceprint images used in *Psalms*. Those representations of the monks' song at prayer reflect the second directive of these verses: "sing a hymn of praise."

Diane M. von Arx's text treatments are marked by bold colors and strong images. In addition to this treatment in Sirach,

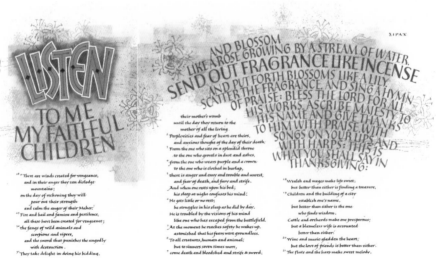

SIRACH 39:13-15

THE ART OF THE SAINT JOHN'S BIBLE

she also contributed the dramatic *For I Know That My Redeemer Lives* (Job 19:25), *Send out Your Bread upon the Waters* (Eccl 11:1), and *Faithful Friends* (Wis 6:14-22, located at Sir 7). Each of her treatments has a unique script and different color palette.

Let us look back at one other treatment by Diane M. von Arx, *Faithful Friends* (Sir 6:14-22). This passage picks up on themes in Proverbs and Ecclesiastes and celebrates the good life enjoyed by those who seek wisdom. The wise appreciate the value of friendship and of discipline and so are rooted and happy into old age. Their lives are built on a solid foundation, like the brick wall behind the calligraphy. Diane M. von Arx adds to this the subtle honeycomb pattern. Like so many texts in *Wisdom Books*, this one is rich with metaphors: friends are a treasure and a saving medicine; Wisdom is a good seed planted by those who toil in her garden; these laborers will harvest her fruits. For the undisciplined, however, wisdom is a heavy stone to be cast aside. This colorful treatment keeps the truth of good values before us, instructing us to cultivate wisdom and be disciplined. The result will be lasting friendships and peace in our relationships well into old age.

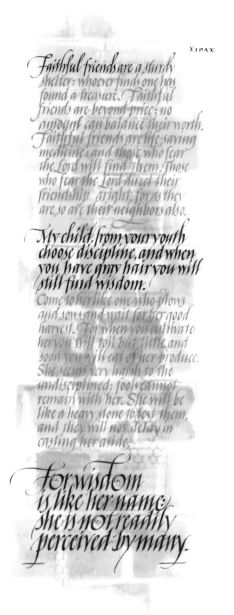

SIRACH 6:14-22

WISDOM BOOKS 139

Praise of Wisdom

SIRACH 24

Come to me, you who desire me, and eat your fill of my fruits. (24:19)

What images from Praise of Wisdom *do you see in the illumination?*

The final illumination in Sirach is by Suzanne Moore. The key motif here is fertility, as it was in her illumination *Ruth the Gleaner*. It is everywhere, in the fruits and the wheat and in the female figure at the top right, with breasts and navel, that looks like an ancient totem of fertility. All things lead to and proceed from her, another evocation of Wisdom. As we see in the text, Wisdom invites: "Come to me, you who desire me, / and eat your fill of my fruits, / for the memory of me is sweeter than honey, / and the possession of me sweeter than honeycomb" (24:19-20). Comparing this illumination with *The Prophetess Hulda* in 2 Kings and *Last Judgment* and *Calming the Storm* in Matthew's gospel, you will see that, as each moves from chaos to divinity, the image is marked by sweeping arcs and the same filigree stamp we see here. Platinum is used on the circles on both sides of the image.

This illumination also draws on the comparison made by Christian theologians between Christ and Wisdom. Jesus claims to be the bread of life and living water, and in this chapter Wisdom claims: "Those who eat of me will hunger for more, / and those who drink of me will thirst for more" (24:21). A taste of wisdom makes one want more, as insatiable as the desire between the lovers in the Song of Solomon. The fertility figure at the top of the page is also cruciform, triggering associations with the cross. Wheat is a common liturgical symbol of Jesus as the bread of life, and at the bottom is a round orange shape bisected with a cross shape that resembles other images of eucharistic loaves of bread in this Bible. The image on the lower left appears to be a perfume bottle with an open mouth, from which rises a moonlike bubble. This image corresponds to verse 15: "Like cassia and camel's thorn I gave forth perfume, / and like choice myrrh I spread my fragrance." So beautiful are these two verses, in fact, of wisdom

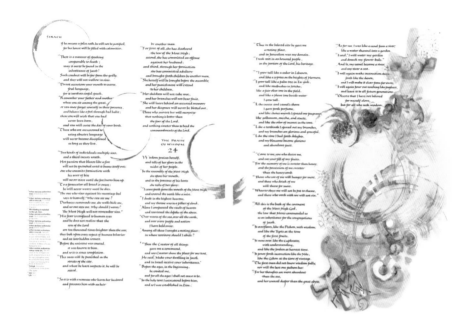

as honey and as perfume, that each is given a separate text treatment. Sirach 24:19-20 by Sally Mae Joseph appears in the margin at Sirach 13, and Sirach 24:12-17 weaves in and out of the text like vines in an elaborate treatment by Sue Hufton placed at Sirach 44–45.

❧ *If you were writing a song to wisdom, what imagery and current metaphors might you use?*

Like Clay in the Hand of the Potter

SIRACH 33:13

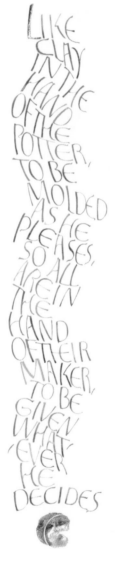

This text treatment by Donald Jackson again picks up the themes of creation, distinctiveness, God's care, and growth through wisdom. It is God who has molded us and assigned us each our particular talents and quirks. Like a hand-fashioned work of pottery, each piece is unique and reflects its maker. The dynamic shape of the text and the subtle shifts of color speak to God's playfulness, making us "as he pleases" in all our diversity. None of us is perfect, but we are all made by God. And God continues to mold us as we seek wisdom and grow. The text itself conforms to the shape of a hand cupping rotating clay. Finally, as a potter puts a mark on a finished work, so this text treatment ends with a gold stamp or mark, as if God's thumb were pressed to the page.

A carpet page closes the volume of *Wisdom Books*. However, this is more of a stand-alone piece than other carpet pages— a text treatment and image. The second function of a carpet page, to distract from and diminish the show-through of a heavy illumination on the other side of the skin, is not necessary here at the end of the volume. It is more intentionally decorative. The stamp made from the mirrored cloth we saw most prominently in *Seven Pillars of Wisdom* is used again here, in colors we recognize from the garden in the Song of

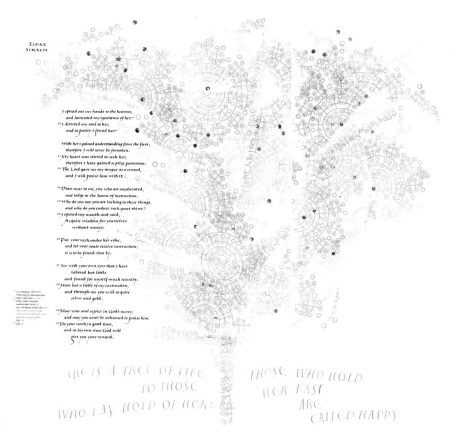

ΣΙΡΑΧ
SIRACH

I spread out my hands to the heavens,
and lamented my ignorance of her;
I directed my soul to her,
and in purity I found her.

With her I gained understanding from the first;
therefore I will never be forsaken.
My heart was stirred to seek her;
therefore I have gained a prize possession.
The Lord gave me my tongue as a reward,
and I will praise him with it.

Draw near to me, you who are uneducated,
and lodge in the house of instruction.
Why do you say you are lacking in these things,
and why do you endure such great thirst?
I opened my mouth and said,
Acquire wisdom for yourselves
without money.

Put your neck under her yoke,
and let your souls receive instruction;
it is to be found close by.

See with your own eyes that I have
labored but little
and found for myself much serenity.
Hear but a little of my instruction,
and through me you will acquire
silver and gold.

May your soul rejoice in God's mercy,
and may you never be ashamed to praise him.
Do your work in good time,
and in his own time God will
give you your reward.

SHE IS A TREE OF LIFE
TO THOSE
WHO LAY HOLD OF HER:

THOSE WHO HOLD
HER FAST
ARE
CALLED HAPPY

SIRACH CARPET PAGE

Solomon. The fragments from the garden are also mixed in to give more structure to the tree. The wisdom tree can be compared to the tree of life carpet page at the end of the Gospel of Luke, which was also based in part on textile patterns. It reminds us too of how much nature there has been in this volume: trees, birds, lilies, fish, and butterflies fluttering at the margins. Trees weave the natural world into the text, filling it with images of beauty, complexity, and fruitfulness. We leave the Wisdom Books with one final aphorism. We should hold on to wisdom as we embrace life. In holding on to wisdom we will find happiness. In these books we have taken up some of the heavy and dark issues of human existence: suffering, injustice, exile, longing, and death. In the end we are encouraged to live, to experience beauty, and always to seek God and God's partner in creation, Wisdom.

❧ *If you were going to take with you a few "words of wisdom" from these books, what would they be? How will you carry these words with you?*

PSALMS

W HEN THE REPRODUCTION VOLUME of *Psalms* was published, many people asked, "Where are the illuminations?" During discussions about how to render *Psalms*, the first and most important understanding shared by the team was that the book of Psalms is a prayer book. Throughout the centuries psalms have been sung and chanted by those in relationship with God. The psalms have been a way that people have approached God and sought deeper understanding of their relationship to the divine. As such, the desire of Donald Jackson and the Committee on Illumination and Text (CIT) was for a text that was as open as possible for use in the prayer life of those who turned to it. The intention was for the script to sing on the lips and in the hearts of those who read them. Although the psalms are full of images, the team did not want *The Saint John's Bible* to be an intermediary between the one who prays the psalms and the text itself.

INTRODUCTION

Psalms is a liturgical book used by Christians and Jews for thousands of years. The word *liturgy* comes from the Greek for "work of the people," and refers to various forms of public worship, usually structured around song and text. Judaism and Christianity share many of the same liturgical texts from the Old Testament but with different theological emphases. For example, consider Psalm 23. Christians have long layered this text with John 10:11: "I am the good shepherd. The good shepherd lays down his life for the sheep." When praying this text, the association with Jesus as the good shepherd often comes through.

Think of how the psalm resonates in light of the Israelites' wanderings in the desert and arrival in the Promised Land or their return from the Babylonian exile. In Christian liturgies, Psalm 23 has been used in funerals, with its association of "the valley of the shadow of death" and everlasting life. This Christian theology of death and resurrection is not present in other religious traditions. Psalm 23 is also used in Jewish funerals and memorial services but for its emphasis on comfort and trust in God.

The psalms were collected during the time of judges and kings, during the Babylonian exile, and after the return and rebuilding of Israel. In

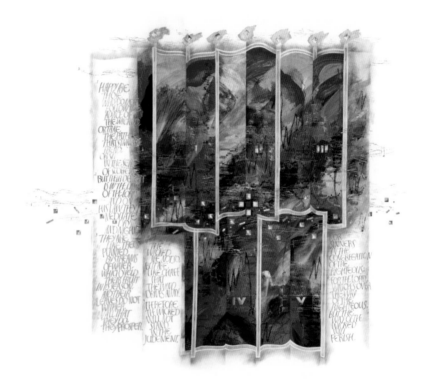

PSALMS FRONTISPIECE

THE ART OF THE SAINT JOHN'S BIBLE

addition to songs written during this period (most famously the psalms attributed to David), the book of Psalms collected even earlier songs from the time of wandering in the desert with Moses. They were organized into five books (actually scrolls), and used by the people when they gathered at the temple to remember and reaffirm their experience of God.

The organization of the book of Psalms is not random. The interpretation that guides this volume of *The Saint John's Bible* was offered by Irene Nowell, OSB, an Old Testament scholar and a member of the CIT. She asserts the psalms make up a book that is organized and tells a story—the same story told in the historical books and by the prophets of the Old Testament, the story of God's faithfulness and Israel's journey into nationhood. This time, it tells the story in song. Think about the story of Deborah and the death of Sisera in Judges 5:1-31. First the story was told in prose and then in song.

Because it is not a historical book, to tie the images in the psalms to a specific historical period would be to diminish the vitality and life of the text. According to Nowell, "In the biblical worldview, to remember is to make present." The psalms do not simply collect stories of God's faithfulness in the past. Just as they did for the people gathered to sing them at the temple, they remind us of our history with God, the covenant and call to follow God's commands today.

In the Wisdom of Solomon chapters 10–11 we had the major events of Genesis and Exodus retold and depicted in the illumination *Creation, Covenant, Shekinah, Kingdom*. It's also been driven home in the story of the good king Josiah and the prophetess Huldah and the prophet Nehemiah gathering the people into the square in Jerusalem after exile that it is important to continue to tell the stories. The book of Psalms, then, is vital to our continuing practice of making God present.

The psalms are also deeply important to the Benedictines of Saint John's Abbey and other monastic communities around the world. The Rule of Benedict goes into great detail in laying out a schedule by which the monks will recite all the psalms in a cycle. This practice of chanting psalms, along with prayers and readings, is known as the Divine Office. The monks of Saint John's Abbey follow a four-week cycle of Morning, Noon, and Evening Prayer during which they recite all one hundred fifty psalms. Yes, there are still monastic communities who recite all one hundred fifty psalms every day! At this moment, in some monastic cell or choir stall in your time zone or another halfway around the world, someone is praying the psalms.

Monastic communities that have chanted these psalms in daily prayer experience the beauty of the cycle of lament and praise, exile and return, pilgrimage and nationhood, wisdom and knowledge. The psalms are meant to be read prayerfully, slowly, and meditatively, but also liturgically—that is, in public worship. The abstract images found in the *Psalms* volume of *The Saint John's Bible* lead the mind to a greater appreciation of the complexity and grandeur of God.

The Text

The text here, as throughout *The Saint John's Bible*, is from the New Revised Standard Version (NRSV). As in the other volumes, any verses that appear in the Rule of Benedict are marked with a small black cross in the margin. There are more verses from Psalms in the Rule than from any other book in the Bible. This is not surprising given Benedict's emphasis on praying the psalms. It's text he would hope the monks had written on their hearts.

You will notice that many of the psalms include rubrics. Rubrics are instructions for how the assembly or the leaders are to carry out the liturgy. For example, the rubric at Psalm 4 reads, "To the leader: with stringed instruments," and for Psalm 5, "To the leader: for the flutes." Both are identified also as psalms written by David.

The word "Selah" is occasionally written in the right margin. The word appears seventy-one times in thirty-nine of the psalms. The origin of this word is unclear, and its meaning cannot be determined exactly. Most scholars think it is used in the Bible like "Amen." It probably comes from the Hebrew word *calah* meaning "to hang," as in to weigh something by hanging it on a scale in comparison to another item. *Calah* is translated elsewhere in the Bible as "measure," usually related to measuring something's value. Selah, then, is thought to be a call for the reader to pay special attention, to "take measure" of the passage to which it refers.

Donald Jackson and the CIT agreed that the design and text needed to reflect the five-book structure of the Psalms. Each book was assigned a color, which was used in the headings and initial caps, and for the "Amen, Amen" that closes each book. Even more significantly, each book is written in its own script. The five books of *Psalms* were split between three calligraphers: Brian Simpson for book 1 (Pss 1–41), Sally Mae Joseph for book 2 (Pss 42–72) and book 5 (Pss 107–150), with Jackson writing book 3

and book 4 (Pss 73–106) and doing the text treatment for Psalm 1 and the frontispiece illuminations.

The average reader might have difficulty seeing the differences between the scripts. However, for the calligraphers it was a welcome challenge and change. A close look reveals differences in style such as spacing, slant of the letters, and roundness. Joseph and Jackson, who did two books apiece, devised separate scripts for each book they wrote so that all five books would be unique. In the end, *Psalms* perhaps draws more attention to the art of calligraphy than any of the other volumes. Calligraphy, Donald Jackson has said, is a form "that makes you look like you really mean what you're saying." It makes the words sing—which is what the book of Psalms is all about.

ORNAMENTATION AND FRONTISPIECES

Still, *Psalms* is not without ornamentation. Because the psalms are so closely related to chant and song, Jackson started with the question, "How can we represent song in image?" The decision was made to use oscilloscopic voiceprints of the monks of Saint John's Abbey chanting at prayer. The voiceprint is represented horizontally on the page with gold bars that ground the image and tie it to musical notation. The chant of the monks flows throughout the psalm text. Look at Psalms 23–27, where the songs of David burst with gold chant.

The major illumination for *Psalms* is found on the two-page frontispiece before Psalm 1. Here you see how the five volumes, set up like open scrolls, also come together to make another menorah image in these volumes. The first illumination for the entire project was Jackson's menorah for the Genealogy of Jesus, which is the frontispiece for the book of Matthew. Second, he made the menorah family tree of Abraham and Sarah that we've already read about in Genesis. This particular menorah draws our attention again to the wholeness of the story, the shared traditions. In *Historical Books* we also saw many menorah images, as it became the symbol of the nation of Israel and its developing religious heritage, separate from the religious culture of Egypt, Canaan, and Babylon.

Additionally, the five-book structure of Psalms imitates the five books of the Pentateuch. The open scrolls were used again at the beginning of each of the five books of Psalms. Jackson layered them to create an image with one open scroll for book 1, two for book 2, three for book 3, and so

BOOK I

Psalm 2

Why do the nations conspire,
　and the peoples plot in vain?
² The kings of the earth set themselves,
　and the rulers take counsel together;
　against the LORD and his anointed, saying,
³ "Let us burst their bonds asunder,
　and cast their cords from us."

⁴ He who sits in the heavens laughs;
　the LORD has them in derision.
⁵ Then he will speak to them in his wrath,
　and terrify them in his fury, saying,
⁶ "I have set my king on Zion, my holy hill."

⁷ I will tell of the decree of the LORD:
　He said to me, "You are my son;
　today I have begotten you.
⁸ Ask of me, and I will make the nations
　your heritage,
　and the ends of the earth your possession.
⁹ You shall break them with a rod of iron,
　and dash them in pieces like
　a potter's vessel."

¹⁰ Now therefore, O kings, be wise;
　be warned, O rulers of the earth.
¹¹ Serve the LORD with fear,
　with trembling ¹² kiss his feet,
　or he will be angry, and you will perish
　in the way;
　for his wrath is quickly kindled.

Happy are all who take refuge in him.

Psalm 3

A Psalm of David,
when he fled from his son Absalom.

O LORD, how many are my foes!
　Many are rising against me;
² many are saying to me,
　"There is no help for you in God."　　　Selah

³ But you, O LORD, are a shield around me,
　my glory, and the one who lifts up my head.
⁴ I cry aloud to the LORD,
　and he answers me from his holy hill.　　Selah

⁵ I lie down and sleep;
　I wake again, for the LORD sustains me.
⁶ I am not afraid of ten thousands of people

Psalm 1

Happy are those
　who do not follow the advice of the wicked,
　or take the path that sinners tread;
　or sit in the seat of scoffers;
² but their delight is in the law of the LORD,
　and on his law they meditate day and night.
³ They are like trees
　planted by streams of water,
　which yield their fruit in its season,
　and their leaves do not wither.
In all that they do, they prosper.

⁴ The wicked are not so,
　but are like chaff that the wind drives away.
⁵ Therefore the wicked will not stand
　in the judgment,
　nor sinners in the congregation
　of the righteous;
⁶ for the LORD watches over the way
　of the righteous,
　but the way of the wicked will perish.

BOOK I: FRONTISPIECE

150　　　　　THE ART OF THE SAINT JOHN'S BIBLE

Help, O LORD, for there is no longer
 anyone who is godly;
the faithful have disappeared
 from humankind.
2 They utter lies to each other;
 with flattering lips and a double
 heart they speak.

3 May the LORD cut off all flattering
 the tongue that makes great boas

Book I Brian Simpson

The mighty one, God the LORD,
 speaks and summons the earth
 from the rising of the sun to its s
2 Out of Zion, the perfection of beal
 God shines forth.

3 Our God comes and does not keep.
 before him is a devouring fire,
 and a mighty tempest all aroun
4 He calls to the heavens above

Book II Sally Mae Joseph

On the holy mount stands the city he fi
2 the LORD loves the gates of Zion
 more than all the dwellings of Jacc
3 Glorious things are spoken of you,
 O city of God.

4 Among those who know me I mentior
 Rahab and Babylon;
 Philistia too, and Tyre, with Ethic
 This one was born there," they say.

Book III Donald Jackson

O LORD, you God of vengeance
 you God of vengeance, shine fo
2 Rise up, O judge of the earth:
 give to the proud what they de
3 O LORD, how long shall the wi
 how long shall the wicked exul

4 They pour out their arrogant wc
 all the evildoers boast.
5 They crush your people, O LORD

Book IV Donald Jackson

I was glad when they said to me,
 "Let us go to the house of the Lo
2 Our feet are standing
 within your gates, O Jerusalem.

3 Jerusalem—built as a city
 that is bound firmly together.
4 To it the tribes go up,
 the tribes of the LORD,
 as was decreed for Israel,

Book V Sally Mae Joseph

A selection of passages from the psalms, showing the work of
different scribes.
The headings for all the psalms were written by Brian Simpson.
A different color is used for each book.

on. Again, the vertical panels reflect not only the layout of the page in columns but also the fractals of the illumination *Creation*.

Another recurrent motif on these pages is the stamped gold archways inspired by the cathedral at Compostela. In this context, the archways speak to both the temple of Jerusalem where people first met to sing these songs and to contemporary places of worship. Our visions of chant tend to be very grand. When we hear the word "chant," we're most likely to think of a religious community in robes or habits singing Gregorian chant as they solemnly process down a long aisle or fill the choir stalls of a Gothic cathedral in Europe. This is the way we've seen chant represented in books, movies, and even television commercials. On high-quality recordings, professional voices in unison echo off the stone walls. The reality is that liturgical chant today does not happen in cathedrals but most often in small communities that meet regularly to intone or chant the psalms as part of their daily prayer life. The stamped archways, however, also act as symbols of the way song can usher us into the presence of God.

The Five Books

Psalms 1 and 150 stand as bookends to the collection. They are independent of the five-book structure but still thematically connected to the books in which they appear. To note their importance, they receive special treatment. The first psalm appears in its entirety in the frontispiece of the volume and is repeated at the beginning of book 1. The psalm introduces a book that is primarily laments, although all the laments end on a note of hope for the righteous.

FROM PSALM 89

THE ART OF THE SAINT JOHN'S BIBLE

Psalm 1 lays out the terms and consequences of the covenant: "Happy are those . . . [whose] delight is in the law of the LORD," and at the end, "The LORD watches over the way of the righteous, but the way of the wicked will perish" (Ps 1:1, 2, 6).

Book 2 ends with a messianic psalm (Psalm 72). Messianic psalms are part of the theology that defines Jesus as the Christ and sees him as descended from the royal line of King David. *Messiah* from Hebrew and *Christ* from Greek both mean "anointed one." In book 2, the monarchy is seen in a very positive light, although the actual monarchy of that time was a mixed bag of faithful and corrupt kings. Books 1 and 2 probably formed the original Psalter, the songbook of David's kingdom. They seem to have been written during the time David's line was in power (the tenth to sixth century B.C.E.). Most of the psalms in books 1 and 2 have notes indicating they belong in the Davidic collection. There is even a note at the end of Psalm 72: "The prayers of David son of Jesse are ended."

Books 3 and 4 probably belong to the period right before the Babylonian exile (the sixth century B.C.E.) and the time of the return from exile. Book 3 ends with another messianic psalm (Psalm 89) that begins positively with a statement of God's promise that David's dynasty will last forever but ends with the cry: "Lord, where is your steadfast love of old, which by your faithfulness you swore to David?" (Ps 89:49). The psalmist claims God's promise, even though the promise seems all but crushed by Israel's unfaithfulness.

BOOK IV: FRONTISPIECE

Psalm 150

Praise the LORD!
Praise God in his sanctuary;
praise him in his
* mighty firmament!*
Praise him for his mighty deeds;
praise him according to
* his surpassing greatness!*
Praise him with trumpet sound;
praise him with lute & harp!
Praise him with
* tambourine and dance;*
praise him with strings & pipe!
Praise him with
* clanging cymbals;*
praise him with
* loud clashing cymbals!*
Let everything that breathes
praise the LORD!
Praise the LORD!

Book 4 begins with the only psalm attributed to Moses (Psalm 90): "Lord, you have been our dwelling place in all generations" (v. 1). The people have returned to restore the faith and the nation of Israel. By the end of the book, lament has turned to praise, and the psalmist exclaims, "Praise the LORD! O give thanks to the LORD, for he is good; for his steadfast love endures forever" (106:1). The first three books ended "Amen, Amen" but the last two end with "Praise the LORD!" Book 5 is a book of thanksgiving and praise by the re-stored people of Israel. The temple is rebuilt and the promise of a dynasty is heard again. This book explodes with praise in Psalms 146–150, which reflects both the gratitude of a liberated and restored people and the tone of their liturgies in the new temple as they recom-mitted themselves to the covenant with God.

Psalm 150 has been set as a song many times. It is a glorious conclusion to the psalter. Psalm 150 was writ-ten in gold by Sally Mae Joseph. The choice of gold was related to the text treatment for the *Magnificat*, Mary's hymn of praise in the first chapter of Luke. Jackson saw a similarity between the two hymns and suggested to Joseph that she tie them together visually by using the same script and burnished gold on gesso but not putting it on a background of color. In the end, the Psalms had established themselves as text on vellum, and to background one was to remove it too dramatically from the whole.

VOICEPRINTS

The constructions that begin each of the five books of *Psalms* introduce other elements to the monk's chants. They are shaped like open scrolls although the elements, like song, float out beyond the borders. They are richly layered, as though you look deeply into them. The gold squares are characteristic of early notation for Gregorian chant, called "neumes." Squares

stacked on a four-line staff mark ascending notes, while diamonds reading left to right show descending notes. This kind of notation is still used by many monastic communities. The interplay between the vertical and horizontal reappears in the chant voiceprints that are the dominant element here.

In addition to the gold filigree voiceprints of the Benedictines, there are multicolor representations of other chant traditions made by two different computer programs that translate sound to visual prints, resembling the wave patterns on an oscilloscope in one instance and rubbings or technical data in another. The Benedictine chant of the monks of Saint John's Abbey runs horizontally, and vertically are chants from the Jewish, Native American, Taoist, Hindu Bhajan, Greek Orthodox, Muslim, and Buddhist Tantric traditions. People have commented that they look like a cardiogram—a welcome association. Music is sometimes used to calm an erratic heartbeat and is intimately tied to the rhythms of the heart, which are, of course, the rhythms of life itself.

The representations of other chants are included here below. Notice what they say about the nature of the voice or voices. The evenness of the Taoist chant is in strong contrast to the long tones followed by shifts in the Jewish and Native American chant. The close harmonies of the Greek Orthodox chant are easy to imagine.

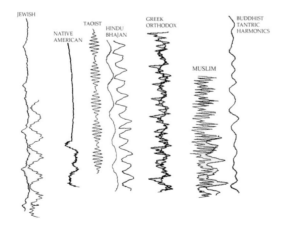

Finally, this simple presentation of the psalms inspires the reader to put his or her own images with the poetry of the text. The frontispiece includes the complete text of Psalm 1—a good example of the imagery found in the book of Psalms. Those that follow God's commands "are like trees planted by streams of water, which yield their fruit in its season" (Ps 1:3). The wicked, however, "are like chaff that the wind drives away . . . [They] will not stand in the judgment" (Ps 1:4-5). Elsewhere you will find people compared to "the grass on the housetops that withers before it grows up" and the colorful claim, "The plowers plowed on my back; they made their furrows long" (Ps 129:6, 3). The poetry brings to our mind's eye the thatched roof and the painful marks of the whip. In the final analysis, for *Psalms*, the poetry is enough. The images exist in the minds and hearts of the community that prays and sings them. The focus in this volume, therefore, is on the calligraphy, the art that is the lifeblood of *The Saint John's Bible*.

BOOK V: FRONTISPIECE

THE ART OF THE SAINT JOHN'S BIBLE

PROPHETS

INTRODUCTION

A CONTEMPORARY PICTURE of a prophet is almost always of someone standing in a city park or on a street corner, wild-eyed and marginal, proclaiming that the end of the world is near. They are there to tell us that we have one last chance but that time—and chances—are running out. We also associate prophecy with seeing the future. Prophets tell us what will happen, again usually in a negative context. We might hear the media describe scientists warning about global warming or economists predicting the collapse of an economy as "doomsday prophets." If they let loose with a particularly vehement rant, it might be called a "jeremiad," after the prophet Jeremiah's dark messages. If you page through *Prophets*, you will certainly see some dark and frightening images. However, you will also see rainbows—glorious rays of color filling up some of the illuminations. Where did those come from?

The truth is that the prophetic literature of the Old Testament is about hope as well as destruction. The prophets were not trying to cast down the people but to lift up and sustain them in a time of trouble. They were calling the people to live better, to make a perfect society, to return to right worship of God, and in times of pain and exile to realize that God was still calling them and waiting to take them back. In fact, God had a plan for them and for all nations. The hope at the center of the prophecies is the messiah, the one who would come to restore God's kingdom on earth. For Christians, these messianic prophecies point to Jesus Christ.

The basic comparison between the prophets of the Old Testament and some modern-day, self-styled prophets holds. They did bring a basic message that unless the people turned to God they would continue to face exile, collapse, and ruin. What is different, however, is that the call of the Old Testament prophets is not personal—not made to individuals accused of sin in an effort to get them to turn their lives around—but is collective. The call is for the nation of Israel to return to God in right worship and to build a society based on justice and compassion. The salvation is for the whole people, the promise of a king whose kingdom will be eternal, a Prince of Peace, Wonderful Counselor, Everlasting Father, Emmanuel. The vision is larger than the recruitment of individuals to a personal relationship with

Jesus. It is a vision of God's plan through all time: the transformation of the world.

The Old Testament prophets are primarily concerned not with the future but with the present. They live and speak during a time of great upheaval and pain. The Israelites lost the Promised Land, their kingdoms fell, and even the temple was destroyed. They were carried off in bondage and exile, their religion crushed, and their society dismantled. They looked to the prophets for answers about what had befallen them. How could this have happened to God's chosen people?

One explanation offered by the prophets is that the people had, through years of disobedience and idol worship, driven God from the sanctuary. Some prophets see the fall and exile as God's punishment for breaking the commandments, particularly the first commandment not to worship idols. In any event, the prophecies never end in judgment but always proceed to the promise of God's love and mercy and desire for Israel's return. The description of God's wrath and punishment is always followed by the promise of forgiveness and the establishment of a new and perfect kingdom.

Throughout these books, Donald Jackson mixed images from the British Museum that corresponded to the landscapes seen by the Israelites on the streets of Babylonian cities with images from our current time. In this way, Jackson is able to reflect on how the themes are still present in our world, particularly in the illuminations of the *Suffering Servant* and *Valley of Dry Bones*. He is also able to reflect the way the strange world of exile fed the visions, particularly in *Vision at the Chebar*.

When Jackson presented this volume to the Committee on Illumination and Text (CIT) at the Hill Museum & Manuscript Library at Saint John's University, he lovingly paused over pages of solid text. It is tempting to jump from illumination to illumination, as we are sometimes tempted to jump to the more entertaining or better-known passages in the Bible itself. Stopping at a set of columns on the page, however, Jackson said, "Look at the nobility there." What he saw was the calligraphy, the heart of the project and the heart of his art, the letters on the page, making words, making lines of words. It is about a steady and even hand in every sense. It is about balance and order, white spaces and inked figures.

On these pages your eye might be drawn to the shift between the lighter italic of the poetry and the solid prose text. Consider the care and attention that goes into these two forms, put on the page by different artists as they created a page.

Also consider the themes emphasized by *The Saint John's Bible*. In this volume you will see the theme of transformation again and again, in the calls to the prophets and the appeals they make to the people. You will also see the theme of justice for God's people, a strong theme for the prophets, who are speaking to a people looking for restoration and restitution. What is it God has called the people to become? If God is to return and dwell with them again, what kind of place does God require for a dwelling? What kind of people can show God to the world?

Prophets begins with what Donald Jackson has called a "reverse carpet page," because it is found at the beginning of the book instead of at the end. *Historical Books* also began with a carpet page. Here we get a rest between *Psalms* and the vastly different territory of *Prophets*. But also, if you read the opening of Isaiah, it is quite frightful. It is set before exile, during the rule of some very bad kings, and God speaks out harshly, denouncing the people and foretelling their punishment through the prophet Isaiah.

The thematic elements of the seraphs' wings and the temple path grid, introduced here, are important in the whole

volume. This pattern also appears at the end of the individual prophetic books in the volume (Amos, Haggai, Zechariah) in whatever space is available after the text. In a larger way, however, this piece opens and closes *Prophets*, enclosing it and perhaps attempting to contain it.

The image refers to a major theme in the prophetic literature. The seraph wings most obviously allude to God's messengers and more particularly to God's direct interaction with the prophets. These messages and messengers, however, are part of a larger focus in the volume on transformation. The prophets are called to dramatic service to God, and they also call on the people of Israel to change their ways and transform their society in order to renew and maintain their covenant with God. The stamps are made from a manipulated image of a wing, which Donald Jackson took from an Assyrian relief in the British museum. The grid echoes the path of Ezekiel through the vision of the temple and so reflects the journey of the prophet and of the people of Israel, a journey of exile and return as they seek out the ways of God.

Finally, above the book title and incipit for Isaiah are five lamps. The first column of text is further punctuated by three sets of five gold blocks. The gold blocks, in the opening page and throughout *The Saint John's Bible*, reveal the presence of God. They are sometimes placed randomly, as on the previous page, to suggest that God is present throughout the world of human action. At other times these blocks (and sometimes bars) are used to draw together and make more orderly the other, more chaotic elements of an illumination. In the first column of text in Isaiah the lamps and squares add a sense of royalty, an elevated nobility. Several of the prophetic visions describe God on a throne, represented in the illuminations as a larger block of gold. The image of God as king was important to Israel during this time of siege and collapse. This opening of the prophetic books is a reflection of what lies within—transformation, journey, and also the unfolding of the story of God as king—and what lies ahead—God as messiah and savior.

Make Yourselves
Clean and
He Shall Judge
Between the Nations

ISAIAH 1:16-17 / ISAIAH 2:4

*They shall beat their swords
into plowshares. (2:4)*

Justice for God's people, and the importance of creating a just society, is one of the three major themes emphasized in *The Saint John's Bible*. It appears here in two text treatments for Isaiah 1 and 2 by Sally Mae Joseph. Again, it is important that we pay attention to the words of the prophets and the portrait they paint of a hopeful future. The call is to "seek justice" and work on behalf of the oppressed and vulnerable. The words of Isaiah 2:4 have been repeated as a slogan and, in fact, engraved on monuments for peace throughout the ages. The great African American spiritual "Down by the Riverside" used this verse in its jubilant refrain: "Ain't gonna study war no more." This verse was picked up by the peace movement of the 1960s and '70s and is sung today by scouts around the campfire.

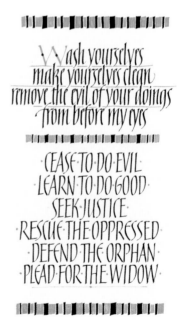

ISAIAH 1:16-17

THE ART OF THE SAINT JOHN'S BIBLE

Turning swords of war into plowshares for growing food is a powerful image. It is so central that it is repeated again in Micah 4:3. The vision of God's perfect kingdom is, first of all, one where there is no war. As set down in the opening of the Bible, the creation in Genesis, God's vision is for fruitfulness, for growth and renewal and peace. Interestingly, both these text treatments use the word "Learn": "Learn to do good," and then "Neither shall they learn war any more." In the fallen world, living up to God's purpose is hard work, and it is a process. We have to study and learn it, consciously turning our attention to it.

He shall judge
between the nations
and shall arbitrate
for many peoples
they shall beat their
swords into plowshares
and their spears
into pruning hooks

NATION·SHALL·NOT·LIFT·UP·
SWORD·AGAINST·NATION·
NEITHER·SHALL·THEY·
LEARN·WAR·ANY·MORE·

ISAIAH 2:4

I saw the Lord sitting on a throne, high and lofty; and the hem of his robe filled the temple. (6:1)

What elements of Isaiah's vision do you see in the illumination?

The book of Isaiah begins with a series of prophetic messages. God speaks first. In the poetry we hear God's sorrow and disappointment, frustration and anger at the people. We hear the call to return, to follow and learn the ways of God, and we hear the promise of God's glory. It is not until chapter 6 that the book backs up and gives us the story of the call of Isaiah—the subject of the first major illumination.

The call of Isaiah is a royal and frightening vision. It frightens him because, as he says, he is unclean and living among unclean people. He recognizes that the people of Israel have not lived up to God's desires for them. He also surely knows the part of the Torah that says no one can see God directly and live. As a Jew in this period he would be concerned with purification and holiness—only the priests who had a certain level of ritual purity could approach God in the temple, and only the high priest could enter the holy of holies where the presence of the Lord dwelled in the ark. For God to appear to him surrounded by seraphim would be for the very essence of holiness to mix with the impure—a dangerous combination in the Old Testament. However, one of the seraphim comes to him with a burning ember and purifies his lips. He will not just see God; he will carry God's message to the people.

The figure of Isaiah is sprawled across the bottom of the center panel. He is naked, vulnerable, *human*, and yet also seems held by seraph wings. You can see the red ember held to his mouth by long gold tongs, also extending from a seraph's wing. This is the only mention of seraphim in the Old Testament, although some scholars have linked them to the fiery serpents in the book of Numbers. Their name comes from the Hebrew word for fire, and because of this passage in Isaiah, Christianity associates them with the fire and light of both purification and God's glory.

To make this image, Donald Jackson first went in search of images of wings from the time of the Babylonian exile.

These wings come from images found on Assyrian reliefs at the British Museum. Jackson wanted to find images for all the strange visions of the prophets that might reflect the imagery of the world they lived in. As our dreams are often made of the stuff we see around us in our waking life, Jackson believed the prophetic visions were informed by the images—strange to us but common to them—adorning the temples and public buildings of the Assyrian and Babylonian world of the exile. Once he found the images of wings from the period, Jackson manipulated them on the computer until they had the twisted, active shapes he wanted. He converted these to stamps that are used throughout the volume.

It is also said that the seraphim are "in attendance" on the king (6:2). Ultimately, the core of this image is the figure of God as king. The image consists of three arches and is further framed by ten lamp stands. The smoking lamps add to the atmospheric interior, perhaps suggesting the smell of burning oil or sacrificial incense. Fragments of a palace wall run through it. Purple, for royalty, is the dominant color of the piece. The red cloth pieces are the hems of the garment that Isaiah sees filling the temple. Temple and royal court are thus combined in this vision. The throne itself is a box of gold framing a human figure's head and shoulders. It is similar to a piece of the shaft of gold we will see in the frontispiece for the Gospel of Luke, *Birth of Christ*, where the image of God is a gold shaft emanating from a stylized, throne-like manger. In fact, this vision and Luke's account of Jesus' birth have much in common, with angels and purification and revelation—the in-breaking of the divine into the world.

Also introduced in this piece are blocks of rainbow colors. This motif will run throughout the book, joining gold as a sign of divine presence. The image comes from Ezekiel 1:28, where Ezekiel says: "Like the bow in a cloud on a rainy day, such was the appearance of the splendor all around. This was the appearance of the likeness of the glory of the LORD." Again, it is the glory that is emphasized. Of course, rainbows always connect us with the Genesis account of Noah and God's first covenant not to destroy the people. The ongoing nature of this

promise is ever more important as the people find themselves under siege, overthrown, and marched off to exile, their cities and even the temple destroyed.

It is from this passage that we get the "Holy, Holy" song of the angels. This hymn, sung by most Christian denominations during their eucharistic prayer, is also called the *Sanctus*, the Latin word for "Holy." It is one of the earliest pieces of Christian liturgy, appearing throughout the Christian world in the late third and early fourth centuries. In the illumination you

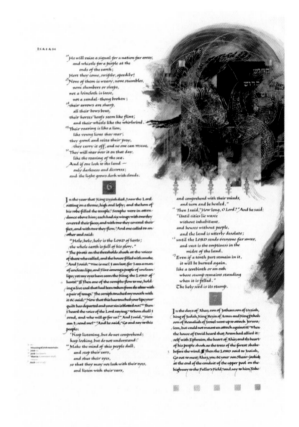

VISION OF ISAIAH

will see it three times in three languages: Hebrew at the top left, Greek in the center, and Latin at the right.

This actually represents yet another major theme in *The Saint John's Bible*: attention to Christian prayer and worship. Because this is a Bible commissioned by a community of Benedictine monks, the parts of Scripture that surface in the liturgy get special attention. The *Sanctus* makes an early connection by Christians back to Old Testament texts, and, in fact, Isaiah is quoted more often in the New Testament than any other book

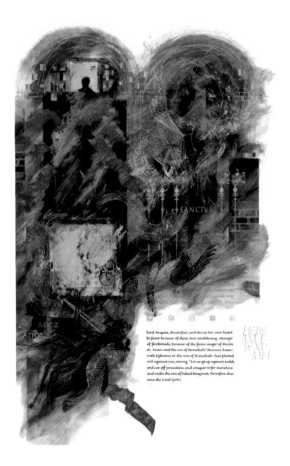

but Psalms. Christians looked to the prophets for answers to what was happening in their own time. For this reason you will see illuminations for many passages that foretell the coming of a messiah whom Christians identify as Jesus.

Finally, in the margin we see Isaiah's response to God's call. After the seraph has cleansed his lips with the burning ember, he answers: "Here am I: Send me!" When he leaves this temple it will be as God's prophet with a message for the people, who also need to be cleansed and made holy.

◖ *As you consider Isaiah's vision, reread the opening chapters of the Gospel of Luke. What similarities do you see?*

What do the names in this illumination tell us about the Messiah?

This full-page illumination is by Thomas Ingmire, whose work we have discussed at length. This illumination can be compared with his contributions *Ten Commandments* (Exod 20), *Beatitudes* (Matt 5:3-12), and *I AM Sayings* (John 6–15). We made reference to this illumination when discussing his dramatic treatments at the end of Job, where God's curses come out of the base on ribbons of text.

The passage in Isaiah is familiar to many people from Handel's great work, *The Messiah*. Sung often at Christmas, it is crowned by the great Hallelujah chorus. This illumination is likewise crowned with Hallelujahs! You can almost see the trumpets raised and blasting with the announcement. Also here are echoes of the rainbow motif, not in color but in shape. The names of God are written on the bows: "Prince of Peace," "King of Kings," "Everlasting Father," "Immanuel," and the announcement: "For unto us a child is born" and "God is with us."

In addition to the bows and the words of this piece, there is the intricate geometric gold stamp we have seen in many other illuminations. It sparkles and shines here like the stars or the sun or even bursts of fireworks. This is truly an illumination of celebration.

The image of a birth foretold is indeed a glorious one. If you read the whole of chapters 8–11 you will see that they primarily foretell the destruction of the disobedient and unfaithful people. But these dark predictions are balanced by hope. Again, the prophet's messages contain the promise of God's ultimate plan for the people, one of reconciliation, of communion with God, and not of abandonment and destruction. And it is a message for all the nations, as seen in chapter 11, not just the remnant of Israel. Every Christmas season Christians celebrate with the same sense of wonder and anticipation of God's promises.

Messianic Predictions

ISAIAH 9:2-7; 11:1-16

For a child has been born for us. (9:6)

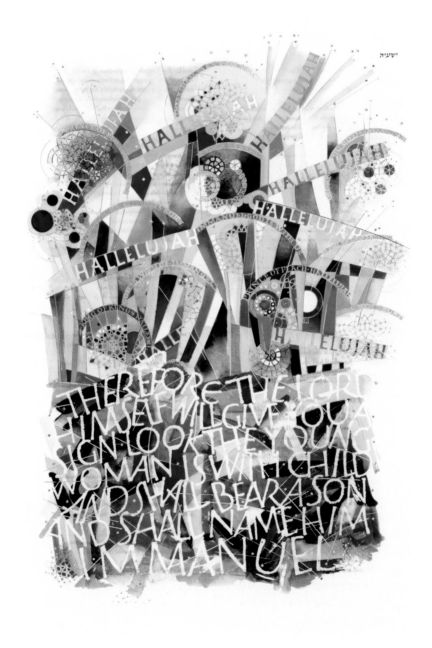

MESSIANIC PREDICTIONS

THE ART OF THE SAINT JOHN'S BIBLE

Donald Jackson has said of this page, "it is truly a living thing." In its original the inks and gold leaf do seem to make the letters dance. Everything stands out clearly and distinctly, and the page has depth and, well, movement. Especially wonderful is to think of turning to it in a book, watching the words lift and rise, then fold out of sight.

❧ *How does it affect your reading of the books of the prophets if you put them in a liturgical context? How do they work as part of a performance of the story of God and God's people?*

SCARAB

At Isaiah 30 we encounter the first of five insect illustrations by Chris Tomlin for the margins of *Prophets*. Over the course of writing *The Saint John's Bible*, this was the first volume where Tomlin used less-than-desirable creatures from the natural world. Now we encounter them after seeing all the warring insects in *Historical Books*, but at the time of *Prophets'* release, it was a surprise after the beautiful butterflies and flowers of earlier volumes to see less-celebrated insects take center stage.

The first is a scarab, a very important insect in antiquity. In ancient Egypt the scarab was as symbolically sacred as the cross is to Christians. Scarabs permeated the culture, as amulets and ornaments and as seals. Made out of clay, a scarab would be inscribed on the flat or abdomen side with names, mottos, or other patterns, and glazed in dark blues and greens. There is clear evidence that the scarab spread beyond Egypt's borders, and many have been found in Palestine, the Near East, Spain, Italy, Greece, and elsewhere.

Often the images in the margins are purely for decoration, but in this case it does amplify the text of Isaiah 30:1-5. These verses scold the Israelites for going to seek shelter from their enemies in Egypt instead of trusting God to deliver them. Any association with Egypt, given that the primary story of the people of Israel is their deliverance from Egypt under Moses and Aaron, is a grave turning away from God. The close ties gained from living for generations in Egypt, albeit under slavery, must have remained a great temptation for the people. After all, in the wilderness they spent a lot of time grumbling that things were better in Egypt, where at least there were resources.

The major claim against the Israelites is that they turned and worshiped other gods. To turn to the amulets of Egypt for protection, instead of to God, would indeed, as the passage reads, become their shame and disgrace (Isa 30:3, 5). The scarab was used as a seal in much the same way as we use rubber stamps today to impress something with an image. This is another resonance with the work of Donald Jackson, who has very frequently employed stamps in the illuminations of *The Saint John's Bible*.

In the margins at Jeremiah 17 we find an illustration of two black crickets. These field crickets are plentiful in Minnesota, the home of Saint John's Abbey. They are also closely related to the more voracious and mobile locusts we read about in the Old Testament, particularly in connection with plagues. Locusts are found not only in the plagues against Egypt in Exodus but also in many of the prophets including Isaiah, here in Jeremiah, and in Joel, Amos, and Nahum. At Jeremiah 35 is another loud insect that can be heard in central Minnesota, where the whine of the cicada is a sign of summer.

The final insect in the margins by Chris Tomlin is found at Ezekiel 22. This insect has particular resonance for Saint John's Abbey and Minnesota. It is the dreaded black fly! Although mostly just a nuisance, black flies are related to mosquitoes, and the females get their sustenance from blood. The bite of a black fly is more painful than a mosquito's and brings up an alarming welt. In the northern regions, particularly in the lakes and woods close to the Canadian border, the swarms of black flies can be intense and, indeed, plague-like. The lakes of Minnesota and Canada are a perfect breeding ground for the noxious insect.

TWO FIELD CRICKETS

A text treatment of Isaiah 40:1-5 complements the text treatments at the opening of the book of Isaiah and extends the messianic nature of Isaiah's prophecies. Isaiah 40 marks a major shift in the book of Isaiah. The rest of the book is called "Second Isaiah" because it was written long after Isaiah 1–39 by a separate author. There are references showing that the exile is officially over and the people are able to return from Babylon. The end of exile and return to Jerusalem is, in fact, heralded like a new Exodus—God delivering the people from bondage. This word of comfort lets the people know that their suffering is at an end and also urges them to participate in the return. It is an announcement of the beginning of a new age for Israel, a call to return and to build God's kingdom of justice and right worship in Jerusalem. Putting it together with the accounts of *Historical Books*, this verse could be the song sung by Nehemiah and the people entering Jerusalem. For reference, take a look back at Nehemiah 8:1-12 and the illumination *Square before the Watergate* by Hazel Dolby.

The "one who cries out in the wilderness" is identified by Christians as John the Baptist. Isaiah 40:3 is quoted in each of the four gospels to introduce John (Matt 3:1, Mark 1:3, Luke 3:4-6, and John 1:23). In Matthew 17:13 the correspondence is deepened when Jesus tells the disciples that Elijah has already returned to prepare the way, and they know he is talking about John the Baptist. The message the Baptist brings is the beginning of the reign of God, the transformation of society according to God's plan.

A second text treatment, Isaiah 49:1-4, *Listen to Me, O Coastlands*, draws attention to the universalism so evident in Isaiah. The prophet is calling to those nations and peoples outside Israel. He is proclaiming a vision of God's kingdom on earth that includes the Gentiles—another important theme to early Christian communities. This reading is also associated with John the Baptist. It is from the first reading during the Liturgy of the Word for the feast of Saint John the Baptist, June 24. As the patron saint of Saint John's Abbey and the abbey's church, John the Baptist is celebrated particularly by the monks. The verse also resonates with the Rule of Benedict, whose first

word is "Listen." Texts that call us to listen are important to Benedictines.

The ink used for this treatment and others in *Prophets* came from a family firm in Japan. You will notice the variation in the color here, another way that the materials often affect the result of the calligraphy.

Comfort · O comfort my people,
says your God
Speak tenderly to Jerusalem
and cry to her
that she has served her term
that her penalty is paid
that she has received
from the LORD's hand
double for all her sins

· ◎ ·

A voice cries out ·
In the wilderness
prepare the way of the LORD
make straight in the desert ·
a highway for our God
· Every valley shall be lifted up
and every mountain & hill
be made low
the uneven ground
shall become level
and the rough places a plain
· Then the glory of the LORD
shall be revealed
and all people shall see it together
for the mouth of
the LORD has spoken

Listen · to · me
O · coastlands,
pay attention · you peoples
from far away! the LORD
called me before I was born
while I was in my
mother's womb he named me
He made my mouth like
a sharp sword, in the shadow
of his hand he hid me he
made me a polished arrow
In his quiver he hid
me away · And he said
to me · you are my servant ·
Israel, in whom I will be
glorified · But I said I have
labored in vain I have
spent my strength
for nothing and vanity
yet surely my cause is
with the LORD and my
reward with my God

ISAIAH 40:1-5

ISAIAH 49:1-4

ISAIAH 52–53

Surely he has borne our iniquities and carried our diseases. (53:4)

What does this illumination have to say about human suffering and its relationship to God?

One of the more alarming illuminations in *The Saint John's Bible* is *Suffering Servant*. The passage is important to both Jews and Christians. In the Jewish tradition, the Suffering Servant is often identified with the people Israel, the prophet himself, or someone who fits the context of the time the book was written. The portrayal of the Suffering Servant is significant because it shows a positive purpose for suffering. This is contrary to the biblical tradition that sees suffering as punishment, as we saw espoused by Job's friends and in that first chapter of Proverbs.

Christians, of course, see the Suffering Servant as a vision of Christ, whose redemptive suffering is central to the Christian faith. Particularly following the *Messianic Predictions*, it is jarring to be brought back into the world of death and human suffering by this passage. These two illuminations together, however, bring out the true nature of Christ. Though he was God, he became one of us. Though he was the king of kings, he identified with us completely in our suffering.

This meditation on human suffering brings together many types of pain and oppression in the world today. There is the chain-link fence familiar from refugee camps and wartime prisons, familiar to anyone who has been separated and barred from entry. This image was taken from pictures of the fence around Guantanamo Bay, Cuba. Closer to the figure the confinement is still more oppressive, suggestive of prison bars. It even suggests the narrow bars of the Door of No Return at Elmina Castle in Ghana, the passage through which Africans were taken onto ships, bound for slavery in the New World. This association is also echoed by the figure itself. Drawn from images of starving children, victims of the African famines, it is a familiar portrait of suffering and one that never ceases to move us. Oppression, injustice, neglect, war, and poverty are indeed the result of our iniquity. Here stands a figure who is vulnerable and yet able to redeem us.

At the base of the illumination is a lamb on a field of red and purple. As the biblical passage reminds us, this is the story of our sacrificial lamb, the one "like a lamb that is led to the

slaughter." Like this text in Isaiah, the crucifixion accounts in the four gospels draw attention to the silence of Jesus as he is led from his arrest and before his accusers. Above the figure is a cross, also constructed of bars, but this time bars of light. The distance between the Suffering Servant and the cross of gold is traversed by red and purple, again the colors of blood sacrifice but also of royal promise.

◀ *Are we able to see in this Suffering Servant an image of Christ? What does it mean to our imagination and store of images to see Christ the Redeemer in this image?*

SUFFERING SERVANT

Turn the page from the *Suffering Servant*, and you will see a highlighted text, Isaiah 55:1-3. The CIT asked Donald Jackson if he could find a way to draw attention to this text, visually highlight it in some way. In the end, Jackson decided it should be simply underlined, as a way to draw the eye but also in a way that "annotates" the text as many people annotate important texts. Many read the Bible with a pen in hand, and even a notebook. It is almost impossible to read the text without being moved or wanting to preserve some piece of it in your mind and heart. For centuries, readers have left their mark on books by writing notes in the margin or simply underlining passages they want to return to.

This passage is particularly soothing after a contemplation of the *Suffering Servant* illumination. "Ho, everyone who thirsts, come to the waters; and you that have no money, come, buy and eat!" (55:1). Again, there are parallels to the Gospel of John's portrayal of Jesus as the living water and to the eucharistic meal. However, on an even more basic level, this is a call for everyone who is suffering to come and be satisfied. Again it draws attention to God's concern for the poor and suffering and God's desire to meet these needs. This annotation also draws our attention to another important word—"listen." With this slight nod to the Rule of Benedict and acknowledgment that the pages of poetry here are constantly shifting and full of promise, we hear again the command to pay attention to the word of God, to "listen to God and live."

Ho, everyone who thirsts,
 come to the waters;
and you that have no money,
 come, buy and eat!
Come, buy wine and milk
 without money and without price.
2 Why do you spend your money for
 that which is not bread,
 and your labor for that which does not satisfy?
Listen carefully to me, and eat what is good,

This text treatment by Sally Mae Joseph seems to complete the cycle from birth through suffering to resurrection. It is another messianic prediction, declaring that the light of the world will come to all peoples. In addition to the text itself, these two pages are strewn with small gold points of divine light, encouraging us to read all the good news in chapters 60–62. The red chapter heads also link the chapters and further tie them to the color of the text treatment. In the beginning was light, and light has been a constant throughout the Scriptures. The continuing work of creation is celebrated in the renewing light of this passage.

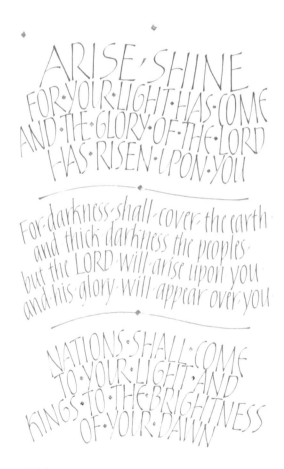

ISAIAH 60:1-3

Chapter 61 begins with another well-known verse: "[The Lord] has sent me to bring good news to the oppressed, to bind up the brokenhearted, to proclaim liberty to the captives, and release to the prisoners" (61:1). Liberation from exile is another opportunity to be made anew, to create the kingdom God has had in mind from the beginning.

Gold leaf, at the center of illumination, reflects light throughout *The Saint John's Bible*. The light shines in the frontispiece of Luke's gospel, where the birth of the Savior is portrayed as a shaft of gold light that illuminates the human observers. We saw this divine light also in Wisdom Books, where wisdom reflects God's glory as in a mirror.

Chapter 62 repeats the theme of light: "For Zion's sake I will not keep silent, and for Jerusalem's sake I will not rest, until her vindication shines out like the dawn, and her salvation like a burning torch" (62:1). This light is apparent in the haloes behind the heads of the disciples in Acts 5, the illumination of the early Christian community. God continuously brings light into the world and invites us to shine.

THE ART OF THE SAINT JOHN'S BIBLE

This text treatment by Thomas Ingmire has more in common with the text treatments in *Wisdom Books* than the others in *Prophets*. The text speaks of Jerusalem as a woman: "I will extend prosperity to her like a river, and the wealth of the nations like an overflowing stream; and you shall nurse and be carried on her arm, and dandled on her knees." However, the verse shifts here, and suddenly not Jerusalem but God is compared to a mother: "As a mother comforts her child, so I will comfort you; you shall be comforted in Jerusalem."

It is a complex analogy and uplifting in the extreme to the people in exile: Jerusalem will once again be a comfort and source of nurture to her people. She will be the place where the people will be nurtured and comforted by Mother God. This feminine nature of God is explored in more depth in *Wisdom Books*, where Wisdom becomes the archetypal image of the feminine presence of the divine, but this female vision will ultimately culminate with *Woman and the Dragon* in the book of Revelation.

ISAIAH 66:12-13

*I appointed you a prophet to
the nations. (1:5c)*

How does the call of Jeremiah differ from the call of Isaiah?

There are some key differences between the account of Jeremiah's calling and Isaiah's vision. The encounter here more closely resembles the relationship between parent and child. The Lord speaks directly to Jeremiah, beginning not with a command but with a statement of love and creation: "Before I formed you in the womb I knew you, and before you were born I consecrated you." Isaiah also expresses this conviction, and it is a source of comfort as well as authority. Jeremiah has been lovingly created and chosen by God.

Like Isaiah, Jeremiah responds by speaking of his own unworthiness. How can he speak for God when he is only a boy, even a specially chosen son of God? Again, God is gentle with Jeremiah. Like a parent speaking to a child, God says: "Do not say, 'I am only a boy,'" and then "Do not be afraid of them, for I am with you to deliver you." Finally, God touches Jeremiah, putting his words directly into Jeremiah's mouth. In contrast to the vision of fiery seraphim with embers, God touches Jeremiah. Rather than burning his mouth with an ember, this touch seems to us readers reassuring and nurturing. God proceeds to teach Jeremiah how to prophesy like a father with a child, again beginning with a question: "Jeremiah, what do you see?" The scene has the gentleness of the call of Samuel back in 1 Kings.

This is a strange start for the kind of prophet Jeremiah will become. The word "jeremiad" has come down through the language from this prophet because of his fiery laments. A jeremiad is a doomsday prediction or excessive outpouring of grief and anger. The message that comes out of Jeremiah's mouth will be one of fiery destruction.

He will also, here and in the short book of Lamentations that follows, give expression to Israel's complaints, even against God, as they pour out their own grief and frustration to God over their suffering and feelings of abandonment. Similar poems called laments are also found in Psalms. Always Jeremiah's predictions are tempered by God's promise that if the

The words of Jeremiah son of Hilkiah, of the priests who were in Anathoth in the land of Benjamin, to whom the word of the LORD came in the days of King Josiah son of Amon of Judah, in the thirteenth year of his reign. It came also in the days of King Jehoiakim son of Josiah of Judah, and until the end of the eleventh year of King Zedekiah son of Josiah of Judah, until the captivity of Jerusalem in the fifth month. ¶ Now the word of the LORD came to me saying,

"Before I formed you in the womb I knew you,
and before you were born I consecrated you;
I appointed you a prophet to the nations."

Then I said, "Ah, Lord God! Truly I do not know how to speak, for I am only a boy." But the LORD said to me,

"Do not say, 'I am only a boy';
for you shall go to all to whom I send you,
and you shall speak whatever I command you.
Do not be afraid of them,
for I am with you to deliver you,
says the LORD."

Then the LORD put out his hand and touched my mouth; and the LORD said to me,

"Now I have put my words in your mouth.
See, today I appoint you over nations
and over kingdoms,
to pluck up and to pull down,
to destroy and to overthrow,
to build and to plant."

The word of the LORD came to me, saying, "Jeremiah, what do you see?" And I said, "I see a branch of an almond tree." Then the LORD said to me, "You have seen well, for I am watching over my word to perform it." The word of the LORD came to me a second time, saying, "What do you see?" And I said, "I see a boiling pot, tilted away from the north." ¶ Then the LORD said to me: Out of the north disaster shall break out on all the inhabitants of the land. For now I am calling all the tribes of the kingdoms of the north, says the LORD; and they shall come and all of them shall set their thrones at the entrance of the gates of Jerusalem, against all its surrounding walls and against all the cities of Judah. And I will utter my judgments against them, for all their wickedness in forsaking me; they have made offerings to other gods, and worshiped the works of their own hands. But you, gird up your loins; stand up and tell them everything that I command you. Do not break down before them, or I will break you before them. And I for my part have made you today a fortified city, an iron pillar, and a bronze wall, against the whole land—against the kings of Judah, its princes, its priests, and the people of the land. They will fight against you; but they shall not prevail against you, for I am with you, says the LORD, to deliver you.

The word of the LORD came to me, saying: Go and proclaim in the hearing of Jerusalem, Thus says the LORD:
I remember the devotion of your youth,
your love as a bride,
how you followed me in the wilderness,
in a land not sown.
Israel was holy to the LORD,
the first fruits of his harvest.
All who ate of it were held guilty;
disaster came upon them,
says the LORD.

¶ Hear the word of the LORD, O house of Jacob, and all the families of the house of Israel. Thus says the LORD:
What wrong did your ancestors find in me
that they went far from me,
and went after worthless things, and became
worthless themselves?
They did not say, "Where is the LORD
who brought us up from the land of Egypt,
who led us in the wilderness,
in a land of deserts and pits,
in a land of drought and deep darkness,
in a land that no one passes through,
where no one lives?"
I brought you into a plentiful land
to eat its fruits and its good things.
But when you entered you defiled my land,
and made my heritage an abomination.
The priests did not say, "Where is the LORD?"
Those who handle the law did not know me;
the rulers transgressed against me;
the prophets prophesied by Baal,
and went after things that do not profit.

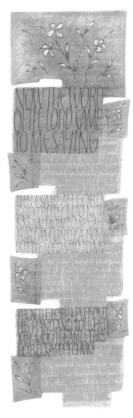

JEREMIAH FRONTISPIECE

people return to worship, change their ways, and follow God, they will be redeemed and the covenant restored. However, Jeremiah's work as a prophet will be hard and unfruitful. God tells him at the very outset that he will speak but no one will listen. Maybe this is why God is so gentle with Jeremiah, promising him that he has been with him before he was born and is there with him like a parent with a child.

◖ *If God were to speak to you, what would God say? Have you ever felt comforted, strengthened, or given courage through prayer?*

Turning to the opening of Jeremiah, you might or might not be struck by the complexity of the page. One of the biggest challenges of *Prophets* for the team in Wales was the constant shifting between prose and poetry. These pages certainly demonstrate that challenge. In fact, one of the first decisions about the style of the book was not to use elaborate capitals at the beginning of each chapter. The capitals had been a hallmark of *Pentateuch* and *Gospels and Acts*, written before *Prophets*, but they wouldn't work here. The primary reason was the number of chapters that begin with poetry. The poetry is in a different, lighter script closer to italic and also needs to be spaced carefully to meet the standards for use of the New Revised Standard Version. Instead of elaborate initial capitals, Donald Jackson decided the focus would be on the chapter numbers; there are 219 colored boxes with gold numerals in this volume.

On the two-page spread that ends the book of Isaiah and opens the book of Jeremiah, you are looking at the work of seven artists. Donald Jackson did the book title for Jeremiah as he did the book titles for all the other prophetic books. The challenge was to manage the scale of the boxes and text so that one that held the name of Jeremiah and Zechariah looked consistent with the shorter names of Joel, Amos, and Hosea. The Hebrew name of the book, "Isaiah" in the left-hand margin, and "Jeremiah" above the book title, were done by Izzy Pludwinski, who did all the Hebrew lettering. Sue Hufton, meanwhile, did the English text for all the running heads. Sally Mae Joseph did the text treatment of the call of Jeremiah, and also the italic text, in other words the lighter-weight poetry on the two pages. She was working in spaces left on the ruled page by Susan Leiper, who was the scribe for the heavier prose text of the passage. Finally, Brian Simpson wrote the capital in gold in the blue box for chapter 2 when he went through and added all the chapter numbers. Of course, no artist could approach the pages before the hide had been scrutched and sanded, dried and prepared. Once the skin was ready, Sarah Harris, who was then the studio assistant but later the studio manager, carefully ruled it with lines that are scarcely visible even on the vellum.

A book like *Prophets*, with pages of poetry and also the columns of justified prose text, presented specific challenges to the scribes. The texts had to be written and spaced on the page carefully. In italics, you can more often see the variation in the text from scribe to scribe, as the descenders and ascenders are more pronounced.

The tiny italic and formal script used for marginal notes was also very technically demanding, especially since these notes have to be readable even in the reduced size of the

ISAIAH 22:1–23:6

reproduction books. The notes were generally done by the scribe who wrote the majority of the text on each page.

Something that seems as simple as the chapter numbers was also a challenge for the Wales team. One difficulty is laying down a block of color. The paints and ink have to be fairly dry because if they are too wet on the page the vellum may pucker at that spot. Also, what colors should they be? For the 219 colored boxes in this volume, Donald Jackson, Sally Mae Joseph, and Brian Simpson made a sort of game of it. They took turns choosing colors from a selection pinned on a board and assigned them to a number. This way the colors would be somewhat randomly chosen but also complement the other colors on the pages where they appeared.

Another quirk of the page numbers is the sizing. Despite computerized layouts of each page, they realized there was not enough space for large chapter numbers on each page. You'll notice there are two sizes of chapter headings. For example, look at Isaiah 20–23. The chapter numbers are significantly smaller than those on the following page (chs. 24–26).

What pieces of Ezekiel's vision can you identify in the illumination?

No matter how you view it, Ezekiel was an eccentric character. He acted out versions of the prophecy he was given for the people. He ate dung, lay on one side and then the other for years, and did not mourn for his wife when she died—all at God's direction. Readers wonder if Ezekiel's wild use of metaphors and images came from his own idiosyncratic imagination or from the disorientation he felt as an Israelite in exile.

For the illumination of Ezekiel's first vision, Donald Jackson returned to the British Museum and to artifacts from

EZEKIEL 1:1–3:27

As I was among the exiles by the river Chebar, the heavens were opened, and I saw visions of God. (1:1)

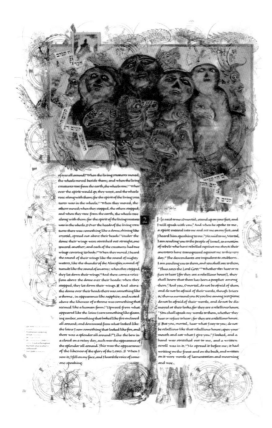

VISION AT THE CHEBAR

the world of the Babylonian exile. His thinking about these visions was that they were probably made up of the kind of images the prophets and other exiles regularly saw in the temples and courts of the Babylonian Empire. He wanted to find images of figures and architectural details that might have fed the fearsome visions of the exiles.

When Spanish conquistadors arrived in Latin America they often sent back outlandish "visionary" accounts of what they saw. What we would take for granted now as merely exotic birds and wildlife were so strange to their European eyes that they could not make sense of what they saw. As conquerors selling a vision of the New World, the Spanish explorers' accounts often described great wealth and luxury they hoped to make their own. The experience of an oppressed exile like Ezekiel might put the strange images in a very different context!

In Ezekiel's description of this vision, he repeatedly says he saw "something like . . ." Built into his account is the fact that words can only approximate what he saw. When he describes the throne and rainbow of God's presence, he says, "This was the appearance of the likeness of the glory of the Lord" (Ezek 1:28b). It is the glory of God seen through the lens of "likeness" and "appearance," never directly.

The elements of the vision are incorporated into the illumination, but there is no attempt to render a picture of what Ezekiel says he saw. In some ways the vision of four beasts with four heads, wings all around, and wheeled feet moving in any and all directions is too absurd to be drawn realistically. Donald Jackson was struck by the description of noise in the passage: "I heard the sound of their wings like the sound of mighty waters, like the thunder of the Almighty, a sound of tumult like the sound of an army" (1:24). Even this short piece of a verse is packed with three similes: roaring water, thunder, and an army. The effect Donald Jackson wanted to convey was of the sound of the overwhelmingly strange and somewhat frightening vision that surrounded the exiles' camp.

There are three main elements in this illumination: the messengers, the wheels, and God's throne. The first are God's messengers. According to Jackson there are enough pieces

here—heads, legs, bodies—to make four complete creatures. The four heads for each have become important symbols in the Christian tradition. The human, lion, ox, and eagle are often used to represent the four evangelists: Matthew (human), Mark (lion), Luke (ox), and John (eagle).

The gloomy, spooky heads with yellow eyes usually strike people first. These figures are based on a low relief portrait on a ceramic lid of a casket made, it is said, under Greek influence. These burial masks certainly have an otherworldly feel. The eagle, ox, and lion heads likewise come from images out of the period and region of Babylonian exile.

At the top left is the image of the figure on the throne, with fragments of sapphires and rainbows. This passage is the source of the image of the rainbow for God's glory, and the rainbow continues at the bottom of the image and reappears on the next page where Ezekiel sits eating the scroll. On both sides of the scroll (both in the illumination and in this marginal piece) are printed the words "lamentation," "mourning," and "woe" (see Ezek 2:10). Still, when Ezekiel eats the scroll he says: "in my mouth it was as sweet as honey" (3:3).

The wheeled chariot throne is one of the famous images from Ezekiel. He describes the wheels as a wheel within a wheel. These wheels were based on Assyrian relief carvings. You will notice that the sides of the wheels actually have eyes as described in the vision. However, Donald Jackson said a scholar at one of the exhibitions told him something interesting about those eyes. The scholar claimed that "eyes" was a mis-translation of a word that would otherwise mean bronze studs. The studs prevented wear to the rims, like tires. Going back to the source image, Donald saw that in fact the chariot wheel from the period did seem to have metal studs along the rim. Although he kept the more traditional image from the vision of wheels with eyes, it is certain that the actual wheels would have made quite a clatter as they passed through the streets, one source of the noise that probably frightened the exiles.

How does this image compare to Isaiah's call? How to Jeremiah's?

VISION AT THE CHEBAR

EZEKIEL 37:1-14

Prophesy to these bones, and say to them: O dry bones, hear the word of the LORD. (37:4)

What unusual images do you see in this valley? In what way are they comparable to "dry bones"?

This two-page illumination again draws on the contrasts between destruction and promise in Old Testament prophetic visions. In this case it is an image of the promise of new life to be breathed into the dry bones of a destroyed society. In Ezekiel 37, God takes Ezekiel to stand in a valley of bones and tells him, "these bones are the whole house of Israel" (37:11). The vision is of a dead people, a wasteland filled with the bones of the victims of many invasions. The people are not just physically dead; the entire society is spiritually dead and "dry," having turned from God. The montage along the bottom of the page points to the destruction of war, a contemporary valley of bones more like a trash heap, the detritus of a spiritually dead society.

Donald Jackson began this illumination with an internet search, a far cry from his research among the British Museum's antiquities. With the help of Sarah Harris he gathered a set of horrific documentary photos chronicling the human suffering of the recent past. The skulls are based on photos taken of genocide and war in Armenia, Rwanda, Iraq, and Bosnia. The piles of broken glass suggest the broken windows caused by car bombs, suicide bombers, and terrorist attacks, as well as the empty shells of vandalized and abandoned buildings. At the center is a pile of eyeglasses, a well-known image from the Holocaust. This image is mixed with a heap of bones, skulls, broken glass, and trashed automobiles. For Donald Jackson the waste of ecological disaster is part of the larger image of the valley filled with bones. The automobile hulls (there are three) are one sign of the spiritual death of society.

Among the wreckage, however, there is a glimmer of hope. The lightly colored spot on the right side is an oil slick. Just as an oily puddle will appear to have a rainbow on its surface, so also in the midst of this valley of dry bones there is hope and God's presence. The gold squares that have been used throughout the volumes of *The Saint John's Bible* to indicate the presence of the divine are also here even in the darkest

spaces of the image. Indeed, the words along the bottom of the page speak of promise, not judgment: "I will put my spirit within you and you shall live."

Dramatically different from the heaps of death and destruction is the rainbow across the top of the page. These overlapping circles of rainbow seem torn and pasted, again as in a collage. The image foreshadows what is to come a few pages later, in Ezekiel's vision of the temple.

Finally, the image is punctuated by seven menorahs, a link to creation and covenant. The menorah has been an ongoing sign of the covenant between God and the people in *The Saint John's Bible* since Genesis. Here the seven gold and black bars are intersected by arcs that end in points of light. Seven menorahs with seven points of light rise out of and transcend the wreckage and wrongdoings of humankind, a sign of the renewal of both creation and the covenant described at the end of Ezekiel 37. The illumination *Creation* included a seven-by-seven grid of gold squares, and these squares are turned to make up the forty-nine points of light here. Seven is a symbolic number meaning completion or totality. There is a contrast between what God has envisioned for creation and what humans have made of it. Despite the darkness, it is always God's faithfulness and promise that predominate.

◀ *Where do you see the "dry bones" of society? And where do you see God's presence working to restore Creation?*

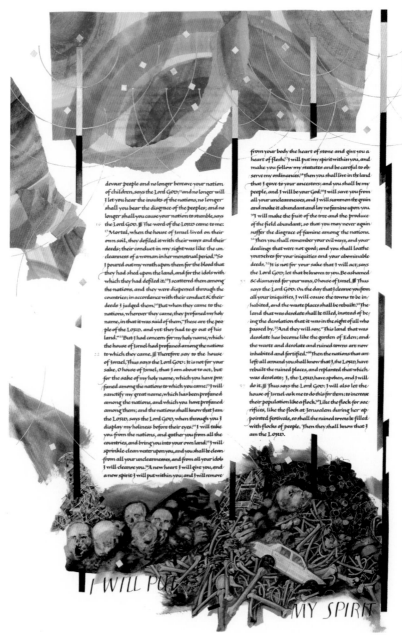

devour people and no longer bereave your nation of children, says the Lord GOD; [14]and no longer will I let you hear the insults of the nations, no longer shall you bear the disgrace of the peoples; and no longer shall you cause your nation to stumble, says the Lord GOD. [16] The word of the LORD came to me: [17]Mortal, when the house of Israel lived on their own soil, they defiled it with their ways and their deeds; their conduct in my sight was like the uncleanness of a woman in her menstrual period. [18]So I poured out my wrath upon them for the blood that they had shed upon the land, and for the idols with which they had defiled it. [19]I scattered them among the nations, and they were dispersed through the countries; in accordance with their conduct & their deeds I judged them. [20]But when they came to the nations, wherever they came, they profaned my holy name, in that it was said of them, "These are the people of the LORD, and yet they had to go out of his land." [21]But I had concern for my holy name, which the house of Israel had profaned among the nations to which they came. [22] Therefore say to the house of Israel, Thus says the Lord GOD: It is not for your sake, O house of Israel, that I am about to act, but for the sake of my holy name, which you have profaned among the nations to which you came. [23]I will sanctify my great name, which has been profaned among the nations, and which you have profaned among them; and the nations shall know that I am the LORD, says the Lord GOD, when through you I display my holiness before their eyes. [24]I will take you from the nations, and gather you from all the countries, and bring you into your own land. [25]I will sprinkle clean water upon you, and you shall be clean from all your uncleannesses, and from all your idols I will cleanse you. [26]A new heart I will give you, and a new spirit I will put within you; and I will remove

from your body the heart of stone and give you a heart of flesh. [27]I will put my spirit within you, and make you follow my statutes and be careful to observe my ordinances. [28]Then you shall live in the land that I gave to your ancestors; and you shall be my people, and I will be your God. [29]I will save you from all your uncleannesses, and I will summon the grain and make it abundant and lay no famine upon you. [30]I will make the fruit of the tree and the produce of the field abundant, so that you may never again suffer the disgrace of famine among the nations. [31]Then you shall remember your evil ways, and your dealings that were not good; and you shall loathe yourselves for your iniquities and your abominable deeds. [32]It is not for your sake that I will act, says the Lord GOD; let that be known to you. Be ashamed & dismayed for your ways, O house of Israel. [33] Thus says the Lord GOD: On the day that I cleanse you from all your iniquities, I will cause the towns to be inhabited, and the waste places shall be rebuilt. [34]The land that was desolate shall be tilled, instead of being the desolation that it was in the sight of all who passed by. [35]And they will say, "This land that was desolate has become like the garden of Eden; and the waste and desolate and ruined towns are now inhabited and fortified." [36]Then the nations that are left all around you shall know that I, the LORD, have rebuilt the ruined places, and replanted that which was desolate; I, the LORD, have spoken, and I will do it. [37] Thus says the Lord GOD: I will also let the house of Israel ask me to do this for them: to increase their population like a flock. [38]Like the flock for sacrifices, like the flock at Jerusalem during her appointed festivals, so shall the ruined towns be filled with flocks of people. Then they shall know that I am the LORD.

I WILL PUT

MY SPIRIT

VALLEY OF DRY BONES

192 THE ART OF THE SAINT JOHN'S BIBLE

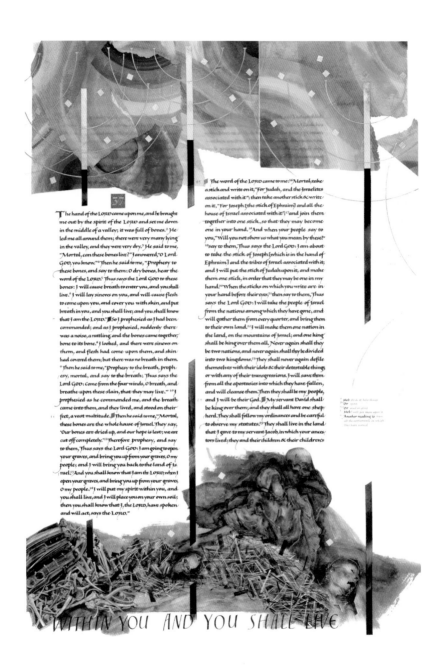

The hand of the LORD came upon me, and he brought me out by the spirit of the LORD and set me down in the middle of a valley; it was full of bones. ² He led me all around them; there were very many lying in the valley, and they were very dry. ³ He said to me, "Mortal, can these bones live?" I answered, "O Lord GOD, you know." ⁴ Then he said to me, "Prophesy to these bones, and say to them: O dry bones, hear the word of the LORD. ⁵ Thus says the Lord GOD to these bones: I will cause breath to enter you, and you shall live. ⁶ I will lay sinews on you, and will cause flesh to come upon you, and cover you with skin, and put breath in you, and you shall live; and you shall know that I am the LORD." ⁷ So I prophesied as I had been commanded; and as I prophesied, suddenly there was a noise, a rattling, and the bones came together, bone to its bone. ⁸ I looked, and there were sinews on them, and flesh had come upon them, and skin had covered them; but there was no breath in them. ⁹ Then he said to me, "Prophesy to the breath, prophesy, mortal, and say to the breath: Thus says the Lord GOD: Come from the four winds, O breath, and breathe upon these slain, that they may live." ¹⁰ I prophesied as he commanded me, and the breath came into them, and they lived, and stood on their feet, a vast multitude. ¹¹ Then he said to me, "Mortal, these bones are the whole house of Israel. They say, 'Our bones are dried up, and our hope is lost; we are cut off completely.' ¹² Therefore prophesy, and say to them, Thus says the Lord GOD: I am going to open your graves, and bring you up from your graves, O my people; and I will bring you back to the land of Israel. ¹³ And you shall know that I am the LORD, when I open your graves, and bring you up from your graves, O my people. ¹⁴ I will put my spirit within you, and you shall live, and I will place you on your own soil; then you shall know that I, the LORD, have spoken and will act, says the LORD."

The word of the LORD came to me: ¹⁶ Mortal, take a stick and write on it, "For Judah, and the Israelites associated with it"; then take another stick and write on it, "For Joseph (the stick of Ephraim) and all the house of Israel associated with it"; ¹⁷ and join them together into one stick, so that they may become one in your hand. ¹⁸ And when your people say to you, "Will you not show us what you mean by these?" ¹⁹ say to them, Thus says the Lord GOD: I am about to take the stick of Joseph (which is in the hand of Ephraim) and the tribes of Israel associated with it; and I will put the stick of Judah upon it, and make them one stick, in order that they may be one in my hand. ²⁰ When the sticks on which you write are in your hand before their eyes, ²¹ then say to them, Thus says the Lord GOD: I will take the people of Israel from the nations among which they have gone, and will gather them from every quarter, and bring them to their own land. ²² I will make them one nation in the land, on the mountains of Israel; and one king shall be king over them all. Never again shall they be two nations, and never again shall they be divided into two kingdoms. ²³ They shall never again defile themselves with their idols and their detestable things, or with any of their transgressions. I will save them from all the apostasies into which they have fallen, and will cleanse them. Then they shall be my people, and I will be their God. ²⁴ My servant David shall be king over them; and they shall all have one shepherd. They shall follow my ordinances and be careful to observe my statutes. ²⁵ They shall live in the land that I gave to my servant Jacob, in which your ancestors lived; they and their children and their children's

WITHIN YOU AND YOU SHALL LIVE

EZEKIEL 40:1–48:35

*Mortal, this is the place of my
throne and the place for the
soles of my feet, where I will
reside among the people of
Israel forever. (Ezek 43:7)*

How does this image of the temple compare with Solomon's Temple *in 1 Kings?*

The destruction of Solomon's temple in Jerusalem is the sign of
absolute destruction for the people of Israel in exile. Ezekiel's
visions focus more than once on the image of the temple, tying
it to the narrative of Israel's exile and return. In Ezekiel 10 and
11 the prophet has a vision of God leaving the temple on his
throne-chariot. This vision assigns blame for their downfall to
the people of Israel, whose disobedience and worship of idols
in effect drive God from their midst. The vision of God's return
to the temple is a vision of renewal and restored covenant.

The book of Ezekiel spends a total of eight full chapters
describing this vision! In it the Lord lays out a blueprint for re-
building the temple, although it is not a blueprint any architect
would want to follow. Still, people have tried, and the basis for
this illumination is a seventeenth-century engraving for a Dutch
reconstruction (on a smaller scale) of Solomon's temple. The
engraving has been digitally manipulated to give the effect of
a vision and turned into more of a labyrinth or maze than a
blueprint. A gold ribbon, used at the beginning and end of this
volume with the wing motif, metaphorically traces Ezekiel's
path through the labyrinth. In this way the vision again speaks
to the theme of transformation, this time in terms of a journey.
The prophet takes a winding path through the areas of the new
temple, with plenty of backtracking and long loops, much like
the circuitous path of Israel back to God. As Donald Jackson
has said about this image, it is better to get lost in the labyrinth
seeking God's holy of holies if it means truly finding oneself.

The vision is also eschatological, a description of the eternal
temple of God. The journey is not logical or straightforward
but belongs to the world of the vision. After being taken to
various areas by "a man who shone like bronze" (40:3), mea-
suring various areas of the courts, Ezekiel says, "The spirit lifted
me up and brought me into the inner court" (43:5). At the top of
a mountain at the center of the temple, Ezekiel is shown God's
ultimate plan. This temple is not about the present but is the
eternal home of God where all people will come to worship.

Ezekiel is not the only prophet to have a more apocalyptic vision of the end of time. The prophet Daniel speaks particularly of the kingdom of God as a place that will endure forever. Further, in the New Testament Jesus compares himself to the temple at Jerusalem, saying he will pull down the temple and rebuild it in three days, referring to his death and resurrection. Furthermore, the Bible ends with John's vision in the book of Revelation of the New Jerusalem, where we will see remnants of this image again.

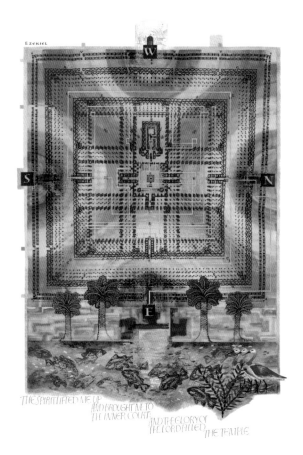

VISION OF THE NEW TEMPLE

יחזקאל

N דאובן · Reuben

יהודה · Judah

לוי · Levi

E יוסף · Joseph

בנימין · Benjamin

דן · Dan

S שמעון · Simeon

יששכר · Issachar

זבולון · Zebulun

W גד · Gad

אשר · Asher

נפתלי · Naphtali

TRIBES OF ISRAEL

In a way the vision of the temple is a creation story, and the garden at the East gate is a restoration of the Garden of Eden. Outside the East gate are images described in the vision. The palm trees are based on Assyrian engravings. The egret images come from Egyptian wall paintings of the eighteenth-century dynasty at Karnack. The fish stamps appear again, as in the illumination *Loaves and Fishes* in the book of Mark. The new creation, like the old creation, will populate the earth, sea, and air, and the focus is on fruitfulness and fertility.

The gold block we have come to associate with God's throne is at the base of the temple gate. It seems reflected on the water outside the temple, ushering us in. The glory of the Lord, in the form of a rainbow, does indeed fill every space in the temple. The technique makes it look as if the paint is absorbed into the vellum like stain, as though it saturates the entire space with color. The effect is that the illumination is enhanced and, combined with the manipulated grid, takes the viewer to the mesmerizing space of the vision, out of the mundane world of "cubits."

On the facing page the twelve tribes of Israel are placed beneath the letter standing for their gate, as is prescribed in the biblical text. It is significant that all twelve tribes are listed, a sign of further restoration. At the time of the destruction of the first temple of Jerusalem the only tribes still in the Promised Land were Benjamin and Judah. The ten tribes to the north, named after the other heirs of Jacob, are sometimes referred to as the "lost tribes" of Israel. Little record of them exists following the Assyrian invasion in the eighth century B.C.E. Here, however, they are reunited as guards of the four gates, three tribes on each side, another sign of the apocalyptic nature of the vision.

A few pages later is a delicate piece of marginalia. The papaya tree makes the connection with the medicinal and food trees mentioned in the *Vision of the Temple*. Young trees like this are at the heart of reforestation projects throughout the world.

❧ *What would you picture in a vision of a new temple, a restored creation?*

THE ART OF THE SAINT JOHN'S BIBLE

Although not a special text treatment, the litany sung by Shadrach, Meshach, and Abednego while in the fiery furnace makes for an impressive piece of calligraphy that again demonstrates what it means that this Bible is written by hand. Here Sally Mae Joseph wrote "Bless the Lord" and the refrain "sing praise to him and highly exalt him forever" forty-three times. You can see the slight variation in the capital *B* and the tail of the *f* in "forever." Like a work of fine craftsmanship, *The Saint John's Bible* could be stamped: "Handmade: no two alike" or "variations in the text are due to the nature of the process" as is found on some handwoven goods to reflect natural variation in wool. Here the variation draws attention to the consistency and craft and adds beauty to the poem. An artist has sat at the table before a piece of vellum, with quill and ink, and written these lines. This song is also marked at the beginning with a cross in the margin and the note "RSB." That means this verse is referenced in the Rule of Benedict. Also part of the Liturgy of the Hours, this litany is one of the texts for Sunday Morning Prayer.

Bless the Lord

DANIEL 3:52-90

DANIEL

54 Blessed are you on the throne of your kingdom,
 and to be extolled and highly exalted forever.
56 Blessed are you in the firmament of heaven,
 and to be sung and glorified forever.

57 "Bless the Lord, all you works of the Lord;
 sing praise to him and highly exalt him forever.
58 Bless the Lord, you heavens;
 sing praise to him and highly exalt him forever.
59 Bless the Lord, you angels of the Lord;
 sing praise to him and highly exalt him forever.
60 Bless the Lord, all you waters above the heavens;
 sing praise to him and highly exalt him forever.
61 Bless the Lord, all you powers of the Lord;
 sing praise to him and highly exalt him forever.
62 Bless the Lord, sun and moon;
 sing praise to him and highly exalt him forever.
63 Bless the Lord, stars of heaven;
 sing praise to him and highly exalt him forever.

64 "Bless the Lord, all rain and dew;
 sing praise to him and highly exalt him forever.
65 Bless the Lord, all you winds;
 sing praise to him and highly exalt him forever.
66 Bless the Lord, fire and heat;
 sing praise to him and highly exalt him forever.
67 Bless the Lord, winter cold and summer heat;
 sing praise to him and highly exalt him forever.
68 Bless the Lord, dews and falling snow;
 sing praise to him and highly exalt him forever.
69 Bless the Lord, ice and cold;
 sing praise to him and highly exalt him forever.
70 Bless the Lord, frosts and snows;
 sing praise to him and highly exalt him forever.
71 Bless the Lord, nights and days;
 sing praise to him and highly exalt him forever.
72 Bless the Lord, light and darkness;
 sing praise to him and highly exalt him forever.
73 Bless the Lord, lightnings and clouds;
 sing praise to him and highly exalt him forever.

74 "Let the earth bless the Lord;
 let it sing praise to him & highly exalt him forever.
75 Bless the Lord, mountains and hills;
 sing praise to him and highly exalt him forever.
76 Bless the Lord, all that grows in the ground;
 sing praise to him and highly exalt him forever.
77 Bless the Lord, you springs;
 sing praise to him and highly exalt him forever.
78 Bless the Lord, seas and rivers;
 sing praise to him and highly exalt him forever.
79 Bless the Lord, you whales and all that
 swim in the waters;
 sing praise to him and highly exalt him forever.

Gk. *hand*
Aram *a small she-goat*
Meaning of Aram
word uncertain

DANIEL 3:52-90

Vision of the Son of Man

DANIEL 7:1-28

I, Daniel, saw in my vision by night . . . (7:2)

What elements of destruction and elements of hope do you see here?

This illumination by Donald Jackson includes a contribution by Aidan Hart, an icon painter who has done many of the faces in the volumes. In this vision Donald Jackson suggested that he render the face of Christ in monochromatic blue, a challenge for someone used to dealing in traditional flesh tones.

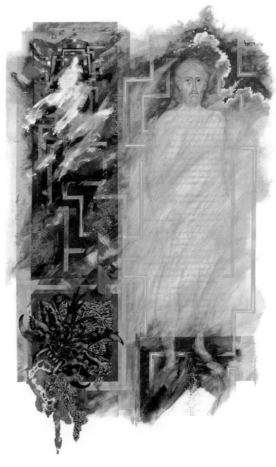

VISION OF THE SON OF MAN

The face here can be compared with the image of Christ in the *Sower and the Seed* (Mark 4:3-9).

Daniel's vision was a source for the author of the book of Revelation and is classified more as apocalyptic literature than as prophecy. It seems to describe the final working out of God's plan, although it also addresses the immediate situation of the people. Apocalyptic literature can be found in many cultures and even in more recent times—for example, in Native American or postcolonial African literature. It tends to be written in times of extreme persecution, when the situation looks hopeless and only supernatural intervention seems able to turn things around. The dream of the four beasts parallels the rule of the empires of Babylon, Medea, Persia, and finally Greece. After the Babylonian exile and return to Jerusalem under the Persians, Israel remained an occupied land. The Greeks in particular tried to assimilate Israel to its culture and religious practices. It is easy to see why the author of Revelation, living in a time of extreme persecution under the Romans, would turn to the book of Daniel for inspiration.

The two sides of this diptych represent the two sides of the vision. On the left is the great beast, with its ten horns and tusks and fiery eyes. You can also see the small horn among the ten that has an eye and "a mouth speaking arrogantly." The background is based on enlarged microscopic images of streptococcus bacteria, a contemporary form of a devouring beast.

This kingdom is described in the explanation of the vision as "a fourth kingdom on earth that shall . . . devour the whole earth, and trample it down, and break it to pieces" (Dan 7:23). This was understood as describing the Greek Empire and the arrogant, persecuting little horn as the Emperor Antiochus Epiphanes, who gained power by uprooting others. That Daniel should have this vision fits the narrative. His fame within the Babylonian Empire became well known at King Belshazzar's feast (Dan 5:1-30), where Daniel interprets the vision of the handwriting on the wall.

More interesting in this vision is the dual image of God, the deliverer. On the left side we see an image of the Ancient One. As in earlier prophetic visions, particularly the vision

of Isaiah, the figure is pictured on a throne, this time with clothing "white as snow" (7:9). The throne is surrounded by rainbow blocks, the motif for the glory of God we also saw in Isaiah and Ezekiel. Daniel describes wheels of fire, and the wheel stamps from Ezekiel's *Vision at the Chebar* are here on a field of red. One of the wheels is grinding over the beast with four leopard heads sketched in black. Looking closely, you can see the image of a multitude, like a crowd of "thousand thousands" at the foot of the throne. The left panel, then, shows the overthrow of the great beast by the Ancient One, the God of Israel, that has been depicted throughout the books of the prophets.

This part of the image is linked to the right-hand side by a grid reminiscent of the temple path in Ezekiel. Icons also use these geometric frames to highlight a divine image. Here two strains of the prophecies—the ongoing reign of God and the messianic visions—come together. Daniel sees not only the Ancient One but also the Son of Man. Before we look at this more closely, a note needs to be made on the translation. The NRSV reads, "I saw one coming like a human being," with a note in the margin explaining that an alternative translation of the term used here is "son of man." The NRSV has chosen "human being" because the translators aim to choose more gender-inclusive language when possible. However, in doing so it loses the connection to Jesus calling himself the Son of Man in the gospels. The word for "son of man" in Aramaic means "someone" or "somebody." In the gospels it takes on the role of a proper title, "Son of Man," and it is this that the early writers use as a reference to Christ. *The Saint John's Bible* maintains that connection by using an icon of Christ as the Son of Man. Daniel's vision describes the relationship between the Father and the Son.

Unlike Isaiah's messianic visions that stressed the suffering servant or a child, here the messiah comes as the triumphant one sent from the skies to have "everlasting dominion" and establish a kingdom that will never pass away. The figure here is a depiction of the prophecy, as is the image on the left. The Son of Man is seen coming "with the clouds of heaven."

Above his head are the gold boxes that signal the presence of divinity. His feet are planted on the earth, and beneath his feet is a stamp like a rich carpet. This stamp was used to adorn the robes of the risen Christ when he appears to Mary Magdalene in John 20.

All of the imagery here will come together in the illuminations in the book of Revelation. The print of Mary Magdalene's dress in the illumination in John, the image of the Son of Man on a throne, and even the horned beast, can all be found in the two-page spread holding the image of the *Woman and the Dragon*, part of the final cosmic battle. The labyrinth of gold is finally resolved in the *Vision of the New Jerusalem*, where there is no longer a human figure but the abstracted Son of Man governing a peaceful, rainbow-washed landscape.

◀ *What do you think is the purpose of these apocalyptic visions and their effect on the people?*

AMOS 4

*The locust devoured your fig
trees and your olive trees; yet
you did not return to me, says
the Lord. (4:9b)*

What does this passage tell us about God's mercy and judgment?

In addition to illuminations we have already discussed, Suzanne Moore also wrote two text treatments for *Pentateuch*, *I Call Heaven and Earth* (Deut 30:19-20) and *The Lord Bless You* (Num 6:24).

Moore has commented that the passages she has dealt with in the project have all been about choice, the alternatives of light and dark, obedience and disobedience. This includes the illuminations she did for the book of Ruth and others. They all demonstrate human responsibility for our own destiny as we respond to God's promises. The connection between Deuteronomy 30 and Amos 4 seems very direct. Deuteronomy 30 begins with a prediction of the exile, naming it as one of the curses that will come upon Israel as a consequence of disobedience. The opening verses read:

When all these things have happened to you, the blessings and the curses that I have set before you, if you call them to mind among all the nations where the LORD your God has driven you, and *return to the LORD your God*, and you and your children obey him with all your heart and with all your soul, just as I am commanding you today, then the LORD your God will restore your fortunes and have compassion on you, gathering you again from all the peoples among whom the LORD your God has scattered you." (vv. 1-3; emphasis added)

Deuteronomy 30 ends with the passage treated by Suzanne Moore:

I call heaven and earth to witness against you today that I have set before you life and death, blessings and curses. Choose life so that you and your descendants may live, loving the LORD your God, obeying him, and holding fast to him; for that means life to you and length of days, so that you may live in the land that the LORD swore to give to your ancestors, to Abraham, to Isaac, and to Jacob.

The people have a choice, to follow the commandments and thus "choose life" or to disrupt God's order and turn from God's blessings. In this passage from Amos, God's lament is that, despite all that God has done to try to draw Israel back, they do not return. So the poetry of verses 6-11 lists God's attempts to get Israel's attention: lack of bread, drought, blight, mildew, locusts, pestilence, war, and defeat. The refrain rings out poignantly, as we feel God's sadness: *"yet you did not return to me."* It is these words that Moore has taken for her illumination. She sees them, fragmented and repeated, as a sign of the fragmentation of creation itself. For the primary text in gold boxes she used the same script as for *I Call Heaven and Earth*, heightening the connection between the two passages.

The illumination is broken into seven pieces, but the pieces are not even and ordered like the days of creation. Inside them, the black, blue, and green panels representing sky, sea, and earth are also not fruitful and ordered but chaotic. This is a reminder that God did not just try to turn the people's hearts with plagues and punishments but first tried to draw them close with all the beauty, order, and fruitfulness of the Garden.

It is the people's choice not to follow God that has made creation this way.

The book of Amos is known for its vision of social justice. The fractured words also refer to the ways injustice and inequality fracture society. At the heart of this prophecy, however, is a reminder of the law and the covenant. God is a God of compassion, not violence and punishment. The people have a choice, and yet they turn from God and do not put in place the society that welcomes God and in which God can live.

Another motto close to the hearts of Benedictines comes from Micah 6:8. Sally Mae Joseph's text treatment is again of a piece with the others in the volume and again points to God's goodness and desire to see humans act with love. The people ask the question: "With what shall I come before the LORD?" Wanting to make amends for their transgressions and regain God's favor, they wonder what kind and number of sacrifices God will require. The passage here is the answer, and it highlights three Benedictine values: justice, hospitality, and humility. God does not want sacrifices but right behavior and longs for a people who "do justice," "love kindness," and "walk humbly" with God.

Do Justice, Love Kindness, Walk Humbly

MICAH 6:8

MICAH 6:8

ZECHARIAH 9:9-17; 10:1-5

Lo, your king comes to you; triumphant and victorious is he, humble and riding on a donkey, on a colt, the foal of a donkey. (9:9b)

Are the words and images in this illumination complementary or in tension?

This final messianic vision is by Hazel Dolby and includes text from Zechariah 9:9: "Lo, your king comes to you; triumphant and victorious is he." However, the tone of the image is not what we might expect for an illumination titled "Rejoice!" For that mood we would do better to return to *Messianic Predictions* in Isaiah. This image draws on the link made between this passage in Zechariah and the Triumphant Entry celebrated on Palm Sunday. Jesus arrives in Jerusalem on a donkey, greeted

זכריה

⁹ Rejoice greatly, O daughter Zion!
 Shout aloud, O daughter Jerusalem!
Lo, your king comes to you;
 triumphant and victorious is he,
humble and riding on a donkey,
 on a colt, the foal of a donkey.

and be full like a bowl,
 drenched like the corners of the altar.

¹⁰ On that day the LORD their God will save them
 for they are the flock of his people;
for like the jewels of a crown
 they shall shine on his land.
¹⁷ For what goodness and beauty are his!
 Grain shall make the young men flourish,
 and new wine the young women.

LO YOUR KING COMES TO YOU

TRIUMPHANT AND VICTORIOUS IS HE

¹⁰ He will cut off the chariot from Ephraim
 and the war-horse from Jerusalem;
and the battle bow shall be cut off,
 and he shall command peace to the nations;
his dominion shall be from sea to sea,
 and from the River to the ends of the earth.

¹¹ As for you also, because of the blood of my
 covenant with you,

10

Ask rain from the LORD
 in the season of the spring rain,
from the LORD who makes the storm clouds,
 who gives showers of rain to you,
 the vegetation in the field to everyone.

REJOICE!

by people singing Hosanna and calling him the messiah, the Son of David, laying down palms in his path (Matt 21:1-10). He does not come to rule, however, but to prepare for his crucifixion.

"The king" here arrives on a donkey, with head bowed. The donkey is a colt, and the man's feet hang almost to the ground. Even the donkey looks sad! The palm trees remind us of Palm Sunday but also of Ezekiel's vision of the temple with its palm trees in the garden outside the gate. In the upper left-hand corner of the image is the shadow of a city. This is another indication that the vision has an eschatological dimension. The kingdom is not of this world, not even of Jesus' time. Victory, we are being told here, is not found in the portrait of a proud, conquering hero, but in our Suffering Servant.

This is the last illumination in *Prophets*, aside from the closing motif of the winged seraphs and temple grid. It is quiet and filled with paradox, like the beginning of the Christian Holy Week. Jesus rides the donkey to Jerusalem, aware of what will happen there. What will happen is necessary for the ultimate glory of Easter and salvation and the final glorious vision of God's kingdom. It is proper that the book ends with a vision of a journey. All of these prophets have taken their own journeys, responded to the call, and acted their part in salvation history.

◀ *What has your journey been? How do the books of the Prophets prepare us for the New Testament?*

GOSPELS AND ACTS

INTRODUCTION TO GOSPELS

T HE FOUR GOSPELS give us four distinct views of Jesus and his ministry. They were written by followers of Jesus who had their own voices and literary styles and who wrote for specific audiences, for liturgical use in specific communities that had their own traditions. Each gospel has its own focus and character. For example, only Matthew and Luke tell the story of Christ's birth. The Gospel of Mark focuses on Jesus' ministry. John's gospel most often uses highly metaphorical language, as when Jesus identifies himself as the light of the world, the bread of life, living water, the gate, and the true vine. Always when we read and contemplate the New Testament, our goal is not to assemble the historical details of Jesus' biography but to gain a deeper understanding of God with us, Emmanuel, his divinity and humanity, and the wonderful promise fulfilled by his death and resurrection.

The gospels and their accounts have inspired artists for centuries. There are great traditions of Byzantine icons, medieval illuminations, and renaissance paintings that reflect the sensibilities of believers in various places and times. An illuminated New Testament that hopes to speak to contemporary readers has even more to draw upon in terms of the history of the book and Christian art.

The Roman Catholic Lectionary, the course of readings used by Catholics during liturgies throughout the year, emphasizes the importance of each gospel. The church spends most of the year (except for Advent, Lent, the Easter season, and special feast days) reading accounts from a single gospel. In a three-year cycle, the church reads primarily texts from Matthew (Year A), Mark (Year B), and then Luke (Year C). John's unique gospel, full of metaphor and with its detailed accounts of Christ's passion and resurrection, is read primarily during the forty days of Lent and fifty days of Easter each year. This lectionary, developed in the 1960s after the Second Vatican Council with the participation of Godfrey Diekmann, OSB, a monk from Saint John's Abbey, also became the model for new lectionaries developed by Protestant denominations. The 1992 Revised Common Lectionary used by at least twenty-five Protestant denominations in North America was a

The GOSPEL ACCORDING TO MATTHEW

¹ AN ACCOUNT OF THE GENEALOGY OF JESUS THE MESSIAH, THE SON OF DAVID, THE SON OF ABRAHAM·

² ¶ ABRAHAM WAS THE FATHER OF ISAAC, AND ISAAC THE FATHER OF JACOB, AND JACOB THE FATHER OF JUDAH AND HIS BROTHERS; ³ AND JUDAH THE FATHER OF PEREZ AND ZERAH BY TAMAR, AND PEREZ THE FATHER OF HEZRON, AND HEZRON THE FATHER OF ARAM, ⁴ AND ARAM THE FATHER OF AMINADAB, AND AMINADAB THE FATHER OF NAHSHON, AND NAHSHON THE FATHER OF SALMON, ⁵ AND SALMON THE FATHER OF BOAZ BY RAHAB, AND BOAZ THE FATHER OF OBED BY RUTH, AND OBED THE FATHER OF JESSE, ⁶ & JESSE THE FATHER OF KING DAVID·

¶ AND DAVID WAS THE FATHER OF SOLOMON BY THE WIFE OF URIAH; ⁷ AND SOLOMON THE FATHER OF REHOBOAM, & REHOBOAM THE FATHER OF ABIJAH, AND ABIJAH THE FATHER OF ASAPH, ⁸ AND ASAPH THE FATHER OF JEHOSHAPHAT, AND JEHOSHAPHAT THE FATHER OF JORAM, AND JORAM THE FATHER OF UZZIAH, ⁹ AND UZZIAH THE FATHER OF JOTHAM, AND JOTHAM THE FATHER OF AHAZ, AND AHAZ THE FATHER OF HEZEKIAH, ¹⁰ AND HEZEKIAH THE FATHER OF MANASSEH, AND MANASSEH THE FATHER OF AMOS, AND AMOS THE FATHER OF JOSIAH, ¹¹ AND JOSIAH THE FATHER OF JECHONIAH & HIS BROTHERS, AT THE TIME OF THE DEPORTATION TO BABYLON.

¹² ¶ AND AFTER THE DEPORTATION TO BABYLON: JECHONIAH WAS THE FATHER OF SALATHIEL, AND SALATHIEL THE FATHER OF ZERUBBABEL, ¹³ AND ZERUBBABEL THE FATHER OF ABIUD, AND ABIUD THE FATHER OF ELIAKIM, AND ELIAKIM THE FATHER OF AZOR, ¹⁴ AND AZOR THE FATHER OF ZADOK, AND ZADOK THE FATHER OF ACHIM, AND ACHIM THE FATHER OF ELIUD, ¹⁵ AND ELIUD THE FATHER OF ELEAZAR, AND ELEAZAR THE FATHER OF MATTHAN, AND MATTHAN THE FATHER OF JACOB, ¹⁶ AND JACOB THE FATHER OF JOSEPH THE HUSBAND OF MARY, OF WHOM JESUS WAS BORN, WHO IS CALLED THE MESSIAH.

¹⁷ ¶ SO ALL THE GENERATIONS FROM ABRAHAM TO DAVID ARE FOURTEEN GENERATIONS; AND FROM DAVID TO THE DEPORTATION TO BABYLON, FOURTEEN GENERATIONS; AND FROM THE DEPORTATION TO BABYLON TO THE MESSIAH, FOURTEEN GENERATIONS·

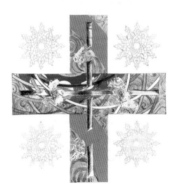

result of this ecumenical process. Many of the illuminations in this volume correspond to key texts from Sunday gospel readings.

Gospels and Acts was the first volume of *The Saint John's Bible* to be completed at Donald Jackson's scriptorium in Wales. As such, it established some of the visual elements and motifs that we've already seen. Because this is a Christian Bible, it understands both the Old and New Testament as the story of Jesus Christ revealed as the salvation of humanity. For that reason, and because of the richness of the tradition of gospel illumination, this volume is heavy with significant illuminations.

Again, we invite you to take your time with both text and image, reading the full Scripture passage before the essay for each illumination. Even if you know the story, reading the text again might bring forward a new insight. Also remember that nothing written here is definitive or exhaustive. As we exhibit pages from *The Saint John's Bible* around the country, people share insights and make connections we had not considered before. It is our hope that as you spend time with *Gospels and Acts*, you will be attentive to more than the biographical lives of Jesus and the apostles. We hope that you will read with open eyes, ears, and heart, allowing the Holy Spirit to speak as you contemplate the Word.

How does this passage and illumination work as a transition between the Old Testament and New Testament?

The place that each gospel begins is important. Each gospel is an account of Jesus, his life and ministry, written for use in a particular church. Only Matthew and Luke start with Jesus' birth, and they emphasize different pieces of the story. Only Matthew includes the genealogy, our starting place for considering the New Testament.

If you've been reading the Bible along with this guide, you've spent a long time getting to this place. Many Christians focus only on the New Testament, and pocket New Testaments, sometimes with the Psalms included, have been popular for decades. How does it strike you to encounter this illumination and the genealogy after reading and thinking about the Old Testament?

There is much here we've seen before. For one thing, there is the presence of women in this genealogy, and these are not women with good credentials. Rahab is the harlot who saved Joshua and his men in Jericho (Joshua 2:1-7) and Ruth was not a Jew but a Moabite, a despised people. Tamar (Genesis 38) and Bathsheba (2 Samuel 11 and 12), also included in Matthew's genealogy, are more infamous than famous from their stories in the Old Testament.

In the illumination, two more names are added to the base of the menorah, which acts here as a family tree. At the base is Abraham with Sarah on one side and Hagar on the other. Hagar is the mother of Abraham's son Ishmael, a branch of this tree pointing to Islam. Sarah's name is written in Hebrew and Hagar's written in both Hebrew and Arabic, further connecting the three monotheistic traditions. The illumination adds another name, not even a name but a descriptor, "Pharaoh's Daughter," to the list. This acknowledges Egypt's role in getting us to this place, when Pharaoh's daughter rescued Moses from the rushes. Egypt has also been an important part of this story, one that Jesus and all the Jews bring with them still into Christianity.

The menorah works wonderfully here as a device for giving the genealogy. Matthew was writing to a Jewish community,

Genealogy of Jesus

MATTHEW 1

An account of the genealogy of Jesus the Messiah, the son of David, the son of Abraham. (1:1)

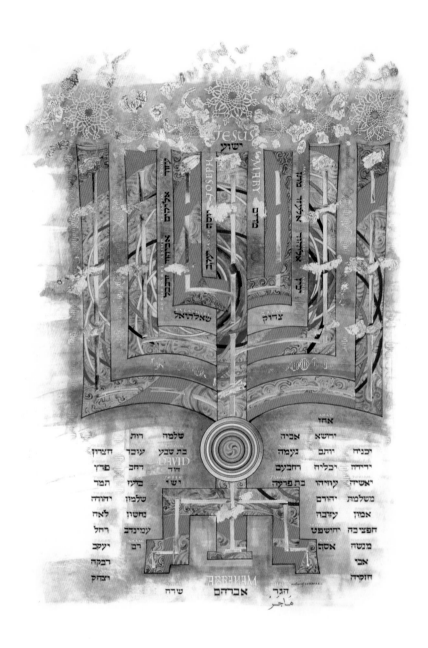

GENEALOGY OF JESUS

who would have found it natural to begin the story of Jesus with his pedigree. Tracing his lineage to King David and Abraham would be important for establishing his divinity. This back and forth between women and kings, good kings and bad kings, and, in fact, Gentiles as well as Jews, mirrors the accounts we've been reading so far. In *Prophets* we saw Jesus as suffering servant and as king of kings. Here at the beginning of the New Testament we get a vision of the messiah that will cross boundaries and be both humble and in the lineage of kings.

This full-page illumination was the first Donald Jackson made for *The Saint John's Bible* project. It was done before many of the decisions about the Bible were made, before the script was even finalized. In that way, perhaps, Jackson had the most free rein with this illumination. He has said his ultimate aim was to suggest "the connectedness of all seekers of enlightenment." He did this by including symbols from several traditions. The image also draws us to reflect on life, creation, history, redemption, and identity.

The gilded stamps used in the center of the illustration come from illuminations of the Koran. A mandala is incorporated into the base of the menorah, again a sign of cosmic unity and wholeness found in many religious traditions. The illumination is not just linear, rising vertically in a straight line to Jesus. Behind the menorah/tree are swirling bands of color over turbulent, churning water. Again creation is with us, as God brings order from the chaos of the human and natural world. We see this churning water again in Matthew 8:23-28, when Jesus calms the storm.

Even more striking than these abstract elements are the stamps of a double helix. With its spiral shape, it is reminiscent of many things, perhaps even Jacob's ladder from Genesis. The contemporary symbol of identity fixed by DNA ties the Bible to the twenty-first century reader and emphasizes the incarnation, the humanity of Jesus.

◖ *What more can you find in this illumination and text that tie them to our Old Testament discussion of* The Saint John's Bible?

Beatitudes

When Jesus saw the crowds, he went up the mountain . . . Then he began to speak, and taught them, saying . . . (5:1-2)

What can you make out from the text on the right side of the image?

The illumination chosen for the Sermon on the Mount is the text of the Beatitudes. The complete text for the Sermon on the Mount is Matthew 5:1–7:24. In these chapters are many of the core teachings of Jesus, including the Lord's Prayer at Matthew 6:9-13. This prayer is highlighted in a special text treatment, and elaborate initial capitals for chapters 5–8 are linked to the color scheme of the *Beatitudes* illumination and text treatment.

The illumination of the Beatitudes is by Thomas Ingmire, and this was his first illumination for the project. The gospel writer sees a parallel between Moses going up Mount Sinai to receive the Law and Jesus going up the mountain to deliver a "new law." What parallels and what differences do you see between Thomas Ingmire's illumination of the Ten Commandments and this one for the Beatitudes? How does this jumble of the word "blessed" match or contrast with the text of the Commandments? Jesus said he came to fulfill the Old Testament Law, not abolish it. Do the two pieces illustrate this relationship?

The Beatitudes have special resonance with the Rule of Benedict and are themes for the monastic life. Notice that there is a cross in the margin at verse 10, "Blessed are the peacemakers, for they will be called children of God." This marginal cross denotes that the verse appears in the Rule of Benedict. One motto of the Benedictines is *Pax*, Greek for peace, and their vows center on the values of simplicity, hospitality, and prayer. Some say the colors and shapes of the text remind them of the stained glass windows at Saint John's Abbey Church.

❧ *What is the nature of this new law, this litany of "Blessed be"?*

BEATITUDES

Many of the prayers and hymns in the gospels receive text treatments in *The Saint John's Bible*. This again reminds us of the use of Scripture in liturgy by the community. If you're tracking the crosses in the margin that reflect passages in the Rule of Benedict, there are many on these two pages, including three verses of The Lord's Prayer and four in the list of directives that close out the Sermon on the Mount in Matthew 7.

One of the lovely things about this text treatment is that it is integrated directly into the text. Rather than repeating text that is written in the columns of the page, verse 9 introduces the text treatment: "Pray then in this way:" and the text treatment follows.

The text treatment itself, by Donald Jackson, is layered with gold and color. The color is picked up in the initial capitals on the page.

The heavy rule lines beneath each line of text also points to ancient manuscripts. The rules used to guide the scribes in the columns of text here are invisible, but most ancient manuscripts contain the heavy rules laid down to keep the calligrapher's writing straight. The way these rules include gaps in places suggests they may even have been laid down after the text was written.

◀ *What is your history with this prayer and what is the experience of encountering it like this?*

Lord's Prayer

MATTHEW 6:9-15

Our Father in heaven, hallowed be your name. (6:9)

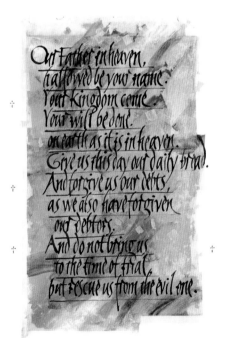

LORD'S PRAYER

*What sort of man is this,
that even the winds and the
sea obey him? (8:27)*

*Which side of this illumination most closely parallels
your own inner state?*

The illumination *Calming of the Storm* by Suzanne Moore is, in
its abstraction, a great place to consider interiority, the trans-
formation Jesus promised to bring about for believers. From
the early days of Christianity, the calming of the storm was
seen as a metaphor for the salvation of those following Christ.
Even more than that, the story is one Christians turn to in
times of turmoil when their peace is threatened.

The five dramatic verses where Jesus calms the storm come
in the middle of a longer passage. The main focus of chapters
8 and 9 are the miraculous healings Jesus is performing. These
healings have a lot in common—they are reflections of the
faith of those desiring to be healed. The centurion says that
Jesus doesn't even have to come to touch his servant but only
"speak the word . . . and my servant will be healed" (Matt
8:8). The woman with hemorrhages believes she only has
to touch the hem of Jesus' garment to be healed (9:21). The
demons fear him and beg to be cast into swine (8:31). The
paralytic man rises from his bed when Jesus declares his sins
are forgiven.

What happens when we put all these miracles in the context
of the storm? The disciples wake Jesus up and ask him to save
them, and he says, "Why are you afraid, you of little faith?"
All around them, faith is transforming people and bringing
them life. The disciples, however, have yet to claim that faith
for themselves. Again we are in the territory of transformation
that runs throughout *The Saint John's Bible*. This transformation
is not about following the law but about turning to Jesus in
faith. Those who practice contemplative prayer in the Christian
tradition may resonate particularly with this passage.

In the illumination by Suzanne Moore, the movement is
from roiling sea to a serene and abstract image of God's pres-
ence. The pale blue background seems crowned in gold, with
shapes that call to mind arches and church windows. You will
recognize these sweeping arcs and filigree from other Suzanne
Moore illuminations. This one has much in common with the

sweeping circles of fertility in her *Praise of Wisdom* illumination (Sirach 24). Suzanne Moore's abstract style, emphasizing chaos and calm, dark and light, works particularly well here and stands out among more representational illuminations.

❧ *Have you ever tried sitting in silent prayer for fifteen minutes? When you quiet yourself in prayer, do the roiling storms resolve to a peaceful perception of God's presence?*

CALMING OF THE STORM

Throughout Matthew are some excellent examples of the marginal ornamentation in *The Saint John's Bible*. On the page for Matthew 11 is one of Chris Tomlin's insects, a dragonfly. On the next page, in the margin of Matthew 14, are a mandala and key marginal notes.

The marginalia in *The Saint John's Bible* is decorative and enhances the aesthetic pleasure of the volumes. In *Gospels and Acts*, the first volume to be completed, the marginalia seems more purely decorative than elsewhere. The closest images to this dragonfly we've seen have been the warring insects in *Historical Books*, which also served the purpose of drawing attention to the theme of conquering. The dragonfly is common to Collegeville and throughout Minnesota, like the butterflies in other margins. The mandala here is also called an arabesque. Arabesques derived from Islamic art were common to illuminated manuscripts. Its presence here is casual and decorative, a sign that the copyist took a pause, as we ask readers of the Bible to pause and reflect along the way.

As mentioned before, above the notes from the NRSV are sometimes found a small cross and the letters "RSB." In this case the citation is Matthew 13:52. If you look at the verse, you'll see a corresponding cross in the margin below the verse number 51. These notes refer to Bible citations found in the Rule of Benedict, tying the book again to the Benedictines of Saint John's Abbey. There are 126 biblical citations in the Rule of Benedict, a very large number for such a brief document.

Reading the Bible is central to Benedictine spirituality, including the practice of *lectio divina*. In this form of prayer, the reader dwells meditatively on a text, usually Scripture, reading it slowly several times and letting it reveal multiple meanings and significance. A process much like *lectio divina* was used by Donald Jackson and the members of the Committee on Illumination and Text (CIT) in determining and developing all the artwork for this Bible. Following these markers, you may begin to see a pattern for monastic life emerging from the text. You will see even more in *Letters*, where Benedict draws heavily on Paul's words as a guide to Christian life in community.

You will notice one other feature in the margins as you go through the gospel text. Turn back to Matthew 6–8, the Sermon on the Mount. In the margin you'll see a word that appears to be in Hebrew, followed by a small red diamond. The word is actually in Aramaic, a language that looks a lot like Hebrew. The red diamond can be found in Matthew 6:25. In the NRSV text, the verse quotes Jesus saying, "You cannot serve God and wealth." The NRSV note, signified by the small red letter *a*, explains that the Greek text has the word "mammon" instead of "wealth." It is a familiar verse most of us know from the King James Version: "Ye cannot serve God and mammon." Mammon is actually an Aramaic word. The CIT decided that the Aramaic words that appear in the gospels would appear in the margins in their original.

Another good example is found at Matthew 27:45. Here the NRSV has kept the Aramaic, and when Jesus dies on the cross he cries out, *"Eli, Eli, lema sabachthani?"* which is then translated as "My God, my God, why have you forsaken me?" In the margin is the actual Aramaic text. Again, when Jesus opens the ears of the deaf man in Mark 7:32-35 he says, *"Eph-phatha,"* which means "be opened." The Aramaic text is in the margin. Most often, the NRSV has kept the Aramaic word in its translation, but even when a translation is given ("wealth" for *mammon* or "my teacher" for *Rabbouni* in Mark 10:51), *The Saint John's Bible* gives the Aramaic in the margin.

Peter's Confession

MATTHEW 16:13-23

*But who do you say that I
am? (16:15)*

*What does Peter mean when he says, "You are the
messiah, the son of the living God"?*

Jesus' promise at Peter's confession, that the gates of Hades
will not prevail upon the community of the faithful, has pro-
vided hope to Christians in distress.

The illumination at Matthew 16 by Donald Jackson is a
tryptich or three-part image. Like the previous illumination,
it charts the territory of chaos to transformation through
Christ. In fact, this illumination is part of three illuminations in
Matthew that all seem to describe this movement, beginning
with Suzanne Moore's *Calming of the Storm* and ending with
her *Last Judgment* illumination at Matthew 24–25.

If we started the book of Matthew with Jesus' "creden-
tials" as messiah in the genealogy, we have continued through
the bulk of this gospel with the dialogue between Jesus, the

PETER'S CONFESSION

crowds, and the disciples to learn what kind of messiah Jesus is. In truth, it has been hard for the disciples to get a hold of Jesus' message. Similarly, it has confused the Pharisees and Sadducees. They've asked him questions: Why don't you wash your hands before eating as tradition commands? Why don't your disciples fast like those of John the Baptist? The disciples ask him: What are you going to do about the storm? What will we eat since we forgot to bring bread? To all these questions, Jesus points beyond the physical realities, beyond the law, to get them to focus on the transforming power of his being. Of course, they won't fully understand until the crucifixion and resurrection.

When he hears Peter confess the message aright, Jesus proclaims that this is the cornerstone of his teaching, the kingdom he came to build. We have seen several images of the temple already: built, destroyed, reimagined, restored. Now we have Peter, the Christian community, the beginning of the Christian church.

Just as we have previously seen three realms, particularly in *Historical Books* with the realm of the kings, prophets and heavenly realm, we see three realms depicted in this illumination. At the right we can make out the face of Peter nestled into the space below and to the left of the text. There is a human face there, but the cubist style makes the face seem built of rock, reflecting the words of Jesus: "on this rock I will build my church" (16:18). The image includes crosses and fragments of flags. The flags reappear in the illumination at Acts 1, *Pentecost*, and connect to Saint John's Abbey and University, part of the legacy of Peter's church, where bright flags fly at special events. The connection between the revelation of the messiah and the crucifixion is made in the cross. In this same passage Jesus tells the apostles he must suffer and die, and Peter's reaction receives a strong rebuke.

Jesus' head is also framed not just by a halo but a cross. At the center of the illumination, he is a figure in gold, revealed as the messiah, the one who was promised to bring salvation. This figure of Jesus has the most in common with the figure in John's frontispiece or the crucifixion. Where Jesus is revealed

to the apostles as the messiah or Son of God he is depicted in gold, the fullest incarnation of the divine.

The left section of the illumination is based on a historical description of the place where Peter made his confession, at the foot of Mount Heron in Caesarea Philippi, a religious center of the Greco-Roman world. One of the sources of the Jordan River issued from a large cave at the site. During Jesus' time the area was under the control of a son of Herod the Great, Herod Philip, who constructed there his palace and a temple to Pan, the Greek god of the forest and the underworld. The cave opening where the waters emerged was believed to be an opening to the underworld. It is here that Jesus says: "I will build my church, and the gates of Hades will not prevail against it" (16:18).

The vision of hell in this illumination combines several elements. It is identified by the Hebrew word for the underworld (*Sheol*), has a representation of Assyrian gods (the eagle-beaked, winged horse), and a microscopic view of the AIDS virus (a contemporary vision of the experience of hell). The Assyrian images were further manipulated when Donald Jackson developed the illuminations for the visions in *Prophets*. Here they are close to their original form.

❦ *How might you depict this story as an illumination? What would you emphasize?*

This text receives special treatment in three gospels. The same text will be given a special treatment where it appears at Mark 12:29-31 and yet again in the margin of Luke 10:27. All three treatments were done by calligrapher Hazel Dolby, who also did a treatment of the text in Deuteronomy 6:4-5. Referred to as the first commandment, it is another foundation for Jesus' teaching.

In each case, this text is treated simply and clearly. Let there be no mistake of what the first commandment is and how Jesus presents it—Love God *and* Love Your Neighbor. The texts look like banners that could be hanging on any church wall. If we are, as God instructs, writing text on our hearts, this is a good place in Scripture to begin.

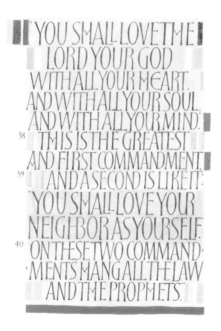

MATTHEW 22:37-40

Last Judgment

MATTHEW 24–25

The kingdom of heaven will be like this. (25:1)

What do you make of this representation of the Last Judgment and Second Coming?

In this extensive passage from the Gospel of Matthew, Jesus lays out a vision of the end of the age and of his return. The illumination has great similarities to the two we've just discussed. There is a great deal of darkness and chaos in the first part of the image, but the overwhelming sense we get from the image is of openness, brightness, and God's presence.

The central portion, with its sweeping arches and open spaces, its circular motion and gold of divine presence, is the heart of the image. The cross and the circle come together, an image of the reconciling action of the crucifixion. To the right are more circles bisected by crosses, and at the bottom rises a refreshing patch of green foliage. We live in the period between Jesus' resurrection and his return, as did the church of Matthew.

Suzanne Moore created this illumination and the one at Matthew 8:23-26 depicting the calming of the storm. All the illuminations in Matthew, then, convey in one way or another what it means that the Messiah has broken into history. The *Genealogy, Beatitudes, Calming of the Storm, Peter's Confession,* and this image of the *Last Judgment* all present a vision of Christ as the New Covenant, defeating death and chaos. This might explain the sharp distinction between the dark, swirling first panel and the gold arcs, compared to the more subtle shift to the final portion of the image. Jesus' death and resurrection defeat death and chaos altogether. The coming of the kingdom, however, is more gradual.

There is still another way to read this image, if we see the left side of the illumination as a representation of the world. The right side of the image uses the same colors as the left, although the quality and effect are very different. This continuity suggests not a break from the world as it is but a transformation.

None of us can possibly know what the Last Judgment will be like. Jesus' words here are not a literal prediction of future events but use a variety of literary styles: parable for the story

THE ART OF THE SAINT JOHN'S BIBLE

³ another; all will be thrown down." ¶ When he was sitting on the Mount of Olives, the disciples came to him privately, saying, "Tell us, when will this be, & what will be the sign of your coming and of the end of the age?" ⁴ Jesus answered them, "Beware that no one leads you astray. ⁵ For many will come in my name, saying, 'I am the Messiah!' and they will lead many astray. ⁶ And you will hear of wars and rumors of wars; see that you are not alarmed; for this must take place; but the end is not yet. ⁷ For nation will rise against nation, and kingdom against kingdom, and there will be famines and earthquakes in various places; ⁸ all this is but the beginning of the birth pangs. ¶ ⁹ Then they will hand you over to be tortured and will put you to death, and you will be hated by all nations because of my name. ¹⁰ Then many will fall away, and they will betray one another & hate one another. ¹¹ And many false prophets will arise & lead many astray. ¹² And because of the increase of lawlessness, the love of many will grow cold. ¹³ But the one who endures to the end will be saved. ¹⁴ And this good news of the kingdom will be proclaimed throughout the world, as a testimony to all the nations; and then the end will come. ¶ ¹⁵ "So when you see the desolating sacrilege standing in the holy place, as was spoken of by the prophet Daniel (let the reader understand), ¹⁶ then those in Judea must flee to the mountains; ¹⁷ the one on the housetop must not go down to take what is in the house; ¹⁸ the one in the field must not turn back to get a coat. ¹⁹ Woe to

those who are pregnant & to those who are nursing infants in those days! ²⁰ Pray that your flight may not be in winter or on a sabbath. ²¹ For at that time there will be great suffering, such as has not been from the beginning of the world until now, no, and never will be. ²² And if those days had not been cut short, no one would be saved; but for the sake of the elect those days will be cut short. ²³ Then if anyone says to you, 'Look! Here is the Messiah!' or 'There he is!'—do not believe it. ²⁴ For false messiahs and false prophets will appear and produce great signs and omens, to lead astray, if possible, even the elect. ²⁵ Take note, I have told you beforehand. ²⁶ So, if they say to you, 'Look! He is in the wilderness,' do not go out. If they say, 'Look! He is in the inner rooms,' do not believe it. ²⁷ For as the lightning comes from the east & flashes as far as the west, so will be the coming of the Son of Man. ²⁸ Wherever the corpse is, there the vultures will gather. ¶ ²⁹ Immediately after the suffering of those days

the sun will be darkened,
 and the moon will not give its light;
the stars will fall from heaven,
 and the powers of heaven will be shaken.

³⁰ Then the sign of the Son of Man will appear in heaven, & then all the tribes of the earth will mourn, & they will see the Son of Man coming on the clouds of heaven with power and great glory. ³¹ And he will send out his angels with a loud trumpet call, and they will gather his elect from the four winds, ³² from one end of heaven to the other. ¶ From the

of the bridesmaids, apocalyptic poetry for its account of signs in the sky, prophetic formulas that echo Isaiah and Jeremiah. In the same way, the illumination suggests and represents the theological truth: the old order of sin and chaos shall come to an end, and the kingdom of God shall be present in its place.

This interpretation is particularly important to keep in mind as we move through *Letters and Revelation*. The early Christians were living in a time of great apocalyptic fervor. Various communities expected that Christ's return would be imminent. This passage takes us back to the vision of the Son of Man in Daniel and forward to the book of Revelation for one image of fulfillment of the promise of God's kingdom. It is interesting to realize this image was made by Suzanne Moore at the beginning of the project. It would probably have been a much different illumination if it had been done after *Prophets* and *Letters and Revelation* were completed and if it had been made by Donald Jackson, steeped as he was in the imagery of those other prophetic visions of the end of days.

◀ *Does this image reflect your sense of the passage in Matthew? What other pieces of the text do you see here?*

Where do you see the markers of humanity and divinity, the two worlds of heaven and earth, and how do they come together in this illumination?

John the Baptist is the patron of Saint John's Abbey, and so it was important to give him a strong place in the illuminations. Mark's gospel is the one account that states John actually baptizes Jesus. Although Luke's gospel covers the ministry of John the Baptist more extensively, this account gives the fullest story of the baptism. As the gospel that focuses most exclusively on Jesus' ministry, Mark opens with not his birth but his baptism. This passage gave Donald Jackson the basis for a complex and exuberant illumination.

At the front of the frame is the Baptist. The fact that it is John the Baptist and not Jesus who is the focus of this illumination is itself unusual. Notice his hands and feet. He moves forward, and he gestures in invitation, even as he looks back. He is not contained by the frame of the image. He is the Forerunner, placed before the image depicting the main event. His gaze backward is not to the past but to the scene of the baptism itself, the story he was sent to proclaim. In the scene are many figures: a crowd on shore, others in the water, and Jesus truly rising up, almost indistinguishable from the gold swatches surrounding him.

The sky is open and angels, much like those in the illumination of Jacob's ladder, descend and ascend. More angels—or are they birds?—circle the heavens in blue. Remember the special properties of birds we've seen from *Creation* through *Wisdom Books* and *Prophets*, metaphorically linking the divine and human worlds.

The image is not without darkness. Red eyes peer out from the left-hand side, along with two large spiders. These images introduce the temptation awaiting Jesus in the desert. According to the text, after the baptism Jesus heads immediately into the desert where he is tempted for forty days and nights. John the Baptist is not a celebratory figure in this scene but a somber one, as though he sees more deeply into the revelation of Jesus' divinity. Above John is also the stamped figure of the

Baptism of Jesus

MARK 1:1-29

And just as he was coming up out of the water, he saw the heavens torn apart and the Spirit descending like a dove on him. (1:10)

BAPTISM OF JESUS

THE ART OF THE SAINT JOHN'S BIBLE

arches of Compostela we've seen so many times. They could be a reflection of the larger ministry and the role of baptism as initiation in the church.

Although this illumination was made years before the illuminations in *Historical Books*, it is interesting that John is washed in purple. There also seems to be some continuity between the fields beside him and the illumination *Saul Anthology*. John the Baptist is most often associated with the prophet Elijah. How does this figure work with the images of the Old Testament prophets and kings?

◀ *What strikes you most about this image?*

He began to teach them many things in parables, and in his teaching he said to them: "Listen! A sower went out to sow." (4:3)

Who is the Sower in this illumination? Does the image match your understanding of who the sower is in the parable?

There is a lot going on in this two-page spread. *Sower and the Seed* has become one of the favorite illuminations and a source of reflection for many groups working with the *Seeing the Word* project developed by Saint John's University School of Theology. That project engages people in what is being called *visio divina*, a take on the Benedictine prayer practice of *lectio divina*, where people slowly read and prayerfully contemplate a text. The practice of *visio divina* combines slow reading of the text with contemplation of the image from *The Saint John's Bible* as people reflect on what the passage might be saying to them.

Parables, walking a line between allegory, metaphor, and narrative, don't break open easily and are a great subject for contemplation. Read the parable before considering the image and see what you can see, hear what you can hear.

This image presented a challenge for Donald Jackson. Who, asked the Committee on Illumination and Text, should be the figure of the sower? He is understood to be a metaphor for Christ's ministry sowing the Word. But Christ himself is the Word being sown. How then should the sower be shown? Whenever a passage of Scripture is treated through representative figures, it becomes interpreted, explained, or set more clearly. The team creating *The Saint John's Bible* wanted always to avoid that kind of "illustration" of biblical texts and leave the images open to the kind of reflection suggested by *visio divina*.

The solution was found in the Eastern Church tradition of iconography. This technique was used (here and elsewhere, for example in the faces of Moses and the prophets) in part to honor the common heritage that the churches of the East and West share. It was also an acknowledgement of the precious visual language that the Eastern Church has developed to express theological concepts and doctrine. Also interesting is that a maker of icons is said to "write" an icon, not paint

it. We don't usually think of someone writing a picture. In what way does this tradition demand that we see differently?

Although we might first encounter this image as a basic picture of "what happens" in the parable, as an icon we are invited to look closer, or differently. The basic style of the image is that of the sacred icon, "written" by iconographer Aidan

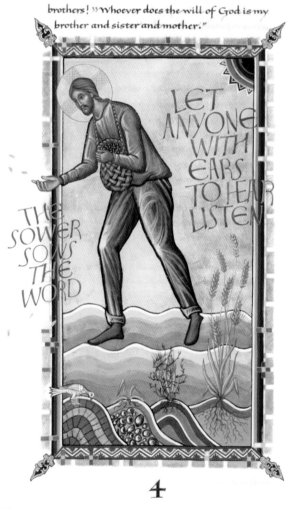

SOWER AND THE SEED

Hart, and the face of the sower is that of Christ. We are looking, therefore, at a sacred, symbolic action, not just a farming scene. On the other hand, the artist has clothed this Christ in ordinary Western work clothes, jeans and a sweatshirt. We are also called to sow the seed, just as we are called to be receptive ground for the seed to grow in us. Icons are meant to open up our understanding of the sacred, just as they paradoxically tie them to a concrete image. Is this image showing us Christ or God the Father (who cannot be imaged)? Yes and no. Are the seeds the works of Christ or Christ himself being given for the salvation of the world? The answer is not one or the other, but "both and." (Notice how the seed scatters across the page into the text itself.)

You'll also notice that there was an error on this page. The scribe writing the text left out a line at verse 20. This was the first incidence of an error like this in the text, and it was when the idea of the "line of return" was established to point to the place where the line should go. Furthermore, the means of conveying the line to its place ties directly to the illumination on the page. This bird resembles the bird pecking away at the seed on the path. It's a playful treatment, but in it we can imagine that bird flying up, after doing its duty, to get those gold seeds strewn across the column.

On the opposite page, a monk sits reading with an icon hanging on the wall next to him. This is a purely decorative piece of marginalia, the kind that we find (as with the mandala in Matthew) in this early volume that gives way to more thematic marginalia as the project proceeded. It also makes sense here, however, in effect showing us a monk practicing *lectio divina* and, with the icon, extending it to contemplation of an image.

❡ *Have you ever had the experience of going to a familiar passage in Scripture and hearing it as though for the first time? What was the insight available to you through contemplation? What does it mean to "have ears to hear"?*

CORRECTION BIRD

Why do you think the artist showed the healing miracles this way, rather than with a dramatic image of someone before and after being healed?

Iconography is employed again in the story of the healing of the woman with hemorrhages and the daughter of the leader at the synagogue. The panels make great use of the structure of the story. The woman who touches the hem of his garment appears as he is going to the girl's home. A story of faith is inserted inside a story of faith. A woman who is unclean is bold in reaching out to touch Jesus. Jairus travels from the synagogue to where Jesus is in order to get him to lay hands on his daughter so that she may be healed. Observe Jesus' hands in the illustrations. In the first he makes a sign of blessing, in the second he holds up his cloak, from which power has gone out, and in the third he grasps the wrist of the girl, while again making the sign of blessing.

In these images, also, Jesus is surrounded. The boy in the crowd breaks the frame of the second panel, showing how large the crowd is that surrounds him. Three figures join him in the other panels, old and young, of different levels of status.

The narrative effect is stronger as the buildings of town appear closer in the second panel, again break-ing the frame, unable to be contained. What do you make of the female figures—those dressed in white who receive Jesus' healing power and the figure be-hind the girl's bed? What do you make of the expres-sions on the apostles' faces in the first panel, as they seem to be pushing Jesus forward? Facial expressions and hand gestures are important in icons, and there is a great variety here for us to contemplate. A similar treatment is given in John 7:53–8:11 of the woman taken in adultery. Take what you can learn in reading these two icons into your study of other parables and stories in the gospels.

◁ *Can you see yourself in these panels? Can you get beyond the "story" to a different perception of Jesus and his ministry?*

Two Cures

MARK 5:25-43

She said, "If I but touch his clothes, I will be made well." (5:28)

TWO CURES

Loaves and Fishes

MARK 6:33-44; 8:1-10

Taking the five loaves and the two fish, he looked up to heaven, and blessed and broke the loaves, and gave them to set before the people. (6:41)

What images of abundance and transformation do you see here?

Mark's gospel has not one but two accounts of the multiplication of loaves and fishes. In the first, Jesus feeds five thousand and in the second, four thousand. These are often interpreted as being about the salvation message extended to both the Jews and the Gentiles, and the subtly different coloring between the left panel and right illustrate the movement from the twelve tribes of Israel to the Gentiles, both recipients of the bountiful gifts of God.

Originally this was planned as a quarter-page illumination, but clearly the artwork as well as the food was multiplied! The imagery is so rich and so central in Christianity: the desert places, the fishermen apostles, the breaking and blessing of bread, the gathering up of the remnants. The fish and bread have a prominent place in the illumination, the bread rendered in gold and marked by the cross to link it to the eucharistic bread. Do you also see the little brown bars and angles like pieces of bread scattered around the page, or the scale-like marks representing the pieces of fish? The fish and bread images are inspired by a Byzantine mosaic from Tabgha, a spot on the shore of the Sea of Galilee where tradition locates this miracle.

The basket designs swirling around the illumination have their origin in ancient Native American Anasazi basketry. Like the mandala images throughout *The Saint John's Bible*, the spiral on the basket appealed to Donald Jackson and here suggested the exponential multiplication of the miracle. The image connects the Bible again to the American setting, but more important to Jackson is that the baskets connect to the dizzying sense of the miracle and are "sacred geometry."

The multiple layers of imagery here refer to the overwhelming gifts of a prodigal God. Donald Jackson described the way these gifts radiate into the human community, saying: "My understanding is that every act of sharing or goodwill multiplies itself. I want to try to establish a sense of multiplicity of the exponential acts of love, sharing, or charity." In that

way the image flows around the page like the flow of love. The blue batons, meant to give the design fixed points, also serve as obstacles to this movement. In Jackson's words, "they represent sins of commission, moments when our actions interrupt the flow of love." Sins of omission are represented by blank spots, "times we should act with love but don't."

Additionally, there is an Aramaic word in the margin of the right page with a small red diamond, referencing Mark 7:11 and the word "Corban," defined as "an offering to God." This term, like "Mammon" earlier, is culturally specific and tied to Jesus' criticism of the Pharisees who, Jesus said, privileged outward shows of piety to following the commandments they were given.

❧ *How do the human and divine come together in this story and illumination?*

LOAVES AND FISHES

things.⁵⁵ When it grew late, his disciples came to him & said, "This is a deserted place, and the hour is now very late; ³⁶ send them away so that they may go into the surrounding country and villages and buy something for themselves to eat." ³⁷ But he answered them, "You give them something to eat." They said to him, "Are we to go and buy two hundred denarii worth of bread, and give it to them to eat?" ³⁸ And he said to them, "How many loaves have you? Go and see." When they had found out, they said, "Five, and two fish." ³⁹ Then he ordered them to get all the people to sit down in groups on the green grass. ⁴⁰ So they sat down in groups of hundreds and of fifties. ⁴¹ Taking the five loaves and the two fish, he looked up to heaven, and blessed & broke the loaves, and gave them to his disciples to set before the people; and he divided the two fish among them all; ⁴² And all ate and were filled; ⁴³ and they took up twelve baskets full of broken pieces and of the fish. ⁴⁴ Those who had eaten the loaves numbered five thousand men. ▊ Immediately he made his disciples get into the boat & go on ahead to the other side, to Bethsaida, while he dismissed the crowd. ⁴⁶ After saying farewell to them, he went up on the mountain to pray. ▊ When evening came, the boat was out on the sea, and he was alone on the land. ⁴⁸ When he saw that they were straining at the oars against an adverse wind, he came towards them early in the morning walking on the sea. He intended to pass them by; ⁴⁹ But when they saw him walking on the sea, they thought it was a ghost and cried out; ⁵⁰ for they all saw him and were terrified. But immediately he spoke to them & said, "Take heart, it is I; do not be afraid." ⁵¹ Then he got into the boat with them & the wind ceased. And they were utterly astounded, ⁵² for they did not understand about the loaves, but their hearts were hardened. ▊ When they had crossed over, they came to land at Gennesaret and moored the boat. ⁵⁴ When they got out of the boat, people at once recognized him, ⁵⁵ and rushed about that whole region and began to bring the sick on mats to wherever they heard he was. ⁵⁶ And wherever he went, into villages or cities or farms, they laid the sick in the marketplaces, and begged him that they might touch even the fringe of his cloak; and all who touched it were healed.

7

Now when the Pharisees and some of the scribes who had come from Jerusalem gathered around him, ² they noticed that some of his disciples were eating with defiled hands, that is, without washing them. ³ [For the Pharisees, and all the Jews, do not eat unless they thoroughly wash their hands, thus observing the tradition of the elders; ⁴ and they do not eat anything from the market unless they wash it; and there are also many other traditions that they observe, the washing of cups, pots, and bronze kettles.] ⁵ So the Pharisees and the scribes asked him, "Why do your disciples not live according to the tradition of the elders, but eat with defiled hands?" ⁶ He said to them, "Isaiah prophesied rightly about you hypocrites, as it is written,

'This people honors me with their lips,
but their hearts are far from me;
⁷ in vain do they worship me,
teaching human precepts as doctrines.'

⁸ You abandon the commandment of God & hold to human tradition." ⁹ Then he said to them, "You have a fine way of rejecting the commandment of God in order to keep your tradition! ¹⁰ For Moses said, 'Honor your father & your mother'; and, 'Who ever speaks evil of father or mother must surely die.' ¹¹ But you say that if anyone tells father or mother, 'Whatever support you might have had from me is Corban' (that is, an offering to God)— ¹² then you no longer permit doing anything for a father or mother, ¹³ thus making void the word of God through your tradition that you have handed on. And you do many things like this." ▊ ¹⁴ Then he called the crowd again and said to them, "Listen to me, all of you, and understand; ¹⁵ there is nothing outside a person

קרבן

The denarius was the usual day's wage for a laborer
Meaning of Gk uncertain
Other ancient authorities read and when they come from the market they do not eat unless they purify themselves
Other ancient authorities add and beds
Gk lacks to God

And his clothes became dazzling white, such as no one on earth could bleach them. And there appeared to them Elijah with Moses, who were talking with Jesus. (9:3-4)

What central story of Jesus is emerging from these gospel illuminations?

For a second time God's voice comes from heaven to announce, "This is my Son, the Beloved" (v. 7). Look at the faces of Moses and Elijah, wonderfully rendered by iconographer Aidan Hart in this collaboration with Donald Jackson.

Moses holds two tablets, as religious figures in medieval and renaissance paintings often hold a symbol of their identity. That is helpful because the faces of these two figures are not the same faces we've seen in earlier illuminations of them in *Pentateuch* and *Historical Books*. Again, these are not literal depictions of historical figures but embodiments of theological concepts and doctrine. Also, as we can easily see, this Jesus is not in any way the same figure we saw in *Sower and the Seed*. It's also not the same figure that was in the *Baptism of Jesus* that opened the Gospel of Mark.

There are a few similarities to the illumination at the beginning of Mark's gospel—the first place God announced his Son. There are similarities in the brush strokes and other elements, perhaps reflective only of Donald Jackson's painting style. There is no border to this image. The crosses in the background of the John frontispiece, *The Word Made Flesh*, are the same as in Christ's robe here. The blue of the sky and the purple of the earth give more gravity to the concrete world where the event takes place, but it is Elijah and Moses who stand on the ground, like John the Baptist, with their detailed, human feet. The sky in the Transfiguration points again to the importance of the cosmos—pointing all the way back to creation. Peter is wrong to think Elijah and Moses are equal to Jesus, but he is right that this is sacred ground.

Unlike the frightened apostles, we have insight into the Christ who is here revealed. The painting goes even further than our ordinary imagination might. We are likely to imagine three figures, more or less the same, but with Jesus in a white robe instead of blue or red. This illumination says no, Jesus is transfigured, his glory is revealed. If you look closely at his robe, you will see it is not an ordinary garment like the one

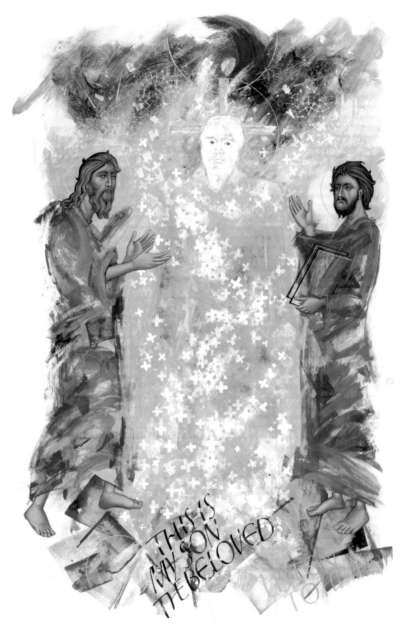

THE TRANSFIGURATION

worn by Moses and Elijah—it appears kingly, perhaps more like priestly vestments. His clothed body is fully there, but it is dazzling, gold shot through with white crosses, a representation of all that is being revealed. What draws our attention most, however, is his face. Both present and absent, dazzling but piercing us with his gaze, what do you make of this vision of God's Son? Is this the Son of Man from Daniel? Is it difficult for us to process—as would be Jesus fully revealed?

When they descend the mountain, we are told in verse 15 that "when the whole crowd saw [Jesus], they were immediately overcome with awe, and they ran forward to greet him." Do they also get a glimpse of what has been revealed on the mountain? "Listen to Him" is repeated three times, first faintly on the bottom of the illumination, then across the page, and finally in a special text treatment by Sally Mae Joseph before the parables of Mark 12. Everything is pointing to the revelation of Christ in the world.

❧ *Returning to the passage, how do we respond to Jesus when he is revealed to us in the midst of our ordinary lives?*

How is this illumination of butterflies in their various states helpful in understanding the two endings of Mark's gospel?

If you begin at the first verse of Mark 16 and read, you see how jarring it is to end at the first part of verse 8: "So they went out and fled from the tomb, for terror and amazement had seized them; and they said nothing to anyone, for they were afraid." Ending on a note of fear—before Jesus has been seen by the disciples, before the disciples have been commissioned and sent out, and before Jesus' ascension into heaven—is dissatisfying. It was dissatisfying to the early community who used this gospel, and they were presumably the ones who added to the ending the two passages we see here. A third version is given in red in the margin under the footnote for verse 8b, adding the commission of the disciples. It seems no one could leave this gospel alone. Whether the ending of the original manuscript of Mark was lost or the manuscript actually ended this abruptly is unknown, but the endings presented here were composed very early and have long been part of the accepted Bible.

Monarch butterflies, here rendered by Chris Tomlin, are often symbols of resurrection. The three stages of their life—caterpillar, chrysalis, and butterfly—correspond to life, death, and resurrection. Monarchs are prevalent in the Minnesota landscape surrounding Saint John's Abbey.

Maybe it is appropriate that the Gospel of Mark ends with a simple carpet page, as if to say, "Where's the rest of it?" This carpet page was lightly stamped and stenciled by Sally Mae Joseph from a pattern she designed and a pattern that Donald Jackson adapted for use throughout the New Testament letters. In that way it is a link between the gospels and letters, books written specifically for early Christian communities.

The pattern here can also be called a "diaper pattern," from the French word *diapré* meaning variegated. In the Middle Ages the term applied to woven fabrics and later to repetitive geometric patterns stamped on fabrics. Many of Joseph's

patterns are derived from textiles. They can be found not just on the carpet pages but throughout the volumes.

This page is vertical, mirroring the monarch illumination on the previous page. The carpet page at the end of the Gospel of Luke, also by Joseph, "The Tree of Life," is more figurative and also reminiscent of the interlocking forms and circles found in the Book of Kells and Lindisfarne Gospels, two other famous illuminated manuscripts. The Tree of Life design was adapted from an appliqued bedspread from India.

This carpet page backs the heavy illumination *Birth of Christ* that begins the Gospel of Luke. It provides us with a pause before we head into the next gospel and meet the master storyteller, Luke.

◀ *What do you think Mark's gospel contributes most to our understanding of Jesus and his ministry? What story do you think* The Saint John's Bible *is emphasizing in its choice and approach to illuminations?*

How is this image traditional? How is it unusual?

This frontispiece for Luke draws us into the seasons of Advent and Christmas, where Luke's account of the nativity is the focus. The revelation of the divine is seen in the shaft of gold coming from the manger, into which peer Mary, shepherds, and one of the kings. Notice their expressions of awe and wonder and Mary's intimate leaning in and wise smile. The shepherds are women and children, one holding a small child. This was probably the reality in the time of Jesus' birth. Remember that David was a young shepherd, and Rachel met Jacob when she was watering her father's sheep at the well. Shepherds and sheep, like the ram in front, play an important role not just in this story but throughout the Old and New Testaments. A similar horned sacrificial ram is seen in the *Prophets* illumination *Suffering Servant*.

LUKE 2:1-20

And she gave birth to her firstborn son and wrapped him in bands of cloth, and laid him in a manger, because there was no place for them in the inn. (2:7)

Again the illumination has many sections that you can "read," finding echoes to other illuminations: the angels from *Jacob's Ladder*, the filigree that has appeared in many illuminations, the stars from *Abraham and Sarah* and *Creation*. All that has been promised is being fulfilled; God is revealed to humanity; the two worlds are bridged.

At the forefront of the scene are the animals. All the figures circling the manger draw our attention to the coexistence of the earthly and the spiritual in this event. The donkey and the ram are easy to relate to a biblical context. In addition to the parables of the sheep and the metaphor of Jesus as the Good Shepherd, there is the ram given in the place of Isaac as a sacrifice back in Genesis. Jesus will also be our sacrificial lamb. Jesus will enter Jerusalem on a donkey on Palm Sunday, another connection between the birth and passion.

The vertical shaft of light from the manger, together with the horizontal line of angels, makes the figure of the cross. This image also reminds us that the crucifixion is tied to the birth, the reason Christ came. Additionally, it connects to the ancient legend that the wood of Christ's crib was used to make his cross.

But what do you make of the ox? This ox is modeled on one of the Neolithic cave paintings of great aurochs at Lascaux, France. Does it make you think of the song "Away in the Manger" and the line, "The cattle are lowing," or the "Little Drummer Boy" where the ox and sheep kept time? In traditional Christian art, each of the evangelists is assigned a figure. Medieval manuscripts are often stamped or illustrated with these figures. Matthew is represented by a man, Mark a lion, John an eagle, and Luke an ox, which we see here at the beginning of his gospel. We first encountered the four figures in the illumination *Vision at the Chebar*. However, that illumination was made long after this illumination in Luke. It is possible that Jackson would have woven some of those animal figures into this image instead—think how different that would be!

This illumination draws attention to our attachment to traditional images of the Nativity. However, the shaft of gold light where we expect to find a baby disrupts the image. The Feast of the Epiphany is associated with the arrival of the wise men (or kings) and the revelation of the Incarnation to the world. This image captures the effect of that word "Epiphany," a sudden revelation and awareness of a larger truth, the truth of God's love and presence in the world through Christ.

Some have pointed out that the manger looks like a book cover. It is actually rendered in the "reverse perspective" style of icon paintings. In "linear perspective" drawing, which we are used to, the front of the manger would be wider than the back because the back is farther away from us. In Byzantine icons, however, the opposite is true. Compare this to the illumination of the Christian community at Acts 4. The altar there has the same shape and perspective as this manger. All these associations are helpful and draw attention to the purpose of all four gospels, which is to make the glory of God known. God as altar, God as Word, and God as infant in a manger are just some of the images that come together for those who meditate on the illumination.

Finally, the text draws our attention to the prophecy spoken by Zechariah. He says, "By the tender mercy of our God, the dawn from on high will break upon us, to give light to

those who sit in darkness and in the shadow of death, to guide our feet into the way of peace" (Luke 1:78-79). This is the message that John the Baptist will bring to the world about Jesus, a message given at John's birth. It is the text of the Canticle of Zechariah, which is used in the monastic Liturgy of the Hours at Morning Prayer. The illumination is crowned with the hymn of the angels, "Glory to God in the Highest Heaven," a hymn Catholics repeat in every liturgy except during Lent. Again we see this is a liturgical book and recognize how we use the Bible in our own worship, with crèches and nativity scenes throughout Advent and Christmas and songs to recognize this event in our congregations.

◀ *If you were to make a new visual interpretation of the Nativity, what might it look like?*

BIRTH OF CHRIST

Chrysography

LUKE 1:46-55 AND 68-79

My soul magnifies the Lord.
(1:47)

Unlike Matthew, Mark, and John, the book of Luke has no decorated incipit, or beginning. The first paragraph is set off from the rest of the text, but it is not in a different script. The initial is no more elaborate than those beginning other chapters, and in some ways less elaborate. Our attention is on the illumination of the Nativity, whose text is in chapter 2. When we turn the page, however, we encounter three major text treatments.

The *Magnificat*, which is Mary's reply to Elizabeth, is one of the great hymns of the church. It is sung daily at Evening Prayer by the Benedictines of Saint John's Abbey. The tradition of chrysography, the Greek term for "writing in gold," goes back to early Christianity. In these treatments the text was written in gesso with a quill before being gilded with gold leaf and burnished. In ancient times purple was also significant. Pages of dyed purple parchment are found in Byzantine books as early as the sixth century. It was a color that signified royalty and wealth. Plus, it showed off the gold! There was no higher text treatment than gold writing on purple background.

The Canticle of Zechariah is also an important Christian hymn, and it is recited as part of the Liturgy of Hours at Morning Prayer. The third canticle, that of Simeon, appears in blue at Luke 2:29-32 and is recited at Compline, the last set of prayers for the day. These special treatments are another connection between the liturgy of the church and the text of the Bible.

They are also a cycle of hymns that draw our attention to the Epiphany that is the appearance of the divine in our midst through the birth of Christ. All of these figures—Mary, Zechariah, and Simeon—recognize their roles and the divinity of the child. The emphasis in these texts is again on fulfillment. Mary speaks of this directly in the *Magnificat*, in language that sounds very much like the language of the Old Testament prophets: "He has brought down the powerful from their thrones and lifted up the lowly; he has filled the hungry with good things and sent the rich away empty. He has helped his servant Israel in remembrance of his mercy, according to the

promise he made to our ancestors, to Abraham and to his descendants forever" (2:52-55).

When we discussed *Hannah's Prayer* in 1 Kings, we pointed out the resonance with the *Magnificat*. Zechariah and Elizabeth are another aged, childless couple, like those we saw throughout the Old Testament. Using this language is all part of Luke's style of writing, drawing attention to the significance of the birth of Christ for his readers and giving it some context. It also makes for beautiful hymns and gives us a place for deeper reflection.

MAGNIFICAT

She stood behind him at his feet, weeping, and began to bathe his feet with her tears and to dry them with her hair. Then she continued kissing his feet and anointing them with the ointment. (7:38)

What distinguishes the left side of this illumination from the right? What unites them?

The illuminations for the Gospel of Luke focus on story. It is in this gospel we get a long account of Jesus' nativity, along with the story of John the Baptist's birth, visits, visitations, and canticles. Also in Luke are a collection of beloved parables. The quarter-page illumination of the dinner at the Pharisee's house was designated by the Committee on Illumination and Text because of the themes of forgiveness and salvation and the charge made against Jesus that he too often associated with sinners.

We have no reason to think poorly of Simon in this story. Even Jesus says that he is a good person, like the one who has a small debt to be forgiven. The woman, however, is a gatecrasher, an interloper, and a known sinner. She brings chaos into the household, which Donald Jackson represents here by the messy and upset elements of the tidy household. The words of Christ in the middle of the scene mediate between the chaos the woman has created and her intense focus on her task, which is to express her love. Does the viewer see the love or chaos? Do we prefer the tidy household or the intensity of love?

The strong black line dividing the illumination represents the chasm between the world of the sinful woman and that of the Pharisees. On the line rests a whole circle, like a halo or church window, inscribed with a cross, another mandala, visible on both sides of the illumination. What is holiness? How is it related to love? The woman is represented as unconventional, wildly dressed, her hair in green and pink. The world that the woman has put in disarray is symbolized by the white scarf, on which Hebrew words are written related to rituals of temple sacrifice. The scarf stretched across the image makes another kind of border; the conventional world, in every place and time, is never receptive to those on the margins. Here, that world attempts to block this marginal woman from access to Jesus. However, the scarf is crumpled, disrupted by the uninvited guest. "You gave me no kiss," Christ says to the Pharisee (v. 45). The reproach highlights the woman's action—"she has shown great love" (v. 47). She

has recognized what it means that her sins are forgiven and responded out of that realization.

Think about the similarities and differences between this illumination and those in Matthew and Mark. In Matthew, Christ calms the seas and conquers death and chaos. In this story it is love that is chaotic, disrupting a world whose order is empty. The illumination *Loaves and Fishes* in Mark also shows the same kind of messy overflowing and abundance of Christ's love. When God breaks into history as Jesus Christ, there is a disruption of the world in its usual state. The next major illumination, the *Parables*, builds on this theme, with more examples of God's abundant love and forgiveness.

❦ *What examples do you have of how your life has been disrupted by love?*

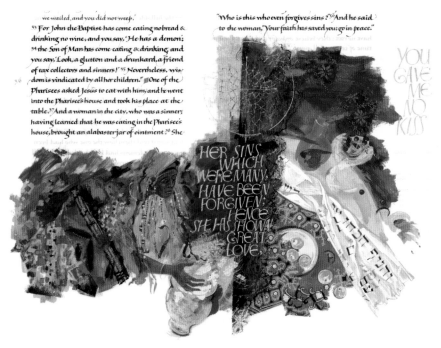

we wailed, and you did not weep.'
33 For John the Baptist has come eating nobread & drinking no wine, and you say, 'He has a demon; 34 the Son of Man has come eating & drinking, and you say, 'Look, a glutton and a drunkard, a friend of tax collectors and sinners!' 35 Nevertheless, wis-
36 dom is vindicated by all her children." ¶One of the Pharisees asked Jesus to eat with him, and he went into the Pharisee's house and took his place at the table." And a woman in the city, who was a sinner, having learned that he was eating in the Pharisee's house, brought an alabaster jar of ointment." She

"Who is this who even forgives sins?" And he said to the woman, "Your faith has saved you; go in peace."

YOU GAVE ME NO KISS

HER SINS WHICH WERE MANY, HAVE BEEN FORGIVEN; HENCE SHE HAS SHOWN GREAT LOVE.

DINNER AT THE PHARISEE'S HOUSE

Do you have a favorite parable illuminated here? What does the illumination add to the story?

Jesus taught with parables, and this anthology page captures some of the most beloved parables in the Gospel of Luke. At the right are Martha and Mary listening to Jesus, and the words, "There is need of only one thing," from Luke 10:42. That one thing is to listen, and Mary has chosen the better part. Here Martha stands in her apron with hands on hips and looks impatient, but at the same time she is, like her sister seated beside her, also gazing at the Lord. Martha and Mary

LUKE ANTHOLOGY

are two sides of love and care, two images of hospitality, a value that is central to the Benedictine tradition. The Rule of Benedict instructs the monks to welcome all visitors as Christ. The parables portrayed here are all about love and care as well. This image also has some resonance with the image in *Historical Books* of Ruth and Naomi. Those women also sit with their backs to us, and their story is also one of hospitality and care.

All of these parables draw attention to some key teachings in the Gospel of Luke. God is not impressed by wealth and

status within society or religion but rather by the love and care shown to others. God is always forgiving. God is generous beyond measure and cares for the least in society. Jesus loves sinners and has come to save not just the righteous but also those on a different path, the tax collectors who come to hear him and with whom he eats, much to the chagrin of the religious elite.

The Parable of the Good Samaritan is represented by text from the story. We hear of those who passed by and of the Samaritan who stopped. These quotations draw attention to the sectarian nature of the tale—the priest and Levite both have high status within Judaism. Priests would be at the top of the social hierarchy and served at the temple, but Levites were descendants of the tribe of Israel, set aside as priests and charged with special duties. The Samaritan, on the other hand, is lower even than tax collectors and sinners, seen as ethnically inferior, thought to have no privileged relationship to God or understanding of what is good. At the center is a vision of compassion: "[A Samaritan] was moved . . . and bandaged his wounds" (vv. 33-34). This quote leads our eye to the image in gold of the Twin Towers. Why do you think this image is in gold? Why is it located here between the Parables of the Lost Son, the Good Samaritan, and Dives and Lazarus?

"The parable [of the Lost Son] is all about forgiveness," said Donald Jackson. He used the image of the Twin Towers as a contemporary example of the challenge of forgiving evil. "You're really challenged to overcome your anger. It's got to be really difficult to forgive." It is an example, he said, "representing the difficulty of achieving pure, unreasonable love." In the parable, we see a father's love for his wayward son, here painted by Aidan Hart, but what a radical step to apply that same love to the entire human family! The Good Samaritan is this kind of story too: love that passes boundaries, love for the other, without fear.

How else is the theme of lost and found played out in this illumination? Nine ghostly coins dance around the moonlike lost coin. Which is more precious? The lost sheep looks from darkness toward the angels and God's love. What do you think

THE ART OF THE SAINT JOHN'S BIBLE

of this sheep? It is not moving toward the light but needs the shepherd to come even farther to restore its place with the others. Again we see divine love that goes beyond reason.

Still, the illumination is not without a scene of judgment. At the bottom is Dives, the wealthy man who did not attend to the beggar Lazarus at his door. Now he claws at the banner scene—do you see a vision of those still on earth or of hell? He seems crushed by the weight of it, as he now asks Lazarus, finally comforted in the arms of Abraham, for assistance. Or has he wrenched the banner from its diagonal place as a sign of his desperation that the others be warned? Lazarus, meanwhile, is comforted by Abraham and tended to by angels. Above them is the Hebrew word *Abraham*, taking us back to the genealogy of Matthew, reminding us of Christ's presence in all these stories.

Pieces of the mandala from Matthew's genealogy are worked into the diagonals and border by Sally Mae Joseph. They are meant, according to Donald Jackson, to suggest the way the mind and intelligence work to interpret and understand concepts, like teasing out the meaning of parables and applying them to our contemporary lives.

◖ *What image of Jesus is formed through these parables and how does it relate to the earlier passages we've discussed in Luke's gospel?*

Eucharist

LUKE 22:14-20

This is my body, which is given for you. Do this in remembrance of me. (22:19b)

How do you understand the three parts of this illumination?

The Last Supper has often been illustrated with the disciples gathered around Jesus at the table, as in Leonardo DaVinci's famous painting. This illumination focuses on the liturgical connection between the Passover meal celebrated by Jesus and the apostles and Christian eucharistic celebrations. It recognizes the connection between Passover and Eucharist and also reflects Catholic and other Christian liturgies where this Bible passage forms the basis for prayers of consecration. The first panel shows the gifts brought forward, the unconsecrated bread and wine. They are brought as a sacrificial offering, and the people recite, "May the Lord accept this sacrifice."

In the center panel is the lamb that is at the heart of the Passover meal and story, also an image for Jesus as the sacrificial lamb. At the elevation, many Christian liturgies share the response, "This is the Lamb of God, who takes away the sins of the world." The cup with the wine is connected to the lamb by blood. The image draws us into a deeper sense of the body and blood nature of the mystery. As Jesus said at the Last Supper, "This is my body. . . . This is my blood."

Finally there is the image of a ciborium, where the consecrated Eucharist is reserved for the sick and dying. The three images together present a theology of the celebration of Eucharist. As the passage reads, "This is my body, which is given for you. Do this in remembrance of me" (v. 19b). When Christians come together for Eucharist, it is a meal and a sacrifice, affirming faith and the new covenant. Note also the stamped border that divides the three panels of this triptych. One has the six-sided star of David used in Judaism and the other has the Christian cross. Note how the initial capital *N* of chapter 22 repeats the motif of the star of David.

Why do you think the creators of The Saint John's Bible *chose to illuminate the crucifixion in Luke's gospel? Why did they use so much gold in this illumination?*

Looking backward and forward to the endings of the four gospels, you will see the emphasis on different aspects of Jesus' death and resurrection. In Matthew's gospel Suzanne Moore's abstract illumination of the Last Judgment is the final major illumination. In Mark, where the text is fragmentary and disputed, we see the Monarch butterflies of resurrection. Looking forward to John, the meeting between the risen Jesus and Mary Magdalene is the focus. In the first century, many texts about Jesus, his life, and his ministry, were written. Only four made it to the official canon of the New Testament for widespread acceptance and use. To be included in the canon, the book had to tell the story of Christ's death and resurrection.

Luke's gospel has both the story of the crucifixion and detailed accounts of Jesus' appearance to the disciples. The crucifixion is not the last major illumination; it is followed by a depiction of the disciples on the road to Emmaus. What is more, this illumination comes after we have encountered the revealed Christ in several significant ways: in the genealogy of Matthew, in Peter's Confession, the Last Judgment, Baptism, Transfiguration, and the Birth of Christ. Each place that Jesus reveals his divinity, gold leaf was used. In the anthology of parables in Luke, also, where God's radical love is the focus, Jesus appears in the upper left hand in dazzling gold leaf. It is the idea of God showing himself in his divine love for humanity that the Gospel of Luke emphasizes.

Donald Jackson and the Committee on Illumination and Text took great care in the way they represented Christ. The images vary, from the icon in workman's clothes for the Parable of the Sower, to the shaft of gold light emanating from the manger in Luke's nativity scene. This illumination also draws on traditional Christian representations and at the same time departs from that vision. In early sketches for the piece, Donald Jackson used the famous Gero Cross for the image

The Crucifixion

LUKE 23:26-49

It was now about noon, and darkness came over the whole land until three in the afternoon, while the sun's light failed; and the curtain of the temple was torn in two. Then Jesus, crying with a loud voice, said, "Father, into your hands I commend my spirit." Having said this, he breathed his last. (12:44-46)

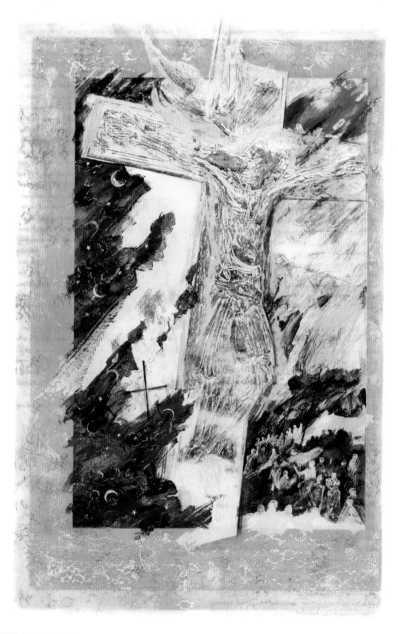

THE CRUCIFIXION

of Christ. That cross, found in the cathedral in Cologne, Germany, is surrounded by an almond-shaped panel of gold (called in iconography a "mandorla") with rays radiating from it like a sunflower. The crucifixion with all its pain does not diminish the glory of God.

Other elements of the story are also represented. The left side shows the three hours of darkness and many moons, a reflection of the way the crucifixion brought about an end to time. Night and death are destroyed by this act, in the moment and for all time. The many moons again give it the feel of literature in *Prophets*. The shreds of purple may represent the rending of the temple veil, the end not just of darkness but of earthly separation from God. Purple was luxurious, worn only by royalty or the wealthy. Here it also shows the destruction of worldly kingship and the establishment of Christ's kingdom. As Luke's gospel has demonstrated from the *Magnificat* forward, wealth and status are unimportant and the only significant value lies in attentiveness to God's presence.

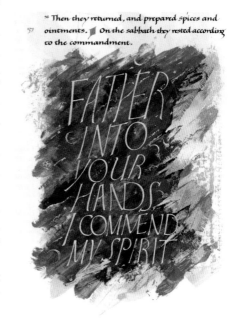

Another cross rises into the gold background, a reflection of the thief on the cross beside Jesus. The procession on the lower right may be the procession of those saved by Christ's death and resurrection or a reflection of the procession with the cross to Golgotha. The entire image breaks through the frame, a sign of how the crucifixion broke through the limits of the human world and of time.

Both the crucifixion and the nativity are times when Jesus' humanity seems most in evidence. However, in both cases *The Saint John's Bible* represents Jesus as pure divinity, an abstract figure of gold. How does that affect our reflection on these events? How does it heighten our sense of Epiphany?

LUKE 23:46

Road to Emmaus

LUKE 24:13-36

While they were talking and discussing, Jesus himself came near and went with them, but their eyes were kept from recognizing him. (24:15-16)

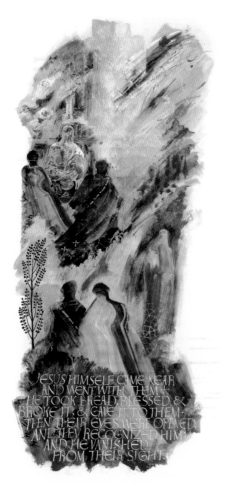

What elements of the story are emphasized in the illumination?

In some ways, this is the first story of the new community that would come to be known as Christians. Its elements are very much like the stories in the book of Acts, which has been attributed to the same author as Luke's gospel. We find two disciples going out, sharing the story of Jesus with someone they meet on the road, receiving instruction while sitting under a tree, and then sharing a meal. These actions are all liturgical.

When the stranger breaks bread they recognize it is Jesus himself. In the illumination we see the two disciples, in much the same attitude as Mary and Martha, listening and gazing up at Jesus. There is a tree, reminiscent of the tree of life, one that we will see again in the images from Jesus' passion in the *Resurrection* illumination in John. It is representative of the Garden of Olives and the fact that here the disciples recount the story of Jesus' passion to him on the road. There are also two images of Jesus, first as an unrecognizable stranger, and then breaking bread with the shadow of the cross behind him. Again we see the filament of gold patterned here and there—the presence of the church.

The stories in Luke are illuminated in a very different style from the stories in Mark. In the latter, there was a strong use of iconography and formal panels to tell stories of Jesus ministering and healing others. In this gospel, Donald Jackson used more of a collage style in layering images from the narratives. What is interesting to note, also, is how many pieces are represented in each illumination. This

layering would remain a hallmark of Jackson's illuminations right through the book of Revelation, where, in illuminations like *The Four Horsemen of the Apocalypse*, *Woman and the Dragon*, and *Vision of the New Jerusalem*, Jackson uses different pen and brush strokes and styles to compose complex illuminations.

◀ *How does the progression of the image, from bottom to top, tell us the meaning of the story?*

The Word Made Flesh

JOHN 1:1-14

In the beginning was the Word, and the Word was with God, and the Word was God. (1:1)

Which verses of these fourteen can you tie directly to the illumination?

The Committee on Illumination and Text saw in the prologue to the Gospel of John the biggest challenge of the four frontispiece illuminations. John's writings are more abstract than the other gospels and contain some of the core ideas of Christian theology. Jesus is here "the Word" that was God and with God at the time of creation. He is also in this passage the Light of the World. John the Baptist is mentioned as the one who testified to him, but the focus is clearly on Jesus who had the power to bring people into the truth, in other words to reveal the nature of things through his words and his life.

The image here incorporates some of these key ideas. You will recognize the stenciled crosses from the transfiguration illumination. The filigree we've seen before has also demonstrated the presence of the divine. How does this particular passage relate to Genesis and creation? The image of Christ seems to be stepping from the darkness that recalls the chaos and nothingness of the creation story and moving toward light and order. In fact, the texture behind Christ's head is inspired by an image taken from the Hubble Space Telescope and reflects the cosmic character of the event. To the left, a keyhole recalls the tradition of locked and hinged manuscripts securing, protecting, and holding the "key" to the Word of God. It might also make you think of standing at the door and knocking, of locked diaries, and of secret prayers of the heart.

The text in cursive script over the left side of the illumination is from Colossians 1:15-20. It expands on the announcement in John's gospel that "The Word became flesh and lived among us" (v. 14). It connects the theology of reconciliation through the crucifixion and resurrection to the original creation and the final judgment, the alpha and omega:

> He is the image of the invisible God, the firstborn of all creation; for in him all things in heaven and on earth were created, things visible and invisible, whether thrones or dominions or rulers or powers—all things have been created through him and for him. He himself is before all things, and in him all

things hold together. He is the head of the body, the church; he is the beginning, the firstborn from the dead, so that he might come to have first place in everything. For in him all the fullness of God was pleased to dwell, and through him God was pleased to reconcile to himself all things, whether on earth or in heaven, by making peace through the blood of his cross.

How do you conceptualize the idea that "the Word became flesh"?

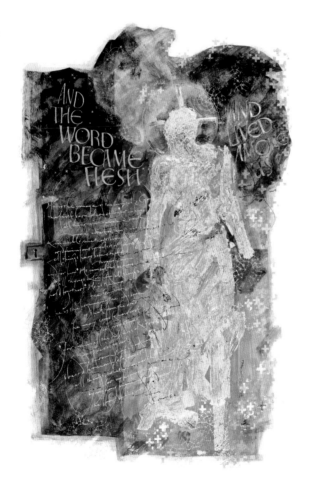

THE WORD MADE FLESH

Call of the Disciples

JOHN 1:35-51

He found Philip and said to him, "Follow me." (1:43)

What do you think is going on in the bottom right corner of this illumination?

This illumination captures the crowds, the sense of purpose, and the joy of following Jesus. It is hard to pick out the figure of Christ, although he is at the center. He is painted in white, which connects him to the circling angels, but he also almost blends in with the people surrounding him. He is the same color as the angels, but he is also the same color as the lamb in the bottom right corner. The words of John the Baptist declare that Jesus is the Lamb of God. He is only called by this title twice in the gospels, both times in John, but it is important to our conception of Eucharist and Jesus as the Passover sacrifice. So it is that Eucharist images appear in this same corner of the illumination, along with a piece of cloth that can remind us of the liturgical nature of the event, or of any one of a number of associations we're building around these images. Look at the color of Mary Magdalene's garment in the illumination *The Resurrection* at John 21. She is often referred to as the apostle to the apostles, the one who proclaimed Christ's resurrection to the apostles. That can be seen as a connection to John the Baptist who is announcing Jesus' divinity here. What do you make of the fact that the cloth breaks the boundary of the image? How are other important colors used in this illumination?

The Committee on Illumination and Text drew attention to the nature of the call in John's theology. "Discipleship has long been an important part of the Christian life, a concept which gained greater prominence with the life and writings of the twentieth-century martyr, Dietrich Bonhoeffer." In this passage, "Two disciples hear [Jesus called the Lamb of God] and immediately follow Christ. They recognize their salvation and act on it. Such a response to the presence of Christ lies at the heart of Christian vocation and, therefore, the monastic one."

◀ *We have seen people called by God before, most notably Samuel and the prophets Isaiah and Elijah. How is this call to follow Jesus different than those—or even of John the Baptist's call? How is it similar?*

ᐧ

262

THE ART OF THE SAINT JOHN'S BIBLE

How do you understand these five names for Jesus? What is revealed in each?

This is another illumination by Thomas Ingmire. As you remember, he illuminated the *Ten Commandments* in Exodus, *Messianic Predictions* in Isaiah, and the *Beatitudes* in Matthew's gospel. All of these were focused on text, on God's word and names. The connection between God and word has always been a favorite of scribes, some of whom spent their lives trying to convey God in words on a page. This, of course, has special resonance with calligraphers.

At issue here again is the identity of Jesus. Who is he? Who does he say that he is? This passage significantly connects the logos that John introduced in his first verse ("In the beginning was the Word") and the Old Testament revelation. In fact, the phrase "I AM" used in John's gospel is a direct reference to Exodus 3:14, "God said to Moses, 'I AM WHO I AM.' He said further, 'Thus you shall say to the Israelites, "I AM has sent me to you."'" In Hebrew, "I am who I am" is the ineffable name of the Lord God—YHWH, written without vowels to show that it cannot be uttered aloud. John the evangelist identifies Jesus with his heavenly Father every time he uses I AM in the gospel.

These sayings also connect to the Old Testament metaphors for God, which makes them even richer. We have already heard him pronounced by John the Baptist as the Lamb of God. Each name here adds to the attributes of Christ: gate, bread, vine, light, and way. Each is a living symbol of who Christ is, deepening our understanding of the revelation.

How is this illumination built like the others, particularly the *Ten Commandments*? Again there is a series of vertical panels, this time five for the five metaphors of the I AM statements: the bread, the gate, the way, the light, and the true vine. (We have, of course, seen other fives, among them the books of the Pentateuch and the books of Psalms.) The text

I AM Sayings

JOHN 6:25-40; 8:12-20;
10:7-18; 14:6-14; 15:1-11

I am the way, and the truth, and the life. No one comes to the Father except through me. (14:6)

of the Ten Commandments dissolved down from the base of the illumination, whereas here the base is the word YHWH. The illumination rises here, sending up geometrical sparks and spinning suns, as well as the arcs we recognize from Ingmire's illustration of the *Beatitudes*.

◖ *What name of Jesus here resonates with you the most? Which one the least? Why?*

I AM SAYINGS

THE ART OF THE SAINT JOHN'S BIBLE

Which figures draw your attention in each panel? With whom do you identify?

In this illumination by Aidan Hart, with contributions from Donald Jackson and Sally Mae Joseph, we see a return to the Orthodox icon style. A comparison of what has changed in the two panels tells us all we need to know about this story.

In the first panel, one of the temple officials holds the Hebrew word for adultery out of the frame. He is literally using the Law as a weapon, a word in one hand and a stone in the other. The word extends beyond the frame to implicate us in the judgment, along with the direct gaze from the man standing beside him, who seems to hold the stone out to us. Jesus, however, bends away from these figures, distancing himself. The woman's face and hands register fear and pleading.

In the second panel, much has changed. The scene is now between Jesus and the woman, whose face and gesture register repentance and gratitude. Beside her is a pile of stones, and there are three behind Jesus too, as though dropped by the two men who stood behind him in the first panel. In this panel the curtain that was drawn over the doorway is moved aside. Jesus raises his hand in blessing, extending an invitation to her to proceed into the gold hallway, into a world where she is commanded not to sin again. In this panel we can identify with the woman instead of with her accusers. We also are forgiven, in relationship with Jesus, and invited into the kingdom.

◖ *What do you make of the fact that the woman doesn't have a veil in the first panel, but she does in the second?*

Woman Taken in Adultery

JOHN 7:53–8:11

Let anyone among you who is without sin be the first to throw a stone at her. (8:7b)

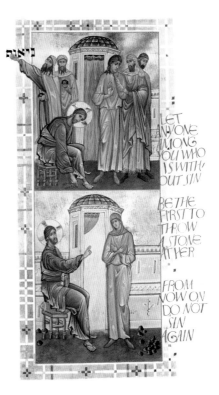

Raising of Lazarus

JOHN 11:1-57

When he had [prayed, Jesus] cried with a loud voice, "Lazarus, come out!" (11:43)

What moment in this dramatic story is captured by the image?

In this illumination we are inside the tomb, behind Lazarus, looking out at Christ bathed in the tunnel of light. A death-head moth spreads its patterned wings amidst the patterned wrappings of Lazarus' shroud. Lazarus is completely in darkness. The scene is a contrast between the powers of darkness and powers of light. The white light of the tunnel from which Christ is calling Lazarus forth reminds us of stories of people who describe near death experiences. The figure of Jesus appears in a white light. Looking closely, Jesus appears to be a man with the large gold swath behind him, rising above him. Why in this passage, which tells of a miracle and where

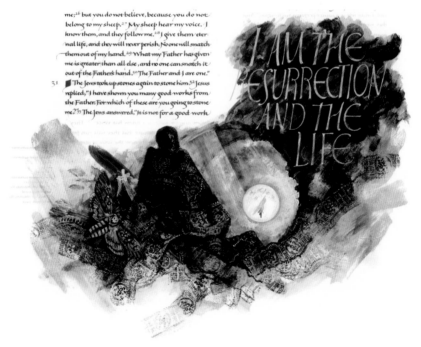

RAISING OF LAZARUS

Martha affirms him as Messiah, would Jesus not be represented as a gold figure or a shaft of gold? Who is Jesus?

More than the figures of Lazarus and Jesus, what is most detailed is the moth, the shroud, and the words of Jesus (another I AM statement). Jesus identifies himself to Martha, saying: "I AM the resurrection and the life" (v. 25). No one escapes physical death, but in Christ all are made alive. At first, Martha can only hope that Lazarus "will rise again in the resurrection on the last day" (v. 24) until Jesus tells her otherwise. These words speak to us, not just Lazarus. Jesus says to Mary and Martha and through the raising of Lazarus that in his very being, in the revelation of God as flesh, all are made alive. As the text treatment on the following page asserts: "Those who believe in me, even though they die, will live, and everyone who lives and believes in me will never die" (v. 26).

It is this miracle that will start Jesus on the road to Jerusalem and the crucifixion, the real triumph of light over darkness, life over death. But here we stand with Lazarus poised on the edge of death and life and contemplate our own faith. Do we live in the darkness of the tomb or the light of Christ?

❧ *Rereading the story, can you put yourself in the place of each of the figures?*

Jesus said to her, "Woman, why are you weeping? Whom are you looking for?" (20:15)

How many elements of the passion of Christ do you see in this illumination?

In this final illumination in John's gospel, one of four different takes on Jesus' passion, crucifixion, and resurrection, the central focus is on Jesus' appearance to Mary Magdalene in the garden. Again, elements from other illuminations should begin to come together for us. Here Christ is robed, as in the Transfiguration, but with shades of royal purple. We stand behind him as we stood behind Lazarus, not direct witnesses of his glory but contemplating the events past, present, and future. In the background we see the same tree we saw in the illumination of Emmaus, a tie to that other resurrection story. Farther back is the tomb, flanked by two figures in white, angels in John's gospel but elsewhere messengers of the resurrection.

Also in the background are the three crosses of Golgotha, luminous now and tinged with gold. The stamped patterns from the carpet pages suggest this is both an end and merely a pause before the beginning. Those same stamped patterns will punctuate the letters of the next volume, drawing a connection to this beginning of Christian community. The vibrant strokes of yellow and blue take us beyond the dawn of Mary's first discovery to the fullness of day in which Christ appears and will appear again.

Like the illumination of John the Baptist at the beginning of Mark's gospel, this one also reverses the view from conventional religious depictions of the scene. Usually it is Jesus who is the central focus. This time Mary is the most detailed figure on the page, fully corporeal in her decorated red garment. Her face is red, reflecting the glory she sees in Jesus' face. Instead of seeing Jesus, we see him in her response. Her hand becomes translucent, however, as she reaches to touch Jesus' face. We can see that she wants to hold on to the Jesus she knew on earth, but he tells her to embrace instead the fullness of the resurrection, the new life of Jesus ascended to the Father.

For those who read Hebrew, the word beside Mary Magdalene may look like a misspelling, *"Rabbouli."* Actually, the writing is the Aramaic word for rabbi, or teacher, *Rabbouni.* What appears to be the Hebrew "lamed," or letter *l*, is pro-

nounced as *n* in Aramaic. The Committee on Illumination and Text chose the Aramaic spelling to show the connection to one of the oldest Christian churches in existence—the Syrian. The original New Testament was written in Greek, but it was translated very early into Aramaic to be used by the Syrian church. Their translation of the Bible is the closest example we have of the language actually spoken by Jesus and his disciples.

What does it mean that the gospel illuminations end with this image? How does it complete the story of Jesus' ministry and purpose?

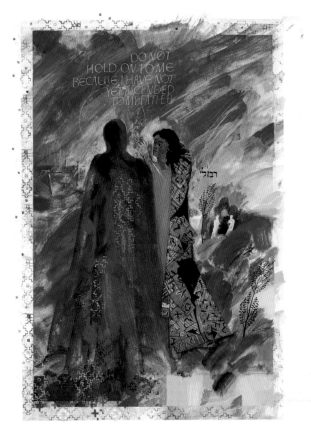

THE RESURRECTION

INTRODUCTION TO ACTS

WHY DO YOU THINK the Committee on Illumination and Text included Acts in the same volume as the gospels? It feels right to turn the page from the gospels and enter immediately into the life of the church described in the book of Acts. John's gospel ends with Jesus commissioning Peter to go out and "Feed my lambs" (v. 15). Matthew's gospel also ends with the Great Commission, and in Mark's gospel the apostles' ministry appears in both the short and long endings. The author of Luke, who also wrote Acts, ends with Jesus telling the disciples to stay in Jerusalem until they are clothed with power—which happens in Acts 2 during the feast of Pentecost. In other words, Acts picks up right where the gospels leave off.

References to discipleship have been made throughout the gospels and occur again in this story of the founding of the church. Acts falls into two basic parts: chapters 1–12 center on the apostle Peter, while chapters 13–28 focus on Paul. In a sense, the book is about the acts of the two apostles Peter and Paul. Peter was one of the twelve apostles with Jesus during his ministry on earth, one of the apostles present at the transfiguration, a key figure in the passion accounts. We have met him already at Peter's confession, where Jesus said he would build his church on Peter.

Paul did not know Jesus and, in fact, was a Pharisee who persecuted the early Christians after Jesus' death and tried to stamp out what was then a sect of Judaism. After his dramatic conversion recounted in chapter 9, he went on to be the primary founder of Christianity among the Gentiles. His letters to various churches are the earliest pieces of writing in the New Testament. His theology was also embraced by Martin Luther in the sixteenth century, whose interpretation of Paul shaped many of the ideas of the Protestant Reformation. That theology is derived primarily from Paul's letters, however, and not from the story of his mission as recounted here in Acts.

As a book about the founding of the Christian church, Acts provided Donald Jackson with the opportunity to focus on the sponsoring abbey and university, the church in action today at Saint John's in Collegeville. Three of the four major illuminations directly reference Saint John's University and Abbey. Although we've seen plenty of flora and fauna references to

the area throughout the volumes, it is in Acts that we see images of Saint John's distinctive architecture.

In a way the book of Acts is a bridge between the gospels and letters. It can also be read as a parallel to Jesus' own story. Peter and Paul follow Jesus in making journeys, teaching in synagogues and on the road, and proclaiming salvation and God's kingdom. Before Jesus died, he promised to give his Holy Spirit, to further reveal God and build up the church. The book of Acts begins with Pentecost and the origins of the church.

And suddenly from heaven there came a sound like the rush of a violent wind, and it filled the entire house where they were sitting. (2:2)

In what way does this illumination make reference to both the past and present life of the church?

This illumination captures the event of Pentecost, when the Holy Spirit was poured out on the apostles as a fulfillment of time and history. It is the start of the Christian church, and from this moment forward the good news will be proclaimed and people will be baptized in the name of Jesus Christ. As the text notes, "devout Jews from every nation under heaven" are already in Jerusalem for the great Jewish pilgrimage feast of Pentecost, fifty days after Passover (2:5). Luke's passage sets this event in the context of the prophecy in Isaiah: "In days to come the mountain of the Lord's house shall be established as the highest of the mountains, and shall be raised above the hills; all the nations shall stream to it" (Isa 2:2). Just so, this illumination places an image of Jerusalem, rising like a mountain peaked in gold, against the Abbey Church in Collegeville, to show the scope of the ministry of the church.

The center of the illumination is marked by a gold column of fire and smoke. At the top of the column are the moon on the left and the sun on the right. Unnamed heavenly bodies dart about as streaks of flame pelting the earth in a visual allusion to the "tongues, as of fire" in Acts 2:3. Much of the imagery comes from the prophecy of Joel (2:28-31), describing the day of the Lord with all its traditional imagery: blood, fire, smoky mists, and heavenly portents, to which Peter refers in his speech (Acts 2:17-21). However, in this scene the Lukan author shows the Day of the Lord as hopeful, a fulfillment and building up, not as one of destruction. The hope of the passage, and of the illumination, is life in the Holy Spirit in history and eternity.

Peter's keys punctuate the call to repentance and the seal of the church. The wall of Jerusalem and the small black figures of the apostles preaching give way to the rising granite edifice of Saint John's Abbey Church. The Abbey Church was designed by Bauhaus architect Marcel Breuer, who designed several buildings on campus. Designed in the 1950s and completed in 1961, it was ahead of its time in terms of

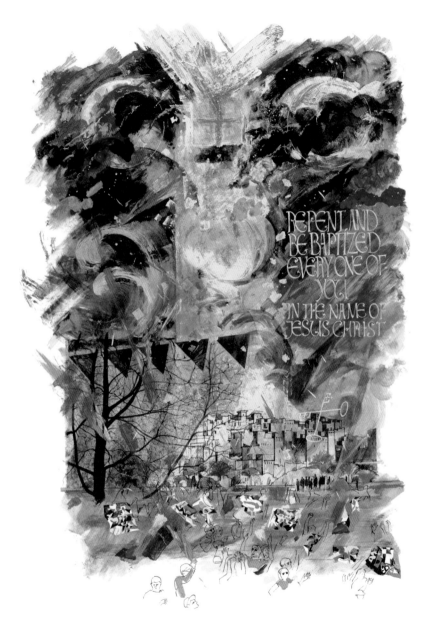

REPENT AND
BE BAPTIZED
EVERY ONE OF
YOU
IN THE NAME OF
JESUS CHRIST

PENTECOST

church architecture, seeming to anticipate the documents of the Second Vatican Council. The church itself is a testament to the abbey's contribution to the liturgical movement of the twentieth century. This movement, led in part by Br. Virgil Michel of Saint John's Abbey, advocated for full participation by the laity in church worship as the most effective way to carry the Gospel into the world. This movement also promoted attention to the disenfranchised people of the world, another theme emphasized in *The Saint John's Bible*.

At the top of the gold column is the cross as seen in the Abbey Church's prominent bell banner. Church bells are but one symbol of the good news announced to the world. Finally, the contemporary figures at the base of the image are based on Donald Jackson's recollection of a Saint John's University football game. The checkered flags fluttering along the ground fly on the Saint John's campus on special occasions. Here at the start of the story of earliest Christianity, the illumination makes good use of the local associations to Saint John's University and Abbey.

What does this illumination say about who makes up the community of believers?

This is a rich illumination that draws directly from Eastern Orthodox icon traditions. The idealized vision of Christ's followers in Acts 4:32-35 is here represented with idealized figures. Aidan Hart's icon painting in this collaboration with Donald Jackson gives this image of Christian unity symbolic weight. Although the passage is brief, the illumination is richly detailed and can be "read" like an icon. Like many early renaissance religious paintings, the illumination includes the pastoral imagery of a deer and various trees to tie it to the contemporary setting. These link the early church to Saint John's Abbey, along with renderings of the Abbey Church with the bell banner on the right and Stella Maris Chapel, a small chapel on the shores of Lake Sagatagan. The palm trees and other exotic trees are based on a painted mural in the Great Hall of Saint John's Abbey, the monk's primary place of worship until 1961.

The main part of the illumination combines elements from Eastern Orthodox icons of Pentecost, the ascension of Christ, and the Last Supper. Pentecost icons traditionally show the twelve apostles sitting on curved benches as they are here. Additionally, there is usually the figure of an old man in the space below, where the altar is in this image. He is called "Kosmos" and holds a white cloth with twelve scrolls on it—one for each of the twelve apostles. He represents the world that the apostles are being sent out into with the Good News. Various figures in this illumination hold scrolls, while others hold books, and one holds a child.

At the center of the community, as in many postresurrection icons, is the Virgin Mary, representing the Christian church. Peter sits at her right hand (holding a scroll), and it is possible that Paul is on her left. Paul often appears in Eastern Pentecost and Ascension icons, although he was not a follower of Jesus until decades later. Icons are not meant to be literal pictures of a story but to reflect the theology of the passage. That is certainly true in this case.

Life in Community

ACTS 4:32-35

Now the whole group of those who believed were of one heart and soul, and no one claimed private ownership of any possessions. (4:32)

LIFE IN COMMUNITY

Six apostles sit on each side, and beyond them are other saints of the church. They are meant to evoke saints throughout church history but are not based on any specific figures. Who do you see there? They are men and women, clerics but also lay people, and as time catches up to the present, the man and woman on the end of each row are more reflective of the world church—a woman wearing a Guatemalan skirt and a man in a Middle Eastern tunic and vest.

THE ART OF THE SAINT JOHN'S BIBLE

All are gathered around the central table set with the elements of a supper or feast. This table is like the "reclining" tables of the first century, although circular to fit the design of the illumination. A fresco at the Holy Monastery of Pec in Kosovo has a scene of the Pentecost on an archway with an image of the Last Supper nested into it, combining icons much like this one. In fact, the muted, sort of scraped quality of the border of this image suggests the look of a fresco in an ancient church.

In front of the seated saints is an altar with the Holy Scriptures and the Eucharist—elements of Christianity that mark the earliest Christian liturgical practices. The altar is painted in reverse perspective like the manger in Luke's nativity. The earliest disciples met in homes to break bread and, as is written in the top left, "gave their testimony to the resurrection of the Lord Jesus" (4:33).

Indeed, crowning the scene is Jesus Christ holding a book open to reveal his identifying name, "I AM," which connects him to God the Father and the Holy Spirit. The image of Christ comes from Eastern icons of the ascension into heaven. He is framed by the Greek letters that spell Jesus Christ. Further, he is seated on rainbows and accompanied by two angels, as in many Eastern depictions of the ascension. The shape of the blue panel behind him is a mandorla, which we saw also in the image of the crucifixion in Luke's gospel. The almond-shaped background is commonly used in depictions of the risen Christ in the Eastern tradition.

This complex illumination brings together three main texts in the opening of the book of Acts: the ascension (Acts 1:6-12), Pentecost (Acts 2), and the ideal community (Acts 4:32-35). The description of the peaceful, united community has had a profound effect on monastic life, where members of orders strive to be "of one heart and soul" and refrain from private ownership. It is no surprise to find the cross in the margin of the text at verses 4:32 and 4:35, indicating that Saint Benedict quoted these verses in his Rule, along with the morality tale in Acts 5:1-11.

Even the early church was beset by strife and conflict, disorganized and argumentative. Benedict's own communities were

said to have attempted to murder him—twice! Still, icons are images meant for meditation, not to reflect historical fact. In this image we keep before us the elements of our unity—the bread and wine and the holy Word of God. We keep in mind that we are called to community, not life alone, and work toward living according to the will of Christ and making God's way known. God's work was not completed by early Christians but continues as we add to the line of saints, who even in this image break the boundary of the circle and continue into the margins, where many of God's people are to be found.

What details from the passages listed here do you see in this image of Paul?

The book of Acts is dominated by two major figures: Peter and Paul. When considering a full-page illumination of Paul, the CIT decided to concentrate on Paul's life and save the development of his theology for the last volume of *The Saint John's Bible: Letters and Revelation*. Still, they wanted a composite or anthology of incidents from Paul's life, as there had been an anthology of parables in Luke. In addition to the challenge of bringing story to life as image, which Donald Jackson faced throughout the process, he was determined that this *Life of Paul* would stand as a unified painting, despite the extraordinary number of details about Paul mentioned in Acts.

The figure of Paul is bigger than life and has transformed history. Nowhere is this more clear than in the image of Paul holding a broken church building. The church has a strong resemblance to Saint Peter's Basilica in Rome, the city where both Peter and Paul nurtured the early Christian community and where both were martyred under the Emperor Nero. This image is not without irony, for there is evidence that these two apostles of the church did not always have an amicable relationship. Further, some have pointed to Paul's place in the Reformation; Martin Luther used Paul's writings to establish some of his most important doctrines. The Reformation literally split the church. What do you make of the fact that Paul cradles both pieces? What does it mean that he is clothed in a Jewish prayer shawl, the sign of his upbringing as a devout Jew? Do these elements work together or in tension?

What, moreover, do you make of Paul's gaze, facing forward, determined, yet giving a sideways glance? This portrait by Aidan Hart can be compared to the final image of Moses in *Pentateuch*, where his gaze captured the whole story. Some have remarked that his figure shows a combination of determination and hesitancy, as though slightly drawn back or unsure. For one who had to take so much on faith and who spoke so much about faith, the combination of confidence and doubt describes a life of faith for every believer.

Life of Paul

ACTS 9:1-22; 15:1-35; 17:16-34; 22:17-21; 25–28

He is an instrument whom I have chosen to bring my name before Gentiles and kings and before the people of Israel. (9:15)

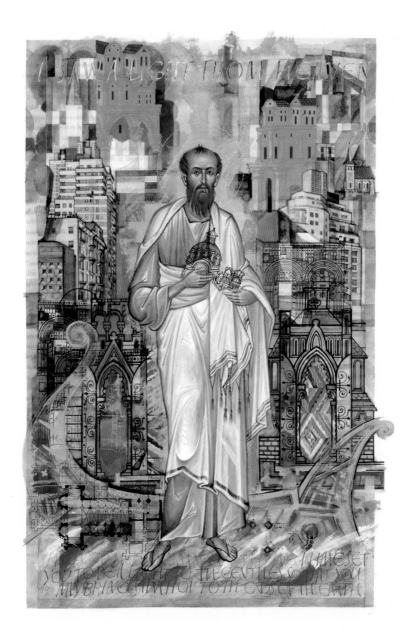

LIFE OF PAUL

Paul was a man of the cities, and buildings dominate this image. The Mediterranean sailing vessel marks him as a traveler, one who took at least three sea journeys and was shipwrecked on one of them. Still, his feet are prominent, clad in sandals, and it was on foot that Paul primarily took his message.

The buildings are a mix of sacred and secular, churches and walls, gates and municipal buildings. They are ancient and modern and include a block of apartments from Fifth Avenue in New York at the top left leading to one of the architect Marcel Breuer's dormitories at Saint John's University. On the upper right is a small image of the Stella Maris Chapel on the abbey grounds and of the cross at the abbey cemetery. At Paul's left elbow are the arches from the entrance to the Basilica of the Holy Sepulcher in Jerusalem. There is the now-familiar image of the arch of the Cathedral of Santiago de Compostela, the final destination of the famous pilgrimage route. Also in the mix are textile patterns behind the open window, more signs of the reach of Paul's mission into communities, many of them along trade routes. The complex of arches and gates speak everywhere of his journey in and out of community, his movement forward and sometimes restriction through imprisonment, his escape through windows and over walls, as he made his way through the labyrinth of the first-century Greco-Roman world.

Two pieces of text frame the image. At the top, from Paul recounting the story of his conversion: "I saw a light from heaven" (Acts 26:13). At the bottom is God's direction to Paul: "I have set you to be a light to the Gentiles, so that you may bring salvation to the ends of the earth" (Acts 13:47). Indeed, light fills the spaces of this illumination.

◖ *If you were making an anthology page for a biblical figure, what images would it include?*

ACTS 1:8

*"But you will receive power
when the Holy Spirit has
come upon you; and you will
be my witnesses in Jerusalem,
in all Judea and Samaria,
and to the ends of the earth."
(1:8)*

*Why end the volume with an illumination of this verse
that appears in the first chapter of Acts and again at
Acts 13:47?*

The final page of this volume uses only two colors, ultra-marine blue and bronze, in addition to black and white. Again the image brings together the unity and chaos of creation, God's presence in heaven and on earth through his follow-ers, and their witness to the resurrection. Although the verse returns the reader to the first chapter of Acts, it is more a prophecy than a coda. At the end of the book of Acts Paul has reached Rome, at that time the center of the civilized world. His mission to the ends of the earth is complete, and the rest is left to us. We are to bring the message of salvation to the ends of the earth, which means something quite different today. From beginning to end, though, the illuminations of the book of Acts have focused on one main message: the call to spread the Gospel.

In this illumination, the earth is shown suspended in the ex-panding universe, the African continent clearly defined. Donald Jackson has pointed out that this is the first handmade Bible to feature the earth as it is actually seen from space. To the ends of the earth in biblical times meant a few thousand miles, the prov-ince of a few empires, and most people didn't travel more than a hundred miles in a lifetime. Today we apprehend both the vastness of the globe and the smallness of it in relation to the universe through high-speed technologies. A comet over-head will remind some readers of Hale Bop, which was visible to the naked eye in the summer of 1997, but also perhaps of the

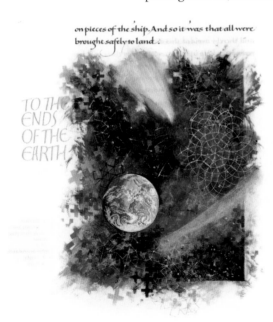

on pieces of the ship. And so it was that all were
brought safely to land.

TO THE
ENDS
OF THE
EARTH

shape of galaxies. Stenciled over the image of the dynamic universe is the cross pattern from the carpet pages. You can also see the interlocking circles of gold filigree that have been a motif throughout the volume.

❧ What does your own journey in spreading the Gospel look like? What has it revealed to you?

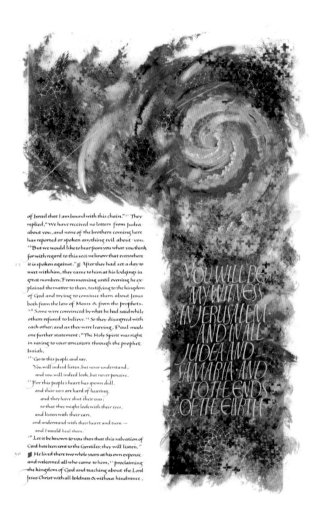

of Israel that I am bound with this chain." ²¹ They replied, "We have received no letters from Judea about you, and none of the brothers coming here has reported or spoken anything evil about you. ²² But we would like to hear from you what you think, for with regard to this sect we know that everywhere it is spoken against." ²³ After they had set a day to meet with him, they came to him at his lodgings in great numbers. From morning until evening he explained the matter to them, testifying to the kingdom of God and trying to convince them about Jesus both from the law of Moses & from the prophets. ²⁴ Some were convinced by what he had said while others refused to believe. ²⁵ So they disagreed with each other; and as they were leaving, Paul made one further statement: "The Holy Spirit was right in saying to your ancestors through the prophet Isaiah,

²⁶ 'Go to this people and say,
You will indeed listen, but never understand,
and you will indeed look, but never perceive.
²⁷ For this people's heart has grown dull,
and their ears are hard of hearing,
and they have shut their eyes;
so that they might look with their eyes,
and listen with their ears,
and understand with their heart and turn —
and I would heal them.'
²⁸ Let it be known to you then that this salvation of God has been sent to the Gentiles; they will listen." ²⁹
³⁰ He lived there two whole years at his own expense, and welcomed all who came to him, ³¹ proclaiming the kingdom of God and teaching about the Lord Jesus Christ with all boldness & without hindrance.

YOU WILL BE
MY WITNESS
IN JERUSALEM
AND IN ALL
JUDEA AND
SAMARIA AND
TO THE ENDS
OF THE EARTH

TO THE ENDS OF THE EARTH

LETTERS AND REVELATION

INTRODUCTION

THE SEVEN VOLUMES of *The Saint John's Bible* were not completed in order. *Gospels and Acts* was the first volume undertaken and *Letters and Revelation* was the last. Because of this schedule, the artists working on *Letters and Revelation* were able to take full advantage of the visual vocabulary and imagery developed during the rest of the project. This volume, though slender compared to some of the other volumes, is a very mature work in terms of the art and calligraphy.

You might be surprised by the number of entries here for *Letters*. This is because of the large number of text treatments. Although they are for the most part simply done, like the incipits we have seen in all the previous volumes, they are rooted in complex theology.

Unlike the earliest text treatments, such as the *Magnificat* and canticles in Matthew, which were inserted into the page where they occur, these text treatments duplicate text on the page. Look, for example, at Romans 5. Rather than integrating the text treatment into the page, it appears twice, first as part of the letter and then set apart as a text treatment. This approach lends a particular architecture to the page and to the reading experience. We encounter some of the great hymns of the church in these letters, first as written into the author's discourse with a specific Christian community and then as we reflect on the treatment or proclaim it in liturgy today.

We will spend more time with these text treatments than we have with those in earlier volumes, because they each have a theological statement to make and demand a little context. It is not like the aphorisms of *Wisdom Books*, where passages were chosen to reflect the feminine nature of divinity or like *Historical Books* where the text treatments formed a sort of running commentary on the rise and fall of the people's relationship with God.

Reading the letters, we are as always engaged with the people of God and their central questions: "Who is God?" and "What is God's relationship to humanity?" If Jesus is the Son of God, sent by God as our Redeemer, crucified, and risen—and promising to come again in glory—then how are we to live as God's people?

These central questions are taken up by Paul and the other letter writers as they engage with people in churches throughout the Greek and Roman world. They provide us with the core of Western Christian theology, a theology that has been taken up and lived out—and that has resulted in more than a few schisms over the past two millennia.

Raymond E. Brown, in his central work, *An Introduction to the New Testament*, considers Paul's theology through a series of questions. One of them is: "What is the theological center of Paul's theology?" He identifies a number of themes identified by theologians, including (1) "justification by faith," (2) "the antithesis between human flesh and the divine Spirit," (3) human experience of salvation through the revelation of faith, (4) "the Christ-event as the consummation and end of history," and (5) sanctification through Christ.* The Reformation was, in part, about the interpretation of Paul's writings on these and other issues. In the end, the whole Christian church has reformed, and recent ecumenical efforts show that on the question of Paul's theology there is a great deal of commonality. The doctrinal differences on issues of justification and sanctification aren't as divisive as they once were.

The Committee on Illumination and Text (CIT) chose passages to be highlighted in the letters that reflect major points of Christian theology, including those listed above. The CIT aimed to put the letters in the context of fulfillment of the eschatological vision, the fulfillment of creation and history in Christ. The gospels proclaim the message of Christ, the letters work out that message in actual churches, and Revelation points to where that message is going: the establishment of God's kingdom.

As you read through the letters and consider Paul's reflections and directions to the churches, we will attempt to situate the highlighted verses in the story of the church (ecclesiology) and Paul's message of God's love and grace. In the end, what is important to Paul is that, through Christ, God gave the gift of salvation to all people independently of the directives of the Jewish Law.

Our response to these letters, then, is much like our response throughout the Old and New Testaments: to offer praise and gratitude to God for the mercy and grace offered us and to find ways to live that reflect that great gift of God's love for us.

* Raymond E. Brown, *An Introduction to the New Testament* (New York: Doubleday, 1997), 440.

A good starting place for considering the letters is the illumination *Life of Paul* in the book of Acts. Paul is the author of many of these letters, and it might help to know who he is and what his story is—a version of which is found in Acts 7:58–28:31—before reading the words attributed to him during his ministry.

Revelation is a book that takes up more specifically the question of eschatology, the end of history, the ultimate fulfillment of the promise of God's kingdom. It is an imaginative and literary masterpiece. It is also rooted in the ecclesiology of the early Christian church. That is to say, it is full of symbols and images related to what it means to be *church*. In fact, it is a letter of a very different sort from those written by Paul, written this time to "the seven churches." It brings together all the creative energy of the prophets, wisdom, history, and gospels, as well as poetry and visions that project forward to a hope for the ultimate and permanent establishment of God's kingdom.

Written and illuminated entirely by Donald Jackson, the book of Revelation is also the culmination of this epic project. Jackson describes his process, working with all eight spreads of Revelation spread out around the room, so that he could see the big picture as well as work on individual pieces. It is a riot of color that builds on the earlier work in *Prophets* and, indeed, all the other books, bringing *The Saint John's Bible* to a close with a final, glorious "Amen."

The Bible began in the book of Genesis with two visions of creation that laid out a vision of who God was in relationship to the cosmos and humanity. We end with a Christian vision of God's ongoing and permanent covenant with humanity through the church, made possible by the sacrifice of God's Son Jesus. As you read Revelation through the illuminations of *The Saint John's Bible*, our hope is that you will see the references to other illuminations and be able to place the story it tells in the context of the Bible as a whole.

Letters and Revelation begins with a reverse carpet page (coming at the beginning, not the end, of a volume). Here Donald Jackson used a stamp based on a length of woven cotton from the Karachi jail in the Sindh region of Pakistan (ca. 1880). Originally, Sally Mae Joseph made a line drawing from the textile design for use on carpet pages at the end of each gospel in *Gospels and Acts*. It was also used in the border of *The Resurrection* (John 20:1-23). Parts of the stamp were sanded down to make the pattern more subtle on the carpet pages in *Gospels and Acts*. In its use throughout the letters, Jackson wanted the same motif as in the gospels but did not sand down the pattern.

The carpet pages throughout *The Saint John's Bible* have also introduced a motif for each volume. Here we find a motif that connects the gospels and the letters, but with more color. We will see the motif repeated throughout the letters, woven into the decorative elements for the text treatments. A lovely use of it is on the pages of the second and third letters of John and the Letter of Jude, where the motif is laid like a piece of lace at the bottom of each brief text.

The book titles for each letter, painted by Donald Jackson, are richly colored and written in gold. The initial capitals in *Letters and Revelation* are handled somewhat differently than in other volumes. In the past, Jackson created unique initial capitals for each chapter in a book. However, to give unity to the letters and to preserve the simple freshness of the genre, Jackson created one alphabet for the initial capitals here and used it throughout. The letter forms don't change, but the colors reflect the individual spreads, often picking up on the text treatments or illuminations.

Similarly, Jackson designed one alphabet and a standard decorative treatment to use in all thirteen text treatments he did in *Letters*. Many of his treatments are of quite long passages, and space was limited. For his text treatments, Jackson chose a hand that, although sophisticated, is direct. He wanted it to capture the spontaneous nature of writing a letter.

There are eighteen text treatments in all in *Letters*, the other five done by calligraphers Thomas Ingmire (1 Cor 11:23-26; 1 Cor 13:1-3), Hazel Dolby (Eph 5:8, 14), and Suzanne Moore (Phil 2:5-11; Heb 8:10).

CARPET PAGE

There is one other element to note on these opening pages—namely, the Benedictine cross in the margins. We have seen these throughout *The Saint John's Bible* to reference places that the Rule of Benedict quotes Scripture. You will see many of them in the margins of *Letters*, as St. Benedict incorporates Paul's and other writers' teaching into his rule of life for monastic communities.

288 THE ART OF THE SAINT JOHN'S BIBLE

Romans is the longest letter in the New Testament and perhaps the most developed in terms of its theological discussion. Interpretation of this letter's key points on grace and salvation has also been at the heart of the major split in Western Christianity (the Reformation). Because it has so many key ideas in it, this letter has the largest number of text treatments. It also has a major illumination. If at one time interpretations of Romans were the reason for division within Christianity, today they can be the reason for unity and mutual growth.

There are only three illuminations in *Letters*, and these are *Fulfillment of Creation* (Rom 8:1-39), *At the Last Trumpet* (1 Cor 15:50-58), and *Harrowing of Hell* (1 Pet 3:18–4:11). As you can see even from the titles, these three emphasize the place of the letters in the eschatological movement of the New Testament, the movement toward the fulfillment of God's plan. The New Testament books dealing with the early Christian church, from the first chapter of Acts and the ascension of Christ, tell the story of looking forward to Christ's return and the fulfillment of the promise of unification with God and the establishment of God's perfect kingdom.

As Paul lived and moved among the churches, he advised the early Christians on life in community and interpreted the message of Jesus. The message was, first and foremost, one of salvation for those who have faith. Much like Matthew's gospel appealed to a Jewish Christian community, Paul's Letter to the Romans is conscious of the Jewish character of the church in Rome, in which there were also Gentiles.

Paul explains justification through faith by citing the example of Abraham. Paul points to Abraham as one who believed God's promise to him and acted accordingly. In this argument, Paul proclaims the possibility of forgiveness of sins and justification before God for everyone, not just the people of Israel. He also claims the Old Testament story of the people of God for all Christians, a single story that began with Abraham and was opened to all through the death and resurrection of Jesus Christ.

The importance of this, says Paul, is that justification is a gift from God. No one can "boast" or put him or herself above

For What Does the Scripture Say and For This Reason It Depends on Faith

ROMANS 4:3 /
ROMANS 4:16-17

others. No one can earn this gift that is given freely by God. Rather, it is bestowed on all as an act of God's grace.

Whereas in *Historical Books* the text treatments appear in the margins, taking a backseat to the illuminations of the stories, in *Letters* the words of Paul and the other authors are central. The eighteen passages chosen for special treatment by the CIT emphasize key elements of Christian theology. Despite the conflicts and disputes, these passages have been the source of hope and joy for millennia.

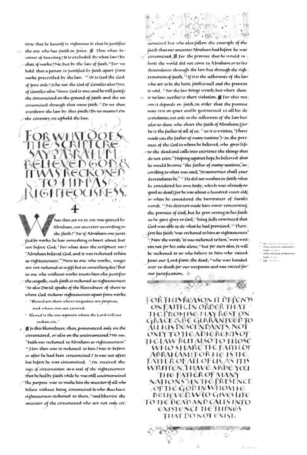

ROMANS 4:3 AND ROMANS 4:16-17

THE ART OF THE SAINT JOHN'S BIBLE

The decorated cross at the top of Romans 5 is a version of the cross at the end of the genealogy that opens the Gospel of Matthew. That genealogy traces Jesus' origins all the way back to Abraham, an important connection for the early Christian community. In this cross in Romans, Donald Jackson has ornamented it with the gold stamp used in the carpet page for *Letters*. In this way he has connected the work of the gospels and Paul's letters in guiding the emerging Christian communities.

Paul continues his argument about salvation in this passage. Salvation has come through God's grace, through the single action of Christ's death and resurrection, and this salvation is available to all. People have lived under the sin of Adam's transgression, and now they live under the salvation gained by Christ's sacrifice.

This passage is often cited as being one of the sources for the doctrine of original sin and how Christ has reclaimed the universe from that sin.

Therefore Since We Are Justified by Faith

ROMANS 5:1-21

ROMANS 8:1-39

*For the creation waits with
eager longing for the revealing
of the children of God. (8:19)*

*What is your understanding of "eternal life" both now
and after physical death?*

In Romans 8:1-39, the apostle Paul declares the Good News:
through the sacrifice of Jesus Christ, God has once and for all
reconciled humanity, fulfilled the covenant, and demonstrated
the power and aim of God's love—to bring all of creation into
communion with God. There will be no more exile, for the
Spirit of God dwells within believers. There is no separation
between the love of God and those who have faith.

When Paul speaks of "death" here, he does not mean literal
death but a state of being that negates life. The life that comes
through Christ is life the way creation was meant to be. As
Paul says in the opening of chapter 6, "Just as Christ was raised
from the dead by the glory of the Father, so we too might walk
in newness of life" (6:4). The Roman Christians to whom this
letter was written knew better than anyone that the "freedom"
they received through grace, and the "enslavement" to Christ,
was neither a free pass to licentious living nor the promise of
immediate joy and freedom on earth. Their reward was more
likely to be persecution by the Romans and possibly a martyr's
death. This is a passage about transformation, and in that way
it doesn't just look forward to life after death—it points to a
life on earth changed by the Good News.

In this way, Paul pointed to the fulfillment of God's vision
on a large scale. What is the reward for believing in God? God
will count it as righteousness. We are sanctified and receive the
gift of eternal life. "The wages of sin are death, but the free
gift of God is eternal life in Christ Jesus our Lord" (6:23). This
illumination links Paul's words about the "free gift of God"
with the richness of this gift; now, through Christ, creation is
reconciled to God completely. Nothing can separate us from
the love of Christ (see 8:38-39).

This passage reveals a different understanding of time from
the one we live with in the day to day. It is a sense that Ein-
stein and visionary mathematicians and scientists point to
in their work. Thomas Ingmire references quantum physics,
astronomy, and computer science in this illumination. He was

fascinated by the way that quantum physics "reduces every-thing to one thing, pure energy." The digital world too, by reducing everything to zeros and ones, unifies our perception. Ingmire began with an image from the Hubble telescope that shows a star in the shape of a cross. He added graphs, equations, and plot points that relate to the way scientists measure distances to individual stars.

At the bottom of the illumination is an echo of the *Creation* illumination from Genesis. We would do well to keep this image in mind for all the illuminations in *Letters and Revelation*.

The creation narrative in Genesis tells us why God creates. God creates out of goodness and love, bringing order to chaos. That creation is incomplete, however, and sin enters the picture.

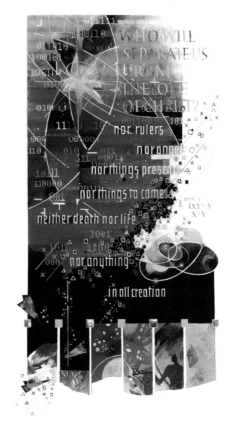

The passion, death, and resurrection of Jesus Christ re-creates creation. In this illumination, the stars, the cosmos, and the echoes of the seven days of creation all proclaim that from the chaos of Christ's death and the glory of his resurrection, new life—eternal life—becomes the norm. It is a new order that unites us to God so completely that there can be no more separation.

❦ *How do the elements of this illumination communicate the fulfillment of creation?*

FULFILLMENT OF CREATION

Once again, nature illustrator Chris Tomlin has graced the margins and open spaces of this volume with his insects and flowers. Unlike the destructive insect life we saw in *Historical Books* and *Prophets*, the insects and plant life in *Letters* are hopeful and bright. They have more in common with the New Testament marginal illustrations of *Gospels and Acts*. They are the harbingers of spring and summer in Minnesota and Wales, although some, like the little butterfly in First Corinthians, are dramatic and even exotic. Here is where you can find them:

1 Corinthians 2–3	Black and White Butterfly (*Nemoptera bipernis*)
2 Corinthians 7	Bee Decoration (Generic Bee, Honey Bee Inspired)
Galatians 3:23-29	Common Butterfly (*Polygonia c-album*)
Colossians 1	Common Blue Butterfly (*Polyommatus icarus*) on Buddleia Flowers
Hebrews 1	Dragonfly on Yorkshire Fog Grass (*Holcus ianatus*)

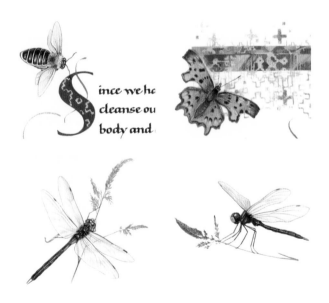

ince we ha
cleanse ou
body and

THE ART OF THE SAINT JOHN'S BIBLE

This final text treatment in the Letter to the Romans takes up again the relationship of faith to the Jews and Gentiles. Throughout their history, particularly in the *Historical Books* leading up to the exile but continuing into the time of the second temple, the Jewish people's fidelity to God has been shaky. We have read the cycles of obedience and disobedience. But we have also read the ongoing cycle of God's forgiveness, mercy, and love for the people. Throughout their checkered past, God has always preserved "a remnant," be it Noah and his family, those who return from exile and continue practicing in the Diaspora, or Esther's family.

What is new, Paul says, is that God's love and salvation has been extended to the Gentiles. He compares Christian Gentiles to the wild branches grafted onto an olive tree.

ROMANS

are holy. ¶ But if some of the branches were broken off, and you, a wild olive shoot, were grafted in their place to share the rich root of the olive tree, "do not boast over the branches. If you do boast, remember that it is not you that support the root, but the root that supports you." You will say, "Branches were broken off so that I might be grafted in." "That is true. They were broken off because of their unbelief, but you stand only through faith. So do not become proud, but stand in awe." For if God did not spare the natural branches, perhaps he will not spare you. "Note then the kindness and the severity of God: severity toward those who have fallen, but God's kindness toward you, provided you continue in his kindness; otherwise you also will be cut off. "And even those of Israel, if they do not persist in unbelief, will be grafted in, for God has the power to graft them in again." For if you have been cut from what is by nature a wild olive tree and grafted, contrary to nature, into a cultivated olive tree, how much more will these natural branches be grafted back into their own olive tree. "So that you may not claim to be wiser than you are, brothers and sisters, I want you to understand this mystery: a hardening has come upon part of Israel, until the full number of the Gentiles has come in. "And so all Israel will be saved; as it is written,

"Out of Zion will come the Deliverer;
he will banish ungodliness from Jacob."
"And this is my covenant with them,
when I take away their sins."

"As regards the gospel they are enemies of God for your sake; but as regards election they are beloved, for the sake of their ancestors; "for the gifts and the calling of God are irrevocable. "Just as you were once disobedient to God but have now received mercy because of their disobedience, "so they have now been disobedient in order that, by the mercy shown to you, they too may now receive mercy." For God has imprisoned all in disobedience so that he may be merciful to all. ¶ O the depth of the riches and wisdom and knowledge of God! How unsearchable are his judgments and how inscrutable his ways!

"For who has known the mind of the Lord?
Or who has been his counselor?"
"Or who has given a gift to him,
to receive a gift in return?"

"For from him and through him and to him are all things. To him be the glory forever. Amen.

BUT IF SOME OF THE BRANCHES WERE BROKEN OFF, AND YOU A WILD OLIVE SHOOT, WERE GRAFTED IN THEIR PLACE TO SHARE THE RICH ROOT OF THE OLIVE TREE, DO NOT BOAST OVER THE BRANCHES. IF YOU DO BOAST, REMEMBER THAT IT IS NOT YOU THAT SUPPORT THE ROOT, BUT THE ROOT THAT SUPPORTS YOU. YOU WILL SAY, BRANCHES WERE BROKEN OFF SO THAT I MIGHT BE GRAFTED IN. THAT IS TRUE. THEY WERE BROKEN OFF BECAUSE OF THEIR UNBELIEF, BUT YOU STAND ONLY THROUGH FAITH. SO DO NOT BECOME PROUD, BUT STAND IN AWE. FOR IF GOD DID NOT SPARE THE NATURAL BRANCHES, PERHAPS HE WILL NOT SPARE YOU. NOTE THEN THE KINDNESS AND THE SEVERITY OF GOD: SEVERITY TOWARD THOSE WHO HAVE FALLEN, BUT GOD'S KINDNESS TOWARD YOU, PROVIDED YOU CONTINUE IN HIS KINDNESS; OTHERWISE YOU ALSO WILL BE CUT OFF, AND EVEN THOSE OF ISRAEL, IF THEY DO NOT PERSIST IN UNBELIEF, WILL BE GRAFTED IN, FOR GOD HAS THE POWER TO GRAFT THEM IN AGAIN. FOR IF YOU HAVE BEEN CUT FROM WHAT IS BY NATURE A WILD OLIVE TREE AND GRAFTED, CONTRARY TO NATURE, INTO A CULTIVATED OLIVE TREE, HOW MUCH MORE WILL THESE NATURAL BRANCHES BE GRAFTED BACK INTO THEIR OWN OLIVE TREE.

ROMANS 11:17-24

This page is a good place to study *The Saint John's Bible* as an artifact handwritten by calligraphers. All six calligraphers were present in Wales when this page was ready to be written, and Donald Jackson decided to split it up between them. It is the only page where all six calligraphers contributed to the same body of text, although there are many examples of pages where multiple calligraphers contributed various elements.

The calligraphers were all trained in the single script used for *The Saint John's Bible*; nevertheless, each developed his or her own idiosyncrasies, including differences in descenders and some capital letters. On this page, however, it is nearly impossible to tell where the work of one calligrapher ends and another begins. Honoring the work of those who went before, each calligrapher closely "stuck to the script" and wrote his or her passage uniformly, contributing to the unity of the page. It's a great tribute to the team.

Then, in the second column, Donald Jackson himself omitted a line! As with others in *The Saint John's Bible*, this line is a particularly important one. (Or perhaps they only seem that way when they are highlighted by being omitted.) The passage is 1 Corinthians 11:23-26, where Paul recounts the Last Supper event that is the source of the Christian practice of Eucharist.

Because of the fragility of the vellum, the work of all the calligraphers on the page, and the work already completed on the other side of the sheet (there is significant show-through on this page from Thomas Ingmire's text treatment for 1 Corinthians 11:23-26), there was no possibility of "erasing" or starting over. The solution, as with other omitted lines, was to write it at the bottom and show where it belongs in the text. Hoping not to distract, the correction is made as simply as possible, a delicate box and line pointing to the space where the text belongs.

Finally, Jackson decided to place a bar at the bottom of the page containing the calligrapher's marks of the six scribes who worked on the project. These marks are like seals, artists' signatures with which the calligraphers identify their work. The marks belong, left to right, to Sally Mae Joseph, Angela Swan, Sue Hufton, Brian Simpson, Susan Leiper, and Donald Jackson.

rifice, they sacrifice to demons and not to God. I do not want you to be partners with demons. You cannot drink the cup of the Lord and the cup of demons. You cannot partake of the table of the Lord and the table of demons. Or are we provoking the Lord to jealousy? Are we stronger than he? ■ "All things are lawful," but not all things are beneficial. "All things are lawful," but not all things build up. Do not seek your own advantage, but that of the other. Eat whatever is sold in the meat market without raising any question on the ground of conscience, for "the earth and its fullness are the Lord's." If an unbeliever invites you to a meal and you are disposed to go, eat whatever is set before you without raising any question on the ground of conscience. But if someone says to you, "This has been offered in sacrifice," then do not eat it, out of consideration for the one who informed you, & for the sake of conscience—I mean the other's conscience, not your own. For why should my liberty be subject to the judgment of someone else's conscience? If I partake with thankfulness, why should I be denounced because of that for which I give thanks? ■ So, whether you eat or drink, or whatever you do, do everything for the glory of God. Give no offense to Jews or to Greeks or to the church of God, just as I try to please everyone in everything I do, not seeking my own advantage, but that of many, so that they may be saved. Be imitators of me, as I am of Christ.

11

■ I commend you because you remember me in everything & maintain the traditions just as I handed them on to you. But I want you to understand that Christ is the head of every man, and the husband is the head of his wife, and God is the head of Christ. Any man who prays or prophesies with something on his head disgraces his head, but any woman who prays or prophesies with her head unveiled disgraces her head—it is one and the same thing as having her head shaved. For if a woman will not veil herself, then she should cut off her hair; but if it is disgraceful for a woman to have her hair cut off or to be shaved, she should wear a veil. For a man ought not to have his head veiled, since he is the image & reflection of God; but woman is the reflection of man. Indeed, man was not made from woman, but woman from man. Neither was man created for the sake of woman, but woman for the sake of man. For this reason a woman ought to have a symbol of authority on her head, because of the angels. Nevertheless, in the Lord woman is not independent of man or man independent of woman. For just as woman came from man, so man comes through woman; but all things come from God. Judge for yourselves: is

it proper for a woman to pray to God with her head unveiled? Does not nature itself teach you that if a man wears long hair, it is degrading to him, but if a woman has long hair, it is her glory? For her hair is given to her for a covering. But if anyone is disposed to be contentious—we have no such custom, nor do the churches of God. ■ Now in the following instructions I do not commend you, because when you come together it is not for the better but for the worse. For, to begin with, when you come together as a church, I hear that there are divisions among you; and to some extent I believe it. Indeed, there have to be factions among you, for only so will it become clear who among you are genuine. When you come together, it is not really to eat the Lord's supper. For when the time comes to eat, each of you goes ahead with your own supper, and one goes hungry and another becomes drunk. What! Do you not have homes to eat and drink in? Or do you show contempt for the church of God & humiliate those who have nothing? What should I say to you? Should I commend you? In this matter I do not commend you! ■ For I received from the Lord what I also handed on to you, that the Lord Jesus on the night when he was betrayed took a loaf of bread, and when he had given thanks, he broke it and said, "This is my body that is for you. Do this in remembrance of me." In the same way he took the cup also, after supper, saying, "This cup is the new covenant in my blood. Do this, as often as you drink this bread & drink the cup, you proclaim the Lord's death until he comes. ■ Whoever, therefore, eats the bread or drinks the cup of the Lord in an unworthy manner will be answerable for the body and blood of the Lord. Examine yourselves, and only then eat of the bread and drink of the cup. For all who eat and drink without discerning the body, eat & drink judgment against themselves. For this reason many of you are weak and ill, and some have died. But if we judged ourselves, we would not be judged. But when we are judged by the Lord, we are disciplined so that we may not be condemned along with the world. ■ So then, my brothers and sisters, when you come together to eat, wait for one another. If you are hungry, eat at home, so that when you come together, it will not be for your condemnation. About the other things I will give instructions when I come.

it, in remembrance of me." For as often as you eat

The church at Corinth, comprised of diverse, multiethnic Greek Christians, had a lot of problems. Paul wrote more to this community than to any other, and he advised them, sometimes harshly, on issues ranging from behavior to church practices.

Paul's letters are ecclesial and liturgical as well as theological. They address concrete questions about how to be church, both how to live together (ecclesial) and how to worship together (liturgical). The passage highlighted in this text treatment by Thomas Ingmire is in the context of a longer discussion about how to worship together. Early Christian communities met in people's homes to share the eucharistic meal, a reenactment of the Last Supper, which was itself a Passover meal shared between Jesus Christ and his disciples.

In Corinth, the church was not celebrating the eucharistic meal in the manner that was expected. Rather than gathering together and sharing bread and wine regardless of station in life, there were some who were holding a private, separate meal before the gathering, to which only a chosen few (those with the most status) were invited. At this meal, meat was being served that originated as sacrifices to other gods.

Paul instructs them by giving them liturgical language that reminds the participants of the significance of the eucharistic meal. Some form of this text, either as Paul has recorded it here or as it is found in the gospels of Matthew, Mark, and Luke, is used in virtually all Christian traditions during their celebration of the Eucharist. *The Saint John's Bible* also features an illumination of the words of consecration found in Luke 22:14-20.

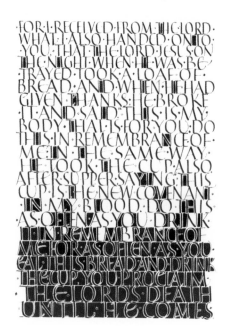

FOR I RECEIVED FROM THE LORD

This text treatment is the final piece we will see in *The Saint John's Bible* by Thomas Ingmire. It is in two parts that convey Paul's specific style of instruction. Paul's words are bold and sometimes absolute. In the first part of the illumination, Paul questions the purpose of any gifts of the Spirit if they are not joined to love. The black text jangles down the right-hand column. Although it is the first part of the passage, the placement on the page makes it feel strident and out of place. It is separated from the well-known litany that begins "Love is patient; love is kind."

Often referred to as the Hymn of Love, this litany is a popular reading at wedding ceremonies. It enumerates the qualities of love and its importance among the values. Ingmire has matched it to the lettering of the passage on the previous page, this time beginning with text saturated in color and moving down the page to more simple text. He also has made a rainbow of the body of the hymn. Packed into the space is some of the most eloquent language in Paul's letters.

Several hymns that Paul has woven into his letters are given special treatment in this volume. These hymns are natural occasions for text treatments, emphasizing the liturgical nature of these letters. The words are probably variations on hymns that were sung by early Christian communities. Paul worshiped with these communities, broke bread with them, baptized them, and also sang hymns of praise to God with them. Other hymns that receive special treatment are found at Ephesians 5:14, Philippians 2:5-11, and Colossians 1:15-20.

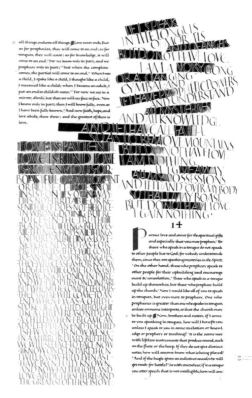

IF I SPEAK IN THE TONGUES OF MORTALS

What surprises you about this illumination?

Before ending this first letter to the Corinthians, Paul points again to the hope of Christians. The sting of death on the previous page is transposed against the soft patterning and words—"we will be changed," the promise of transformation. It is similar to the illumination *Fulfillment of Creation*, which transposed "the wages of sin are death" with the Good News of eternal life.

Hazel Dolby created this illumination and saw in the passage a connection to her earlier illumination *Square before the Watergate* in Nehemiah. As the image in Nehemiah united the people returning from exile, so does this image, with its focus on geometric patterning, suggest an ingathering and transformation in Christ. Here is the ultimate cohesion and unity, with lines of gold suggesting Christ's light. (Note: we will see this theme and a reference to Dolby's work again in the illumination in the book of Revelation, *Vision of the New Jerusalem*.)

Dolby wanted to continue the illumination into the book heading for 2 Corinthians by providing the background. She felt it would further emphasize the movement from bottom to top and from right to left of the transformation. Donald Jackson agreed, and so Dolby painted the background for the book title, and Jackson returned later to add the lettering in gold.

◖ *How would you represent this passage in 1 Corinthians in an image?*

WE WILL BE CHANGED

16

Paul writes to the Christians in Galatia during a time of unrest. These churches have turned away from Paul's teaching of relying on Christ's passion, death, and resurrection for salvation. In this fiery, passionate letter, Paul offers a strong argument to make his point. So we have this compact passage of six verses in which we find key statements by Paul on the role of faith in justification and on the centrality of faith.

Paul's specific ministry was to the Gentiles, which is why he traveled through Galatia in the first place. His vision is of a new community where Gentile and Jew, slave and free, and male and female are united by faith in Jesus. As we saw in the text treatments of Romans 4, his focus on the genealogy from Abraham through Christ opens salvation to all through the death and resurrection of Jesus.

Now before Faith Came

GALATIANS 3:23-29

NOW BEFORE FAITH CAME
WE WERE IMPRISONED
& GUARDED UNDER THE
LAW UNTIL FAITH WOULD
BE REVEALED. THEREFORE
THE LAW WAS OUR
DISCIPLINARIAN UNTIL
CHRIST CAME, SO THAT WE
MIGHT BE JUSTIFIED BY
FAITH. BUT NOW THAT
FAITH HAS COME, WE ARE
NO LONGER SUBJECT TO A
DISCIPLINARIAN, FOR IN
CHRIST JESUS YOU ARE
ALL CHILDREN OF GOD
THROUGH FAITH. AS MANY
OF YOU AS WERE BAPTIZED
INTO CHRIST HAVE
CLOTHED YOURSELVES
WITH CHRIST. THERE IS NO
LONGER JEW OR GREEK
THERE IS NO LONGER
SLAVE OR FREE, THERE IS
NO LONGER MALE AND
FEMALE: FOR ALL OF YOU
ARE ONE IN CHRIST JESUS.
AND IF YOU BELONG TO
CHRIST, THEN YOU ARE
ABRAHAM'S OFFSPRING,
HEIRS ACCORDING
TO THE PROMISE.

NOW BEFORE FAITH CAME

There Is One Body and One Spirit and For Once You Were Darkness

EPHESIANS 4:4-6 /
EPHESIANS 5:8, 14

These text treatments by Hazel Dolby again emphasize the message of unity and salvation for all. Complemented by the gold and purple initial caps and verse markers, the treatments bookend the spread with their light.

The "bookends" serve another purpose here, inviting us to do more than read the highlighted passages. When reading Paul's letters, which are for the most part brief, it is good to dig into the full text. It is best not to rely on a single verse or small group of verses to convey the whole meaning of the letter.

This letter is ecclesial, as Paul instructs the Ephesians to "lead a life worthy of the calling to which you have been called" (4:1). As we read the letter to the Ephesians, we learn more about what it means to "live in the light" as members of one body in Christ.

EPHESIANS 4:4-6

This passage is another example of a hymn in Paul's letters. The text treatment by Suzanne Moore weaves the words "Christ," "Jesus," and "Lord" in fourteen languages into the English translation of the hymn. The hymn itself probably has its origins in earlier Christian hymns. We hear the references to Adam and the Suffering Servant—Old Testament passages that the early Christian community would have seen as prefiguring Christ. It is possible that Paul learned this hymn after his conversion and taught it to the Philippians and other communities as he traveled. An interesting way to experience this hymn is to read it along with the *Suffering Servant* illumination at Isaiah 53 in the *Prophets* volume.

This hymn has two quite beautiful and balanced parts. The first half describes Jesus' position as God who emptied himself and became human, humbled and "obedient to the point of death—even death on a cross" (2:8). The second half turns to resurrection, the position attained by Christ above all and a salvation extended to all people, so that everyone "should confess that Jesus Christ is Lord, to the glory of God the Father" (2:11).

The opening invitation, "Let the same mind be in you that was in Christ Jesus" (2:5), invites the church to share in Jesus' crucifixion and, in so doing, also share in the resurrection.

Are you seeing a pattern in these letters yet? Paul continuously balances death and resurrection, darkness and light, as he invites the early Christians to live in hope and celebrate the gift of Christ's love in very difficult times.

And Every Tongue Should Confess

PHILIPPIANS 2:5-11

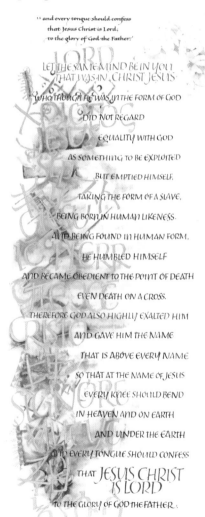

PHILIPPIANS 2:5-11

Index of languages:

English	Lord
Greek	Christ
French	Jesus
Armenian	Lord
Japanese	Christ
Vietnamese	Jesus
Coptic	Jesus
German	Lord
Coptic	Christ
Portuguese	Christ
Chinese	Lord
Italian	Lord
Russian	Jesus
Korean	Lord
Ethiopian	Jesus

HE IS THE IMAGE OF THE
INVISIBLE GOD, THE FIRSTBORN
OF ALL CREATION; FOR IN HIM
ALL THINGS IN HEAVEN AND
ON EARTH WERE CREATED,
THINGS VISIBLE AND INVISIBLE,
WHETHER THRONES OR
DOMINIONS OR RULERS OR
POWERS—ALL THINGS HAVE
BEEN CREATED THROUGH HIM

At the opening of Colossians we find yet another hymn, much like the one in Philippians 2:6-11. This hymn also arranges itself into two parts. This time the first part names Jesus Christ as the firstborn of creation in whom all was created. Rather than the *Suffering Servant*, the Old Testament parallel here is Wisdom, found in the *Wisdom Books* illumination *Seven Pillars of Wisdom* (Prov 8:22–9:6).

Again, the second part of the hymn turns to resurrection. As Jesus is the firstborn of creation, he is also "the firstborn from the dead" (1:18). The hymn stresses again the major points of Jesus' role in creation, the church, and salvation. He is the head of "the body, the church" (1:18) and has reconciled "all things . . . through the blood of his cross" (1:20).

Donald Jackson has written this treatment, and it is worth noting the beauty of the text, the evenness of the execution that, by this final volume, we may be taking for granted. These passages, written after the rest of the text on the page is complete, are less planned and more spontaneous than the daily work of calligraphy in the body of the text. The calligrapher here has to see the line and the whole passage and make decisions, keeping things readable and fresh as the passage unfolds.

For the Lord Himself
and
For Even When We
Were with You

1 THESSALONIANS 4:16-18 /
2 THESSALONIANS 3:10

The letters to the Thessalonians were written very close to-
gether in the early days of Paul's ministry. The story of Paul's
stay in Macedonia and Thessalonica is told in Acts 16 and 17.
The visit was so successful for Paul and his partners, Silas
and Timothy, that they were pretty quickly and continually
run out of town. They left behind a fervent church that was
focused on the Second Coming—so excited, it seems, that
they were neglecting work and the demands of ordinary life
and just waiting.

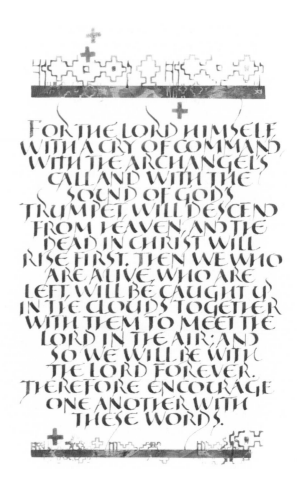

Paul's teaching in these two letters outlines a vision of the Second Coming that has become popularized as the Rapture and Last Judgment.

Certainly the early Christians believed the end of time and establishment of God's permanent kingdom, either in "the skies" or on earth, was imminent. Throughout time, different communities have continued to feel they had identified the date Christ would return, and they check out of life in that belief. In 2011, billboards across America proclaimed that on May 21, 2011, believers would be "taken up" and disappear. Many who believed this went into debt and stopped paying bills, believing the rapture would bring an end to earthly obligations.

The idea that the rapture would involve only a select few is rather recent and not part of church tradition. Paul is talking about the end times, which must be kept within context of all of Paul's writings. All creation is saved. In addition, Christians must always remember what Jesus answers when asked about the end of the world: "But about that day or hour no one knows, neither the angels in heaven, nor the Son, but only the Father" (Mark 13:32).

Paul offers this image of the end times as a source of encouragement, the promise that there will come a time when "we will be with the Lord forever" (1 Thess 4:17). He follows up immediately with the warning that "you yourselves know very well that the day of the Lord will come like a thief in the night" (5:2). His recommendation is that they keep aware and live in the light of salvation.

In his second letter to the Thessalonians, Paul further clarifies. The message that Christ will return is not an excuse for idleness or lawlessness. They are to live in community following Paul's example. "Anyone unwilling to work should not eat" (3:10).

Seeing it starkly on the page as a text treatment by Donald Jackson, one cannot help but think of the monastic community who commissioned this book. *Ora et Labora*, prayer and work, is a key principle of Benedictine living. Only the infirm and elderly are relieved from the work of keeping the community going.

This Is the Covenant

HEBREWS 8:10

Suzanne Moore painted this text treatment, revisiting the theme of covenant we have followed from the Pentateuch through the gospels. In quoting Jeremiah 31:31-34, the author of the letter to the Hebrews uses the Old Testament prophet to make the point that Jesus is "the mediator of a better covenant, which has been enacted through better promises" (8:6).

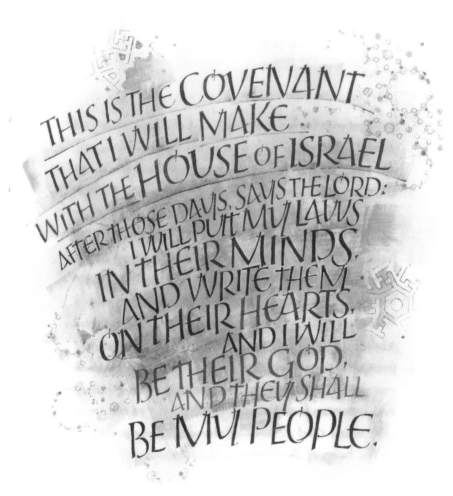

THIS IS THE COVENANT

THE ART OF THE SAINT JOHN'S BIBLE

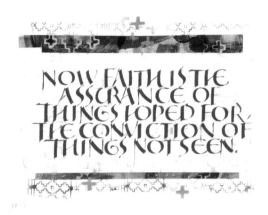

HEBREWS 11:1

This brief text treatment by Donald Jackson focuses the reader's attention on the centrality of faith and the hopefulness of these letters in claiming the promise of eternal life.

This famous verse defining faith is followed by a list of examples of Old Testament figures who exhibited faith and a recounting of the heroic acts and deliverance made possible through faith. Chapter 12 completes the discussion with the claim that Jesus is "the pioneer and perfecter of our faith, who for the sake of the joy that was set before him endured the cross, disregarding its shame, and has taken his seat at the right hand of the throne of God" (12:2). As with so many letters to the early Christian communities, this one exhorts them to follow the example of Christ in the assurance of the gift of eternal life. Again, there is a strong association with the Rule of Benedict and these verses. The Prologue of the Rule ends with these words: "We shall through patience share in the sufferings of Christ that we may deserve also to share in his kingdom."

What Good Is It My
Brothers and Sisters,
But the Wisdom
from Above Is First
Pure, and
Are Any among You
Suffering?

JAMES 2:14-17 / JAMES
3:17-18 / JAMES 5:13-16

Into James's letter are packed three text treatments, all written by Donald Jackson. This brief letter has also been the source of much controversy. Martin Luther felt its author's teachings were in conflict with Paul, particularly claiming that it privileged works over faith.

However, the letter, and particularly these highlighted passages, is full of good instruction for those looking for advice on how to live in the life and light described by Paul. Also, there are a great number of parallels between the letter of James and the Sermon on the Mount in Matthew 5-7.

It is helpful to begin by noticing the Benedictine cross in the margin at verse 2:13, just before the first highlighted passage. This verse is found in chapter 64 of the Rule of Benedict, the chapter on the role of abbot. It is not difficult to see how showing mercy and refraining from judgment would be important to any kind of community life. This verse is in a paragraph in the Rule that begins, "Once in office, the abbot must keep constantly in mind the nature of the burden he has received, and remember to whom he will have *to give an account of his stewardship* (Luke 16:2). Let him recognize that his goal must be profit for the monks, not preeminence for himself" (RB 64.7-8; emphasis in original). As we read the text treatments in James, we realize the importance of acting on our faith and remaining the servants of all. The abbot serves God by showing love to the brothers, just as we serve God in the ways we show love to one another.

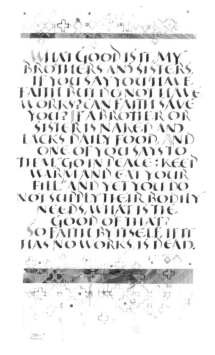

JAMES 2:14-17

The verses in the first text treatment are at the heart of the controversy over faith and works, but one must read beyond the first verse! Read as a whole, the passage sounds like Paul himself talking about the one who speaks in tongues but has no love, or the great teacher who lacks wisdom. It also hearkens back to those Thessalonians

who refused to work because they believed the return of Christ was so imminent. It is a call to social justice, the heart of the commandment in Matthew 28 to feed and clothe the poor, which hearkens back to the prophet Micah's instruction to "do justice" (Mic 6:8), or even further back to Leviticus 19 and the direction to care for the widow, the orphan, the poor, and the alien.

The second passage, James 3:17-18, draws attention to the fruits of wisdom—namely, peace, mercy, gentleness, and truthful living. Again, what you believe and what you do should be in harmony.

Finally, James 5:13-16 gives another model of Christian life in community. The members of the church are to serve one another, confess to one another, anoint one another, and pray with and for one another.

These three passages deepen our understanding of what life in Christ (that very life that has been the subject of Paul's letters) looks like. As a Bible commissioned by a Benedictine community striving to live together as witnesses to the Good News of Christ, these text treatments have even greater resonance.

The Harrowing of Hell

I PETER 3:18–4:11

The harrowing of hell is the traditional name used to describe the redemption of all the people who died before Jesus Christ's incarnation in time. In eternity there is no time; Christ's redemption is for all.

In this illumination, we see yet another depiction of the conclusion of history and the fulfillment of God's kingdom that is at the heart of the letters. For the illumination, Suzanne Moore revisited three of her earlier works for *The Saint John's Bible*: *Calming of the Storm* (Matt 8:23-27), *The Last Judgment* (Matt 24–25), and *Demands of Social Justice* (Amos 3–4). Although all three of these previous works use darkness, chaos, and fragmentation to depict the brokenness of the relationship between God and humanity, the most direct parallels to the current illumination are the two from Matthew's gospel.

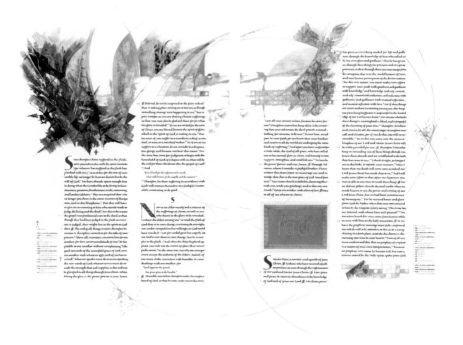

THE HARROWING OF HELL

THE ART OF THE SAINT JOHN'S BIBLE

Moore said the images on the left side "grew unconsciously from other illuminations I have painted." Her inspiration was the "living hell" of Guernica that she used in *The Last Judgment* but also more recent hellish tragedies including Hurricane Katrina and the large-scale devastation of Haiti by an earthquake.

Contrasted to this darkness are the soaring images of paradise. As in her earlier pieces, Moore uses Gothic architecture symbolizing the church, the stamp referred to throughout *The Saint John's Bible* as "sacred geometry," and an image of plant life. "My definition of eternity would have to include a garden," Moore said, "an aesthetic, three-dimensional place, rich with growth and potential." In the openness of the right side of the page, she also invites the viewer to enjoy the possibilities and to "fill in the blank with her/his own definitions of the afterlife."

Notice also the reference to the Rule of Benedict in the margin. 1 Peter 4:11 is found in chapter 57 of the Rule of Benedict, the chapter on artists in the monastery. In this way it is significant to *The Saint John's Bible*, where all the art is meant to give glory to God. This verse also serves as a primary motto and prayer of all Benedictines to this day: "That in all things, God may be glorified" (RB 57.9). This motto is built into the brickwork of the original monastic enclosure of Saint John's Abbey, signified by the Latin initials IOGD (*in omnibus glorificetur Deus*).

The central truth of Christianity—namely, God's love expressed through the life, death, and resurrection of his Son, Jesus Christ, and what it means for Christian life—is eloquently expressed in this final text treatment. We encounter it in *The Saint John's Bible* just before turning to the book of Revelation, wedged between *Harrowing of Hell* and the vivid accounts of the Apocalypse! It can serve as a reminder that these letters concern not just a future promise but also instruction on Christian life in all times.

Looking in the margins, we see two Benedictine crosses marking references found in the Rule of Benedict. 1 John 4:1 is found in chapter 58 about receiving new candidates. In that context, the treatment of those seeking entry to the monastery might seem contrary to Benedictine hospitality, but in reality, being a member of a religious community requires perseverance and a spiritual maturity that are best tested early.

The second reference, 1 John 4:18, is found in chapter 7 of the Rule of Benedict at the close of the long discussion on the twelve steps of humility. The passage reads:

> Now, therefore, after ascending all these steps of humility, the monk will quickly arrive at that *perfect love* of God which *casts out fear* (1 John 4:18). Through this love, all that he once performed with dread, he will now begin to observe without effort, as though naturally, from habit, no longer out of fear of hell, but out of love for Christ, good habit and delight in virtue. All this the Lord will by the Holy Spirit graciously manifest in his workman now cleansed of vices and sins." (RB 7.67-70; emphasis original)

Again, the verses of this text treatment in *The Saint John's Bible* emphasize God's love and the saving action of Christ's sacrifice. The result of this love, the goal of Christians, should be to love one another. "If we love one another, God lives in us, and his love is perfected in us" (4:12).

Reread the vision of the Son of Man in Daniel 7:9-14. What similarities do you see to this vision?

The book of Revelation was written and illuminated entirely by Donald Jackson. He is the scribe of the book and also provided all the visual elements. Although it doesn't have the scale of some other books of the Bible, it certainly has the scope. As the culmination of *The Saint John's Bible* project, the book of Revelation draws on many elements found in previous books of the Bible. The Committee on Illumination and Text (CIT) encouraged Jackson to employ these elements in his effort to bring unity to these pages.

And what a grand opportunity it is! Jackson said in this book that he "turned the volume up full blast," and there is both a richness and intensity to the images and colors. Using the seven colors of the spectrum as in *Prophets*, he hoped "to express the fundamental unity of the visions with roots of imagery in the Old Testament."

Jackson began by laying down color backgrounds, working on all eight spreads at once. Because of that, you will see the shifts in tone even on the two pages without illuminations, through the colors of the capitals and verse markers. You will also notice the expansiveness of the illuminations, which are not isolated on parts of pages or confined to columns but spill even onto the margins.

Such is the case with this first spread, which includes the elaborate book heading, incipit, and a multipaneled illumination. Because Jackson wrote all of Revelation, he was able here and there to adjust the text and space the illuminations accordingly.

The primary reference in this illumination is to the prophecy of the Son of Man in the book of Daniel. The central image of these pages reprises the image of the Son of Man from the *Prophets* volume of *The Saint John's Bible*. The lampstands are taken from the illumination *Vision of Isaiah*, where the prophet Isaiah witnessed God seated on a throne surrounded by lampstands.

Revelation Incipit with the Son of Man

REVELATION 1:1-20

"I am the Alpha and the Omega," says the Lord God, who is and who was and who is to come, the Almighty. (1:8)

Both images have a rich liturgical feel. For this opening illumination of Revelation, the CIT suggested that Jackson recreate the feel of an ornate, incense-filled church. The Revelation to John was written to be proclaimed at churches throughout Asia Minor, and, as such, it is a liturgical book. You will notice the artwork also has a liturgical feel throughout, especially in the first two spreads and the final illumination, *The Great Amen*.

In addition to the visual images from *Prophets*, Jackson used the stamp he made from a textile covered with mirrors that was used for the tree of life in *Wisdom Books* (see Sirach carpet page). We also see here the fish that have been used throughout, most notably in *Loaves and Fishes* (Mark 6:33-44).

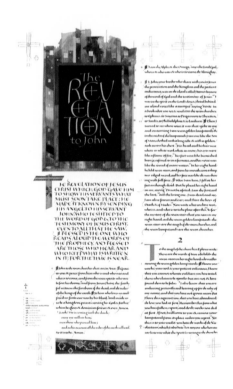

REVELATION INCIPIT WITH THE SON OF MAN

For marginal quotations, Jackson wrote the verse, "'I am the Alpha and the Omega,' says the Lord God" (1:13). He added another verse that describes the state John was in as he received and wrote the letter. As John describes, "I was in the Spirit" (1:10). The verse announces that what we are reading is not a literal experience. As in the visions of the Old Testament prophets, the language is often that of approximation and comparison. I saw "something like . . . ," says John, just as the prophet Ezekiel grasped at language to describe the creatures in his *Vision at the Chebar*. The state of the seer/prophet is also a basis for the enhanced color and imagery that is to come.

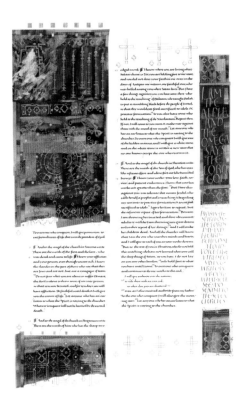

Letter to the Seven
Churches with the
Heavenly Choir

REVELATION 2:1–5:14

*Let anyone who has an ear
listen to what the Spirit is
saying to the churches. (3:22)*

*Which of these messages to the churches resonates with
you? What message of hope do these letters offer?*

Although Revelation is certainly treated as an "open letter" to
all churches, it was written specifically to seven churches in
the western section of Asia Minor. Just like the other letters
in the New Testament, these brief letters offer exhortations,
warnings, and correction. The problems that the churches
were facing in the first century are also recognizable from
the letters by Paul and others: false teaching, persecution,
and complacency.

As biblical scholar Raymond E. Brown points out in his *An
Introduction to the New Testament*:

> Most modern readers who know something about Revelation
> think of persecution as the only issue addressed and conse-
> quently reinterpret the book in the light of threatening situa-
> tions today. The struggle against complacency may be much
> more applicable to modern Christianity. The false teaching is
> very conditioned by the first century in one way (eating meat
> offered to idols), and yet the underlying issue of Christians
> conforming in an unprincipled way to the surrounding society
> remains a very current problem.*

It is important to recognize the first-century context of
this book, as well as its genre—that of apocalyptic and es-
chatological literature—and not to read it literally or apply it
haphazardly to our own time. The illumination balances the
modern and ancient contexts with imagery and color. The
churches are vivid, painted in the rainbow colors of the vi-
sion. They are adorned with crosses that suggest a variety of
cultural traditions. We also see the seven lampstands. At the
bottom is a golden calf representing the casting out of idol
worship as well as its presence as a threat. The churches are
still surrounded by the pagan cults, and the church at Thyatira
is specifically criticized for eating food sacrificed to idols (2:20).

Among the doorways of the churches is the golden arch-
way from the Cathedral of Santiago de Compostela we have

* Brown, *An Introduction to the New Testament*, 782.

seen throughout *The Saint John's Bible*. It is, significantly, stamped on *Vision of the New Temple* in Ezekiel but also in the detail of the tent image in *David Anthology* in *Historical Books*. You'll also find it in black in *Life of Paul* in the book of Acts. All these things—temple, ark, church—will be unified and perfected by the action of this vision.

Following the letters to the churches, the dramatic action of the vision begins. Forming an informal central panel in this illumination is the slain lamb standing atop the scroll with its seven seals. The lamb is the source of hope for the churches, called forth as the only one worthy to open the scroll and usher in the cosmic battle.

Finally, Donald Jackson has painted banners to depict the triumphant song of the heavenly choir in chapter 4. The words

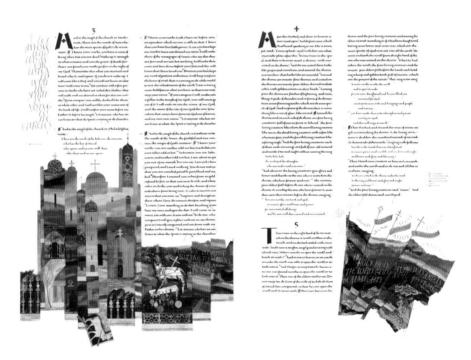

LETTER TO THE SEVEN CHURCHES WITH THE HEAVENLY CHOIR

"Holy, Holy, Holy" are written in Syriac, Greek, and Latin, along with a Greek Orthodox cross and the specific cross used by the Benedictines of Saint John's Abbey. Again, this hymn has resonance with the *Vision of Isaiah*, in which the heavenly choir also sang "Holy, Holy, Holy," a prayer that became one of the earliest pieces of Christian liturgy. In fact, the whole passage describing the elders and angels worshiping God on the throne owes much to the prophetic visions of Ezekiel, Daniel, and Isaiah.

Looking at this piece as a whole, we might be struck by the liturgical feel of the images. In many American Christian churches in recent decades, the sanctuaries have been adorned with brightly colored banners, often depicting the lamb (though not with seven eyes and seven horns!) and words of praise to God. Just as the elders in the vision fully participate in this surreal liturgy, prostrating themselves and "casting their crowns before the throne" (4:10), this illumination invites us to enter in and praise God with our full being.

Of course, the banners here also have a military feel. This panel sets up the movement to the battle depicted in the next two spreads. When the lamb opens the seals, havoc will break out, beginning the final battle between good and evil as the world descends into chaos. However, we already know what side will triumph, and at the center of the restoration will be the lamb that was slain.

THE ART OF THE SAINT JOHN'S BIBLE

What are your associations with the image of the four horsemen of the Apocalypse?

Perhaps no image from Revelation has so entered the popular consciousness as the four horsemen of the Apocalypse. When the lamb, depicted on the left side of the illumination, breaks the first four seals, the four horses and their riders are released: the white horse of conquering war, the red horse of violence, the black horse of famine, and the green horse of death. The horses in this illumination display their banners: bow, sword, scales, and skull and crossbones.

The horses are not alone in this vision—it is a catalog of fearful dark imagery: locusts and pestilence, earthquakes and black clouds, the bodies of slaughtered armies, a bloody moon, and displaced mountains. It is a portrait of environmental, human, and cosmic destruction.

Again, Donald Jackson has brought his modern sensibility to the image, as well as his imagination. He began with images of modern-day cavalry, hulking black tanks coming from both directions.

Jackson doesn't find locusts very scary, so instead he painted in praying mantis figures. The figures from Ezekiel's *Vision at the Chebar* (Ezek 1:1–3:27) are here: the frightening faces and the eagle and lion heads. There are other frightening and frightened eyes emerging from the dark, fiery, bloody landscape. At the center, the bright blue and red swirling soup is made up of microscope images of modern diseases. Down the right side are the bodies, falling and drowned, that appeared in the opening illumination of *Historical Books, Joshua Anthology*—an image of conquest.

Also included in this illumination are images of oil rigs and towers. These images have a twofold resonance for Donald Jackson, given our contemporary context. First, there is the great damage being done to the land in the millennia of human exploitation of natural resources. We blight the land and oceans with powerful rigs for extracting resources. Also, wars often find their root cause in access to these resources.

The Four Horsemen of the Apocalypse

REVELATION 6:1-8

Then I saw the Lamb open one of the seven seals. (6:1)

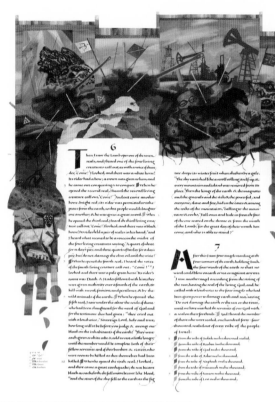

THE FOUR HORSEMEN OF THE APOCALYPSE

Whether it is war in the Middle East or famine, displacement, and war in Africa, oil is often at the heart of the conflict.

Jackson was also completing these pages as Japan struggled to contain and manage the nuclear disaster at its nuclear power plant in Fukushima following the powerful earthquake and tsunami in March 2011. Conscious of the text proclaiming that there was nowhere to hide from this destruction, not even in caves or under the earth (6:15), Jackson was struck by the invisible and pervasive destructive force of radiation. People fled the disaster, but where can we hide from nuclear fallout? To the image he added the triangular signs used to warn of radiation and, in the upper left, a single nuclear tower.

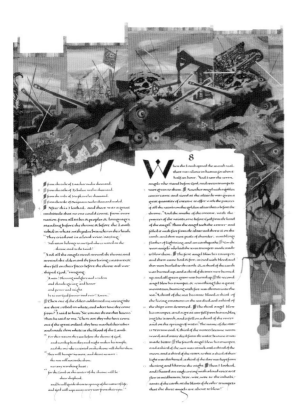

The presence of the divine is also there in the batons sprinkled across the image. However, these are not made of gold leaf or platinum as in other volumes of *The Saint John's Bible*. In Revelation, Jackson used holographic foil. This foil is not a single color but more textured and mirrorlike, reflecting a rainbow of color. It suited his vision of Revelation perfectly, providing a shimmering surface that doesn't always come across in the reproductions. Here it suggests not so much the presence of the divine as the surreal nature of the vision.

❧ *Donald Jackson has substituted some contemporary images for the ones in John's vision. What images might you add to this depiction of a world descending into chaos?*

Woman and the Dragon and the Cosmic Battle

REVELATION 12:1-17

A great portent appeared in heaven: a woman clothed with the sun, with the moon under her feet, and on her head a crown of twelve stars. (12:1)

What do you see in the image of the woman that relates to the story of salvation that unfolds throughout the Bible?

A great narrative plays out in these seventeen verses of chapter 12. Donald Jackson made these notes on the action:

- The woman appears, pregnant (in heaven).
- The dragon appears (in heaven).
- The child is snatched away and taken to God.
- The woman flees.
- The devil is vanquished and hurled to the earth by St. Michael.
- The devil makes war on earth and pursues the woman.
- She is flown to safety by the two wings of a great eagle.

The elements of the story are depicted in two illuminations covering four pages. At their center is the image of the woman and the dragon. The woman is richly clothed, wearing the headdress we saw in the illumination *Esther* in *Historical Books*. The fabric of her clothing includes a reprise of the fabric design on Mary Magdalene's cloak in *The Resurrection* (John 20:1-23). However, the woman is not Esther, Mary Magdalene, Wisdom Woman, or Eve. Neither is she the Virgin Mary nor the church. Rather, she is all the faithful women of our text, and more particular to the allegory in Revelation, she is both Mary and the church. The crown of stars, a reprise of the wisdom tree stamp, surrounds her head. The moon, made of holographic foil, is at her feet. She holds her pregnant belly and looks anxious. Just as Mary gave birth to Christ at a dangerous time in history, so too does the church make Christ present for all times and places.

In the bottom half of the illumination we see the dragon. As depicted by Donald Jackson, the dragon's many faces include human faces with a number of expressions. He meant these to suggest masks and the presence of the evil in all of us. "Do we wear masks behind which parts of ourselves are hidden?" he asks. The devil also has the face of the ten-horned monster from the book of Daniel. Again, this vision has a lot in common with Daniel's vision of the Son of Man. Finally,

we see a reprise of Chris Tomlin's snake from Genesis, "that ancient serpent, who is called the Devil and Satan, deceiver of the whole world" (12:9). The gold lance of St. Michael descends across the image, impaling one of the devil's heads. The lance is itself in the shape of a cross.

Another important piece of the drama is found in the upper left-hand corner, next to chapter 9. Explained by the marginal text, "But her child was snatched away and taken to God and to his throne" (12:5), we find a reprise of the image of the Son of Man from Daniel 7 in *Prophets*. Included in the image is a gold cross, clearly identifying this Son of Man as Jesus. Separated by two pages from the action between the woman and the dragon, the Son of Man has taken his place on the throne of heaven. This image and its placement have special resonance with the apocalyptic moment the first-century Christians held closely. The story unfolding in Revelation is outside of time because, by his death and resurrection, Jesus has already accomplished the victory.

Turning the page, we find a continuation of the narrative in the illumination *The Cosmic Battle*. The devil descends to earth and pursues the woman in war. However, she escapes, represented by the rich fabric of her dress and wings on the right-hand page.

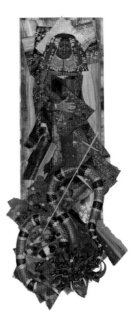

WOMAN AND THE DRAGON

The devil in the form of a snake fills the left half of the illumination. "His angels" are represented here by the praying mantis figures we saw in *The Four Horsemen of the Apocalypse*. The black insects are fitting minions of the devil and blend with the figures of black tanks rolling across the landscape (and maybe also remind us of the skeletons of oil rigs). For the landscape, Jackson used aerial photos of farm fields and also images of a small modern city.

Note how the colors shift slightly in the image of the woman taking flight. Rather than the blue, black, and green of the cosmic battle scene, we see the deep lilac beginning to dominate and the harmonious fields of color. Already the mood is shifting, preparing us for the depiction of the New Jerusalem, the resolution of the battle to renewed creation.

❧ *Where do you see hope in these verses and in the illumination?*

REVELATION 21:1–22:5

*"See, I am making all things
new." (21:5)*

*What elements from other illuminations do you
recognize in this one?*

The great vision finds resolution in this image of the New Je-
rusalem, God's city descending from heaven to earth. It is, like
so many prophetic images, full of metaphors. The description
reminds us of the rebuilding of Jerusalem after exile in Ezra
and Nehemiah. As with the various images of the temple, a
tree and a river are present. And, in fact, this passage in Scrip-
ture reminds us of the instructions for building and rebuild-
ing the temple. However, as John writes, "I saw no temple in
the city, for its temple is the Lord God the Almighty and the
Lamb" (21:22). In fact, this illumination is a place we might

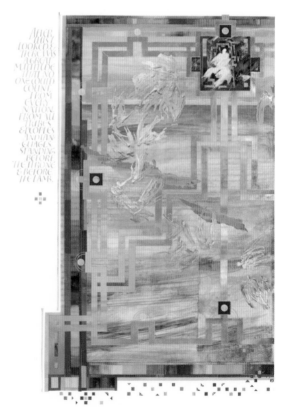

VISION OF THE NEW JERUSALEM

THE ART OF THE SAINT JOHN'S BIBLE

expect to see that gold archway repeated. But it is not here. We have arrived. The Son of Man on the throne inhabits the city.

To capture the images in this passage, Donald Jackson began with a vibrant but more subdued palette of colors. The streets of gold resemble the gold pattern in *Vision of the Son of Man* found in Daniel. Still, the four gates remind us of the temple images. The space includes a triumphant chorus of angels, which are disembodied, more like birds or butterflies than other winged creatures we've seen.

The tree of life is connected to the city and its streets; it bears gold leaves that will heal nations. However, it also stands apart. The design for the tree was adapted from a second-century

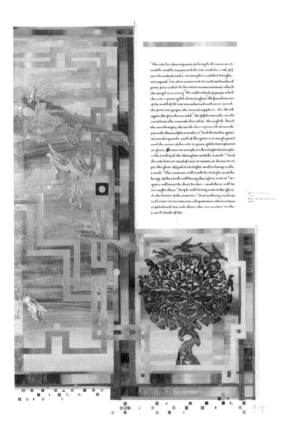

Chinese relief carving. Jackson said he "liked its strength and sobriety in contrast to the radiant celebratory colors of the main New Jerusalem page." In his portrayal, the tree is "rooted" just as the New Jerusalem will be, not a vision of another realm but of a heaven on earth.

The final piece of this illumination was the reprise of the boxes in the lower margin. The design comes from Hazel Dolby's illumination *Square before the Watergate* in the book of Nehemiah.

The CIT requested that Jackson include some image of the people, since the nations and people are so central to the Scripture passage. This is not an otherworldly ideal city but one that is fully inhabited. The people live there by the light reflected by the presence of God, and all good things transpire there. But how to show that in the illumination without adding a portrait of a crowd or something else that would disrupt the unity and simplicity of the vision? Jackson remembered Hazel Dolby's geometric representation of the people entering Jerusalem after the exile at the end of *Historical Books*. He added it to this illumination, where it shows the gathering in of the people, retains the unity that this is ultimately the story of the tribes of Israel, and complements rather than detracts from the vision of the city.

Finally, you will notice the two burnished crosses at the bottom right of the page. On June 18, 2011, Donald and Mabel Jackson presented this illumination to the community of Saint John's Abbey and University in the Abbey Church in College-ville, Minnesota. They processed with the folio through the church during Evening Prayer as part of a celebration of the completion of *The Saint John's Bible*. It was a great liturgical moment, and made one think of Jackson sitting in the pews of the Abbey Church decades earlier, seeing the monks process with the Book of the Gospels before Mass and identifying the monastic community as one that might share his vision of an illuminated Bible. After the procession, Abbot John Klassen, OSB, of Saint John's Abbey and Father Robert Koopmann, OSB, president of Saint John's University, placed the folio on the altar and burnished the two gold Benedictine crosses. This ritual follows a tradition in Judaism whereby the final mark on a new scroll is made by the one who commissioned the work.

The book of Revelation in *The Saint John's Bible* doesn't end with the vision of the New Jerusalem but with a final illumination that ties together the book and again draws attention to its liturgical nature. The colors and text mirror the book title and incipit. Behind this banner of text is a layer from *Vision of the New Jerusalem*. Angels circle a cross, the symbol of salvation.

Notice also the gold voiceprint just above the base of the cross. Voiceprints like these were a regular feature in the *Psalms* volume of *The Saint John's Bible*. There they captured the *schola* of Saint John's Abbey chanting psalms as part of their daily prayer. For this final illumination, Donald Jackson asked Father Robert Koopmann, OSB, president of Saint John's University and an accomplished pianist, if there was a selection of some joyous piece of piano music that could be captured and used

The Great Amen

REVELATION 22:20-21

Come, Lord Jesus! (22:20)

THE GREAT AMEN

in the final illumination. Father Bob recommended a celebratory segment of *"Adoro te Devote"* from his recording *Sacred Improvisations*. Although it is faint on the page, it provides another connection to liturgy and the prayer of the church.

The Saint John's Bible comes to an end with a great Amen and with the hope of Christians, "Come, Lord Jesus!" In liturgy, in our life together as Christians, as we strive to enact justice and mercy within the order of creation, we celebrate and sing.

❧ *How has this consideration of the book of Revelation changed any preconceptions you had?*

BIBLIOGRAPHY

Alexander, Jonathan J. G. *Medieval Illuminators and Their Methods of Work.* New Haven, CT: Yale University Press, 1994.

Backhouse, Janet. *The Illuminated Page: Ten Centuries of Manuscript Painting in the British Library.* Toronto: University of Toronto Press, 1997.

Brown, Michelle P. *Understanding Illuminated Manuscripts: A Guide to Technical Terms.* Los Angeles: Getty Trust Publications, 1994.

Calderhead, Christopher. *Illuminating the Word: The Making of the Saint John's Bible.* Collegeville, MN: Liturgical Press, 2005.

De Hamel, Christopher. *A History of Illuminated Manuscript.* London: Phaidon Press, 1997.

Drogin, Marc. *Medieval Calligraphy: Its History and Technique.* New York: Dover Publications, 1989.

Fingernagel, Andreas, and Christian Gastgeber, eds. *In the Beginning Was the Word: The Power and Glory of Illuminated Bibles.* Los Angeles: Taschen, 2003.

Forest, Jim. *Praying with Icons.* Maryknoll, NY: Orbis Books, 1997.

Hendrix, Lee, and Thea Vignau-Wilberg. *Nature Illuminated: Flora and Fauna from the Court of Emperor Rudolf II.* Los Angeles: Getty Trust Publications, 1997.

Jackson, Donald. *Gospels and Acts. The Saint John's Bible.* Collegeville, MN: Liturgical Press, 2005.

———. *Historical Books. The Saint John's Bible.* Collegeville, MN: Liturgical Press, 2010.

———. *Letters and Revelation. The Saint John's Bible.* Collegeville, MN: Liturgical Press, 2012.

———. *Pentateuch. The Saint John's Bible.* Collegeville, MN: Liturgical Press, 2006.

———. *Prophets. The Saint John's Bible.* Collegeville, MN: Liturgical Press, 2007.

———. *Psalms. The Saint John's Bible.* Collegeville, MN: Liturgical Press, 2006.

———. *Wisdom Books. The Saint John's Bible.* Collegeville, MN: Liturgical Press, 2007.

Kelly, Jerry, and Alice Koeth, eds. *Artist & Alphabet: Twentieth Century Calligraphy and Letter Art in America*. Introduction by Donald Jackson. Boston: David R. Godine Publishers, 2000.

Lovett, Patricia. *Calligraphy and Illumination: A History and Practical Guide*. NY: Harry N. Abrams, 2000.

Nes, Solrunn. *The Mystical Language of Icons*. Grand Rapids, MI: Wm. B. Eerdmans, 2005.

Ouspensky, Leonid. *The Meaning of Icons*. Crestwood, NY: St. Vladimirs Seminary Press, 1999.

Patella, Michael. *Word and Image: The Hermeneutics of* The Saint John's Bible. Collegeville, MN: Liturgical Press, 2013.

Praying the Word: Illuminated Prayers and Wisdom from The Saint John's Bible. Collegeville, MN: Liturgical Press, 2009.

The Saint John's Bible: An Introduction. Collegeville, MN: Liturgical Press, 2008.

Zibawi, Mahhoud. *The Icon: Its Meaning and History*. Collegeville, MN: Liturgical Press, 1993.

For more information on *The Saint John's Bible*, visit the web site: http://saintjohnsbible.org.

APPENDICES

Timeline of *The Saint John's Bible* Project:

1970–1984

Donald Jackson expresses in media interviews his lifetime dream of creating an illuminated Bible.

1995

Following a Saint John's sponsored calligraphy presentation at the Newberry Library in Chicago, Jackson discusses a handwritten Bible with Fr. Eric Hollas, OSB, then-director of the Hill Monastic Manuscript Library at Saint John's University.

1996–1997

Saint John's explores the feasibility of the Bible project; Jackson creates first samples and theologians develop illumination schema.

1998–1999

The Saint John's Bible is officially commissioned, funding opportunities are launched, and the public is introduced to the project.

2000

On March 8, Ash Wednesday, the first words of *The Saint John's Bible* are penned on vellum by Donald Jackson. The verses, from the Gospel of John, mark the beginning of this monumental project. Thus, the first verses are, "In the beginning was the Word, and the Word was with God, the Word was God."

2001

On April 20, in a special ceremony, the first completed volume of *The Saint John's Bible*, *Gospel and Acts*, is revealed to the public.

2003

In August, Donald Jackson arrives to present the second completed volume, *Pentateuch*. The *Pentateuch* is comprised of the first five books of the Old Testament and features the illuminations *Creation*, *Ten Commandments*, and *Death of Moses*.

2004

On April 22, Donald Jackson presents the completed book of *Psalms* at a press conference at the Minneapolis Institute of Arts. This marks the third completed volume.

On May 26, a delegation from Saint John's Abbey and University travels to Rome. Donald Jackson, Abbot John Klassen, OSB, and then–Saint John's University president Br. Dietrich Reinhart, OSB, present the Bible to Pope John Paul II.

2005

Saint John's Abbey and University receive *Prophets*, the fourth volume of *The Saint John's Bible*. The reception coincides with the debut of the national and international tour at the Minneapolis Institute of Arts, April 9 to July 3. The touring exhibition features pages from *Gospels and Acts*, *Psalms*, and *Pentateuch*.

2006

In July, three representatives of Saint John's travel to Monmouth, Wales, to bring *Wisdom Books*, the fifth completed volume, home to Minnesota. Donald Jackson formally presents the volume to the Committee on Illumination and Text at Saint John's on September 28.

Illuminating the Word, the national touring exhibition of *The Saint John's Bible*, is placed on exhibition at the Library of Congress in Washington, DC, from October through December.

2007

The six scribes complete the bulk of the writing for the text of the entire Bible; only the text for the book of Revelation remains to be written. Donald Jackson plans on writing Revelation himself and saves that writing until the end of the project.

On April 1, the *Heritage Edition*, the full-size museum-quality reproduction of *The Saint John's Bible*, officially enters production.

The Saint John's Bible takes its place among other great manuscripts of the world by being exhibited alongside such renowned masterpieces as the *Lindisfarne Gospels* and the *Dead Sea Scrolls*.

2008

On April 4, 2008, His Holiness Pope Benedict XVI is presented with the *Heritage Edition*, *Prophets* of *The Saint John's Bible* and states, "This is a work of art, a great work of art . . . a work for eternity."

The Saint John's Bible national touring exhibition continues with exhibitions in Phoenix, Arizona; Winnipeg, Manitoba; Tacoma, Washington; and Mobile, Alabama.

2009

The bulk of the work on the largest volume in the collection, *Historical Books*, is finished. Two representatives from Saint John's travel to Wales in July to bring 80 percent of this volume home to Saint John's Abbey and University.

The Saint John's Bible is placed on exhibition at the Walter's Art Museum in Baltimore, Maryland. *Wisdom Books* and *Prophets* pages are placed in the historical context of the significant rare book collection of the museum.

2010

In March, Donald Jackson presents the remaining pages of the *Historical Books* volume to the committee at Saint John's. This brings the largest and most challenging volume to completion.

From February to August, *The Saint John's Bible* once again takes its place alongside the *Dead Sea Scrolls* as pages from *Wisdom Books* and *Prophets* are placed on exhibition at the Science Museum of Minnesota in Saint Paul, Minnesota.

Donald Jackson works on *Letters and Revelation*, the seventh and final volume of *The Saint John's Bible*.

2011

On May 9, Donald Jackson pens the final word, "Amen," in *The Saint John's Bible*.

On May 20–21, the entire creative team, spouses, partners, supporters, and two representatives from Saint John's University gather at the Scriptorium in Monmouth, Wales, to view *Letters and Revelation*, the final volume in the collection, and to celebrate the completion and achievement of their work.

Donald and Mabel Jackson present the last volume to the community of Saint John's Abbey and University on June 18 in the Abbey Church during a celebratory prayer service. Abbot John Klassen, abbot of Saint John's Abbey, and Father Robert Koopmann, OSB, then-president of Saint John's University, receive the final page and finish it on the altar of the Abbey Church by each gilding a small Benedictine cross on the corner of the page. This marks *The Saint John's Bible* with the sign of its final home and thus brings the creation phase of the project to completion.

From September 16 to November 13 *The Saint John's Bible* is welcomed back to the Minneapolis Institute of Arts to showcase eighteen pages from the final volume in an exhibition titled *"The Saint John's Bible: Amen!"*

2012

Forty-four pages from *Prophets* and *Wisdom Books* are placed on exhibition at the New Mexico History Museum in Santa Fe, New Mexico, for the entire calendar year.

2013

The completion of the *Heritage Edition*, the full-size museum-quality reproduction of *The Saint John's Bible*, is celebrated on April 26. The 299 sets of the *Heritage Edition* volumes make *The Saint John's Bible* accessible to a wider and ever-growing audience across the world.

Marginalia

2 KINGS 16

2 CHRONICLES 11

GENESIS 4

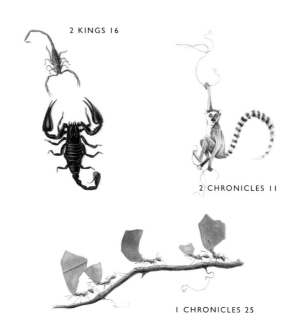

I CHRONICLES 25

Marginalia (cont.)

2 Chronicles 27	Praying Mantis and Banded Damselfly; Both American)	Chris Tomlin
2 Chronicles 36	Harlequin Beetle (*Acrocinus longimanus*); South America	Chris Tomlin
Tobit 14	Wasps	Chris Tomlin
Judith 16	Monarch Butterfly Being Eaten by Whip Spider	Chris Tomlin
1 Maccabees 4	Gold Beetle (*Chrysina resplendens*) and Silver Beetle (*Chrysina bates*); Both Central American	Chris Tomlin
1 Maccabees 11	Glasswing Butterfly (*Greta oto*) and Black Widow Spider (*Latrodectus mactans*)	Chris Tomlin
2 Maccabees 7	Painted Lady Butterfly (*Vanessa cardui*) and Caterpillars; UK	Chris Tomlin
2 Maccabees 15	Chameleon	Chris Tomlin
Wisdom 7	Correction Bee	Chris Tomlin and Sarah Harris
Isaiah 30	Scarab	Chris Tomlin
Jeremiah 17	Two Field Crickets	Chris Tomlin
Jeremiah 35	Cicada	Chris Tomlin

TOBIT 14

I MACCABEES 11

Ezekiel 22	Black Fly	Chris Tomlin
Ezekiel 47:12	Papaya Tree	Sally Mae Joseph
Matthew 10	Dragonfly	Chris Tomlin
Matthew 14	Mandala / arabesque	Andrew Jamieson
Matthew 17	Butterfly	Chris Tomlin
Mark 2	Monk reading	Aidan Hart
Mark 11	"Listen to Him"	Sally Mae Joseph
Acts 12	Butterfly	Chris Tomlin
Acts 20	Moth	Chris Tomlin
1 Corinthians 2–3	Black and White Butterfly (*Nemoptera bipennis*)	Chris Tomlin
2 Corinthians 7	Bee Decoration (Generic Bee, Honey Bee Inspired)	Chris Tomlin
Galatians 3:23-29	Common Butterfly (*Polygonia c-album*)	Chris Tomlin

EZEKIEL 22

EZEKIEL 47

MARK 2

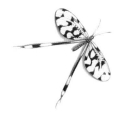

I CORINTHIANS 2–3

Marginalia (cont.)

Colossians 1	Common Blue Butterfly (*Polyommatus Icarus*) on Buddleia Flowers	Chris Tomlin
Hebrews 1	Dragonflies on Yorkshire Fog Grass (*Holcus ianatus*)	Chris Tomlin

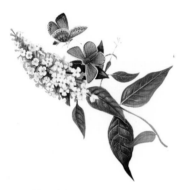

COLOSSIANS I

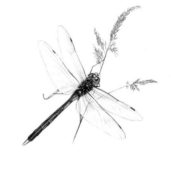

HEBREWS I

Corrections:

Genesis 30	Wisdom 7
Exodus 38	Mark 3
Leviticus 19	
1 Corinthians 11	

Leviticus 19:2 You shall be holy, for I the LORD your God am holy.

Leviticus 19:18 You shall not take vengeance or bear a grudge against any of your people, but you shall love your neighbor as yourself: I am the LORD.

Leviticus 19:34 The alien who resides with you shall be to you as the citizen among you; you shall love the alien as yourself, for you were aliens in the land of Egypt: I am the LORD your God.

Numbers 6:24-26 The LORD bless you and keep you; the LORD make his face to shine upon you, and be gracious to you; the LORD lift up his countenance upon you, and give you peace. *Suzanne Moore*

Numbers 20:12 But the LORD said to Moses and Aaron, "Because you did not trust in me, to show my holiness before the eyes of the Israelites, therefore you shall not bring this assembly into the land that I have given them." *Thomas Ingmire*

Deuteronomy 6:4-5 Hear O Israel: The LORD is our God, the LORD alone. You shall love the LORD your God with all your heart, and with all your soul, and with all your might. *Hazel Dolby*

Deuteronomy 30:19-20 I call heaven and earth to witness against you today that I have set before you life and death, blessings and curses. Choose life so that you and your descendants may live, loving the LORD your God, obeying him, and holding fast to him; for that means life to you and length of days, so that you may live in the land that the LORD swore to give to your ancestors, to Abraham, to Isaac, and to Jacob. *Suzanne Moore*

Excerpts from Joshua 24:8-14 They fought with you, and I handed them over to you, and you took possession of their land. . . . I sent the hornet ahead of you, which drove out before you the two kings of the Amorites; it was not by your sword or by your bow. I gave you a land on which you had not labored, and towns that you had not built, and you live in them; you eat the fruit of vineyards and oliveyards that you did not plant. "Now therefore revere the LORD, and serve him in sincerity and faithfulness." *Donald Jackson*

Judges 2:11 Then the Israelites did what was evil in the sight of the Lord.
All text treatments in the book of Judges are by Donald Jackson

Judges 4:1 The Israelites again did what was evil in the sight of the Lord, after Ehid died.

Judges 6:1 The Israelites did what was evil in the sight of the Lord.

Judges 8:34 The Israelites did not remember the Lord their God, who had rescued them.

Judges 10:6 The Israelites again did what was evil in the sight of the Lord.

Judges 13:1 The Israelites again did what was evil in the sight of the Lord.

Judges 18:1 In those days there was no king in Israel.

Judges 21:25 In those days there was no king in Israel.

Judges 2:18-20 (Found at the end of the Book of Judges) Whenever the Lord raised up judges for them, the Lord was with the judge, and he delivered them from the hand of their enemies all the days of the judge; for the Lord would be moved to pity by their groaning because of those who persecuted and oppressed them. But whenever the judge died, they would relapse and behave worse than their ancestors, following other gods, worshiping them and bowing down to them. They would not drop any of their practices or their stubborn ways. So the anger of the Lord was kindled against Israel.

Ruth 4:17-21 The women of the neighborhood gave him a name, saying, "A son has been born to Naomi." They named him Obed; he became the father of Jesse, the father of David. Now these are the descendants of Perez: Perez became the father of Hezron, Hezron of Ram, Ram of Amminadab, Amminadab of Nahshon, Nahshon of Salmon, Salmon of Boaz, Boaz of Obed, Obed of Jesse, and Jesse of David. *Donald Jackson*

1 Samuel 8:7 And the Lord said to Samuel, "Listen to the voice of the people in all that they say to you; for they have not rejected you, but they have rejected me from being king over them."
All text treatments in the book of 1 Samuel are by Donald Jackson

1 Samuel 13:13 Samuel said to Saul, "You have done foolishly."

שמואל א

sons, has borne him." Then Naomi took the child and laid him in her bosom, and became his nurse. ''The women of the neighborhood gave him a name, saying, "A son has been born to Naomi." They named him Obed; he became the father of Jesse, the father

18 of David. ¶ Now these are the descendants of Perez: Perez became the father of Hezron,''Hezron of Ram, Ram of Amminadab,''Amminadab of Nahshon, Nahshon of Salmon,''Salmon of Boaz, Boaz of Obed, ²¹Obed of Jesse, and Jesse of David.

17 THE WOMEN OF THE NEIGHBORHOOD GAVE HIM A NAME, SAYING, "A SON HAS BEEN BORN TO NAOMI." THEY NAMED HIM OBED; HE BECAME THE FATHER OF JESSE, THE FATHER OF DAVID.'

18 NOW THESE ARE THE DESCENDANTS OF PEREZ: PEREZ BECAME THE FATHER OF HEZRON, HEZRON OF RAM, RAM OF AMMINADAB, AMMINADAB OF NAHSHON, NAHSHON OF SALMON,

21 SALMON OF BOAZ, BOAZ OF OBED, OBED OF JESSE, AND JESSE OF DAVID.'

There was a certain man of Ramathaim, a Zuphite from the hill country of Ephraim, whose name was Elkanah son of Jeroham son of Elihu son of Tohu son of Zuph, an Ephraimite. ²He had two wives; the name of the one was Hannah, and the name of the other Peninnah. Peninnah had children, but Hannah had no children. ¶ Now this man used to go up year by year from his town to worship and to sacrifice to the LORD of hosts at Shiloh, where the two sons of Eli, Hophni and Phinehas, were priests of the LORD. ⁴On the day when Elkanah sacrificed, he would give portions to his wife Peninnah and to all her sons and daughters; ⁵ but to Hannah he gave a double portion, because he loved her, though the LORD had closed her womb. ⁶Her rival used to provoke her severely, to irritate her, because the LORD had closed her womb. ⁷So it went on year by year; as often as she went up to the house of the LORD, she used to provoke her. Therefore Hannah wept and would not eat. ⁸Her husband Elkanah said to her, "Hannah, why do you weep? Why do you not eat? Why is your heart sad? Am I not more to you

9 than ten sons?" ¶ After they had eaten and drunk at Shiloh, Hannah rose and presented herself before the LORD. Now Eli the priest was sitting on the seat beside the doorpost of the temple of the LORD. ¹⁰She was deeply distressed and prayed to the LORD, and wept bitterly. ¹¹She made this vow: "O LORD of hosts, if only you will look on the misery of your servant, and remember me, and not forget your servant, but will give to your servant a male child, then I will set him before you as a nazirite until the day of his death. He shall drink neither wine nor intoxicants, and

12 no razor shall touch his head." ¶ As she continued praying before the LORD, Eli observed her mouth.

a Compare Gk and
1 Chr 6.33–34: Heb
Ramathaim-zophim
b Syr: Meaning of Heb
uncertain
c Gk: Heb lacks and
presented herself before
the LORD
d That is one separated or
one consecrated
e Gk Compare 4QSam
1.22 : MT lacks I will set
him before you and the
days of his life

1 Samuel 13:13 (found at 1 Sam 16) "You have not kept the commandment of the LORD your God."

1 Samuel 17:37 David said, "The LORD, who saved me from the paw of the lion and from the paw of the bear, will save me from the hand of this Philistine."

1 Samuel 28:15 Saul answered, "I am in great distress, for the Philistines are warring against me and God has turned away from me and answers me no more."

1 Samuel 28:17-18 (Found at 1 Sam 31) "The LORD has done to you just as he spoke by me; for the LORD has torn the kingdom out of your hand, and given it to your neighbor, David. Because you did not obey the voice of the LORD."

2 Samuel 12:13 David said to Nathan, "I have sinned against the LORD."

Donald Jackson

Job 19:25 For I know that my Redeemer lives,
 and that at the last he will stand upon the earth.

Diane M. von Arx

Psalm 1 Happy are those
 who do not follow the advice of the wicked,
 or take the path that sinners tread,
 or sit in the seat of scoffers;
 but their delight is in the law of the LORD,
 and on his law they meditate day and night . . .

Psalm 6 O LORD, do not rebuke me in your anger
 or discipline me in your wrath.

Psalm 32 Happy are those whose transgression is forgiven,
 whose sin is covered.

Psalm 38 O LORD, do not rebuke me in your anger,
 or discipline me in your wrath.

Psalm 51 Have mercy on me O God,
 according to your steadfast love;
 according to your abundant mercy
 blot out my transgression.

Psalm 102 Hear my prayer, O Lord;
 let my cry come to you.

Psalm 130 Out of the depths I cry to you, O Lord.

Psalm 143 Hear my prayer, O Lord;
 give ear to my supplications in your faithfulness;
 answer me in your righteousness.

Psalm 150 Praise the Lord!
 Praise God in his sanctuary;
 praise him in his mighty firmament!
 Praise him for his mighty deeds;
 praise him according to his surpassing greatness!
 . . . *Sally Mae Joseph*

Proverbs 1:7-8 The fear of the Lord is the beginning of knowledge;
 fools despise wisdom and instruction.
 Hear, my child, your father's instruction,
 and do not reject your mother's teaching.
 Thomas Ingmire

Ecclesiastes 11:1 Send out your bread upon the waters,
 for after many days you will get it back.
 Diane M. von Arx

ECCLESIASTES 11:1

Isaiah 1:16-17 Wash yourselves; make yourselves clean;
 remove the evil of your doings
 from before my eyes;
 cease to do evil,
 learn to do good;
 seek justice,
 rescue the oppressed,
 defend the orphan,
 plead for the widow. *Sally Mae Joseph*

Isaiah 2:4 He shall judge between the nations,
 and shall arbitrate for many peoples;
they shall beat their swords into plowshares,
 and their spears into pruning hooks;
nation shall not lift up sword against nation,
 neither shall they learn war any more.
 Sally Mae Joseph

Isaiah 40:1-5 Comfort, O comfort, my people,
 says your GOD.
Speak tenderly to Jerusalem,
 and cry to her
that she has served her term,
 that her penalty is paid,
that she has received from the LORD's hand
 double for all her sins.

A voice cries out:
 "In the wilderness prepare the way of the LORD,
 make straight in the desert a highway for our God.
Every valley shall be lifted up,
 and every mountain and hill made low;
the uneven ground shall become level,
 and the rough places a plain.
Then the glory of the LORD shall be revealed,
 and all people shall see it together,
 for the mouth of the LORD has spoken."
 Sally Mae Joseph

Isaiah 49:1-4 Listen to me, O coastlands,
 pay attention, you peoples from far away!
 The Lord called me before I was born,
 while I was in my mother's womb he named me.
 He made my mouth like a sharp sword,
 in the shadow of his hand he hid me;
 he made me a polished arrow;
 in his quiver he hid me away.
 And he said to me, "You are my servant,
 Israel, in whom I will be glorified."
 But I said, "I have labored in vain,
 I have spent my strength for nothing and vanity;
 yet surely my cause is with the Lord,
 and my reward with my God." *Sally Mae Joseph*

Isaiah 60:1-3 Arise, shine; for your light has come,
 and the glory of the Lord has risen upon you.
 For darkness shall cover the earth,
 and thick darkness the peoples;
 but the Lord will arise upon you,
 and his glory will appear over you.
 Nations shall come to your light,
 and kings to the brightness of your dawn.
 Sally Mae Joseph

Isaiah 66:12-13 For thus says the Lord:
 I will extend prosperity to her like a river,
 and the wealth of the nations like an overflowing stream;
 and you shall nurse and be carried on her arm,
 and dandled on her knees.
 As a mother comforts her child,
 so I will comfort you;
 you shall be comforted in Jerusalem. *Thomas Ingmire*

Jeremiah 1:4-10 Now the word of the Lord came to me saying,
 "Before I formed you in the womb I knew you,
 and before you were born I consecrated you;
 I appointed you a prophet to the nations."

Then I said, "Ah, Lord God! Truly I do not know how to
speak, for I am only a boy." But the Lord said to me,
"Do not say, 'I am only a boy';
for you shall go to all to whom I send you,
and you shall speak whatever I command you,
for I am with you to deliver you,
 says the Lord."
Then the Lord put out his hand and touched my mouth;
 and the Lord said to me,
"Now I have put my words in your mouth.
See, today I appoint you over nations and over kingdoms,
to pluck up and to pull down,
to destroy and to overthrow,
to build and to plant." *Sally Mae Joseph*

Micah 6:8 He has told you, O mortal, what is good;
 and what does the Lord require of you
 but to do justice, and to love kindness,
 and to walk humbly with your God. *Sally Mae Joseph*

Wisdom 4:7-9 But the righteous, though they die early, will be at rest.
 For old age is not honored for length of time,
 or measured by number of years;
 but understanding is gray hair for anyone,
 and a blameless life is ripe old age. *Sally Mae Joseph*

Wisdom 6:12 Wisdom is radiant and unfading,
 and she is easily discerned by
 those who love her,
 and is found by those who seek her.
 *(This text receives two special treatments, one found at
 Job 15 by Angela Swan and the other alongside the actual
 verse as part of a longer treatment by Sally Mae Joseph.)*

Wisdom 6:12-18 Wisdom is radiant and unfading,
 and she is easily discerned by those who love her,
 and is found by those who seek her.
 She hastens to make herself known to those who desire her.
 One who rises early to seek her will have no difficulty,
 for she will be found sitting at the gate.

To fix one's thought on her is perfect understanding,
and one who is vigilant on her account will soon be
 free from care,
because she goes about seeking those worthy of her,
and she graciously appears to them in their paths,
and meets them in every thought.

The beginning of wisdom is the most sincere desire
 for instruction,
and concern for instruction is love of her,
and love of her is the keeping of her laws,
and giving heed to her laws is assurance of immortality,
and immortality brings one near to God;
so the desire for wisdom leads to a kingdom.

Sally Mae Joseph

Wisdom 7:26 She is a reflection of eternal light,
 a spotless mirror of the working of God,
 and an image of his goodness.

Susie Leiper (Found at Sirach 35 because
Wisdom 7–8 includes another text treatment
and the full-scale illumination Wisdom Woman)

WISDOM 7:26

Sirach 1:16 To fear the Lord is fullness of wisdom;
 she inebriates mortals with her fruits;
 she fills their whole house with desirable goods,
 and their storehouses with her produce.

Brian Simpson

Sirach 6:14-22 Faithful friends are a sturdy shelter:
 whoever finds one has found a treasure.
 Faithful friends are beyond price;
 no amount can balance their worth.
 Faithful friends are life-saving medicine,
 and those who fear the Lord will find them.
 Those who fear the Lord direct their friendship
 aright,
 for as they are, so are their neighbors also.

SIRACH 1:16

My child, from your youth choose discipline,
and when you have gray hair you will still find wisdom.
Come to her like one who plows and sows,
and wait for her good harvest.
For when you cultivate her you will toil but little,
and soon you will eat of her produce.
She seems very harsh to the undisciplined;
fools cannot remain with her.
She will be like a heavy stone to test them,
and they will not delay in casting her aside.
For wisdom is like her name;
she is not readily perceived by many. *Diane M. von Arx*

Sirach 24:12, 13, 15-17 I took root in an honored people . . .
I grew tall like a cedar in Lebanon . . .
Like cassia and camel's thorn, I gave forth perfume,
and like choice myrrh I spread my fragrance,
like galbanum, onycha, and stacte,
and like the odor of incense in the tent.
Like a terebinth I spread out my branches,
and my branches are glorious and graceful.
Like the vine I bud forth delights,
and my blossoms become glorious and abundant
fruit.
Sue Hufton (Found at Sirach 45 because of the full-
scale illumination Praise of Wisdom *at Sirach 24)*

Sirach 24:19 Come to me, you who desire me,
and eat your fill of my fruits,
for the memory of me is sweeter than honey,
and the possession of me sweeter than the honeycomb.
Sally Mae Joseph (The treatment is found at Sirach 13
because that page includes a full-scale illumination,
Praise of Wisdom*)*

Sirach 33:13 Like clay in the hand of the potter,
to be molded as he pleases,
so all are in the hand of their Maker,
to be given whatever he decides. *Donald Jackson*

Sirach 39:13-15 Listen to me, my faithful children, and blossom
like a rose growing by a stream of water.
Send out fragrance like incense,
and put forth blossoms like a lily.
Scatter the fragrance, and sing a hymn of praise;
bless the Lord for all his works.
Ascribe majesty to his name
and give thanks to him with praise,
with songs on your lips, and with harps;
this is what you shall say in thanksgiving.
Diane M. von Arx

SIRACH 24:12, 13, 15-17

2 Maccabees 12:42-45 And they turned to supplication, praying that the sin that had been committed might be wholly blotted out. The noble Judas exhorted the people to keep themselves free from sin, for they had seen with their own eyes what had happened as the result of the sin of those who had fallen. He also took up a collection, man by man, to the amount of two thousand drachmas of silver, and sent it to Jerusalem to provide for a sin offering. In doing this he acted very well and honorably, taking account of the resurrection. For if he were not expecting that those who had fallen would rise again, it would have been superfluous and foolish to pray for the dead. But if he was looking to the splendid reward that is laid up for those who fall asleep in godliness, it was a holy and pious thought. Therefore he made atonement for the dead, so that they might be delivered from their sin. *Sally Mae Joseph*

Matthew 6:9-13 Our Father in heaven,
 hallowed be your name . . . *Donald Jackson*

Matthew 22:37-40 "You shall love the Lord your God with all your heart, and with all your soul, and with all your mind." This is the greatest and first commandment.
 And a second is like it: "You shall love your neighbor as yourself." On these two commandments hang all the law and the prophets.
 Hazel Dolby

Mark 12:29-31 "Hear, O Israel: the Lord our God, the Lord is one; you shall love the Lord your God with all your heart, and with all your soul, and with all your mind, and with all your strength." The second is this, "You shall love your neighbor as yourself." There is no other commandment greater than these. *Hazel Dolby*

Luke 1:46-55, The Magnificat
 And Mary said,
 "My soul magnifies the Lord,
 and my spirit rejoices in God my Savior,
 for he has looked with favor on the lowliness of his
 servant . . ." *Sally Mae Joseph*

Luke 1:68-79, The Canticle of Zechariah

>"Blessed be the Lord God of Israel,
>> for he has looked favorably on his people and
>> redeemed them.
>
> He has raised up a mighty savior for us
>> in the house of his servant, David,
> as he spoke through the mouth of his holy prophets from
> of old,
>> that we would be saved from our enemies and from the
>> hand of all who hate us. . . ."

Luke 2:14 "Glory to God in the highest heaven,
> and on earth peace among those whom he favors!"

Sally Mae Joseph

Luke 2:28-32, Canticle of Simeon

>"Master, now you are dismissing your servant in peace,
>> according to your word;
> for my eyes have seen your salvation,
>> which you have prepared in the presence of all peoples,
> a light for revelation to the Gentiles
>> and for glory to your people Israel." *Hazel Dolby*

Luke 10:27 "You shall love the Lord your God with all your heart, and
with all your soul, and with all your strength, and with all your mind;
and your neighbor as yourself." *Hazel Dolby*

Luke 23:46 "Father, into your hands I commend my spirit."

Romans 4:3 For what does the scripture say? "Abraham believed God, and
it was reckoned to him as righteousness." *Donald Jackson*

Romans 4:16-17 For this reason it depends on faith, in order that the
promise may rest on grace and be guaranteed to all his descendants,
not only to the adherents of the law but also to those who share the
faith of Abraham (for he is the father of all of us, as it is written, "I
have made you the father of many nations")—in the presence of the
God in whom he believed, who gives life to the dead and calls into
existence the things that do not exist. *Donald Jackson*

Romans 5:1-21 Therefore, since we are justified by faith, we have peace with God through our Lord Jesus Christ, through whom we have obtained access to this grace in which we stand; and we boast in our hope of sharing the glory of God. And not only that, but we also boast in our sufferings, knowing that suffering produces endurance, and endurance produces character, and character produces hope, and hope does not disappoint us, because God's love has been poured into our hearts through the Holy Spirit that has been given to us.

For while we were still weak, at the right time Christ died for the ungodly. Indeed, rarely will anyone die for a righteous person—though perhaps for a good person someone might actually dare to die. But God proves his love for us in that while we still were sinners Christ died for us. Much more surely then, now that we have been justified by his blood, will we be saved through him from the wrath of God. For if while we were enemies, we were reconciled to God through the death of his Son, much more surely, having been reconciled, will we be saved by his life. But more than that, we even boast in God through our Lord Jesus Christ, through whom we have now received reconciliation.

Therefore, just as sin came into the world through one man, and death came through sin, and so death spread to all because all have sinned—sin was indeed in the world before the law, but sin is not reckoned when there is no law. Yet death exercised dominion from Adam to Moses, even over those whose sins were not like the transgression of Adam, who is a type of the one who was to come.

But the free gift is not like the trespass. For if the many died through the one man's trespass, much more surely have the grace of God and the free gift in the grace of the one man, Jesus Christ, abounded for the many. And the free gift is not like the effect of the one man's sin. For the judgment following one trespass brought condemnation, but the free gift following many trespasses brings justification. If, because of the one man's trespass, death exercised dominion through that one, much more surely will

those who receive the abundance of grace and the free gift of righteousness exercise dominion in life through the one man, Jesus Christ.

Therefore just as one man's trespass led to condemnation for all, so one man's act of righteousness leads to justification and life for all. For just as by the one man's disobedience the many were made sinners, so by the one man's obedience the many will be made righteous. But law came in, with the result that the trespass multiplied; but where sin increased, grace abounded all the more, so that, just as sin exercised dominion in death, so grace might also exercise dominion through justification leading to eternal life through Jesus Christ our Lord. *Donald Jackson*

Romans 6:22-23 But now that you have been freed from sin and enslaved to God, the advantage you get is sanctification. The end is eternal life. For the wages of sin is death, but the free gift of God is eternal life in Christ Jesus our Lord. *Thomas Ingmire*

Romans 11:17-24 But if some of the branches were broken off, and you, a wild olive shoot, were grafted in their place to share the rich root of the olive tree, do not boast over the branches. If you do boast, remember that it is not you that support the root, but the root that supports you. You will say, "Branches were broken off so that I might be grafted in." That is true. They were broken off because of their unbelief, but you stand only through faith. So do not become proud, but stand in awe. For if God did not spare the natural branches, perhaps he will not spare you. Note then the kindness and the severity of God: severity toward those who have fallen, but God's kindness toward you, provided you continue in his kindness; otherwise you also will be cut off. And even those of Israel, if they do not persist in unbelief, will be grafted in, for God has the power to graft them in again. For if you have been cut from what is by nature a wild olive tree and grafted, contrary to nature, into a cultivated olive tree, how much more will these natural branches be grafted back into their own olive tree. *Donald Jackson*

1 Corinthians 11:23-26 For I received from the Lord what I also handed on to you, that the Lord Jesus on the night when he was betrayed took a loaf of bread, and when he had given thanks, he broke it and said, "This is my body that is for you. Do this in remembrance of me." In the same way he took the cup also, after supper, saying, "This cup is the new covenant in my blood. Do this, as often as you drink it, in remembrance of me." For as often as you eat this bread and drink the cup, you proclaim the Lord's death until he comes. *Thomas Ingmire*

1 Corinthians 13:1-13 If I speak in the tongues of mortals and of angels, but do not have love, I am a noisy gong or a clanging cymbal. And if I have prophetic powers, and understand all mysteries and all knowledge, and if I have all faith, so as to remove mountains, but do not have love, I am nothing. If I give away all my possessions, and if I hand over my body so that I may boast, but do not have love, I gain nothing. Love is patient; love is kind; love is not envious or boastful or arrogant or rude. It does not insist on its own way; it is not irritable or resentful; it does not rejoice in wrongdoing, but rejoices in the truth. It bears all things, believes all things, hopes all things, endures all things. Love never ends. But as for prophecies, they will come to an end; as for tongues, they will cease; as for knowledge, it will come to an end. For we know only in part, and we prophesy only in part; but when the complete comes, the partial will come to an end. When I was a child, I spoke like a child, I thought like a child, I reasoned like a child; when I became an adult, I put an end to childish ways. For now we see in a mirror, dimly, but then we will see face to face. Now I know only in part; then I will know fully, even as I have been fully known. And now faith, hope, and love abide, these three; and the greatest of these is love. *Thomas Ingmire*

I CORINTHIANS 13:1-13

Galatians 3:23-29 Now before faith came, we were imprisoned and guarded under the law until faith would be revealed. Therefore the law was our disciplinarian until Christ came, so that we might be justified by faith. But now that faith has come, we are no longer subject to a disciplinarian, for in Christ Jesus you are all children of God through faith. As many of you as were baptized into Christ have clothed your-selves with Christ. There is no longer Jew or Greek, there is no longer slave or free, there is no longer male and female; for all of you are one in Christ Jesus. And if you belong to Christ, then you are Abraham's offspring, heirs according to the promise. *Donald Jackson*

Ephesians 4:4-6 There is one body and one Spirit, just as you were called to the one hope of your calling, one Lord, one faith, one baptism, one God and Father of all, who is above all and through all and in all.
Hazel Dolby

Ephesians 5:8, 14 For once you were darkness, but now in the Lord you are light. Live as children of light . . . for everything that becomes visible is light. Therefore it says,
> "Sleeper, awake!
> Rise from the dead,
> and Christ will shine on you." *Hazel Dolby*

those who are disobedient.' Therefore do not be
associated with them.' For once you were darkness,
but now in the Lord you are light. Live as children

FOR ONCE YOU WERE
DARKNESS BUT NOW IN THE LORD YOU ARE LIGHT LIVE AS
CHILDREN OF LIGHT · FOR EVERYTHING THAT BECOMES
VISIBLE IS LIGHT THEREFORE IT SAYS · SLEEPER AWAKE!
RISE FROM THE DEAD AND CHRIST WILL SHINE ON YOU ·

EPHESIANS 5:8, 14

Philippians 2:5-11 Let the same mind be in you that was in Christ Jesus,
who, though he was in the form of God,
did not regard equality with God
as something to be exploited,
but emptied himself,
taking the form of a slave,
being born in human likeness.
And being found in human form,
he humbled himself
and became obedient to the point of death—
even death on a cross.
Therefore God also highly exalted him
and gave him the name
that is above every name,
so that at the name of Jesus
every knee should bend,
in heaven and on earth and under the earth,
and every tongue should confess
that Jesus Christ is Lord,
to the glory of God the Father. *Donald Jackson*

Colossians 1:15-20 He is the image of the invisible God, the firstborn of all creation; for in him all things in heaven and on earth were created, things visible and invisible, whether thrones or dominions or rulers or powers—all things have been created through him and for him. He himself is before all things, and in him all things hold together. He is the head of the body, the church; he is the beginning, the firstborn from the dead, so that he might come to have first place in everything. For in him all the fullness of God was pleased to dwell, and through him God was pleased to reconcile to himself all things, whether on earth or in heaven, by making peace through the blood of his cross. *Donald Jackson*

1 Thessalonians 4:16-18 For the Lord himself, with a cry of command, with the archangel's call and with the sound of God's trumpet, will descend from heaven, and the dead in Christ will rise first. Then we who are alive, who are left, will be caught up in the clouds together with them to meet the Lord in the air; and so we will be with the Lord forever. Therefore encourage one another with these words.

<div align="right">Donald Jackson</div>

2 THESSALONIANS 3:10

2 Thessalonians 3:10 For even when we were with you, we gave you this command: Anyone unwilling to work should not eat. *Donald Jackson*

Hebrews 8:10 This is the covenant that I will make with the house of Israel
after those days, says the Lord:
I will put my laws in their minds,
and write them on their hearts,
and I will be their God,
and they shall be my people.

<div align="right">Suzanne Moore</div>

Hebrews 11:1 Now faith is the assurance of things hoped for, the conviction of things not seen. *Donald Jackson*

James 2:14-17 What good is it, my brothers and sisters, if you say you have faith but do not have works? Can faith save you? If a brother or sister is naked and lacks daily food, and one of you says to them, "Go in peace; keep warm and eat your fill," and yet you do not supply their bodily needs, what is the good of that? So faith by itself, if it has no works, is dead.

<div align="right">Donald Jackson</div>

HEBREWS 11:1

James 3:17-18 But the wisdom from above is first pure, then peaceable, gentle, willing to yield, full of mercy and good fruits, without a trace of partiality or hypocrisy. And a harvest of righteousness is sown in peace for those who make peace. *Donald Jackson*

James 5:13-16 Are any among you suffering? They should pray. Are any cheerful? They should sing songs of praise. Are any among you sick? They should call for the elders of the church and have them pray over them, anointing them with oil in the name of the Lord. The prayer of faith will save the sick, and the Lord will raise them up; and anyone who has committed sins will be forgiven. Therefore confess your sins to one another, and pray for one another, so that you may be healed. The prayer of the righteous is powerful and effective. *Donald Jackson*

1 John 4:7-12 Beloved, let us love one another, because love is from God; everyone who loves is born of God and knows God. Whoever does not love does not know God, for God is love. God's love was revealed among us in this way: God sent his only Son into the world so that we might live through him. In this is love, not that we loved God but that he loved us and sent his Son to be the atoning sacrifice for our sins. Beloved, since God loved us so much, we also ought to love one another. No one has ever seen God; if we love one another, God lives in us, and his love is perfected in us. *Donald Jackson*

Index of Artists

ILLUMINATORS

Donald Jackson (Artistic Director and Illuminator—Monmouthshire, Wales)

One of the world's leading calligraphers, Donald Jackson is the artistic director and illuminator of *The Saint John's Bible*. From his scriptorium in Wales, he oversees scribes, artists, and craftsmen who work with him on the handwriting and illumination of this seven-volume, 1,150-page book. His studio/workshop is the only calligraphy atelier in the United Kingdom where artist calligraphers are still regularly employed as assistants, maintaining the highest traditions of this ancient art in a modern context.

From an early age, Jackson sought to combine the use of the ancient techniques of the calligrapher's art with the imagery and spontaneous letter forms of his own time. As a teenager, his first ambition was to be "The Queen's Scribe" and a close second was to inscribe and illuminate the Bible. His talents were soon recognized and his ambitions fulfilled.

At the age of twenty, while still a student himself, Jackson was appointed a visiting lecturer (professor) at the Camberwell College of Art, London. Within six years, he became the youngest artist calligrapher chosen to take part in the Victoria and Albert Museum's first International Calligraphy Show after the war and appointed a scribe to the Crown Office at the House of Lords. As a scribe to Her Majesty Queen Elizabeth II, he was responsible for the creation of official state documents. In conjunction with a wide range of other calligraphic projects, he executed Historic Royal documents under The Great Seal and Royal Charters. In 1985, he was decorated by the Queen with the Medal of the Royal Victorian Order (MVO) which is awarded for personal services to the Sovereign.

Jackson is an elected Fellow and past chairman of the prestigious Society of Scribes and Illuminators and in 1997 was named Master of six-hundred-year-old Guild of Scriveners of the city of London. His personally innovative work and inspirational teaching, together with books, a film series, and exhibitions in Europe, North America, Puerto Rico, Australia, and China, have led to his being widely acknowledged as a seminal influence on the growth of Western calligraphy over the past twenty-five years. In 1980, he wrote *The Story of Writing*, which has since been published in many editions and seven languages. His thirty-year retrospective exhibition, *Painting with Words*, premiered at the Minneapolis Institute of

Arts in Minneapolis, Minnesota, in August 1988 and traveled to thirteen museums and galleries.

Since the time of his first lectures in New York and Puerto Rico (1968), Donald Jackson has had a very stimulating influence on the growth of modern Western calligraphy in the United States through the many workshops and lectures he has given. It was the first of the International Assembly of Lettering Artists seminars, inspired by Jackson, that brought him to Saint John's Abbey and University for the first time in 1981. He has since attended and lectured at several other of these annual assemblies, including those held at Saint John's in 1984 and 1990. Jackson returned to Saint John's in the summer of 1996 to serve as one of the keynote speakers at *Servi Textus*: The Servants of the Text, a symposium that included a calligraphy exhibition featuring Jackson's work along with that of other artists, many of whom were his past students and past associates of his atelier.

Interpretive illuminations, incipits, and special treatments in these volumes are the work of Donald Jackson, unless otherwise noted below. Jackson wrote and illuminated the entire book of Revelation.

Hazel Dolby (Illuminator—Hampshire, England)

Trained at Camberwell Art College, London, and later at the Roehampton Institute with Ann Camp, Dolby is a Fellow of the Society of Scribes and Illuminators (FSSI). She is a lecturer at University of Roehampton, teaching art and drawn and painted lettering, and teaches workshops in Europe and the United States. Her work is in various collections, including the Poole Museum and the Crafts Study Centre, London.

Deuteronomy 6:4-5	"Hear, O Israel"
1 Samuel 3:1-18	Call of Samuel
1 Kings 3:16-28	Wisdom of Solomon
Nehemiah 8:1-12	Square before the Watergate
Proverbs 31	Hymn to a Virtuous Woman
Zechariah 9–10	"Rejoice!"
Matthew 22	"You Shall Love the Lord"
Mark 12	"Hear, O Israel"
Luke 2	"Master Now You Are"
Luke 10	"You Shall Love the Lord"

1 Corinthians 15:50-58	At the Last Trumpet
2 Corinthians	Book heading
	Contribution to piece by Donald Jackson
Ephesians 4:4-6	There Is One Body and One Spirit
Ephesians 5:8-14	For Once You Were Darkness

Sarah Harris (Studio Manager—Abergavenny, Wales)

Attended the University of Portsmouth where she studied art, design, and media, specializing in illustration. She graduated in July 2001 and moved back to Wales, where she became assistant manager of a country hotel. Sarah joined the scriptorium team in October 2002 as a studio assistant and is now the studio manager and a contributing artist.

Song of Solomon 7–8	Butterflies
	Contribution to work by Donald Jackson
Wisdom 7	Correction Bee Pulley System
	With Christ Tomlin

Aidan Hart (Iconographer—Shropshire, Wales)

Studied in New Zealand, the United Kingdom, and Greece. He was a full-time sculptor in New Zealand before returning to the United Kingdom in 1983. Since then he has worked as a full-time iconographer. Hart is a member of the Orthodox Church, and his work is primarily panel icons but also includes church frescoes, illuminations on vellum, and carved work in stone and wood. His work is in collections in over fifteen countries of the world. He has contributed to numerous publications. Visiting tutor at the Prince's School of Traditional Arts, London.

Deuteronomy 33	Death of Moses
	Collaboration with Donald Jackson
2 Kings 2:1-14	Elijah and the Fiery Chariot
	Collaboration with Donald Jackson
2 Kings 4–6	Elisha and the Six Miracles
	Collaboration with Donald Jackson
Daniel 7:1-28	Vision of the Son of Man
	Contribution to piece by Donald Jackson
Mark 1	Decoration

Mark 9	Transfiguration
	Collaboration with Donald Jackson
Luke 15	Anthology
	Contributions to image by Donald Jackson
John 8	Woman Taken in Adultery
	With contributions from Donald Jackson and
	Sally Mae Joseph
Acts 4	Life in Community
	Collaboration with Donald Jackson

Thomas Ingmire (Illuminator—San Francisco, California)

Trained as a landscape architect at Ohio State University and University of California, Berkeley, before beginning the study of calligraphy and medieval painting techniques in the early seventies. He is the first foreign member to be elected, in 1977, a Fellow of the Society of Scribes and Illuminators (FSSI). Ingmire teaches throughout the United States, Canada, Australia, Europe, Japan, and Hong Kong. He has exhibited widely in the United States. His work is in many public and private collections throughout the world, including San Francisco Public Library's Special Collections; The Newberry Library, Chicago; and the Victoria and Albert Museum, London.

Exodus 20	Ten Commandments
Numbers 20:12	"You Did Not Trust"
Numbers 21:8	A Poisonous Serpent
1 Samuel 1:11; 2:1-10	Hannah's Prayer
2 Samuel 1:19-27	David's Lament (How the Mighty Have Fallen)
Job 38	Out of the Whirlwind: Where Were You
Job 40	Out of the Whirlwind: Now My Eye Sees You
Job 42	He Will Wipe Every Tear
Proverbs 1:7-8	The Fear of the Lord Is the Beginning of Knowledge
Isaiah 6	Messianic Predictions
Isaiah 66:3-13	As a Mother Comforts Her Child
Wisdom 1:16–2:24	Let Us Lie in Wait

Matthew 5	Sermon on the Mount
John 6	The "I AM" Sayings
Romans 6:22-23	But Now That You Have Been Freed from Sin
Romans 8:1-39	Fulfillment of Creation
1 Corinthians 11:23-26	For I Received from the Lord
1 Corinthians 13:1-13	If I Speak in the Tongues of Mortals

Andrew Jamieson (Illuminator—Somerset, England)

Trained at Reigate School of Art and Design, specializing in heraldry and calligraphy and manuscript illumination. He works as a heraldic artist and illustrator. His work is in public and private collections in Europe and the United States.

Matthew 14	Middle Eastern Arabesque
Acts 27	"To the Ends of the Earth"
	Contribution to image by Donald Jackson
Acts 28	"You Will Be My Witnesses"
	Contribution to image by Donald Jackson

Sally Mae Joseph (Scribe/Illuminator and Senior Artistic Consultant—Sussex, England)

Studied illumination, calligraphy, and heraldry at Reigate School of Art and Design and calligraphy, applied lettering, and bookbinding at the Roehampton Institute, London. Fellow of the Society of Scribes and Illuminators (FSSI). She has exhibited and lectured in Europe and the United States. She has contributed articles to numerous publications. She was a lecturer at Roehampton Institute from 1991 to 1993. Her work is in many public and private collections.

Genesis 50	Carpet Page
Leviticus 19:2	"You Shall Be Holy"
Leviticus 19:18	"You Shall Not Take Vengeance"
Leviticus 19:34	"The Alien Who Resides"
Deuteronomy 33	Death of Moses
	Contribution to piece by Donald Jackson in collaboration with Aidan Hart
Deuteronomy 34	Menorah Decoration

Suzanne Moore (Illuminator—Vashon Island, Washington)

Earned a BFA in printmaking and drawing at the University of Wisconsin at Eau Claire, followed by the study of lettering and book design. She began creating manuscript books in the early 1980s and melds traditional scribal techniques with contemporary aesthetics in her book work. Moore has taught and exhibited widely, and her books have been acquired for private and public collections in the United States and Europe, including the Pierpont Morgan Library; the Library of Congress; and the James S. Copley Library, La Jolla, California.

Numbers 6:24	"The Lord Bless You"
Deuteronomy 30:19-20	"Choose Life"
Amos 4	Demands of Social Justice
Ruth 1:16-18	Ruth and Naomi
Ruth 2:2-23	Ruth the Gleaner
2 Kings 22:1-20	The Prophetess Huldah
2 Kings 23:1-3	Scroll Detail
Sirach 24	Praise of Wisdom
Matthew 9	Calming the Storm
Matthew 24	Last Judgment
Philippians 2:5-11	And Every Tongue Should Confess
Hebrews 8:10	This Is the Covenant
1 Peter 3:18–4:11	Harrowing of Hell

Chris Tomlin (Natural History Illustrator—London, England)

Trained at the Royal College of Art, London, studying natural history illustration. He has worked for Oxford University Press and the National Trust, as well as other publishers. He also studies flora and fauna in the field on expeditions as far from home as Minnesota and Madagascar, where he has worked in the rainforest recording endangered species.

Genesis 2	Garden of Eden
	Contributions to piece by Donald Jackson
Genesis 3	Adam and Eve
	Contributions to piece by Donald Jackson
Genesis 4–6	Butterflies

2 Corinthians 7	Generic Bee (inspired by the honeybee)
Colossians 1	Common Blue Butterfly on Buddleia Flowers
Hebrews 1	Dragonflies on Yorkshire Fog Grass

Diane M. von Arx (Calligrapher—Minneapolis, Minnesota)

A native Minnesotan, Diane von Arx has been a graphic designer for over thirty years, specializing in creative lettering, calligraphy, and corporate identity. She conducts workshops throughout the United States and Canada and has taught in Japan and Australia. She has published three beginning calligraphy workbooks, and her work has been included in numerous exhibitions and private collections. She also designed the logos for the traveling exhibitions of *The Saint John's Bible* and the titling for the documentary of the project.

Job 19:25	For I Know That My Redeemer Lives
Ecclesiastes 11:1	Send out Your Bread upon the Waters
Sirach 6:14-22	Faithful Friends
Sirach 39:13-15	Listen

SCRIBES

Sue Hufton (London, England)

Trained at the Roehampton Institute, London, studying calligraphy and bookbinding. Fellow of the Society of Scribes and Illuminators (FSSI). Lecturer at the University of Roehampton, teaching calligraphy and bookbinding. Teaches in Europe, Canada, and Australia and has led calligraphic retreats to Holy Island (Lindisfarne), United Kingdom. Editor of the SSI journal, *The Scribe*, and has contributed articles to other publications.

Pentateuch, Gospels and Acts, and all running heads

Prophets and *Wisdom Books* (prose text); Sirach 24:12, 13, 15-17; English running heads

Historical Books and *Letters* (prose text); English running heads in *Historical Books*

Donald Jackson (See Biography Above)

> *Pentateuch, Gospels and Acts, Psalms* Book 3 (73–89) and Book 4 (90–106)
>
> *Prophets* and *Wisdom Books* (prose text and poetry text); book titles; capitals; Greek running heads
>
> *Letters and Revelation* (prose text); all capital letters; all book titles; all incipits; all titles of additions in Esther

Sally Mae Joseph (See Biography Above)

> *Pentateuch, Gospels and Acts, Psalms* Book 2 (42–72) and Book 5 (107–50)
>
> *Prophets* and *Wisdom Books* (poetry text); Sirach 24:19
>
> *Historical Books* and *Letters* (prose text)

Susan Leiper (Edinburgh, Scotland)

Born and brought up in Glasgow, Scotland. Studied French at the University of St. Andrews and History of Art at the Courtauld Institute of Art in London. After calligraphy classes in Hong Kong and Edinburgh, Leiper completed the Advanced Training Scheme with the Society of Scribes and Illuminators, of which she is now a Fellow (FSSI). She has undertaken commissions for major institutions, including the British Museum, the National Museums of Scotland, and the BBC, and she contributed to the *Great Book of Gaelic*. She also edits books on Chinese art, which is the main source of inspiration in her own work. She lives in Edinburgh with her husband and four children.

> *Prophets* and *Wisdom Books* (prose text); Wisdom of Solomon 7:26
>
> *Historical Books* and *Letters* (prose text)

Izzy Pludwinski (Jerusalem, Israel)

Started out as a certified religious scribe (*Sofer* STaM) and branched out to calligraphy and design. He studied at the Roehampton Institute, where he completed the certificate in Calligraphy and Design. He has taught in both London and Israel.

> Hebrew running heads in *Pentateuch, Historical Books, Wisdom Books,* and *Prophets*; consultant for all Hebrew writing

Izzy Pludwinski and Donald Jackson did the Hebrew lettering that is extensively found in Pentateuch. Christopher Calderhead supplied some of the Hebrew text on the notes.

Brian Simpson (Leicestershire, England)

Studied calligraphy and heraldry (a fellow student of Donald Jackson) at Central School for Arts and Crafts, London, with Irene Wellington and Mervyn Oliver. He worked as a lettering artist and graphic designer for forty-nine years. Now he concentrates on calligraphy and heraldic art.

> Pentateuch, Gospels and Acts, Psalms Book 1 (1–41), and all chapter numbers and Psalm numbers
>
> Prophets and Wisdom Books (poetry text); all chapter numbers; capitals; Sirach 1:16
>
> Historical Books and Letters (prose text); all chapter numbers; all Greek running heads in Historical Books

Angela Swan (Abergavenny, Wales)

Studied calligraphy and bookbinding at the Roehampton Institute from 1985 to 1988. She was an assistant to Donald Jackson in Monmouth, Wales, for three years. Angela works as a freelance calligrapher. She teaches and exhibits in the United Kingdom and has contributed to various books and publications.

> Wisdom Books (prose text); Wisdom of Solomon 6:12
>
> Historical Books and Letters (prose text); English running heads in Letters and Revelation; all footnotes in the book of Revelation

Other Team Members

> Mabel Jackson: Partner
> Rebecca Cherry, Rachel Collard, Jane Grayer: Project manager
> Sarah Harris: Studio manager
> Vin Godier: Designer and IT consultant; computer graphics
> Sally Sargeant: Proofreader
> Christopher Calderhead: Hebrew script (notes), with Donald Jackson and Izzy Pludwinski (consultant and scribe)

Committee on Illumination and Text

Michael Patella, OSB, SSD, is both professor of New Testament at the School of Theology·Seminary of Saint John's University, Collegeville, Minnesota, and seminary rector. In addition to serving as chair of the Committee on Illumination and Text (CIT) for *The Saint John's Bible*, he has written *The Death of Jesus: The Diabolical Force and the Ministering Angel* (Paris: Gabalda, 1999); *The Gospel according to Luke*, New Collegeville Bible Commentary Series (Collegeville, MN: Liturgical Press, 2005); *The Lord of the Cosmos: Mithras, Paul, and the Gospel of Mark* (New York: T&T Clark, 2006); *Angels and Demons: A Christian Primer of the Spiritual World* (Collegeville, MN: Liturgical Press, 2012); and *Word and Image: The Hermeneutics of* The Saint John's Bible (Collegeville, MN: Liturgical Press, 2013). He has been a frequent contributor to *The Bible Today* and is a member of the Catholic Biblical Association.

Susan Wood, SCL, is a professor of theology at Marquette University, Milwaukee, Wisconsin. She taught in both the theology department and School of Theology at Saint John's University for twelve years and was the associate dean of the School of Theology for five years. She earned her bachelor's degree at Saint Mary College in Leavenworth, Kansas; her master's degree at Middlebury College, Middlebury, Vermont; and her doctorate degree at Marquette University, Milwaukee, Wisconsin.

Columba Stewart, OSB, is the executive director of the Hill Museum and Manuscript Library (HMML), the home of *The Saint John's Bible*, where he has developed HMML's projects of manuscript digitization in the Middle East. Having served on the CIT and as curator of special collections before becoming director of HMML, he often speaks about how *The Saint John's Bible* expresses the vision for the book arts and religious culture at Saint John's University. Father Columba has published extensively on monastic topics and is a professor of monastic studies at Saint John's School of Theology. He received his bachelor's degree in history and literature from Harvard College, his master's degree in religious studies from Yale University, and his doctorate in theology from the University of Oxford.

Irene Nowell, OSB, is a Benedictine from Mount St. Scholastica in Atchison, Kansas. She is an adjunct professor of Scripture for the School of Theology at Saint John's University. Sister Irene received her bachelor's degree in music from Mount St. Scholastica College in Kansas and master's degrees in German and theology from The Catholic University of America and Saint John's University. She holds a doctorate in biblical studies from The Catholic University of America.

Johanna Becker, OSB (1921–2012), a Benedictine potter, teacher, art historian, and Orientalist, combined these in the different facets of her work. As a teacher in the art department of the College of Saint Benedict and Saint John's University, she taught both studio classes (primarily ceramics) and art history, focusing in later years on the arts of Asia. As a specialist in Asian ceramics, particularly those of seventeenth-century Japan, she did connoisseurship for public and private museums, published a book, *Karatsu Ware*, and wrote and lectured worldwide. Her art history classes benefitted from the years she lived in Japan and her time spent in the majority of Asian countries as an art researcher. Sister Johanna held a bachelor of fine arts degree from the University of Colorado, a master of fine arts degree in studio art from Ohio State University, and a doctorate in art history from the University of Michigan. She was a member of the Monastery of Saint Benedict, St. Joseph, Minnesota.

Nathanael Hauser, OSB, is an artist who works in egg tempera, enamel, calligraphy, and mosaic. While teaching art history as an associate professor at Saint John's University, he also taught calligraphy and the theology and practice of icon painting. Father Nathanael has undertaken commissions for churches, monastic communities, and private collections, creating icons, enameled crosses, calligraphy books, reliquaries, and Christmas crèches. His work and papers have been exhibited and presented in the United States and Rome, Italy. Father Nathanael received his bachelor's degree in philosophy from St. John's Seminary College in Camarillo, California. He received his STB from the Pontificio Ateneo di Sant'Anselmo, Rome, and his doctorate in classical and medieval art and archeology from the University of Minnesota.

Alan Reed, OSB, is the curator of art collections at the Hill Museum and Manuscript Library. Brother Alan previously taught design and drawing in the joint art department of Saint John's University and the College of St. Benedict for twenty-five years and, toward the end of that time, was chair of the department for six years. He has a bachelor of arts degree from Saint John's University in studio art, a master of art education from the Rhode Island School of Design, and a master of fine art from the University of Chicago in studio art and art theory.

Ellen Joyce teaches medieval history at Beloit College in Beloit, Wisconsin. Her research interests are in the role of visions and dreams in medieval monastic culture. She also has a passion for the study of illuminated manuscripts and their production and often teaches courses on topics related to books and their readers in the Middle Ages. She served on the CIT while she was employed at the Hill Museum and Manuscript Library and teaching at Saint John's University. Dr. Joyce received her master's and doctoral degrees from the Centre for Medieval Studies at the University of Toronto and her undergraduate degree in humanities from Yale University.

Rosanne Keller (1938–2012) was a sculptor whose work is on permanent display throughout the United States and the United Kingdom. In 1993 she was commissioned to create a ceramic Buddha and eight ritual vessels for the private meditation room of His Holiness, the Dalai Lama. Her sculpture can be seen at St. Deiniol's Library and St. Bueno's Jesuit Retreat Center in Wales; Saint John's University and the St. Cloud Children's Home in Minnesota; Exeter Cathedral; Taize, France; and on the campus of Texas Woman's University. She published a book on pilgrimage, *Pilgrim in Time*, and a novel, *A Summer All Her Own*, as well as texts for literacy programs.

David Paul Lange, OSB, a monk, artist, and teacher, has been a member of the art department of Saint John's University and the College of Saint Benedict since 2001. He has a bachelor's degree from Saint Olaf College in philosophy and a master of fine arts in studio art from the University of Southern Illinois at Edwardsville. A sculptor by training, Brother David Paul also teaches modern contemporary art history and theory, drawing, and foundations.

Brother Simon-Hòa Phan is an associate professor of art at Saint John's University. He holds a bachelor of arts in philosophy from Saint John's Seminary, Camarillo, a bachelor of arts in religious studies from Louvain, a bachelor of fine arts in painting from the Maryland Institute, and a master of fine arts in film and video from California Institute of the Arts. A member of the CIT since 2008, he served as artist advisor for the Bible Project.

Other members of the broader Saint John's community, including Susan Brix, Jerome Tupa, OSB, and David Cotter, OSB, have served at various times on the Committee on Illumination and Text.

Bible Project Director
Valerie Kolarik (1999)
Carol Marrin (2000–2008)
Tim Ternes (2008–present)

Bible Project Leader
Michael Bush (2010–present)